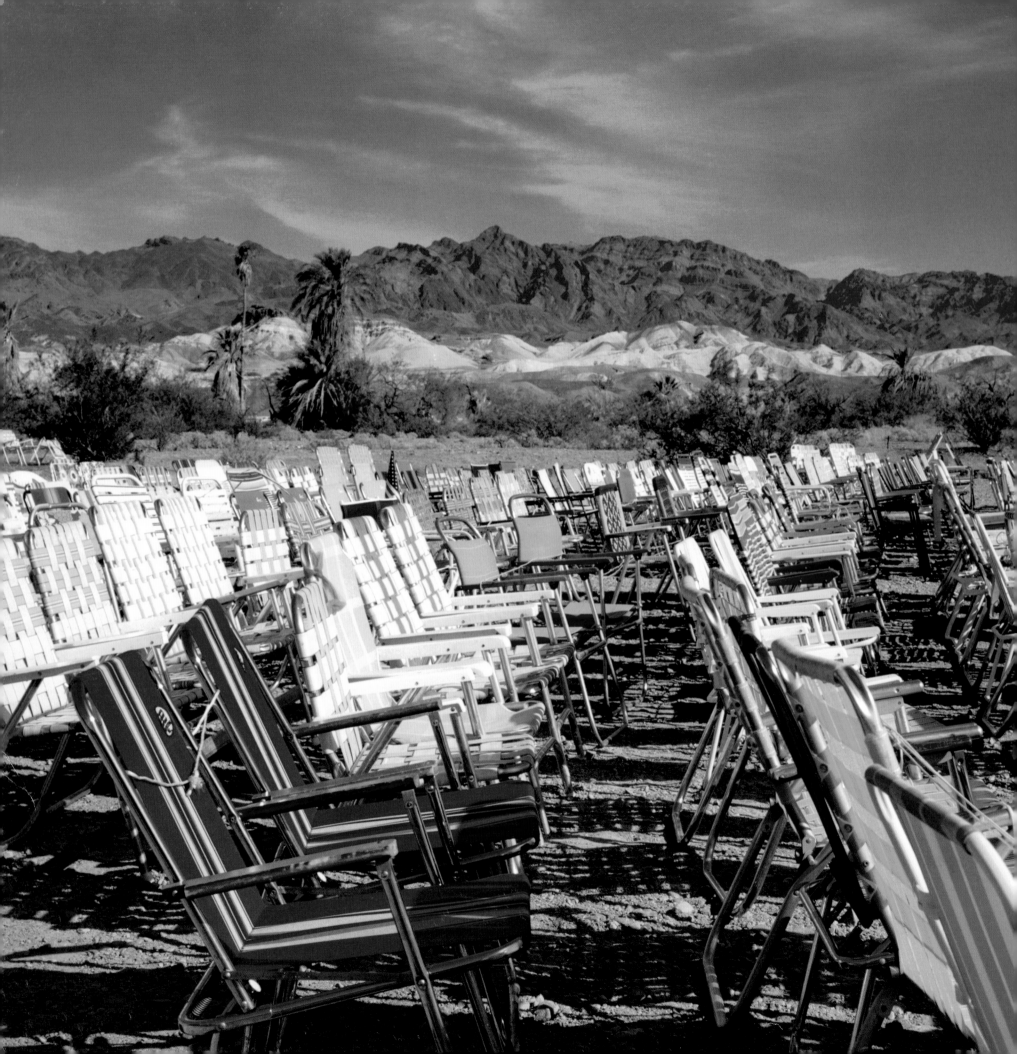

Where We Live

PHOTOGRAPHS OF AMERICA

from the Berman Collection

Judith Keller and Anne Lacoste

With essays by
Kenneth A. Breisch
Bruce Wagner
and Colin Westerbeck

THE J. PAUL GETTY MUSEUM

LOS ANGELES

© 2006 J. Paul Getty Trust
Second printing 2007

"Chorus: The Spirit Room" © 2006 Bruce Wagner

Published in conjunction with the exhibition
*Where We Live: Photographs of America from
the Berman Collection*, held at the J. Paul Getty
Museum, Los Angeles, October 24, 2006–
February 25, 2007.

Getty Publications
1200 Getty Center Drive
Suite 500
Los Angeles, California 90049-1682
www.getty.edu

Mark Greenberg, *Editor in Chief*

John Harris, *Editor*
Jim Drobka, *Designer*
Stacy Miyagawa, *Production Coordinator*

Index by Columbia Indexing Group
Typography by Diane Franco
Printed in Italy
Bound in Germany

FRONT COVER: Doug Dubois, *My Sister, Lise and
Spencer*, New Jersey, 1999 (detail). PLATE 53.

FRONTISPIECE: Karen Halverson, *Furnace Creek,
Death Valley, California*, 1992 (detail). PLATE 160.

LIBRARY OF CONGRESS
CATALOGING-IN-PUBLICATION DATA

Keller, Judith.
 Where we live : photographs of America from the
Berman collection / Judith Keller and Anne
Lacoste ; with essays by Kenneth A. Breisch, Bruce
Wagner, and Colin Westerbeck.
 p. cm.
 "Published in conjunction with the exhibition of
the same name at the J. Paul Getty Museum,
October 24, 2006–February 25, 2007."
 Includes index.
 ISBN-13: 978-0-89236-854-9 (hardcover)
 ISBN-10: 0-89236-854-3 (hardcover)
1. Documentary photography—United States—
Exhibitions. 2. Photography, Artistic--Exhibitions.
3. Berman, Nancy M.—Photograph collections—
Exhibitions. 4. Berman, Bruce—Photograph col-
lections—Exhibitions. 5. J. Paul Getty
Museum—Photograph collections—Exhibitions. 6.
Photograph collections—California—Los
Angeles—Exhibitions. I. Lacoste, Anne. II. Breisch,
Kenneth A. III. J. Paul Getty Museum. IV. Title.
 TR820.5K37 2006
 779'.473092—dc22
 2006011512

CONTENTS

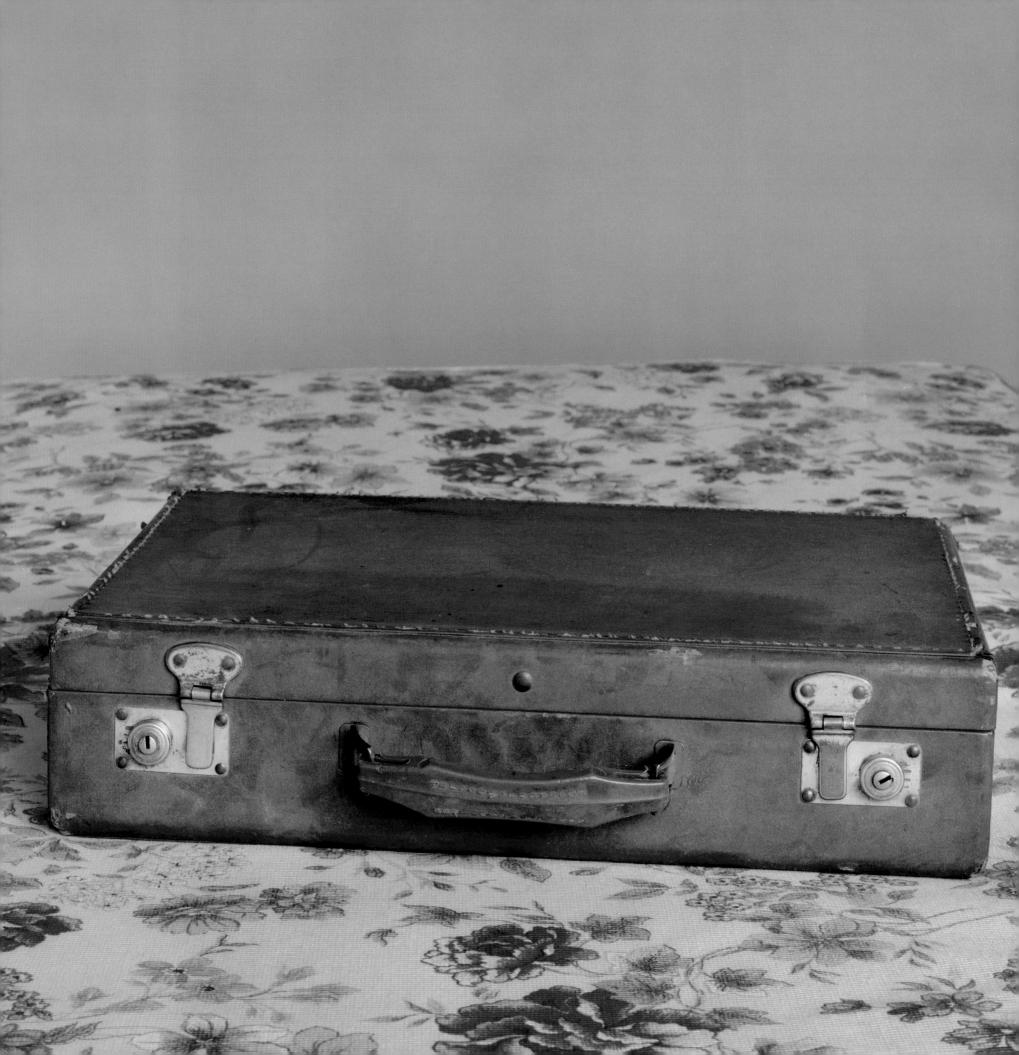

The photographs collection of the J. Paul Getty Museum is remarkable among those of art museums worldwide for its combination of quality, depth, breadth, and accessibility. Created in 1984 by bringing together a number of exceptional American and European private collections, it is also unique among its sister collections at the Getty Museum as the most recently founded. While the collection has grown and filled out significantly in the intervening twenty-two years, it is still characterized by the special strengths and idiosyncrasies of those original private collections. More recently, a new generation of collectors has begun to leave its mark on the Museum's holdings. Few have done so more vigorously—or generously—than Los Angeles collectors Nancy and Bruce Berman, who over the past eight years have been great supporters of our Department of Photographs. *Where We Live: Photographs of America from the Berman Collection* stands as a testament to their discerning eye and the lasting contribution they have made to the character of the Getty Museum collection.

The Bermans' first gift of 198 photographs was made in 1998, heralding the transformation of the Museum's collection of American color photography. Our 1999 exhibition *William Eggleston and the Color Tradition* included a gallery dedicated to works from that first gift, tracing the rise of color photography as an American art form in the years following William Eggleston's landmark 1976 exhibition at the Museum of Modern Art in New York. Over the years the Bermans' generosity to the Museum has continued: they have donated more than 450 photographs to the Getty, and in 2005 Bruce Berman became a founding member of the Photographs Council, a group that supports the Museum's acquisitions, publications, and programs in contemporary photography.

Signaling the Getty's continually increasing commitment to the art of photography, *Where We Live* and the exhibition it accompanies commemorate the opening of the Museum's newly renovated and expanded galleries for the display of photographs. The new galleries are larger and more flexible, allowing us to expand and vary the scope of our photography programs. Plans are also under way for the expansion of cold storage facilities that house color photographs under optimal conditions, which will enhance our ability to build and share this part of our collection.

In Los Angeles there is a tremendously vibrant community for the production, display, and appreciation of photographs, an inspiring atmosphere for museums and collectors alike. We at the Getty Museum strive to contribute to this; there is no doubt that we benefit from it. We are fortunate each year to receive gifts of photographs from collectors from around the world, but Los Angeles-area collectors unquestionably have been among the most active. They are clearly attracted at least in part by our enormously talented curatorial and conservation staff, our active program of path-breaking exhibitions and publications, and our state-of-the-art storage facilities.

I am extremely grateful to Weston Naef, the Getty Museum's curator of photographs, for his dedication to the collection, for nurturing its growth, and for overseeing this project. I am also indebted to our associate curator, Judith Keller, whose freely shared passion for the art of American photography has drawn the Bermans and many others into the Museum's orbit, and who was responsible for shaping this exhibition and publication, aided by assistant curator Anne Lacoste. Most of all, however, I thank Nancy and Bruce Berman, both for their ongoing generosity and for sharing a vision of America—at once grand and intimate—that makes *Where We Live* so hauntingly memorable.

Michael Brand
Director
The J. Paul Getty Museum

Mitch Epstein, *Dad's Briefcase,*
2000 (detail). PLATE 21.

PREFACE AND ACKNOWLEDGMENTS

In the fall—right after Labor Day—I'm going to learn about my country. I've lost the flavor and taste and sound of it. It's been years since I have seen it.... I'm going alone ... I'll avoid the cities, hit small towns and farms and ranches, sit in bars and hamburger stands and on Sunday go to church.
— JOHN STEINBECK, from his introduction to
Travels with Charley, In Search of America (1962)

John Steinbeck had been living in New York for decades when he wrote these words to a friend in 1960. Originally from California, he knew that New York was not America. Neither is "beautiful downtown Burbank," the running joke that Nebraska-born Johnny Carson made famous for decades on *The Tonight Show*. Burbank, just east of Los Angeles, consists mainly of the NBC studios, the Disney studios, and, most importantly for our purposes, the 108 acres of the Warner Brothers studios. While Burbank is definitely not America, it is where Bruce Berman works and where a good portion of his expanding collection of American photographs can be found. The pictures cover the walls of the lobbies, offices, and halls in Berman's ninth-floor suite at the new Warner Brothers Corporate Building on Burbank's Riverside Drive. Above his desk hangs a sign: FUTURE SITE OF THE PAST by Oreste Selvatico. Johnny Carson would have appreciated the wit; John Steinbeck would have appreciated the sentiment.

Bruce Berman—a New Yorker who studied law at Georgetown University and filmmaking locally at CalArts—moved to Los Angeles in 1979 and quickly began rising through the ranks of Hollywood executives. He started at Universal and soon moved over to Warner Brothers; by 1989 he was president of the company's worldwide production. He had also become a serious collector, initially of indigenous crafts such as Navajo blankets and American quilts. This changed when he encountered the recently opened Gallery of Contemporary Photography on Main Street in Santa Monica. Berman was one of the first patrons of Rose Shoshana's gallery (now relocated to the Bergamot Station complex, expanded and renamed the RoseGallery). In the early nineties he began to find his way to the artists and images that spoke to him.

His interest in photography had its own history: he had won a prize for his photographs in high school. Now that he had discovered photography as an area of collecting, Berman realized he might vicariously practice the art through the work of

Oreste Selvatico, *Future Site of the Past*, 2001. Hand-painted banner on cotton duct, 81.3 × 162.6 cm (32 × 64 in.). Collection of Nancy and Bruce Berman. © M. C. McMillen.

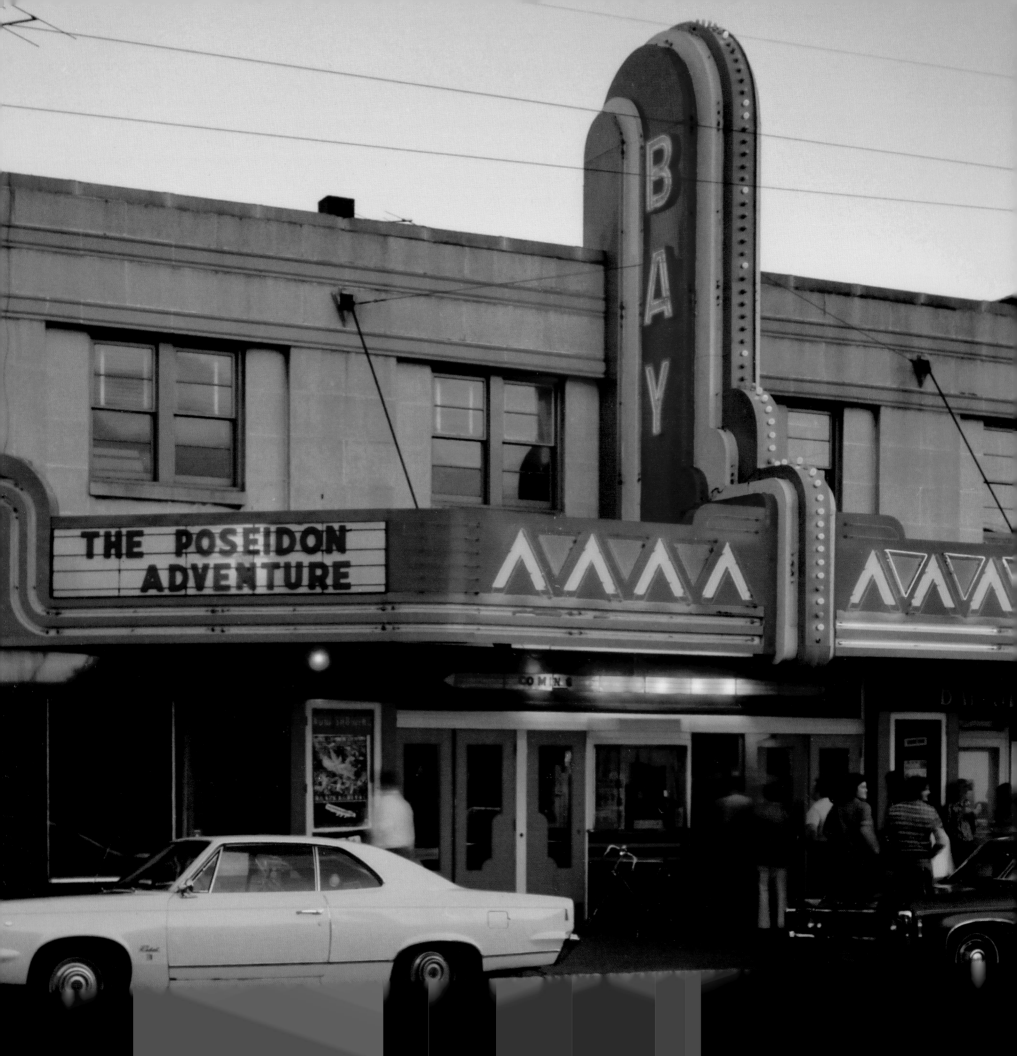

others. He had long admired regional American painting of the 1920s and 1930s and had been introduced to the work of Walker Evans. As a novice collector, though, he felt that the work of Evans was beyond his reach. Instead he decided to combine his respect for Midwestern painters (such as Grant Wood and Thomas Hart Benton) and his love of the bold colors of Indian weaving and Anglo quilts—not to mention his affection for Technicolor movies—into a search for color photographs of the American landscape and built environment.

With the continuing advice and encouragement of Rose Shoshana, he has, over the past fifteen years, amassed several thousand color and black-and-white prints by more than a hundred photographers. This personal collection could be described as an archive of late twentieth-century American life. Berman himself refers to it as a private attempt at "visual preservation." This archive—Andy Warhol might have called it a time capsule—is not the achievement of an enlightened federal agency or part of a national documentary program. No, the images in the Berman Collection—many in the style that Evans called "transcendental documentary"—are the personal recognition by an outstanding collector and by thoughtful, talented photographers that these barns, churches, billboards, these Main Streets, will quickly become part of our past. This collection is, then, the future site of the past, and we are in Bruce Berman's debt for helping to preserve these irreplaceable images so that we—like John Steinbeck—can learn about our own country—"the flavor and taste and sound of it."

To create this record of Nancy and Bruce Berman's collection, and their generous gifts to the Getty Museum, many departments have contributed their considerable talents.

In the Department of Photographs, our colleague Brett Abbott persistently kept the loan and gift procedures on track. The staff of Stanley Smith's newly formed Imaging Services Department applied their digital expertise to the exacting work of reproducing fine color photography; particular thanks go to Gary Hughes, Michael Smith, and Stacey Rain Strickler. In Getty Publications, Jim Drobka, John Harris, and Stacy Miyagawa helped to shape this material according to the Getty's highest standards to ensure a final product that is a thing of beauty as well as a trove of information.

This first exhibition in the new photography galleries was realized with the assistance of designers Leon Rodriguez and Michael Lira, Bruce Metro's hardworking Preparations crew, the editorial patience of Catherine Comeau, and the scheduling acumen of Quincy Houghton's Department of Exhibitions. Deserving enormous thanks for their close attention to this project are Lynne Kaneshiro and Matthew Clark of the Department of Paper Conservation. Marc Harnly, head of Paper Conservation, and assistant conservator Ernie Mack consulted with them as they prepared this extensive show for our expanded galleries.

The wide-ranging knowledge and styles of three guest authors—art historian Kenneth A. Breisch, novelist Bruce Wagner, and critic and curator Colin Westerbeck—helped to meld the photographic imagery of twenty-four photographers into a coherent whole. We are grateful to the authors, the photographers, and the Bermans for their insights into turn-of-the-twenty-first-century American culture and for their cooperation in helping us to make it available to the widest possible audience.

Finally, Bruce Berman himself would like to express his gratitude to Rose Shoshana for her continual encouragement and her finesse at being both an art dealer and friend; to Lea Russo for her hard work and attention to detail in managing his collection; and to Laura Peterson for her wit and style.

Judith Keller and Anne Lacoste
Department of Photographs

Stephen Shore, *2nd St., Ashland, Wisconsin*, July 9, 1973 (detail). PLATE 140.

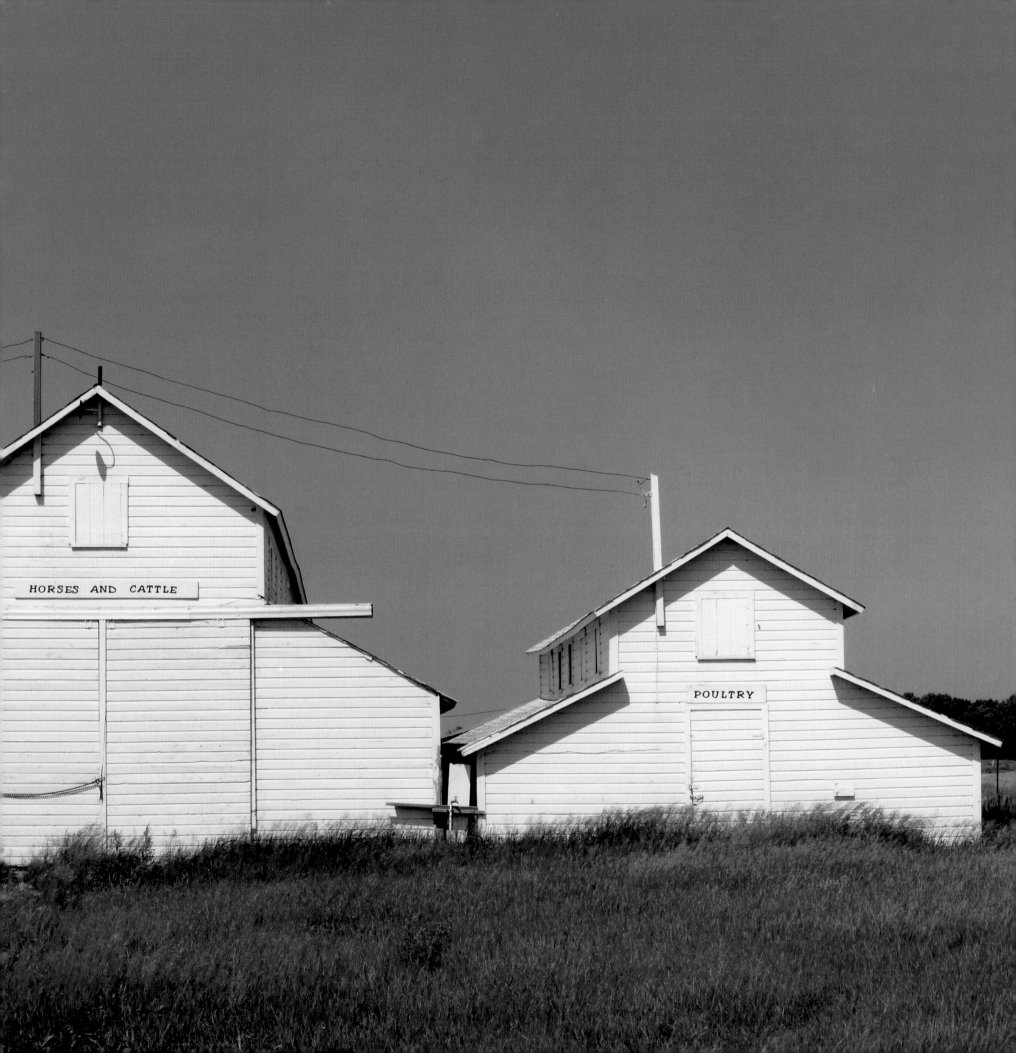

The Scenic Route

A PHOTOGRAPHIC SIDE TRIP THROUGH AMERICA TODAY

Colin Westerbeck

In *American Independents*, Sally Eauclaire said that the photographer Jim Dow takes pictures of "what is quintessentially American…old movie theaters, diners, motels, billboards, barbershops, Masonic lodges, and other vestiges of Americana that have not yet been updated for assimilation into the amorphous middle-American mainstream."[1] This list of subjects, though compiled almost twenty years ago, could serve as a guide to the Berman Collection. Most private collectors devote themselves to connoisseurship and subscribe to an auteur theory of photography. They collect a limited number of masters in as great a depth as time and money permit. That Bruce Berman has a different agenda is obvious from the fact that, if he can't find a rare vintage print, he's happy with a later reprint: the image is what matters. He has collected work by an unusually large number of photographers because certain subjects interest him more than photographic careers. Berman owns a group of Jim Dow prints because Dow has focused on the subject matter Berman thinks important.

Berman is the chairman of Village Roadshow Pictures, a prominent production company affiliated with Warner Brothers, but a profile of him as a photo collector published last year in *Art and Auction* declares that "the collection has almost nothing to do with the movie business."[2] I'm not so sure about that. Among the hits he has had are *Goodfellas*, *Training Day*, *Ocean's Eleven*, *Mystic River*, and the *Matrix* films. All are movies that capture the atmosphere—the mise-en-scène, in filmmaker lingo—of some aspect of American culture whose values and way of life are fast disappearing or have already been left behind by the mainstream culture. Even the *Matrix* films, despite their futuristic effects, are really about how to keep alive in cyberspace the tribal

David Husom, *Big Stone County Fairgrounds, Clinton, MN,* 1980 (detail). PLATE 90.

loyalties and rugged individualism of yesteryear. The photography Berman collects is a record of such ways of life, and of their disappearance.

Remembering the coast-to-coast drives he used to do commuting from California to Washington, D.C., when he was in college over thirty years ago, Berman has said, "I love road trips.... You could say this collection [of photographs] is one very big road trip, where I went way, way off the interstate."[3] You might also wonder whether he wasn't attracted to the top position at "Village Roadshow" because he sees the sort of movies he likes to make as a similar journey off of the main highways of American life. Certainly the photographers he has preferred have almost all gotten off the beaten track to make their pictures.

Robert Adams, for one, has echoed Berman's injunction about how to see the country. He wants people to be able to hear in his photographs the silence inherent in life on the prairie—"a silence in thunder, in wind, in the call of doves, even in the closing of a pickup door." Because he feels that being able to hear what is silent will help you see what is otherwise invisible, Adams admonishes his viewers, "If you are crossing the plains, leave the interstate and find a back road on which to walk; listen."[4] The landscapes and people the photographers in Berman's collection have found by taking these side trips are the ones Berman might most like to reach with his movies—the ones in which the last vestige still survives of the values eulogized in his films. The photographs he collects reassure him that at least some of those places and people are still there.

The photographs that Berman has donated to the Getty Museum form a kind of matrix themselves. Because they are by so many different hands, yet share a core set of concerns and themes, they represent a network in which one might begin at any intersection and, proceeding in any direction, eventually discover all the principles that the collection as a whole contains. Jim Dow's photographs are as good a place as any to begin. The barbershops that Sally Eauclaire mentioned as a favorite Dow subject (PLATE 131) are also to be found in the work of George Tice, whose 1970 study from Paterson, New Jersey, is lit by the nostalgia of late-afternoon sunlight (PLATE 2). Dow's photograph of this subject, made a decade later and 1,500 miles away in Texas, seems less deserted somehow, despite having, like Tice's image, neither barbers nor customers in view.

Photographers are also collectors, in a sense; they collect certain subjects just as Berman collects their photographs. Another subject in which Dow has specialized is roadside signs from the era when vernacular sign painters served the needs of local businesses. Signs like the one for "The Warrior Motel" photographed by Dow (PLATE 167) have been collected by the photographer William Christenberry too, and not just in photographs, but as actual objects.[5] Dow, who first photographed these roadside artifacts twenty-five years ago on a commission from the North Dakota Museum of Art, has recently returned to survey the subject again. Similar reprises are found in the work of other photographers, some of whom have returned not just to the same subject matter but to the exact same examples that they photographed anywhere from a few months to many years earlier.

Thus did Gregory Spaid photograph the same barn in two seasons in 1992 (PLATES 81, 82), while Camilo José Vergara has made return visits years apart to the same tumbledown mansion in Detroit and the same storefront church in Chicago (PLATES 55, 56, 119, 120). The grand homes, now abandoned, that Vergara has photographed in Detroit are what he calls "ghosts of deindustrialization." The decimation

SPAID

PLATE 81

VERGARA

PLATE 55

PLATE 56

DOW

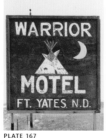

PLATE 167

PLATE 82

DOW

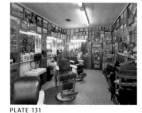

PLATE 131

TICE

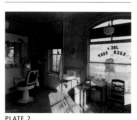

PLATE 2

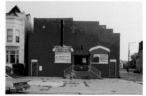

PLATE 119

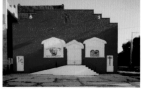

PLATE 120

of entire neighborhoods that they represent has followed upon the collapse of the city's economy. He returned to such sites again and again because he had, as he put it, "a fixation with keeping a record of what was declining, disintegrating, falling into ruin."[6] Now his obsession with photographing subjects of this type has led him to form a "New American Ghetto Archive" consisting of nine thousand slides of his own making.[7]

Although he began photographing in 1965 when he was in college, his major was not photography or the fine arts; it was sociology, which he pursued further as a Ph.D. candidate. His ambition was not to take pictures but to make picture-taking into a rigorous science, a methodology for capturing data from which an archive could be built. Photographer Sheron Rupp also earned her undergraduate degree in sociology, while Rhea Garen's was in biology; and Garen and Mary Kocol both support their personal photography by working professionally as photo archivists at major universities. Even for the photographers in the collection whose education was in photography itself, their commitment to the medium has often been subsumed under what they see as larger concerns that their pictures must serve. This is why Robert Dawson has done an extensive documentation of California's Central Valley (PLATE 80) and cofounded the photographic collaborative "Water in the West."

Like photographers who get off the interstate to wander the back roads, we'll discover some key connections we might otherwise have missed if we spend a little time going from one photographer to another by chance turnings. An experience that the photographic team of Virginia Beahan and Laura McPhee had in rural California demonstrates how photographers get to their best subjects only by stumbling upon them. The two women were looking for a place that Laura's father, writer John McPhee, had seen a decade earlier—a canyon filled to the brim with old tires. But taking a wrong turn, they wound up instead in an almond grove so beautiful it could have been the setting for an ancient poem (PLATE 158).[8] From by-ways in the industrial wasteland of New Jersey, Beahan and McPhee have watched cars whiz by on the Jersey Turnpike with the same pity for the drivers that Berman or Robert Adams might feel watching from a country road. Beahan and McPhee believe that, even in this much-degraded and largely forsaken terrain, there are many history lessons that those hurrying past will miss, but need.[9]

Beahan and McPhee grew up in the Trenton area—George Tice territory—and have photographed some of the same places he has, including Carteret, where Tice once made a photograph of a trailer park in which he had lived as a boy (PLATE 6). Even in this setting, Beahan and McPhee can find scenes that they associate, unlikely as it may seem, with extensive photographic studies they have done in Hawaii (PLATE 63). These are what they refer to by the Hawaiian term *kipuka*, which is an isolated area of a volcanic field that the lava flow has gone around and spared. (Under the tutelage of Laura's father, the two photographers have learned as much about geology and plate techtonics as Vergara knows about sociology.) As John McPhee put it, "Instinctively, Laura and Virginia were drawn off the turnpike and into the kipukas of Carteret, where bungalows with picket fences survive the industrial magma."[10] From Northampton, Massachusetts, to Walltrace, Tennessee, Sheron Rupp has photographed people in the gardens that are their own private kipukas (PLATES 64–67). All the photographers in the collection are searching, along with Berman himself, for a hidden sanctuary or a last refuge like this—for a kipuka.

RUPP

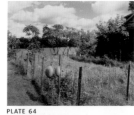

PLATE 64

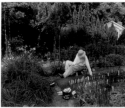

PLATE 65

PLATE 66

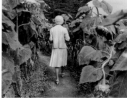

PLATE 67

DAWSON

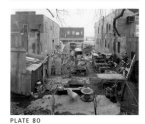

PLATE 80

BEAHAN AND MCPHEE

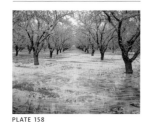

PLATE 158

TICE

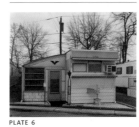

PLATE 6

BEAHAN AND MCPHEE

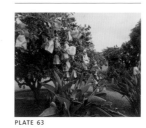

PLATE 63

Once you begin to trace all these little intersections between the backgrounds and the preoccupations of the photographers, more substantial patterns begin to emerge. Besides the coincidences between their careers and Jim Dow's, Vergara, Tice, and Christenberry have something else in common: in a distinct and peculiar way, the photographic career of each has grown out of his family history. All three came from families that were once grand, or at least better off, but had fallen on hard times before the photographer was born. As mentioned above, Tice grew up partly in a trailer park, and from there his family moved, he has said, "back to the projects in Newark." Yet he is a ninth-generation New Jerseyite whose forebears arrived in the Dutch colony of New York in 1663 and were prosperous enough by 1709 to buy five hundred acres in present-day Monmouth County, New Jersey, where Tice still lives. The photographic mission he has been on in recent years he calls "Ticetown," an attempt to document the traces, now all but obliterated, that his family has left on the New Jersey landscape.

Such a history cannot help affecting a photographer's outlook. The "Statement" Tice wrote for his 1972 book *Paterson* is a dour one. He decided to photograph Paterson because, returning from a trip to sunny California, he saw New Jersey through fresh eyes as "a time-colored country, almost an ancient civilization." He spoke of "all the people who have passed through Paterson, spending their lives on the way, the diminishing quality of their lives." Having begun thus, he ended his statement with the poignant observation that the last time he'd visited the city, he saw "a sign in front of a union hall. It read: THIRTY YEARS AND OUT." [11] His photographs of Paterson—Joe's Barbershop (PLATE 2), a girl's bedroom with its neat display of cute stuffed animals (PLATE 5), a 1950s Oldsmobile with a sporty continental kit and a for-sale sign on it looking woebegone in a drab driveway (PLATE 1)—are all in keeping with the tone of his words.

The Christenberrys had neither the august heritage of the Tices nor the considerable wealth that (as we shall see) the Vergara family had. But until shortly before William was born, they had been self-sufficient farmers in the red-dirt region of Hale County, Alabama, the descendants of a long line of, as Allen Tullos put it in a biographical essay on Christenberry,

"smallholders, neither slave owners nor tenants." By the time Christenberry was about to be born, though, the Depression had pushed his family off their land and into the subsistence living conditions of a wage job at a bakery in Tuscaloosa. The pay was so meager that William Senior didn't have money for a doctor to deliver his son, and all the family had to eat was the loaf of bread a day that came with the job. [12]

Although Christenberry has come far as an artist—not only a photographer but a sculptor and creator of installation pieces—all his work has had its roots in the hard-scrabble Alabama of his youth. His photograph *Black Buildings* (PLATE 83) makes it look as if the scorched earth that the Union Army left behind in much of the South took seed there, like kudzu, and has blighted the countryside ever since. "The family's involvement or attachment with [Hale] County…can't help but affect the way I see it," he has written. "For someone who has never really toiled there,… eking out a living, this may be difficult to understand. But I have a very clear and sometimes terrifying and certainly intense view of it." [13]

Vergara's story is different because he has done his photography far from the scenes of his early life in Chile that, nonetheless, have shaped his whole career. His grandfather had owned one of the country's finest haciendas, but by the time that the photographer was an adolescent, he had seen "this…seemingly endless wealth vanish, leaving me with an enduring feeling that things cannot last, and filling my mind with ghosts….Close, sustained encounters with poverty have shaped my character and driven me, perhaps obsessively, to the ghettos." In America, he has made a secure, fulfilling, middle-class life for himself and his family, and yet, he confesses, "I feel that this comfortable existence is transitory."

TICE

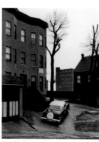

PLATE 2

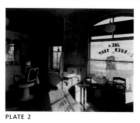

PLATE 1

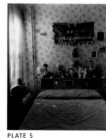

PLATE 5

CHRISTENBERRY

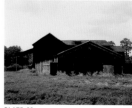

PLATE 83

This sense of irreparable loss resonates with feelings that David Husom had early in his working life. His vocation in photography found its purpose when he made a sentimental journey back to Grand Rapids, Minnesota, "to photograph an art deco gas station I had always liked," he has explained. "I was shocked to find it was gone."[15] This was what set Husom on his career path photographing another endangered species of buildings, the livestock barns on county fairgrounds (PLATES 84–92). Vergara had a similar experience, though it came as a capstone to his career rather than a cornerstone. After all those years of being haunted by his ghosts of destitution and loss, he returned to Rengo, Chile, in 1990 to revisit the house where he grew up, and was stunned to find it "completely gone."[16] Tice, the most pessimistic and stoical of all these photographers, has said flatly that whenever he makes a photograph, "I contemplate how [it] will be seen in the future when the subject matter no longer exists."[17]

Other photographers in the collection have been involved in their work on an equally personal and sometimes even more immediate level. The most obvious example is Mitch Epstein, whose documentation of the last days of his eighty-two-year-

old father's real-estate and furniture business would constitute, as the photographer recognized when he assigned himself the project, a record of the collapse of the entire city of Holyoke, Massachusetts, where he'd grown up. Epstein wisely saw that in order for his document to be a valid one, the only emotions present had to be those that inhered in the events, not any that he himself injected as the photographer of them. As a result, the photographs that are most affecting look almost like spreadsheets, as if they were an accountant's report on a bankruptcy; they are as abstract as a pattern of columns and rows where each calculation gets entered without comment into its appropriate little box.

An office wall on which the keys to all his father's derelict rental properties are hung (PLATE 22) forms the same sort of grid that a neglected game board filled with numbered markers does, now covered with leaves and trash in a park on Mt. Holyoke that no one seems to visit anymore (PLATE 25). The field of stars on an American flag, neatly folded, and perhaps forgotten, in a cleaner's bag hung on a wall (PLATE 20), fits the pattern as well, as does the old-fashioned ice-crystal design on the glass in the door to his father's office marked PRIVATE (PLATE 24). And alternating with all these details are one photograph after another of boarded-up buildings whose rows of identically blank windows and doors are, in effect, the crypts in which both his father's life and that of his hometown are interred (PLATES 17, 18).

HUSOM

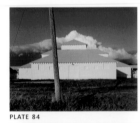

PLATE 84

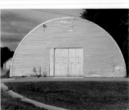

PLATE 87

PLATE 90

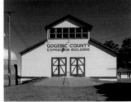

PLATE 85

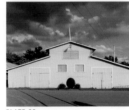

PLATE 88

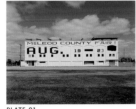

PLATE 91

PLATE 86

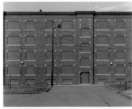

PLATE 89

PLATE 92

EPSTEIN

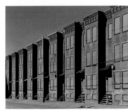

PLATE 17

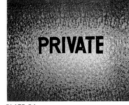

PLATE 22

PLATE 18

PLATE 24

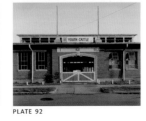

PLATE 20

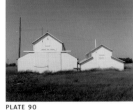

PLATE 25

The narrative that Epstein has written to accompany the photographs is equally dispassionate and, therefore, compelling. Shooting videotape as well as film, he reports at one point, "I'm torn between continuing to film and putting the camera down to give Dad a hand. It's only two weeks since he had his pacemaker implanted." And, a little later, as his father and an assistant are trying to plug in a refrigerator that's in the furniture store's going-out-of-business sale: "He and Charlie struggle to push it to an outlet, and I ask myself, yet again: do I stop filming and start helping? I keep filming."[18] The photographer who has confronted this issue most agonizingly is Doug Dubois. He also photographed his family in a time of crisis, when a serious injury his father had suffered was compounded by the nervous breakdown this induced in his mother. Because the insistence with which Dubois questioned his own motives and values in this situation makes him a spokesman for many of the photographers in the collection, his words are worth quoting at length:

> When I photograph I can be overwhelmed with anxiety. The camera marks me as an outsider; its presence denies my full participation.…With my family, this anxiety has occurred so often that I feel I must be encouraging it. Perhaps I equate the tension with the intimacy I desire in my photographs. I take it as a sign that I am encountering difficult emotions, the ones I think produce the best pictures.…In my most intimate photographs there is a detachment that speaks of my isolation.…In the conflict between intimacy and detachment, I feel the loss of my childhood family.[19]

The photographic series that prompted these reflections Dubois published in 1989 as *Family Photographs*, a title echoed in Epstein's *Family Business*. Shortly thereafter, in another family project, Dubois began to include strangers, but with the same strictures and misgivings in force.

His grandmother's memories of the hard times she had endured in Avella, a Pennsylvania coal town, inspired Dubois to go back with her and photograph what life was like for the people still living there (PLATES 7, 8). Again, he has written eloquently of the experience: "My grandmother insists she doesn't dream. I don't believe her. When she wakes up from her nap she tells stories.… It rained the day of our trip. I saw Avella through a fog of moisture and listened to my grandmother over the wheeze of the window defroster. It was like driving through my grandmother's dreams."[20] A photograph that harks back to his grandmother's era there seems veiled in memory because of the way a tree outside is softened in outline by a curtain rotting on the bedroom window of an abandoned coal-company house (PLATE 15). Life as lived there now also has a dreaminess to it, though of a different quality. A picture of a family with whom he struck up an acquaintance shows the kids and adults scattered around the sidewalk in front of their house with the degree of disrelationship to each other that figures have in Surrealist landscapes (PLATE 11).

The similarity of this photograph to one that Adam Bartos made at a state park on Long Island, New York, is evocative (PLATE 28). It suggests that Bartos is one of the photographers for whom Dubois may have been speaking in his comments on his own work. Bartos was also working with strangers, and the result is a scattered composition just like Dubois's, an effect that's enhanced by the gauzy mosquito netting through which it was shot. This makes the scene look as if it weren't quite real, as if vaguely apparitional, like a half-lost memory or something experienced in a dream through the haze of sleep. A number of Bartos's images at this park were made through the time filter that such netting

BARTOS

PLATE 28

PLATE 29

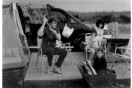
PLATE 30

DUBOIS

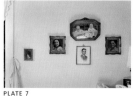
PLATE 7

PLATE 8

PLATE 11

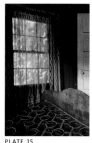
PLATE 15

would seem to provide; and even when the view is sharp, the moment chosen still looks blurred emotionally. Kids, in particular, are listless and bored in appearance (PLATE 29). One photograph (PLATE 30) suggests that Bartos was remembering episodes in his own childhood when car camping was too long a drive to some place where you wound up with too much time on your hands.

Even Joel Sternfeld, the most well traveled, cosmopolitan, and wryly bemused of American landscape photographers, cannot help mingling feelings that stem from his personal memories and private experience with subjects that would seem remote to his own life. His most innovative project has been *On This Site*, for which he sought out the scenes of various famous crimes and catastrophes—the assassination of Martin Luther King Jr. (PLATE 151), the Love Canal neighborhood (PLATE 148), the corner in south Los Angeles where riots erupted after four policemen were acquitted in the beating of Rodney King (PLATE 144). Most of the news stories whose sites he documented received saturation coverage in the media that ultimately turned everyone's response to them from fascination to numbness.

Yet, in his afterword to his book of these pictures, Sternfeld speaks candidly of how going to photograph the grave of a young woman run over by a drunk driver put him in mind of his own brother's death in an automobile accident. "In my mind, I have associated her death with his," he says. Likewise, another grave with a marker reading OUR BOY makes him remember how his father cried "My boy, my boy" when another brother died of leukemia. Even the murder of Jennifer Levin behind New York's Metropolitan Museum, though it revives no tragedy specific to his life, becomes a personal memory when he realizes that a friend also, irresistibly, thinks of Levin whenever he walks by the museum.

All the photographers under consideration here seem to have wrestled with the potential conflict between the disinterestedness necessary to documentary photographs and the private feelings that making such pictures arouses. Doug Dubois identified succinctly the paradox at work when he described how "in my most intimate photographs there is a detachment that speaks of my isolation." We can see this in his work as well as that of Tice, Christenberry, or Epstein. But because it *is* a paradox, the reverse is also true: even in the most detached photographs of this type there is an intimacy that speaks of the photographer's involvement. This contrary proposition is apparent in the photography of Vergara, Bartos, and Sternfeld. The tipping point between holding yourself aloof and permitting yourself to care requires a delicate balance for all the photographers in this collection.

Even though the interest in subject matter that the photographers share with the collector trumps the art of photography per se, there is a singular aesthetic inherent in most of this work. The photographers in Berman's collection have a particular way of approaching each subject that is born out of the powerful feelings it generates, the conflict between intimacy and detachment that can only be resolved by approaching the subject with deference, or at least caution. This photographic treatment is as much an ethic as an aesthetic, a clumsy, unpretentious honesty that reveals the emotional drama entailed but doesn't glamorize it. Consider the resemblance that John Divola's imagery has come to have with Bill Christenberry's, despite the fact that the two men are, by both region and inclination, about as different as can be imagined.

Divola is a hip California photographer whose work has had a decidedly conceptualist bent at least since his 1979 *Zuma* series in which he creatively vandalized abandoned beach houses before photographing them. But in his most recent project, he has taken a more distant view of a comparable kind of house set against the backdrop of the desert rather

STERNFELD

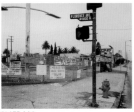

PLATE 144

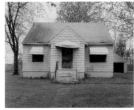

PLATE 148

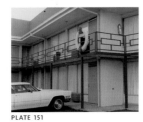

PLATE 151

than the ocean (PLATES 94, 95, 100, 102–5). Some of these *Isolated Houses*, as he calls them, are seen from so far away that they nearly disappear altogether in the landscape. Others, approached more closely, still reflect a hands-off treatment strikingly like that in a classic Christenberry photograph of a comparable subject (PLATES 58, 59).

The Alabama outbuilding to which Christenberry has returned after many years, as Vergara has to tumbledown mansions or storefront churches, is also one of the earliest subjects that he rendered as a three-dimensional model — a sculpture (PLATE 57) — as well as a photograph. What he said of another simple building reproduced the same way, in two media, would also apply to his *Red Building*: that he wants the viewer to experience the "almost primal feeling of it."[21] This phrase could describe the structures Divola has photographed in the barren landscape of the California desert as readily as those Christenberry finds in the backwoods of Alabama. Having started from very different places, each man has worked toward a reduction of his subject to an absolutely elemental form, and he has then photographed it with the minimalist aesthetic that such subjects demand.

Christenberry established his bona fides with photographic history, so to speak, when he did a joint project with Walker Evans near the end of the great photographer's life. Evans's work in the 1930s was the precedent without which almost all the photography in the Berman Collection would be inconceivable, and in 1973 Evans returned to Christenberry's home turf of Hale County, Alabama, to take new photographs for the first time since he'd made the pictures there that were published in his classic 1936 book with James Agee, *Let Us Now Praise Famous Men*. This return to the past in the company of Christenberry, which resulted in the joint publication *Of Time and Place*, would later encourage Christenberry and Vergara in rephotographic projects of their own. But Christenberry is not the only Southern photographer of his generation who has laid claim to Evans's legacy. The other one to do so is Christenberry's friend and in many ways the seminal figure in the Berman Collection, William Eggleston.

When Eggleston first became interested in photography in the early 1960s, he tried to emulate the look of Henri Cartier-Bresson's "decisive moment." But at some point he visited a mass-production printing facility of the sort that does one-day photo processing for drugstores, a lab where automated machines cranked out thousands of prints every night from negatives that amateur photographers using cheap cameras had shot of their families and friends. As German curator Thomas Weski has pointed out, "For Eggleston, this confrontation with visual mediocrity was an altogether exciting and unforgettable experience." The "amateurish, unpretentious treatment" that the subjects received in such photographs suddenly opened up a whole new world of possibilities for Eggleston.[22] In a 1971 interview, Evans would reiterate a distinction he had made many times when asked whether his photographs were works of art or merely documents. Whereas a document was a picture taken by an anthropologist in the field or a forensic photographer at a crime scene, his work, Evans contended, was done in a "*documentary style*," which was something altogether different.[23] By analogy, Weski has astutely observed, "Eggleston uses the *snapshot style*."[24]

DIVOLA

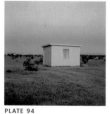

PLATE 94

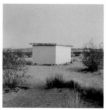

PLATE 95

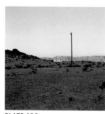

PLATE 100

PLATE 102

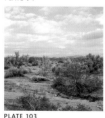

PLATE 103

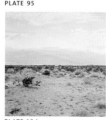

PLATE 104

PLATE 105

CHRISTENBERRY

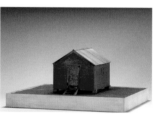

PLATE 57

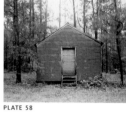

PLATE 58

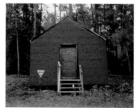

PLATE 59

In 1976 Eggleston's unassuming photographs of the most trivial aspects of everyday life became the first exhibition devoted to color work at New York's Museum of Modern Art, and the response of the press was almost unanimous outrage. At first take, Eggleston's imagery seemed to the critics more like potshots than snapshots (PLATE 49, 50, 54). Typical was the review by *New York Times* critic Hilton Kramer, who dismissed such photography for being "perfectly banal…perfectly boring."[25] But these were the very qualities prized by many young photographers who were themselves bored with a lot of the traditional pictorial values in photography.

Eggleston had seized upon commonplace subjects that had been beneath notice before, and he'd photographed them in a manner that was, appropriately, devoid of all artifice. There was a certain obduracy to the pictures, an audacious refusal to inflect or interpret subjects that were so mundane. This off-putting approach was a way of insisting that these subjects mattered. Robert Adams summed up the change in attitude when he embraced the same term Kramer had used to express disapproval. "Whatever power there is in the…pictures is bound to the closeness with which they skirt banality," Adams wrote. "For a shot to be good—suggestive of more than just what it is—it has to come perilously near being bad, just a view of stuff."[26]

Divola has spoken of his photographs as requiring "the most obvious dumb procedure for the most ambitious possible aspirations."[27] It's a formulation that unquestionably owes something to Eggleston's work, as does Epstein's dogged insistence that making blandly neutral photographs of his father's difficulties was a greater homage than dropping his camera in order to rush to the old man's aid. Whether Stephen Shore was actually influenced by Eggleston's work is questionable, since Shore's own early color photography was almost contemporary with Eggleston's and received a one-man exhibition at the Museum of Modern Art in the same

year, 1976. Nonetheless, Shore's vision coincides with Eggleston's to an extent that invites comparison. In a 1981 catalogue of Shore's work, contemporary-art curator Michael Auping characterized the pictures as "in-between images… a kind of slip-stream in perception. It's the kind of thing that you see only peripherally, on your way to looking at something else."[28] The description fits Eggleston's photographs too, and it defines a mandate with which many of these photographers have wandered the country—Beahan and McPhee, for instance, when that almond grove caught their attention while they were searching for a canyon full of tires.

The essential Shore photograph might be the one taken at an intersection in El Paso, Texas, where a pedestrian with his back to us is standing on the curb (PLATE 143). His stance is flat-footed and round-shouldered in the way that the photographer's is as he takes the picture. Working with an eight-by-ten-inch view camera instead of Eggleston's thirty-five-millimeter hand camera, Shore couldn't make pictures in a snapshot style if he wanted to. His work has, rather, a slow, deliberate, even witless quality to it, as if he were a bit dim, mentally. His pictures are dim optically, in fact, because he liked "the pale color of the sky" in some of the Texas photographs from 1976.[29] Thereafter, he cultivated a rather washed-out look in his color prints. That poor slob with his back to us in the El Paso photograph, waiting patiently for the light to change, could easily be Shore's doppelgänger. But, of course, this is an assumed identity. Shore is playing dumb in order to make a photograph that is smart in the sense of being something new. He is, as Divola says, using "a dumb procedure" to achieve a high ambition.

The subject that made such contrary behavior seem right to both Shore and Eggleston may not have been any particular place, but, rather, the time in which they were working. The 1970s was when both made almost all the photography for which they've been celebrated. It was the era in which Main Street was being undermined by the malls out near the interstate, and the effects were beginning to show. From the

EGGLESTON

PLATE 49

PLATE 50

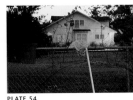

PLATE 54

SHORE

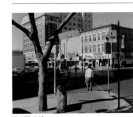

PLATE 143

bombing of Cambodia and the decline of America's cities and towns to the resignation of Nixon and the demise of ugly, tail-finned, gas-guzzling cars, it was a styleless, shabby decade.

The guy with his back to us in Shore's photograph who seems to be in a slump, literally, is a figure of that time. So is the woman in an Eggleston picture taken at a diner sitting with her back to us, her teased-up hair held together by pins like rebar sticking out of a rust-stained crack in concrete (PLATE 135). "I don't particularly like what's around me," Eggleston once told a friend, who said that that might be a reason to take up photography. "You know," Eggleston replied, "that's not a bad idea."[30] This exchange occurred in 1959, and Eggleston's snapshot style was the eventual result. Like Eggleston's style, the practiced mopiness of Shore's pictures was really an anti-style born out of a period when any other way of looking at things had come to seem all wrong.

There are photographers in the collection whose work is more upbeat. From an arch made of antlers outside the Wyoming motel (PLATE 168) to the swoop of a guardrail on Mulholland Drive (PLATE 163), Karen Halverson's work has a flamboyance that is atypical. The lone photograph by Joel Meyerowitz looks out of place as well (PLATE 35). Halverson's use of the panoramic camera and Meyerowitz's love of *Cape Light*, as his most popular series is called, have an exuberance not found in most of the work seen here. Meyerowitz's freshly painted, beautifully sunlit picket fence stands in contrast to the overgrown one photographed by Rhea Garen, which is just barely still standing (PLATE 69). Instead of Meyerowitz's perfect bank of clouds hovering in the background, what we find beyond the fence in Garen's image is a backyard as run-down as the fence itself.

There are many neglected backyards and side yards like this in photographs taken on the wrong side of town by Dawson, Garen, Rupp, Sternfeld, and Jack D. Teemer Jr. Rupp's are the only ones dominated by the presence of people; in Teemer's, though a figure appears here and there, its inclusion seems only incidental (PLATES 71–73, 75, 78). Whoever made them

and whatever the subject may be, the pictures we've been looking at are of empty spaces far more often than not. This, too, is usually an aesthetic choice. "Although people are not represented in this book by portraits, and appear only occasionally as small figures in a landscape, it is still a book about people's lives—about life in America in the 1970's," Tice wrote in his *Urban Landscapes*.[31] Like the working poor in our cities, country people tend to approach strangers with an averted gaze. To do so is a form of courtesy and deference. The photographers often take a similarly oblique view. They show us how their subjects live only by showing us where they live.

Alex Harris has twice collaborated with Robert Coles on books, one about Eskimo villages and the other about a remote and isolated part of New Mexico. When Harris took up the latter project, he was, he wrote, "a quiet person, unsure of my opinions and observations, but…my reticence, which might have been a liability in another profession, seemed to serve me well as a photographer." By being patient and taking time to get to know his subjects, he slowly earned their trust. His manners also led him, however, to an insight perhaps more crucial to his ability to depict these people well. With one subject especially, an *anciano* named Bialquín, he came to see the artistic advantage of working in a roundabout way. "If I ventured into Bialquín's cluttered bedroom the day I met him, I didn't pay much attention to it and would not have realized that a portrait…could be made in that space without including him in the picture."[32] When this realization did dawn on him, the most humane pictures of the project followed (PLATES 37–40).

Though working in the faster, more aggressive culture of the city, Vergara agrees. "The cityscape of poverty is much more meaningful than that captured by people-centered street photography," he says. The seeming banality in the work of all these photographers is related. An aesthetic vision that is

MEYEROWITZ

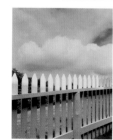

EGGLESTON

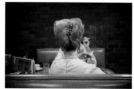

PLATE 135

HALVERSON

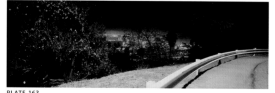

PLATE 163

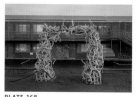

PLATE 168

PLATE 35

GAREN

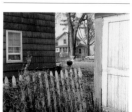

PLATE 69

somehow a negative space allows room for the subjects to impose themselves on us without having to try—indeed, to do so when they are not even present. Vergara wants to make "photographs storing the maximum possible information. To get clear, readable, and stable images I…avoid dark shadows." These priorities, acquired from his education as a sociologist, are what might make his work seem dull or artless to connoisseurs of fine-art photography. But his answer would be that "photographs depicting only an instant, lacking a sense of the whole, and constructed through dramatic light and strong compositions that hide important details, shape more than record reality."[33]

This is yet another way of saying that flat-footed pictures are better. Approaching each subject in a purposely awkward and inefficient way permits us to see something that we would have overlooked had the picturemaker been more suave. The workaday, largely working-class America that these photographers document is disappearing almost as fast as they can get to it. This could easily have made this subject—and in the work of other photographers often does make it—an opportunity for nostalgia. But the photographers toward whom Berman has gravitated are passionate about America, not sentimental. Their feeling for their subject matter springs from an intense, frequently personal relationship with it, tempered by the self-restraint with which they treat it. There is even a degree of self-abnegation in the respectful distance that some of them keep from it and in the reduction to what is elemental that distinguishes the photographic practice of all. What may sometimes seem to be a passive attitude on the photographer's part is in truth an impassivity that comes from being pained by what one loves.

NOTES

1. Sally Euclaire, *American Independents: Eighteen Color Photographers* (New York, 1987), 23.
2. Jori Finkel, "A Career in Pictures," *Art and Auction* (January 2005): 87.
3. Ibid.
4. Robert Adams, *To Make It Home: Photographs of the American West* (New York, 1989), 20.
5. Trudy Wilner Stack, *Christenberry Reconstruction: The Art of William Christenberry* (Jackson, Miss., 1996), 176. Christenberry's collection of such artifacts now numbers more than three hundred objects.
6. For "ghosts of deindustrialization," see Camilo José Vergara and Timothy J. Samuelson, *Unexpected Chicagoland* (New York, 2001), xxi; for Vergara's "fixation with keeping a record," see his preface to *The New American Ghetto* (New Brunswick, N.J., 1995), x.
7. Vergara 1995 (note 6), xii.
8. Virginia Beahan, telephone interview with the author, July 13, 2005.
9. Carol Squiers, "No Ordinary Land," *American Photographer* (May–June 1999): 20.
10. John McPhee, "Laura and Virginia," in Virginia Beahan and Laura McPhee, *No Ordinary Land: Encounters in a Changing Environment* (New York, 1998), 103.
11. George A. Tice, *Paterson* (New Brunswick, N.J., 1972), unpaged.
12. Allen Tullos, "Alabama Bound, Unbound," in Stack 1996 (note 5), 14, 17.
13. William Christenberry, in Thomas W. Southall, *Of Time and Place: Walker Evans and William Christenberry* (San Francisco, 1990), 62.
14. Vergara 1995 (note 6), x–xi.
15. David Husom, "Minnesota County Fairgrounds," statement accompanying a portfolio of photographic prints deposited with the Minnesota Historical Society (November 1985; revised October 15, 1996), unpaged.
16. Vergara 1995 (note 6), ix.
17. George A. Tice, *George Tice: Urban Landscapes* (New York, 2002), 8.
18. Mitch Epstein, *Family Business* (Göttingen, Germany, 2003), 19–20.
19. Doug Dubois, "Family Photographs," in *Close to Home: Seven Documentary Photographers*, ed. David Featherstone (San Francisco, 1989), 48.
20. Doug Dubois, "Mining Avella," *DoubleTake* (Winter 1997): 82.
21. Quoted in Tullos 1996 (note 12), 26.
22. Thomas Weski, "The Tender-Cruel Camera," in *The Hasselblad Award 1998: William Eggleston*, ed. Gunilla Knape (Göteborg, Sweden; Zurich; New York, 1999), 8.
23. Leslie George Katz, interview with Walker Evans, in *Art in America* (March–April 1971): 87.
24. Weski 1999 (note 22), 10.
25. Quoted ibid.
26. Adams 1989 (note 4), 169.
27. From *http://www.cac.ca.gov/CAC/divola/index.html*. The information is no longer accessible on the site.
28. Michael Auping, "An Interview with Stephen Shore," in *Stephen Shore: Photographs* (Sarasota, FL, 1981), 9.
29. Ibid., 11.
30. Weski 1999 (note 22), 8.
31. Tice 2002 (note 17), unpaged.
32. Alex Harris, *Red White Blue and God Bless You: A Portrait of Northern New Mexico* (Albuquerque, 1992), 13.
33. Vergara 1995 (note 6), xv, xiii.

TEEMER

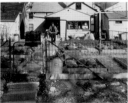

PLATE 71

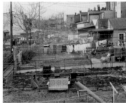

PLATE 72

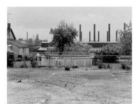

PLATE 73

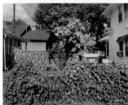

PLATE 75

PLATE 78

HARRIS

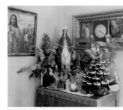

PLATE 37

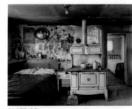

PLATE 38

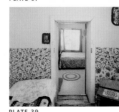

PLATE 39

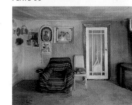

PLATE 40

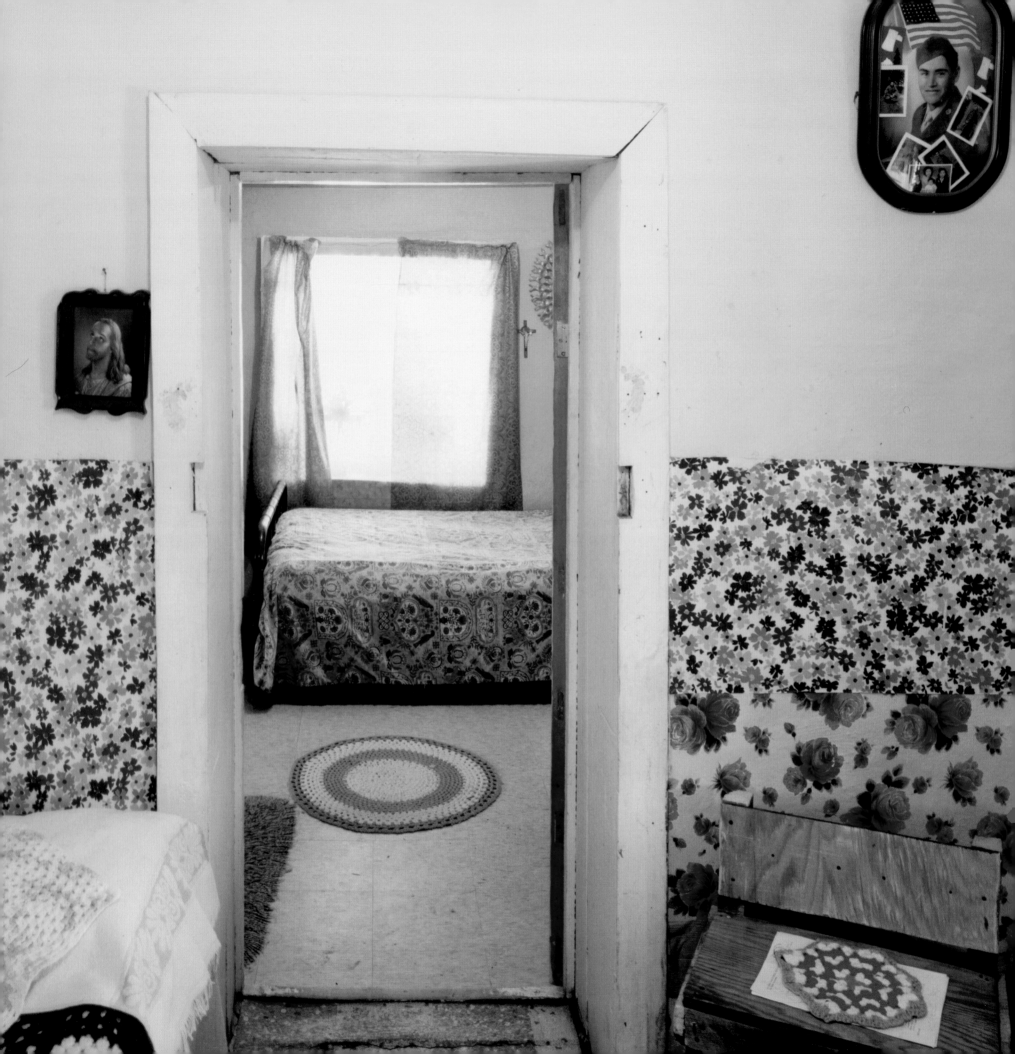

Cultural Landscapes

Kenneth A. Breisch

Taken as a whole, the photographs from the Berman Collection compose a strikingly diverse panorama of the American landscape. These are not sleek images of Case Study houses or staged portraits of powerful and influential people but records of seemingly ordinary places and things. Whether focused on the storefront churches of Chicago (PLATES 108–22); cluttered backyards of working-class communities in Baltimore, Cincinnati, or Cleveland (PLATES 70–79); a desert subdivision near Page, Arizona (PLATE 153); or the intimate interiors of Hispanic homes in New Mexico (PLATES 37–40), many of the photographs in this catalogue document middle- and working-class Americans' struggle to create their own sense of place, capturing their valiant efforts to express unappreciated ambitions and aesthetic sensibilities to an indifferent world.

The word *vernacular* is often used to identify the types of places and buildings depicted in many of these photographs. In contrast to the complex and sophisticated curves of Frank Gehry's Disney Hall, the vernacular forms a language that is generally created, understood, and accepted by a wide spectrum of the population. The *Oxford English Dictionary* defines vernacular as the "native speech, language, or dialect of a country or place"; the "common, everyday language of ordinary people in a particular locality." Like the Creole of Louisiana or the Spanish of New Mexico and Los Angeles, regional vernaculars evolve through the interaction of indigenous speech and local customs and religions with the mother tongue and culture of an educated elite.

Vernacular architecture as understood in its most traditional sense is likewise subject to regional conditions: climate, available building materials, levels of technological expertise, social and political structures, and spiritual beliefs, as well as the interplay of local methods of building with styles of

Alex Harris, *Onésimo and Eleanor Pacheco's House, Vallecito, New Mexico*, May 1985 (detail). PLATE 39.

ornament and with systems of geometry and proportion that derive from an academic tradition. Until recently, the study of the built world focused largely on buildings and landscapes that were the product of this type of practice, which reflects the designs of historically significant architects created for a privileged and typically wealthy clientele.

Like many of the photographers represented in the Berman Collection, students of the built environment during the past few decades have attempted something quite different: to present us with a more democratic and complex view of our world. As a result, in recent years the term *vernacular* has come to identify a wide variety of popular architectural forms, such as drive-ins, gas stations, and suburban tract houses, as well as the traditional and pre-industrial buildings that formed the initial focus of interest for scholars of this genre.

"When we isolate from the world a neglected architectural variety and name it vernacular," folklorist Henry Glassie suggests,

> We have prepared it for analysis. The term marks the transition from the unknown to the known. The study of vernacular architecture is a way that we expand the record, bit by bit. At work, moving toward a complete view of the builder's art, we bring buildings into scrutiny and toward utility in the comprehensive study of humankind....
>
> The study of vernacular architecture, through its urge toward the comprehensive, accommodates cultural diversity. It welcomes the neglected into study in order to acknowledge the reality of difference and conflict.[1]

Artists, while they have often come to their chosen field of representation from a variety of other disciplines, have assisted us in developing new ways of looking at and understanding ordinary structures and spaces, frequently intuiting what academic observers such as Glassie have come to study on a more intellectual plane. Writers from James Agee to Tom Wolfe and William Least Heat Moon have proven to be shrewd observers of the vernacular landscapes that make up so much of America. Photographers from Walker Evans and Robert Frank to Jack Teemer Jr. and Camilo Vergara have opened our eyes to the complex beauty of this world and to its economic, social, and racial inequities; to people's struggles to express control over their own streets, neighborhoods, and yards. Others, particularly William Eggleston (PLATES 49, 50, 134–39), have so insistently and obsessively focused on the mundane nature of our existence that they have jarred our rational sensibilities, forcing us—perhaps for

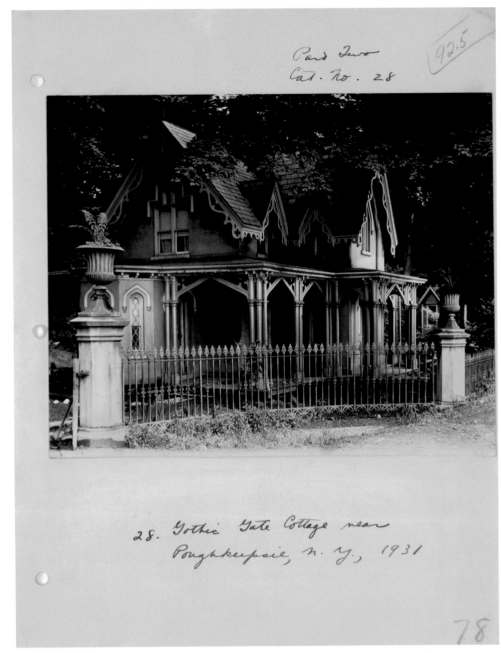

Walker Evans, *Gothic Cottage near Poughkeepsie, N.Y.,* 1931. Gelatin silver print, 15.7 × 19.8 cm (6 3/16 × 7 13/16 in.); mount, 27.9 × 21.6 cm (11 × 8 1/2 in.). 84.XM.956.461.

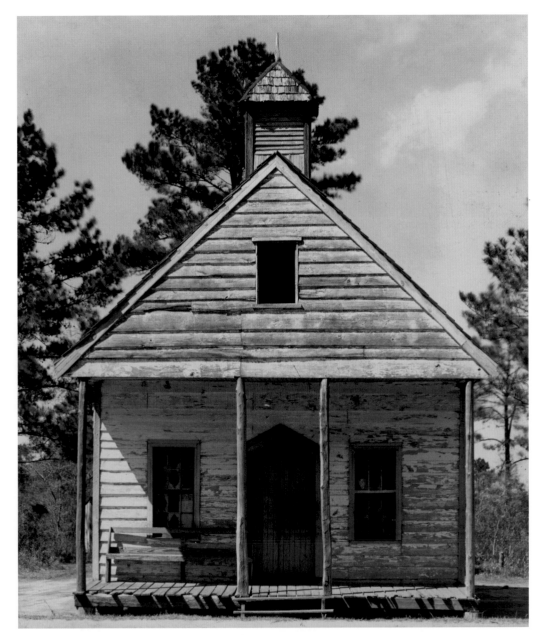

Walker Evans, *Wooden Church, South Carolina,* 1936. Gelatin silver print, 20.9 × 18.3 cm (8 ¼ × 7 ³⁄₁₆ in.). 84.XM.956.448.

the first time—to confront ordinary objects, buildings, and places that we might not ordinarily have noticed. As geographer Donald Meinig has observed, "reading the landscape" is not just an aesthetic and nostalgic exercise but "a humane act, unrestricted to any profession, unbounded by any field, unlimited in its challenges and pleasures."[2]

Anthropologists and ethnographers, architectural historians and folklorists, as well as artists, have, of course, employed photography since its inception as a tool to collect, organize, and analyze information. During the nineteenth century, the United States Geological Survey recorded native peoples and crafts in the American West, and railroad corporations chronicled their march across the continent. As the twentieth century progressed, the new mobility offered by the mass production of automobiles and expansion of road systems into the countryside allowed for an ever-widening and systematic recording of America's rural and roadside architecture and landscapes. In 1930, for example, Walker Evans was engaged by Lincoln Kirstein to photograph Victorian architecture in the Northeast for a publication that Kirstein was intending to publish on this populist style of design (OPPOSITE PAGE). While this book never appeared, thirty-nine images that resulted from a succession of road trips that Evans and Kirstein took with John Brooks Wheelwright were exhibited at the Museum of Modern Art in New York in 1933 under the title *Walker Evans: Photographs of Nineteenth-Century Houses.*[3] Another half century passed before professors of architectural history began to accept these gingerbread-laden reflections of Victorian taste as legitimate subjects for scholarly investigation.

Within a year of his MoMA exhibition, Evans was contemplating the kind of projects he would undertake with James Agee and for Roy Stryker and the Resettlement Administration in 1935 and 1936; ventures that would result in one of the most poignant and important records of everyday American life during the Depression (LEFT): in Evans's words, iconic images of

> Automobiles and the automobile landscape.
>
> Architecture, American urban taste, commerce, small scale, large scale, the city street atmosphere, the street smell, the hateful stuff, women's clubs, fake culture, bad education, religion in decay....[4]

During this same period, Fred Kniffen, a geographer at Louisiana State University, also took to the road, systematically documenting the distribution of vernacular rural house

types in the Louisiana countryside, attempting to discern what he called the "geographical expression of culture" in the patterns of the built forms that he charted.[5] Like Evans and Agee, early historical geographers like Kniffen were attempting to understand the nature and dispersion of culture into the landscape through the way that people occupied space; through the buildings that they constructed and the way they arrayed their houses, their fields, and their yards.

Kniffen prepared for his career during the 1920s, studying with Carl Sauer, chair of the Geography Department at the University of California at Berkeley. Grounding his own work in the disciplines of European folk life and historical geography as they had developed in the nineteenth and early twentieth centuries, Sauer established the concept of the cultural landscape in this country, defining it in 1925 as any geographic area "fashioned from the natural landscape by a cultural group. Culture is the agent, the natural area is the medium, the cultural landscape is the result."[6] Close examination of these culturally manipulated spaces, as postulated by Sauer and his students, could produce new evidence about, and insight into, the history of a people and the places they settled. The built world, they believed, could be read as a less biased record of the way ordinary people conducted and ordered their lives and communities. This was a record that would supplement more traditional methods of historical evidence, such as legal and land records, local histories, autobiographies, and diaries.

Fred Kniffen published a widely influential analysis of his own work entitled *Louisiana House Types* in 1936, just as the Farm Security Administration was gearing up its own program to record the contemporary American scene. Two years earlier, the National Park Service, along with the Library of Congress and the American Institute of Architects, established the Historic American Building Survey in order to record—through drawings, historical narratives, and photographs—the county's most significant historic architectural relics. This program continues today and has expanded to include important engineering and technological achievements and, most recently, the documentation of historic landscapes.[7]

Today, everyday built environments—Sauers's cultural landscapes—have come to be recognized by a wide array of academics and laypeople as significant evidence of our history and culture, as well as a means of identifying the contributions of groups of Americans who a have often been ignored

or marginalized in the past; groups for whom other types of documentation are frequently lacking. The idea of the cultural landscape has even worked its way into common parlance, referring to everything from formally designed gardens to rural and urban patterns of settlement and building; from backyards and front yards to the carefully arranged interiors of the homes that can be seen in the photographs of Alex Harris. Through the initiative of the National Park Service, this broad interpretation of landscape has been accepted by the preservation movement in this country, a group that has begun to identify and attempt to preserve these often peripheral and transient sites of history.

Many of the photographers represented in the Berman Collection have embraced a similar mission, producing a wide-ranging archive of ordinary American places, creating, as in Jack Teemer Jr.'s "environmental portraits" of working-class ethnic backyards, "documents of changing and disappearing social traditions that are unique" to different regions of the country. Where Teemer has focused on "the way people define their spaces through formal organization of color, object & shape relationship and detail"[8] in the urban North, John Divola has photographed twentieth-century homesteads in the Western desert (PLATES 94–107), and William Christenberry has taken it upon himself to produce a record of a rapidly vanishing Southern rural landscape (PLATES 57–60).

Probably no individual is more responsible for the popularization of this more democratic vision of the world we inhabit than John Brinkerhoff (J. B.) Jackson, who in 1951 founded *Landscape* magazine, a small publication whose influence eventually extended well beyond the esoteric confines of academe. "Wherever we go, whatever the nature of our work," Jackson observed in the first issue of this publication,

> We adorn the face of the earth with a living design which changes and is eventually replaced by that of a future generation. How can one tire of looking at this variety, or of marveling at the forces within man and nature that brought it about?
>
> The city is an essential part of this shifting and growing design, but only a part of it. Beyond the last street light, out where the familiar asphalt ends, a whole country waits to be discovered: villages, farmsteads and highways, half-hidden valleys of irrigated gardens, and wide landscapes reaching to the horizon. A rich and beautiful book is always open to us. But we have to learn to read it.[9]

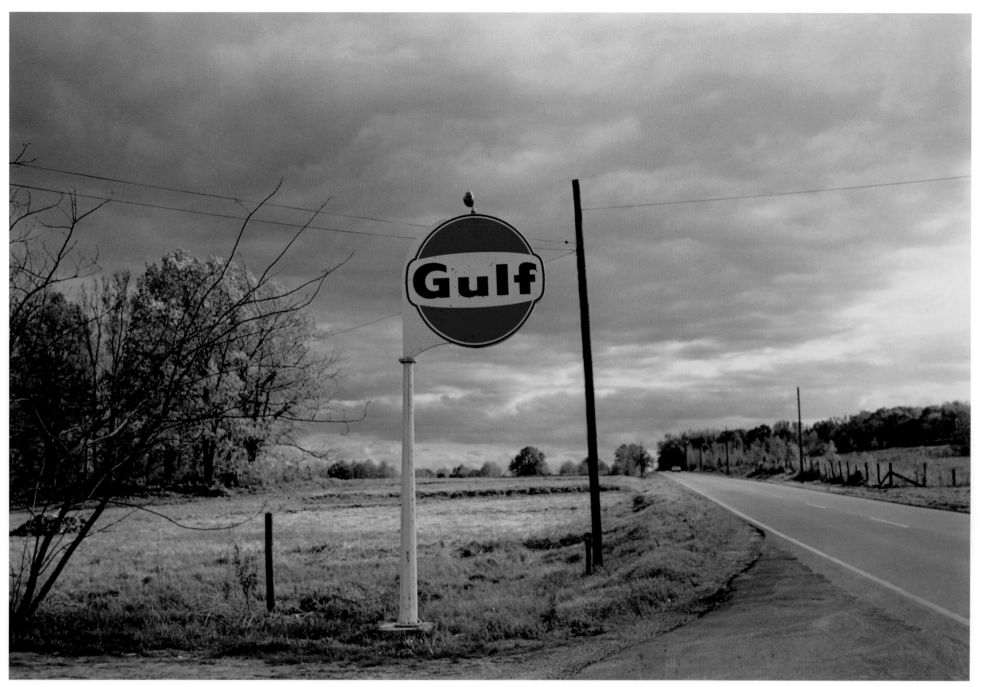

William Eggleston, *Between Memphis and Nashville,* about 1973. Dye transfer print, 31.8 × 46.4 cm (12½ × 18¼ in.). 99.XM.13.6. © Eggleston Artistic Trust.

In his own essays in *Landscape* and elsewhere, Jackson opened many new pages of this book, constantly pushing the geographic and temporal boundaries of his gaze. Where geographers and historians of the vernacular to this point had focused almost exclusively on the study of pre- and early-industrial landscapes, Jackson—like Walker Evans, a well-informed layman rather than an academically trained scholar of his chosen subject—began to examine modern American automobile culture. Facing this uniquely American phenomenon squarely—and anticipating by more than a decade the shrewd observations of Tom Wolfe and the Post-Modern declarations of Robert Venturi, Denise Scott Brown, and Steven Izenour in their influential study of the Las Vegas "Strip"—Jackson called for a serious assessment of service stations, used-car lots, shopping centers, cafes, drive-in movies, souvenir stands, motels, and campgrounds. "It would be hard (but not impossible) to exaggerate the extent of this blight," he admits. "But still we must give these roadside establishments their due. They are entitled to their day in court, and so far have not had it."[10]

As if writing an introduction to the work of William Eggleston or Jim Dow, Jackson would go on to argue in 1966 that—while highways and their attendant commercial development frequently had a negative effect on communities—"even at its most cluttered, the most garish and vulgar specimen has immense potential. Moreover, the highway strip is developing a remarkable aesthetic style of its own. Its lighting effects—not merely the neon signs but the indirect lighting of filling stations and drive-ins—are often extremely handsome; so are the bright colors of the buildings and installations; so are the open spaces, even though they are not coordinated" (PLATES 122–30). Recognizing the profound economic shift taking place in many cities in this country, Jackson proclaimed the roadside strip as the new social and populist landscape of America. "This is where you will find the mixed public we so long to have in our central business district: teenagers, transients, people in search of amusement, doing business, alone and in groups. And this is no ordinary street scene; this is specifically American."[11]

In addition to his embrace of the automobile and the landscapes it engendered, Jackson argued that another salient feature of American culture was its long history of mobility and consequent impermanence. From the very beginning of European settlement, he noted, the vast majority of dwellings, like the insubstantial structures photographed by Divola in the California desert or by William Christenberry in the South, were constructed of wood, built by amateurs, and

never intended to be permanent features in the landscape. In the 1950s, he went on to argue, these earlier "movable dwellings" were replaced with trailers and mobile homes, another subject that often catches the eye of the photographers represented in the Berman Collection.[12]

Common landscapes are among the most difficult of material documents to decipher, and so it is often the artist or the writer who leads the way with images that first arrest our attention and allow us time to contemplate the constantly shifting and changing scenes that their lens or pen has recorded.[13] Constancy of change, in fact, forms a prominent theme in the Berman Collection. City centers succumb to the ravages of time and neglect in Mitch Epstein's intimate portraits of his father's Holyoke (PLATES 17–26) and Vergara's unrelenting chronicles of inner-city neighborhoods and their abandoned and crumbling monuments (PLATES 55, 56). What had once been thriving streetcar boulevards traversing middle- and working-class neighborhoods begin to decay, even as storefront churches—vibrant and colorful symbols of refuge and pride—transform these same areas, proclaiming to the passing automobiles their celebratory appropriation by new spiritual communities. Escaping the strictures of academic principles of design, these structures accept change gracefully in response to new physical, economic, and cultural demands.

The morphology of built form, as witnessed in Vergara's work—like the early typological studies of Fred Kniffen— is also of interest to other photographers in the Berman Collection. Divola catalogues desert houses; David Husom, fairground pavilions (PLATES 84–93); Alex Harris, the interiors of houses and automobiles; Jim Dow, bars and barbershops (PLATES 131, 133); and Beahan and McPhee photograph geological and man-made landscapes. The urge to categorize and catalogue has long been felt by the documentary photographer, but the constantly accelerating speed of change in the modern world seems to have made this urge an imperative, along with the desire to collect these records.

As transient as the nature of many landscapes may appear to be, they often retain visual memories of the past, layers of history that can be read like the exposed strata of an archaeological excavation. Beahan and McPhee's image of Manzanar, the Japanese American internment camp of World War II, for example, depicts the remnants of an apple orchard that predates the camp and accounts for the name of a small town that was established on this site early in the twentieth century (PLATE 159). This community of Manzanar, as well as

the agriculture that sustained it, was devastated when the Los Angeles Department of Water and Power drained the Owens Valley of water with the opening of its infamous aqueduct in 1913. Beneath this ground lies evidence of earlier Native American occupation, the artifacts of a people who, like the Japanese Americans, were also forcibly removed from their land. Similarly rich palimpsests of history and place underlie many other images in the Berman Collection. At times these layers are evident and at others they are hidden from our view, as in Joel Sternfeld's haunting documentation of seemingly innocent sites that possess their own equally oppressive pasts (PLATES 143–52).

More often it is in the totality of an artist's project that these layers begin to be revealed, as in William Eggleston's *Graceland* series, for example, in which he insistently forces us to confront an environment that many would consider to be inconsequential as a serious focus of our attention. Even more so, what he calls his *Democratic Forest*, a compilation of thousands of images produced over many years, represents a complex personal reading of American material culture and the people who created it. Joel Sternfeld's *American Prospects* (PLATES 154, 155, 166) and Stephen Shore's *Uncommon Places* (PLATES 140–43, 164) are two other monumental studies of the American cultural landscape waiting to be mined for information and insights into the ways we have ordered and reordered our everyday environments.

In 1968, after seventeen years of editing and contributing to *Landscape*, J. B. Jackson stepped aside, just as the new landscape tradition was commencing—the photographic tradition to which many of the artists in this exhibition belong. During his tenure as editor of this small publication, he had struggled to comprehend the American landscape "as a symbol of social and religious beliefs and to try to understand blunders as well as triumphs as expressions of a persistent desire to make the earth over in the image of some heaven."[14] One might venture to pass a similar judgment on the photographs in this collection, which document, catalogue, celebrate, and critique the everyday world that we inhabit. Like Jackson, the photographers who made these images have introduced us to new ways of seeing, and perhaps understanding, the vernacular American landscape where we live.

NOTES

1. Henry Glassie, *Vernacular Architecture* (Bloomington, 2000),20.
2. Donald W. Meinig, "Reading the Landscape: An Appreciation of W. G. Hoskins and J. B. Jackson," in *The Interpretation of Ordinary Landscapes: Geographical Essays*, ed. Donald W. Meinig (New York, 1979), 236.
3. Judith Keller, *Walker Evans: The Getty Museum Collection* (Malibu, 1995), 121.
4. Walker Evans to Ernestine Evans, an unfinished letter dated February 1934 (cited ibid., 131).
5. Dell Upton, "Outside the Academy: A Century of Vernacular Studies, 1890–1990," in *The Architectural Historian in America: A Symposium in Celebration of the Fiftieth Anniversary of the Founding of the Society of Architectural Historians*, ed. Elisabeth Blair MacDougall (Washington, D.C., 1990), 206.
6. Paul Groth and Chris Wilson, "The Polyphony of Cultural Landscape Study: An Introduction," in *Everyday America: Cultural Landscape Studies after J. B. Jackson*, ed. Chris Wilson and Paul Groth (Berkeley, 2003), 5.
7. Thousands of these images can be accessed through the Library of Congress, American Memory web site (see *http://memory.loc.gov/ammem/collections/habs_haer/*).
8. From Teemer's cover statement to the portfolio *Color Photographs*.
9. John Brinkerhoff Jackson, "The Need of Being Versed in Country Things," *Landscape* 1 (Spring 1951): 5. See also Groth and Wilson 2003 (note 6), 5–13; and Meinig 1979 (note 2), 210–32.
10. John Brinkerhoff Jackson, "Other-Directed Houses," in idem, *Landscape in Sight: Looking at America*, ed. by Helen Lefkowitz Horowitz (New Haven, 1997), 186. This article was first published in *Landscape* 6 (Winter 1956–57): 29–35. See also Tom Wolfe, *The Kandy-Kolored Tangerine-Flake Streamline Baby* (New York, 1965); and Robert Venturi, Denise Scott Brown, and Steven Izenour, *Learning from Las Vegas: The Forgotten Symbolism of Architectural Form* (1972; rev. ed., Cambridge, Mass., 1977).

11. John Brinkerhoff Jackson, "The Social Landscape," in *Landscapes: Selected Writings of J. B. Jackson*, ed. by Ervin H. Zube (Amherst, Mass., 1970), 148–49. This is reprinted from a lecture Jackson gave at the University of Massachusetts, Autumn 1966.
12. John Brinkerhoff Jackson, "The Movable Dwelling and How It Came to America," idem, *Discovering the Vernacular Landscapes* (New Haven, 1984), 101; and "The Mobile Home on the Range," idem, *A Sense of Place, a Sense of Time* (New Haven, 1994), 53–67.
13. See, for example, Peirce F. Lewis, "Axioms for Reading the Landscape: Some Guides to the American Scene," in *The Interpretation of Ordinary Landscapes* (note 2), 11–32.
14. John Brinkerhoff Jackson, "1951–1968: Postscript," *Landscape* 18 (Winter 1969), 1.

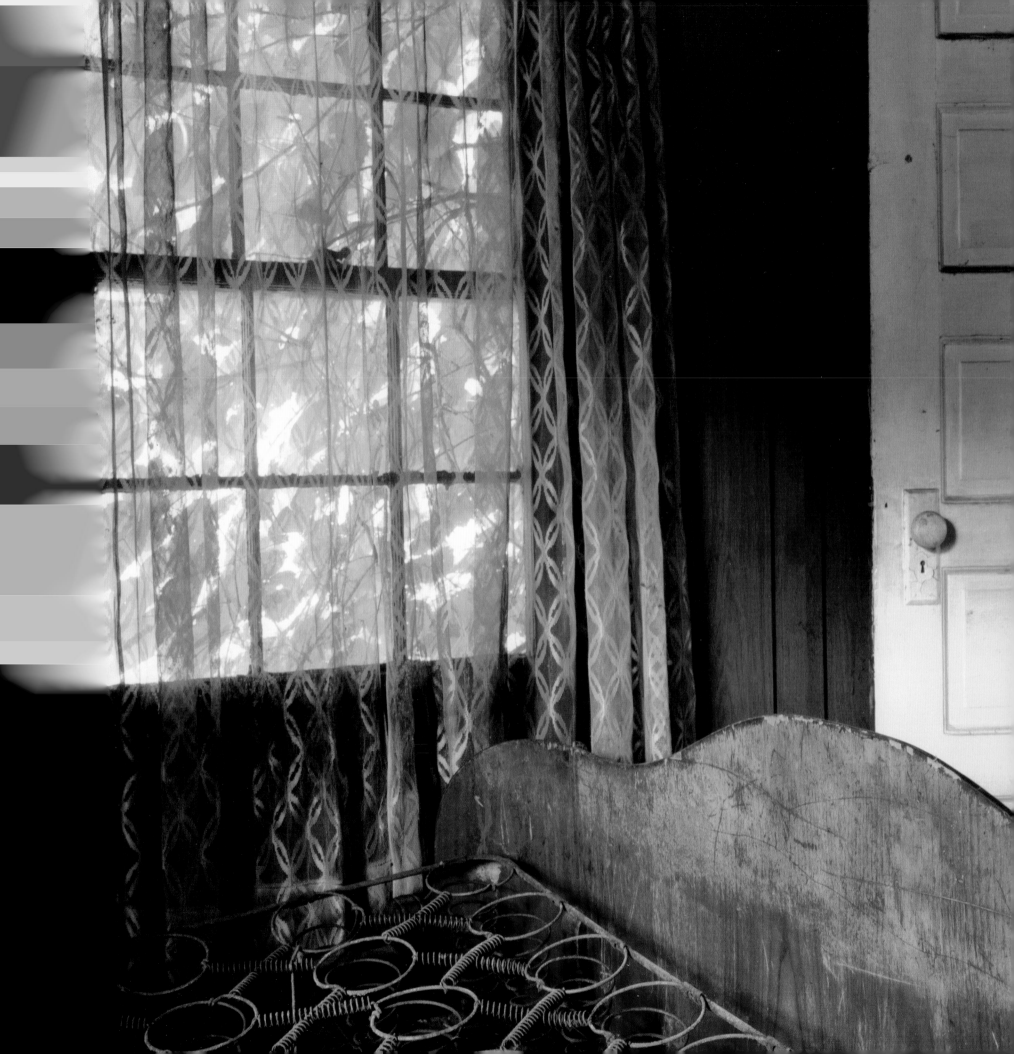

Chorus: The Spirit Room

Bruce Wagner

There is a sacral quietude generated by the vernacular, visionary, demotic images of this collection, the magisterial quiet of a monastery anteroom, or monk's stone meditation cell. They are the gallery of our national church. The images are unified but there is no reason to qualify such homogeneity; the common phrase "One does not know what to think" may be an appropriate response, as would the suspension, or attempt to suspend, *thought*. Ideally, that is how one must approach art—the artful dodger—like a quiet, resolute fighter on the ropes, all Thought suspended, in midair, on the trapeze tightrope of witnessing and perception. This collection is one that represents our tribe, its feints and its shadows: represents our indifference and our demons, gladness and madness, our rags and riches of consciousness, our conscience and hard-won coherence.

This land was made for you and me.

Joel Sternfeld's Niagara Falls house in the neighborhood of Love Canal: *Canal of Love*. The house is not at all bereft—to me—and reminds me of my aunt's place in Milwaukee. (We sold it for her when she retired to the Jewish Home a few years after her husband's death.) It is dilapidated by abandonment yet still buoyant and forgiving, it welcomes, its greens not the lime green of death pits but of Love. One can see no fences or boundaries, and that is the dream of America: land for children and dogs to run wildass. *An open plan.* Some simple sprucing up is all that's needed. Isn't that what everyone of us requires? There is space for terrible and sublime things to happen. There is space for abandonment, for things to be lost or hidden, for Easter egg hunts and radioactive glee, there is space to be abandoned, or to abandon things, or to couple in abandonment, there is time and elegant timelessness. I am thinking of an ancient Indian text where a god tells a warrior not to worry who he kills on the battlefield, be they friend, foe, or guru, "for I have already killed everyone with Time."

Now, look at the colors of Mr. Sternfeld's Colorado valley-scape: the staggering, gorgeous rainbows of rust. Who would have thought or imagined? Mr. Sternfeld and his mechanical eye did. Rainbow of rust and love, spectral spectrum of stained church windows and leafy, natural death, a death so vivid that we can be sure of the mystical axiom that nothing can be created and nothing can be dissolved. For this is an emphatically autumnal graveyard—*after the fall*—and hereby demonstrates that graveyards in autumn can only be cathedrals. What memories lie gathered in the sleeping cars, or link hands and arms round trunks of trees whose arms of leaves themselves are colored by God? The cars do not worry me. They are as organic as the dirt and the blown-out verdancy. This is a religious painting. At bottom, the lea and ravine—the forgotten skeletal chassis of this or that—tumult of humanity, of samsara—as we rise, heavens break open, and Consciousness permeates, obliterating our fears.

Of which we have too many!

So:

All photos in this collection are religious paintings.

To qualify, they do not have to be the ruined mansions, underworld garages, or majestic dominoes of exterminated churches belonging to Camilo José Vergara.

Of late, I've been consumed by a television show called *Cold Case Files*, a documentary series examining crimes—mostly homicides—committed in prehistoric, pre-DNA decades before lab-smocked saints jump-started unsolved murders—

Doug Dubois, *Abandoned Company House, Avella, PA,* 1991 (detail). PLATE 15.

turning over dead motors in frigid exurban grids, the discovery of double-helix, reverse parental, mitochondrial analysis, a nerd-refined god-machine deus ex machina that giddily called killers' bluffs with absurdly veracious, voracious certitude. Waiting like spinsters for their matchmakers, in ghostly, ghostbusters' abeyance to exchange vows with the love (and death) of their lives, the loamy, lonely evidence of The Disappeared mushroomed in police storage closets across the country, archives and repositories of bins and baggies filled with tagged detritus, curled hairs and stained fabric of crimes "gone cold."

The narrator calls those storage places Spirit Rooms. I am unsure if that is how cops actually refer to them (I mentioned the phrase to a friend, a cold case detective named Rick Jackson, and he hadn't heard that one), but still it suits me fine. Why should I care?

Watching *Cold Case Files*, I am continuously amazed to have rarely heard of the counties or townships wherein each drama resides and unfolds—America is vast, its landscape heroic, heroically bleak, beautiful, both. Often the villages have names that are dreamlike distortions of nomenclature that is familiar: one is called Willshire—two l's. Or maybe it was Wilsshire.

A parallel country to the parallel one already in my imagination.

On the gravestone of a wife, the epitaph: **Finally My Tears Have Stopped Falling.**

There are many Spirit Rooms in many mansions. This land is made—

Have you visited the longitudes and latitudes of John Divola? *Description: Isolated yellow and green painted isolated house with two cars parked on side and two dogs within a kennel on left side.* That is the photograph whose formal title is *N34°09.951'W115°49.269'.* (A church described by a lunatic.) Look again at the church. The ascension to consciousness; the floor of dirt. The middle ground is human life—human misery, human bliss, human error. The colors and order and dull, exquisite fracas of this deep blue planet's inhabitants. We do our best, which is often our worst. We are mothered by Earth and its wetness and witnesses. Our longings are merely longitudes, our attitudes latitudes. (Jimmy Buffett had it right.) We are vectors, our pinpointed hearts arranged on landscapes of desuetude and desire. We are in isolated communion, our pimp-ride hearts and spirits parked on the right side and two dogs within a kennel on the left.

But why do I bring up a populist, pop-TV series? For we are not discussing crime here. This isn't a collection of crime shots, far from it; so I mean to do neither the images nor viewer a disservice. I am saturated in the cold case because the collected tribe before us, *tableaux vivants* and *tableaux morts*, is not mordant nor is it cold; rather, it is mordant and cold but ravenously alive and heroically everyday, it is splendor itself, motel lilies of the field and asphalt valley, birthing and (yes) stained (by flowers and rubbish and motor oil and invisible patterns of shoe prints), killing fields both commonplace and extraordinaire, filled with color and redolent of the short time we spend in the lap of our Mother. The tribe of images before us—even when human faces emerge upon the landscape, for even the landscape itself is somehow human; reflected in mirrors, faces are formed of flesh and of wood, fabric, wind, and leaf-strewn water too—the tribe is unforgiving and aromatic, distended and sacrosanct.

This tribe is sentient and with great apprehension, forgives all our trespasses.

Dubois, Wyoming. I have never heard of it. (I told you so.) But Karen Halverson has. She visited an *arch made of antlers in front of a motel.* The curatorial notepad says: *The previous title precised "Horney Motel."* Better the former. There is no room for puns in this cathedral, they are shown the door, high- or lowbrow. The motel is strangely day-glo, it too a church (sorry), the antlers, transient folk art, Gates to Heaven. I am not exaggerating for anyone's benefit. That is the nature of the witnessing of these photographers, that is their unconscious effort, witnesses for the prosecution of the law of the land, which is indeed sacred. These photos are luminous entryways. Each one is a gate unlocking the glorious crime of being alive. Each one beckons us to leave the museum and take the stand as witnesses, *eyewitnesses*, we are sworn in, then, if we are very lucky, we dissolve from the courthouse of our judgments and emotions to become elements of each image until we no longer exist. This is what art does. It forces you not to exist. That is the charity it delivers, its promise, it wants to liberate us, it wants us to stop looking and become what is looked at so that others may do the same. Its desire is that we join the tribe and that we dream with the tribe.

Why do I bring up the cold case.

Because all our cases have grown cold and need to be excavated.

Our hearts have grown cold.

A healer once enlightened me. "Did you know that the muscle of the heart makes four or five different grades of blood?" he said. "From the 'highest' to the 'lowest octane'? Do you know what the heart does with the highest grade? Do you know which organ it directs that blood to?" I told him that it must, of necessity, supply its richest brew to the brain (standard answer). "No," he said. "The heart gives *itself* the purest and richest, the highest of the high. The heart knows it must give itself that *first* because otherwise it can't properly nourish the body. It gives the best to itself."

I am not sure if all physicians know this. If that knowledge is commonplace—but still, it suits me fine.

Why should I care.

A photographer, at his or her very best, makes high-octane blood, shoots images like arrows (or bullets) from Silence; outmoded, antiquey-sounding darkroom become Spirit Room. An artful, artfully dodged collection excavates those spirits and conjoins—which makes for very strong blood. We walk through museum rooms, *many mansions, rented, abandoned, house-proud,* and become thoughtful or bored or agitated as we take in the manifold evidence of our tribe, that tribe which dwells upon this bland, magnificent, terrifying American dreamscape, its collective ethnography played out in unheard-of townships and villages; we tighten our Bible belts, eyes "lifting prints" from awesome, awful, incomprehensible, uncomprehending skies, watching the revolving door of late-afternoon downpours infused with the DNA of the cosmos, the latent cheeks of Consciousness powdered by late-night constellations, dull or quotidian or stupefyingly seraphic midmorning cloud formations…we compare and sift molecular strands and fibers, mundane spiritual residue of this capitol mansion of three hundred million souls, until we get a match—that unfathomable geography, running its gamut from desert-dry to mountain-frozen, those Halloween hillocks and Christmastime cloverleaf highways upon which we do our parking maneuvers, our pedantic U-turns and Mother's Day laundromat strolling chores, petty and exultant, our Sunday reconnoitering of churches—*shadow of steeple*—or jails or Martin Luther King Boulevard liquor stores, this G-d-awful, G-d-given, G-d blessed land of hurricanes and floods, resuscitations and courtships, transcendence and planetary retrograde, of fast food and fotomat and savings and loan drive-thrus, of random agonies and ecstatic secret-laden Fourth of July barbecues, this slow chase Nascar nation of convenience stores and corteges, of assisted-living centers and gated or drug-laden neighborhood grids, of anomie and storms of grief, of longing and rectitude, of casual lies unfurled and promises ever rebroken from sea to shining sea

ribbon of highway, endless skyway, golden valley.

The road to redemption is plain and simple but not easy.

It stretches before us. I walked upon the New Jersey High Bridge of George Tice. *[American, born 1938 (photographer)].* There is even a steeple, top right, at the ascendant. What vagrants and vagaries built these tracks, what thoughts had as they were traveled and shaken upon? It is a strange road Mr. Tice has shot, not of yellow brick but of black and white trestle, reminiscent of an amusement park, though one without sentiment, one that ends in the hard, simple work of Redemption. Who lived in the clapboard houses around it? Who lives there still? The music of the train could drive a person mad—*I Hear a Symphony*—or the music could accompany lovemaking, singing steel rails of ecstasy or horror, horror for those who could not or would not ascend or even move laterally through their world. Spectral trees—like antlered motel gates—hold promise at the end. They are the thousand-armed cousins of this Mother Earth and say: come.

George A. Tice, *Railroad Bridge, High Bridge, New Jersey,* April 1974. Gelatin silver print (selenium toned), 38.4 × 48.6 cm (15⅛ × 19⅛ in.). Collection of Nancy and Bruce Berman. © George A. Tice, Courtesy Peter Fetterman Gallery.

If you can make it this far, we will catapult you to heaven. But, not to be cynical, redemption is sometimes impossible. There is great suffering on this Bridge, but it is only from on high that we will be redeemed. We have no perspective unless we are on a high bridge. We cannot read the book:

This illuminated manuscript of high-octane blood and earth.

This land was made for you and me.

The detectives on cold case squads are called "Closers." When I was in my 20s, I used to sell Tex-Cote door to door, a paint you could spray on like concrete, touted as lasting forever; well, at least there was a twenty-five-year guarantee, which in my book meant "forever." It would last till the next generation, defined by our crew as three to five years forward, when a new generation of Tex-Coted Men convinced the same person or virgin tenant their abode needed a fresh coat. *(Degradation of evidence.)* We Tex-Coters offered to throw scenic rocks into the mix—even paint your New Year's eaves and wood trim for free. But nothing is free. I walked door to door gathering leads, passing the suckerfish to an old man they called the Closer.

What is a closer? The photographers are the closers and these images, their DNA. The results of the lab are in: we are all victims, all witnesses, all perpetrators. What were the odds? (Trillions squared.) The results are in, and a holy and strange thing has happened. The strands of images have been matched to our cellular fibers, to the ligatures that bind our dreams together, to the stains—the human stain—that retains tribal imprint and exhortations. So, in that sense, they are ineffable, and will always point to the scene of the crime, which does not mean there was sin, but sand, the sands of Time with its joyous indifference. Why do the photographers—these *closers*—take so much care with detail? Why do their eyes miss nothing? A man once said that human beings were like the sandcastles made by meticulous children and that when our time on earth is done, we are leveled by the dimpled hand of G-d just as when the castle crumbles after parents shout the day is done. But the photographers kept the evidence. They have dared to make pictures of sandcastles. They remind us that our case, and our hearts, have not grown cold, or if they have, they can be reclaimed, the riddle of our compassion solved.

The photographers are *spirited*, and for that we are humbled and forever grateful. For what is a collection such as this but a nation itself? And what is a nation but a thing that is indifferent, and must be constantly paid homage, revivified,

remembered, and sanctified? What is a Closer but a witness, a sentinel, a guardian, a lab-smocked taxonomist of prayer and of blood?

Blue-green car with chain. From the quick-draw, ubiquitous William Eggleston. *Blue-Green car with chain.* The chain surrounds a post like a rope around an elephant's leg. Debris in the street—dare you admit the litter is unattractive? dare you even speculate?—and the flattened chevrons of a Louisiana-plate Chevy.

(The pole and chain put me in mind of a Rudyard Kipling story. There is a myth among mahouts that on moonlit nights, the betusked jungle kings sometimes escape their moorings and gather in the center of the forest, where they trample out a "ballroom" in which to dance. None of the mahouts has ever seen such a space, but a boy is taken there on the back of a fearful elephant, to bear witness. He sees his host's brethren: bulls and females and babies, strong or crippled or coy, the earth shaking with their rapturous movement. Then it is all over and the boy is returned to his village asleep upon the pachyderm's neck. When he awakens, still exhausted from his hallucination, he stubbornly proclaims what had happened, then leads the disbelieving men to see the ballroom void in the light of day…)

Please: these photos ask you to break away. To leave the confines of this space and meet in the ballroom. Tonight or two weeks from now or anytime. Dreamtime. These photos are a dream collective, just as this life. You are now a part of the dream. You have always been part of the dream. The DNA of the dream has been compared and the results are In, and you have been notified that it is You. This is not academia. This is the New Jersey High Bridge. This is the cabinet of wonder. This is where the world ends and begins. This is rust and rainbows.

This is our life.

Chorus:

And all around me

a voice was sounding

this land

was made

for you and me

AMEN

Plates

The spelling and punctuation of the titles
are the photographers' own.

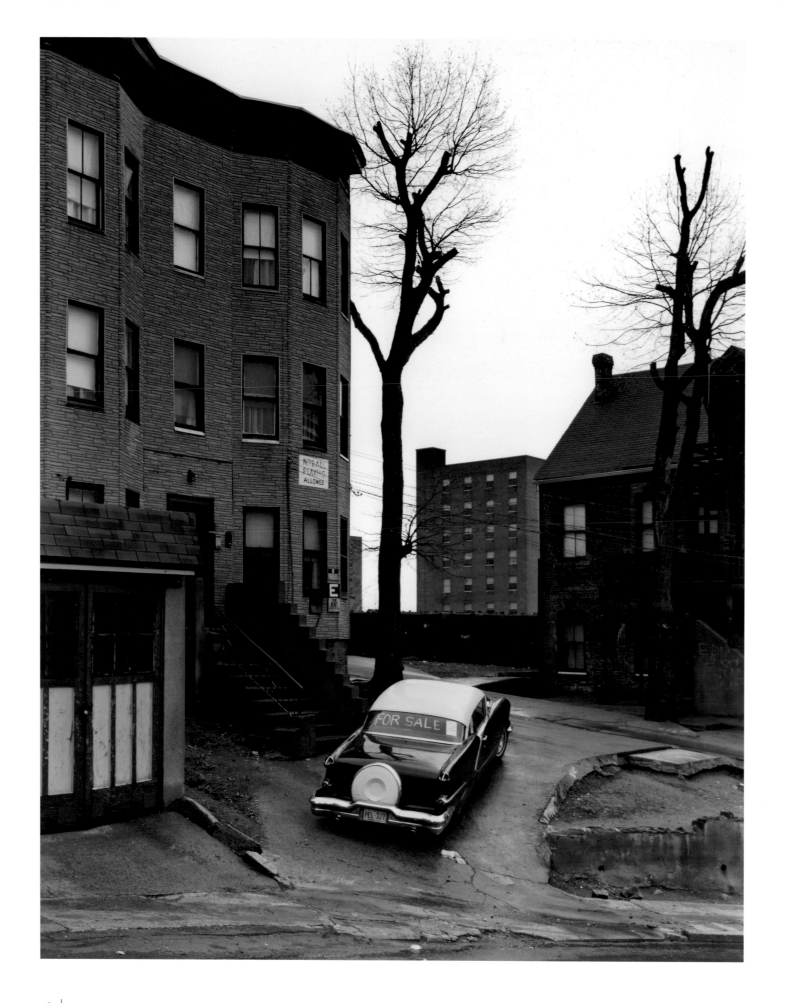

PLATE 1 George A. Tice, *Car for Sale, Paterson, New Jersey, April 1969*

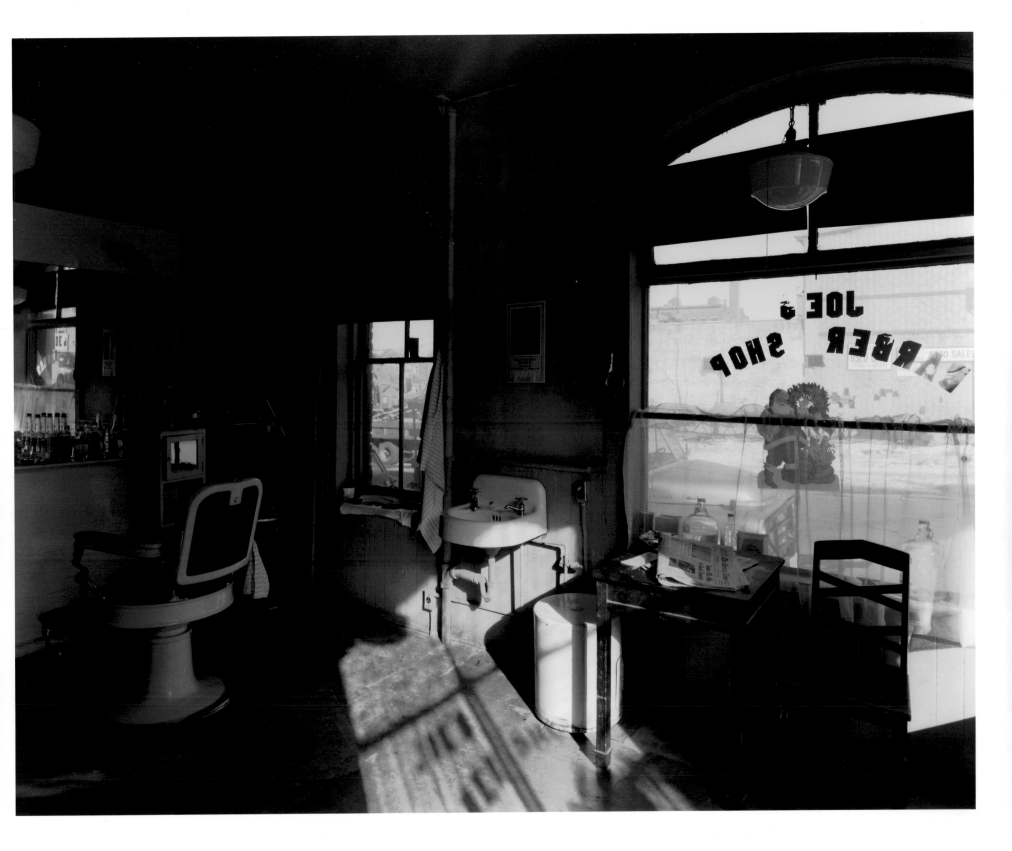

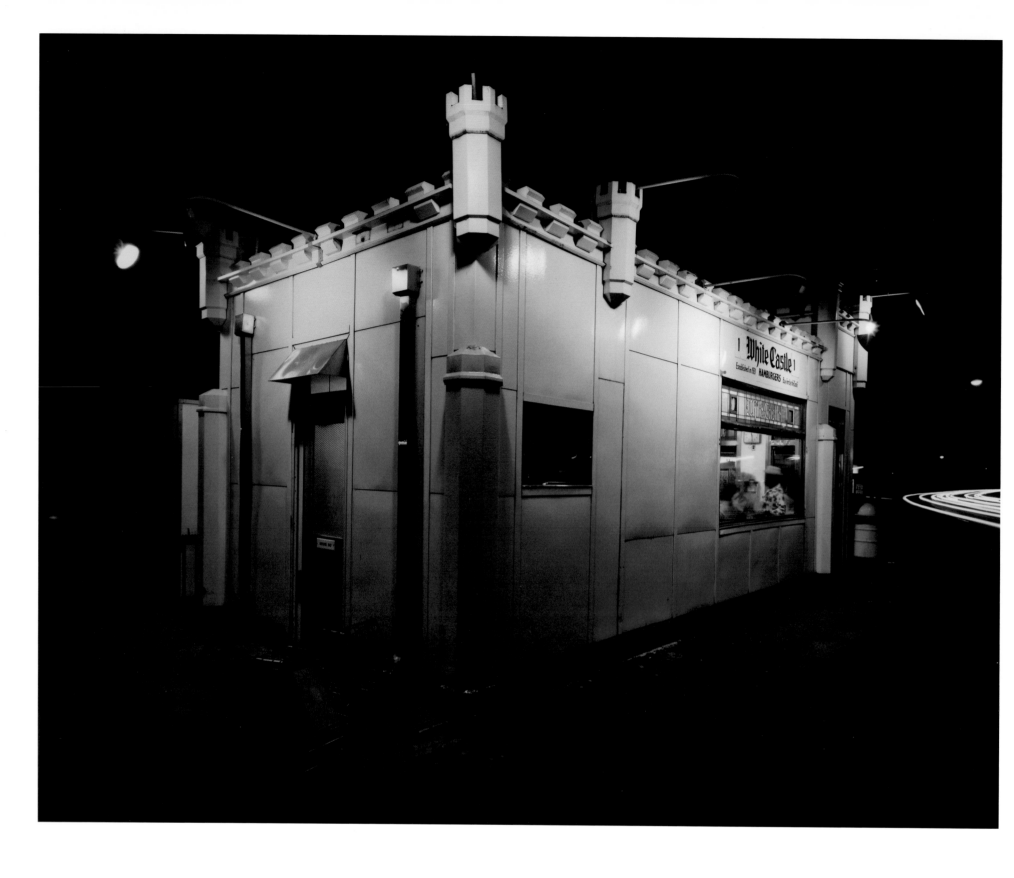

| PLATE 3 George A. Tice, *White Castle, Route #1, Rahway, New Jersey*, September 1973

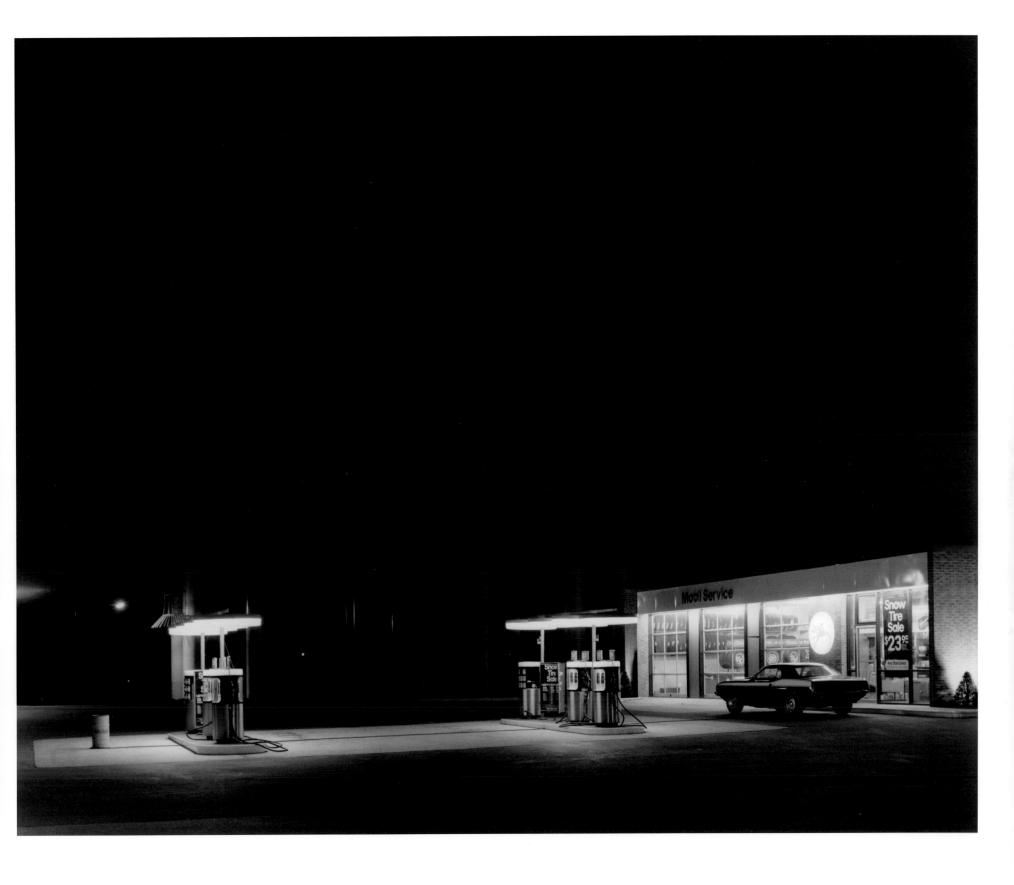

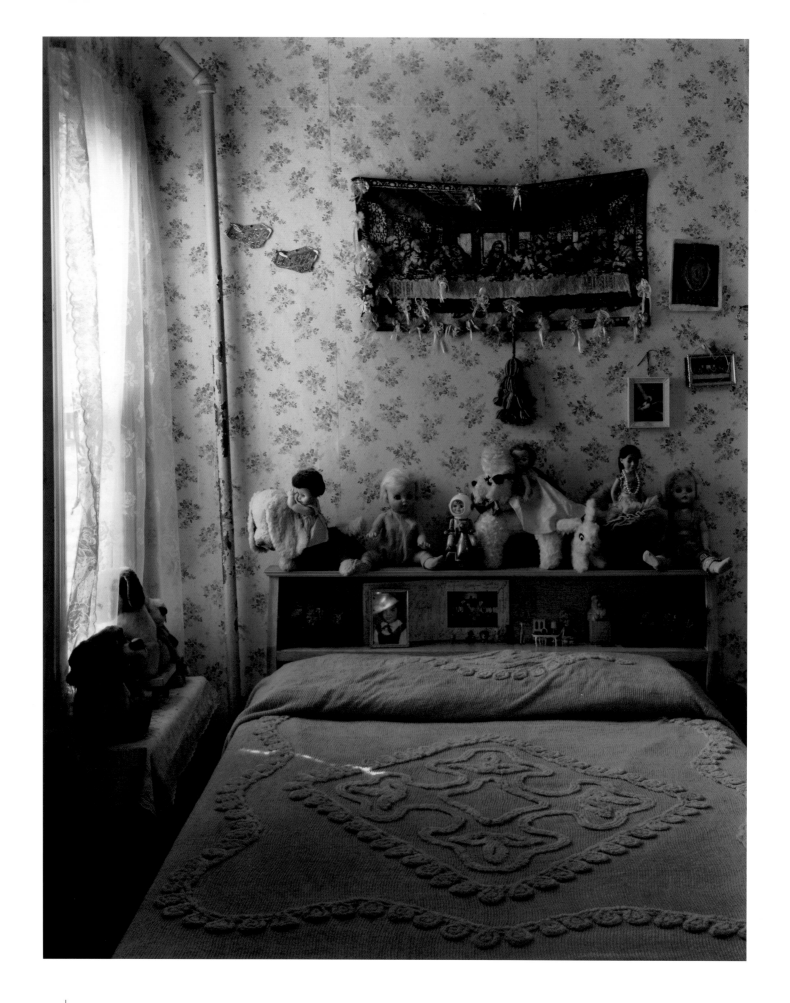

PLATE 5 **George A. Tice,** *Child's Bedroom, Paterson, New Jersey,* April 1971

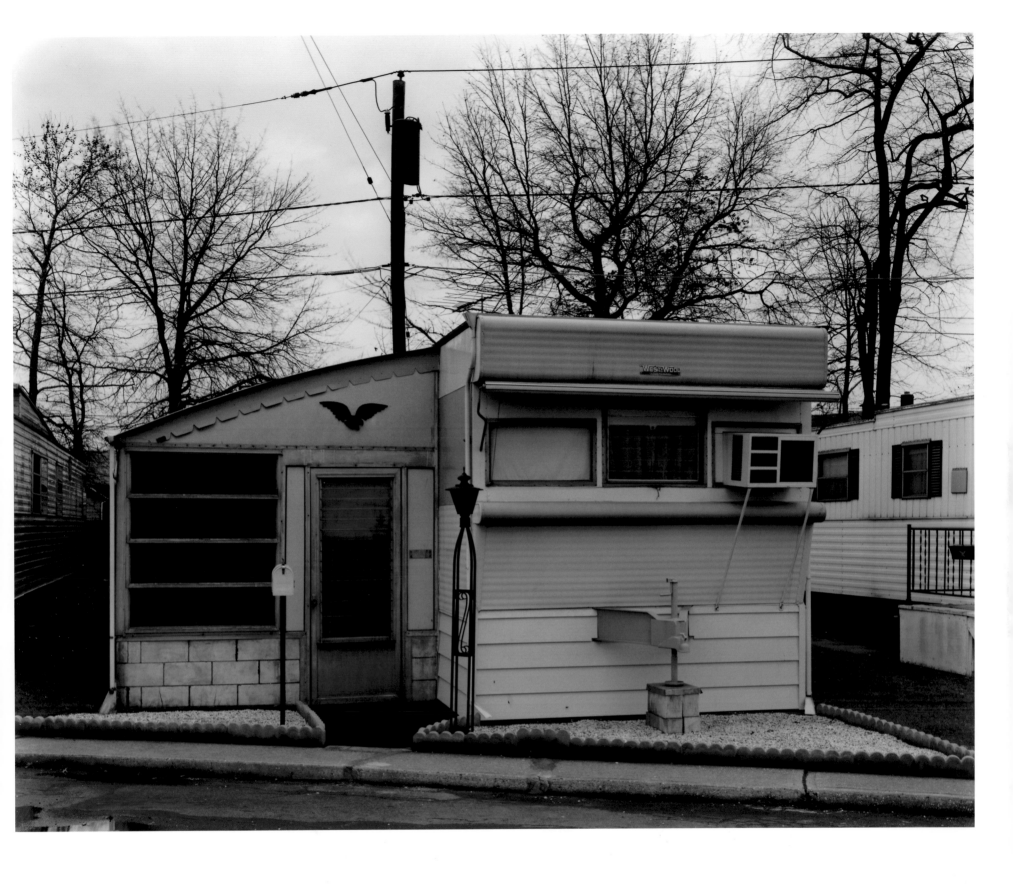

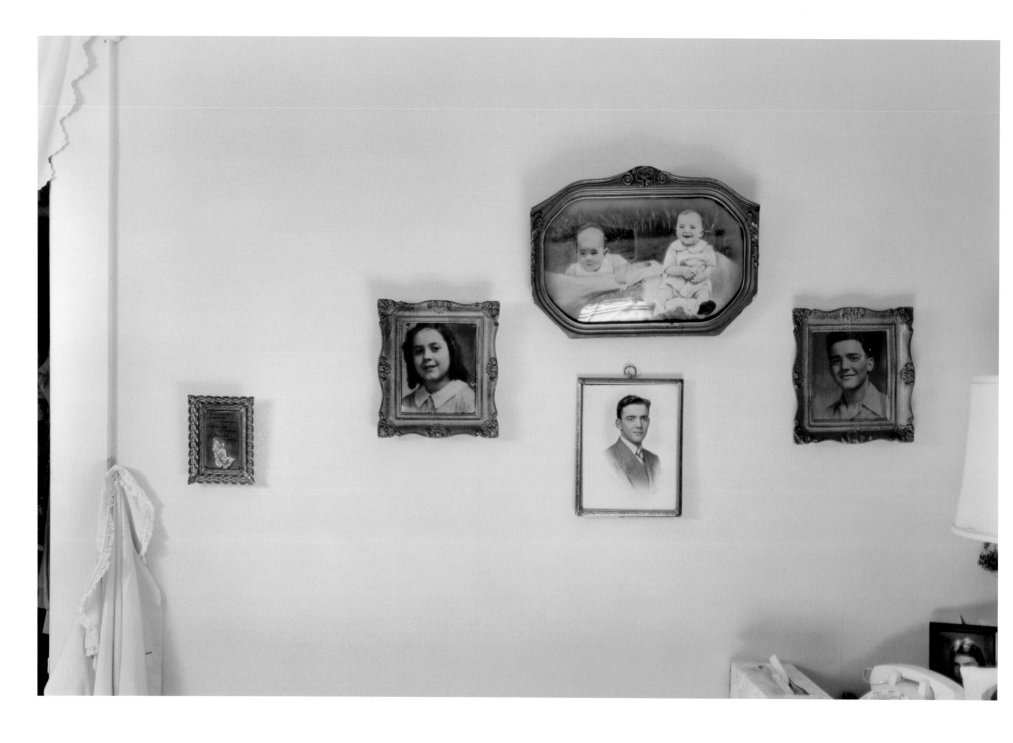

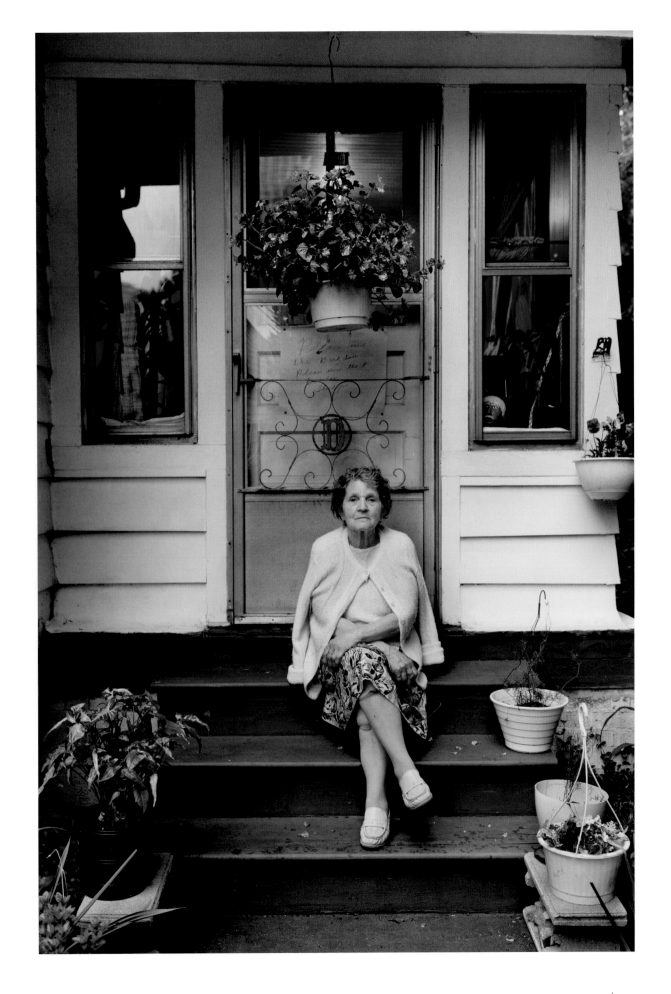

PLATE 8 Doug Dubois, *My Grandmother*, 1990 | 45

PLATE 9 Doug Dubois, *Sign outside Wash House, Shannopin Mine, Bobtown, PA*, 1991

PLATE 10 Doug Dubois, *Laundromat, Avella, PA*, 1991 | 47

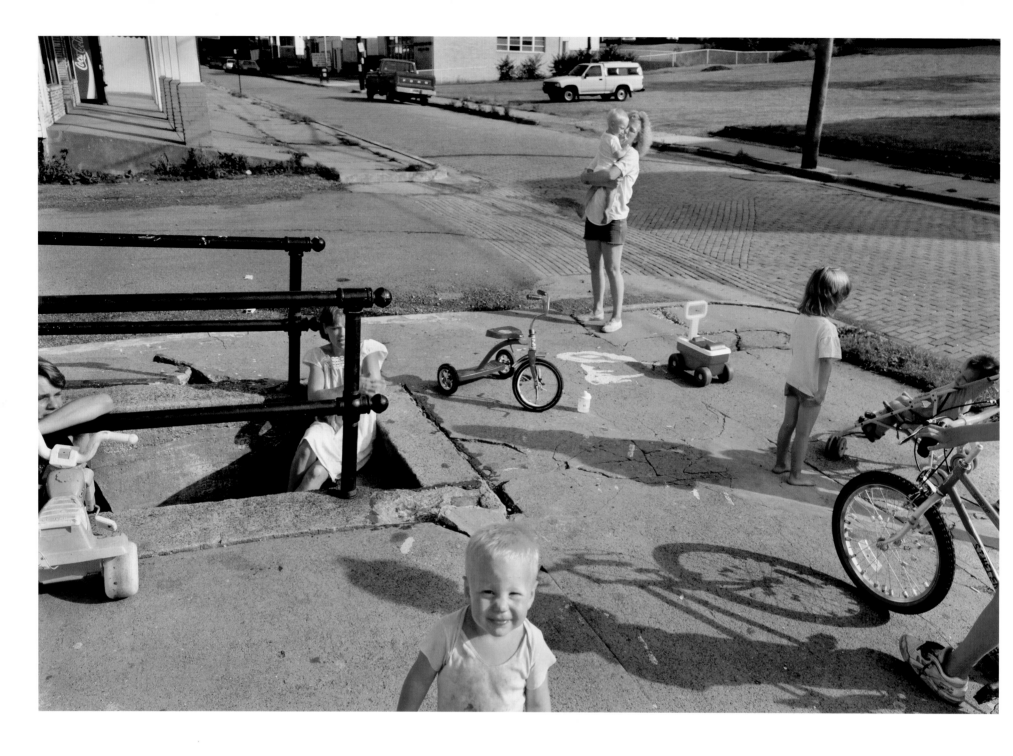

| PLATE 11 Doug Dubois, *Matthew, Tracy, Donna, Devon and Velvet on Main St., Avella, PA*, 1992

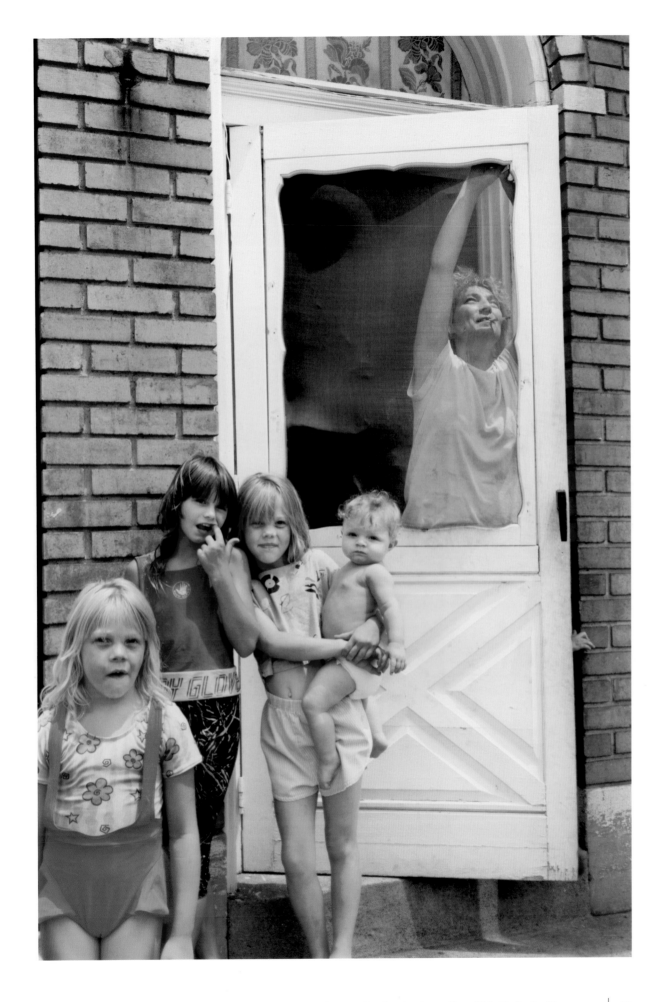

PLATE 13 Doug Dubois, *Main Street Facing North, Avella, PA*, 1991

PLATE 14 Doug Dubois, *Main Street Facing South, Avella, PA, 1991* 51

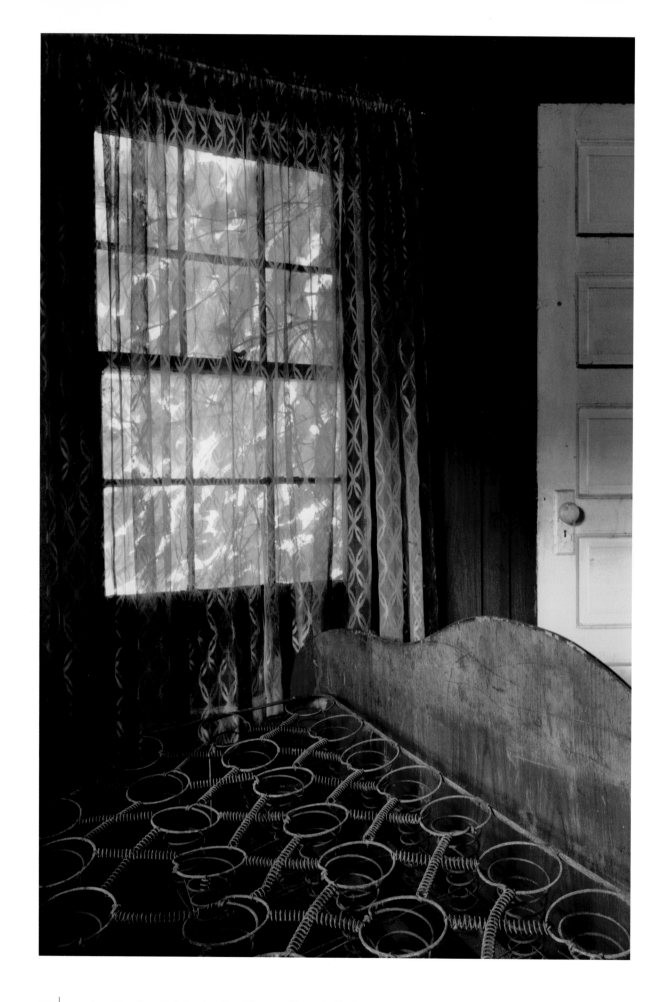

PLATE 15 Doug Dubois, *Abandoned Company House, Avella, PA*, 1991

| PLATE 17 Mitch Epstein, *Newton Street Row Houses, 2000*

PLATE 18 Mitch Epstein, *Pleasant Street, 2000* | 55

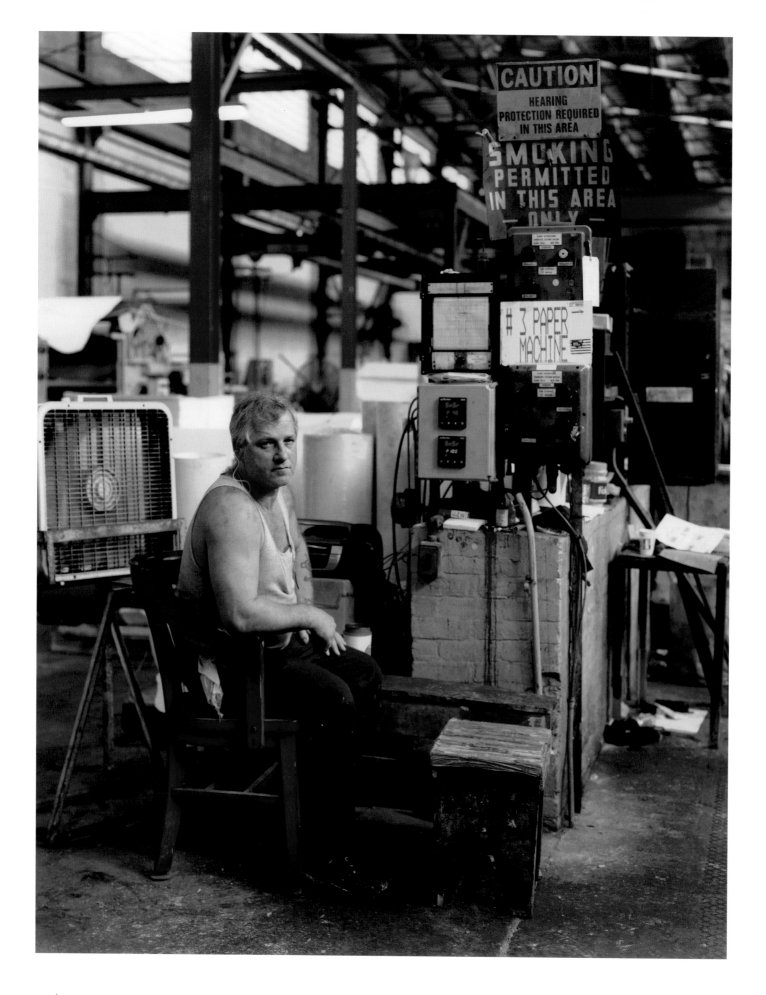

| PLATE 19 Mitch Epstein, *Parson's Paper Company Employee: Clifford M. Collins, 2000*

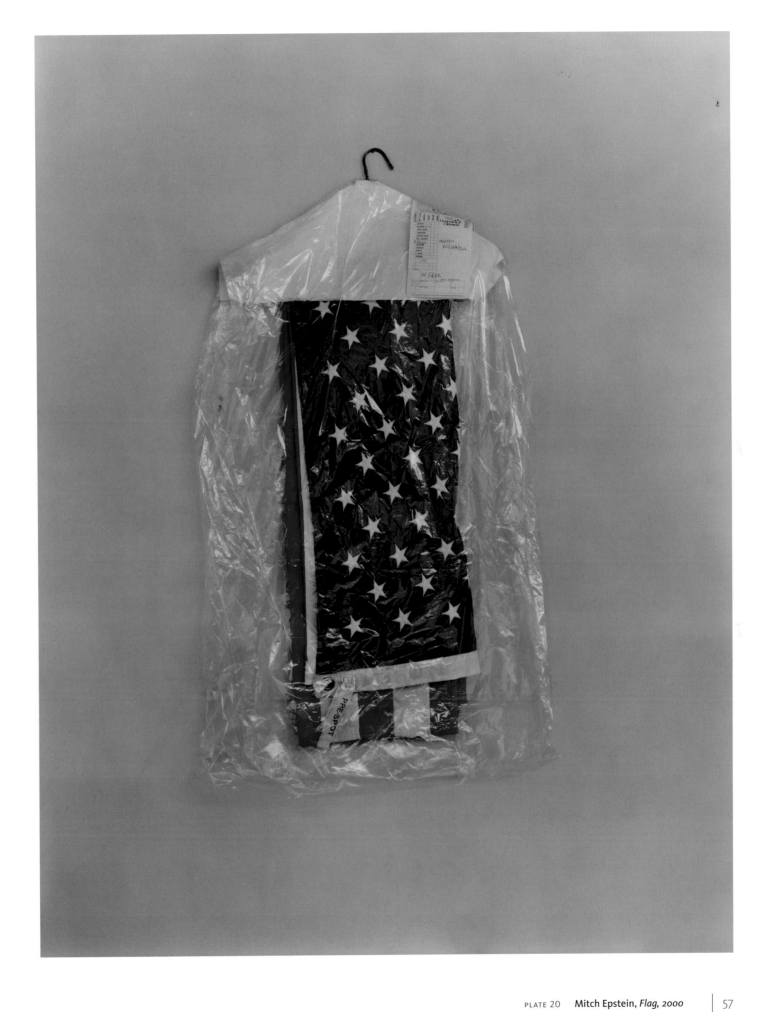

PLATE 20 **Mitch Epstein,** *Flag, 2000* | 57

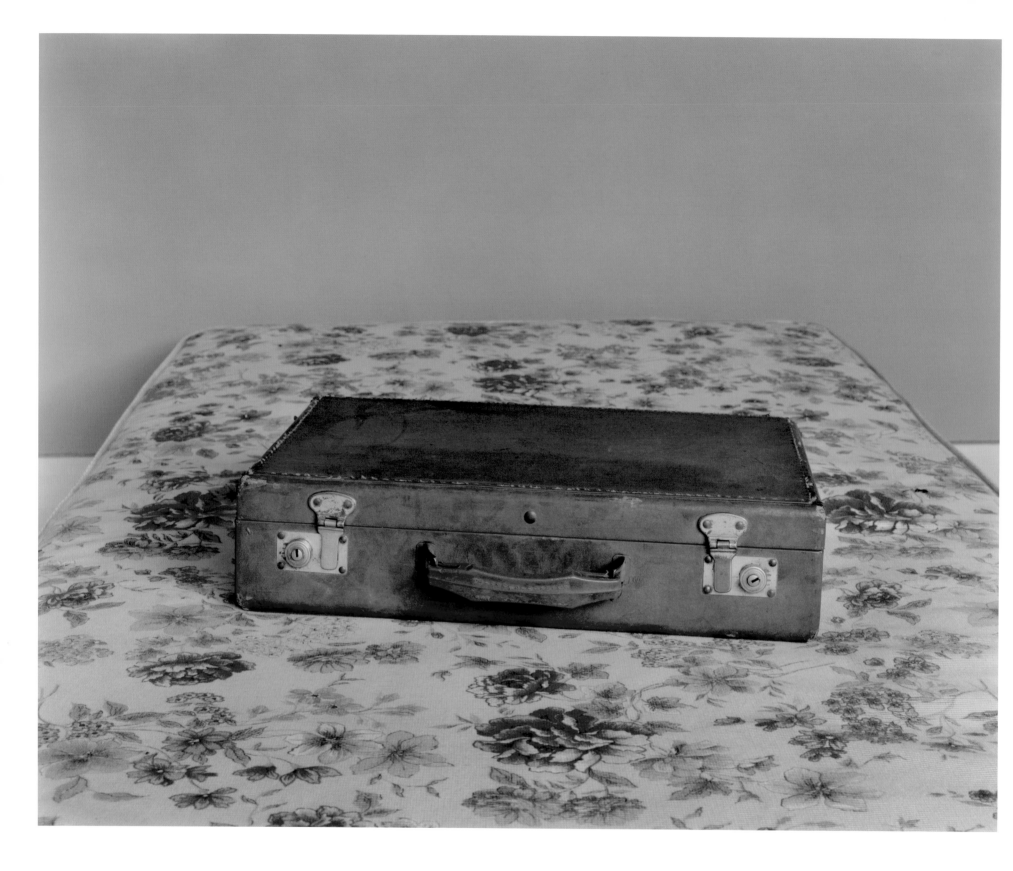

　PLATE 21　Mitch Epstein, *Dad's Briefcase, 2000*

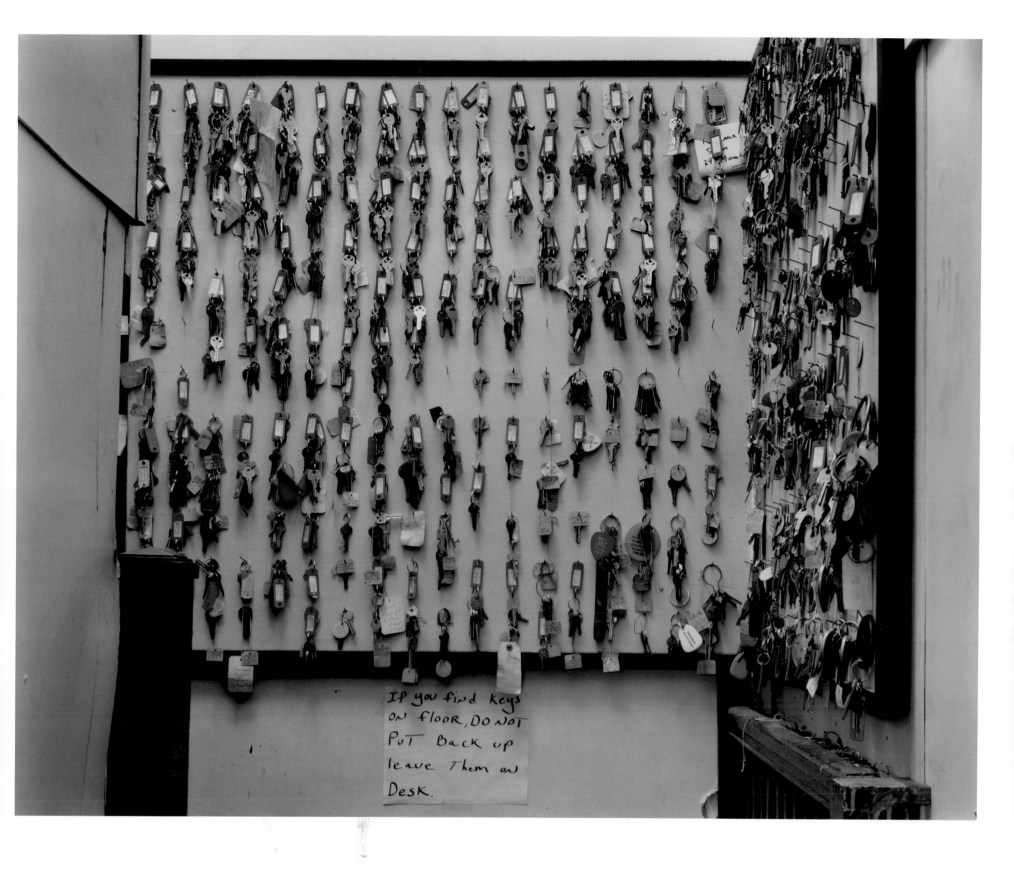

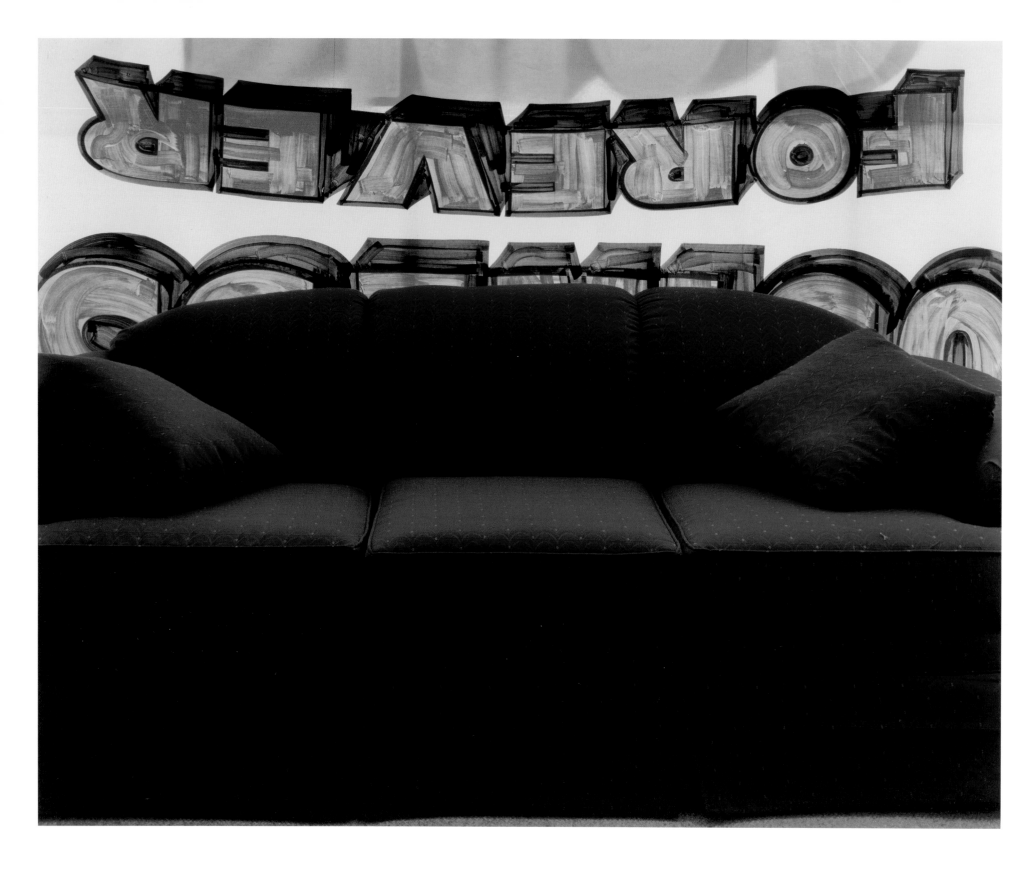

| PLATE 23 Mitch Epstein, *Liquidation Sale I, 2000*

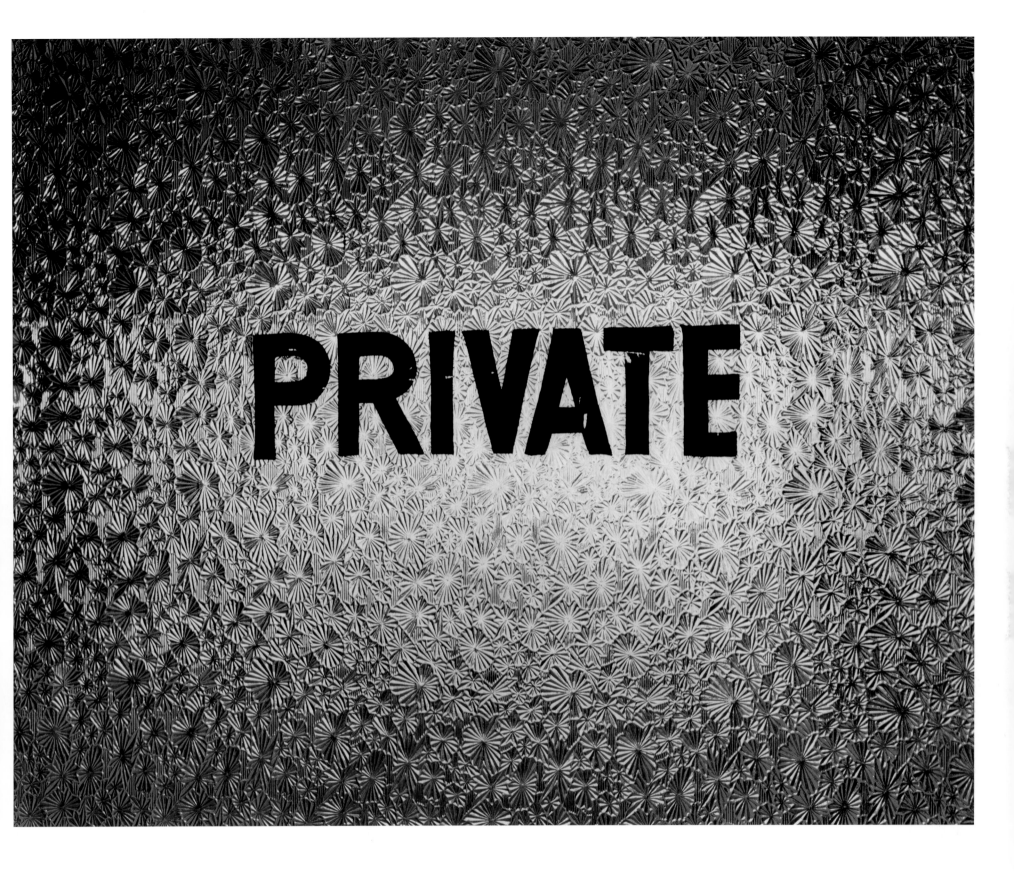

PLATE 24 Mitch Epstein, *Office Door, 2000* | 61

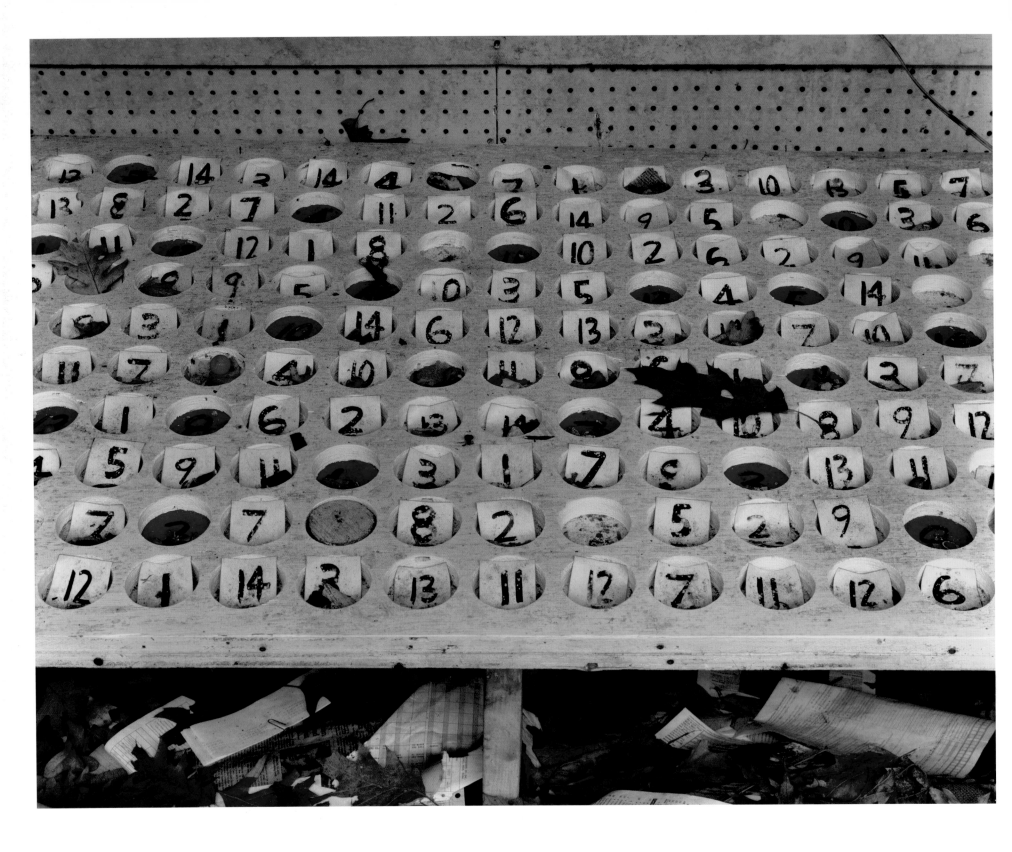

| PLATE 25 Mitch Epstein, *Mountain Park Number Board, 2000*

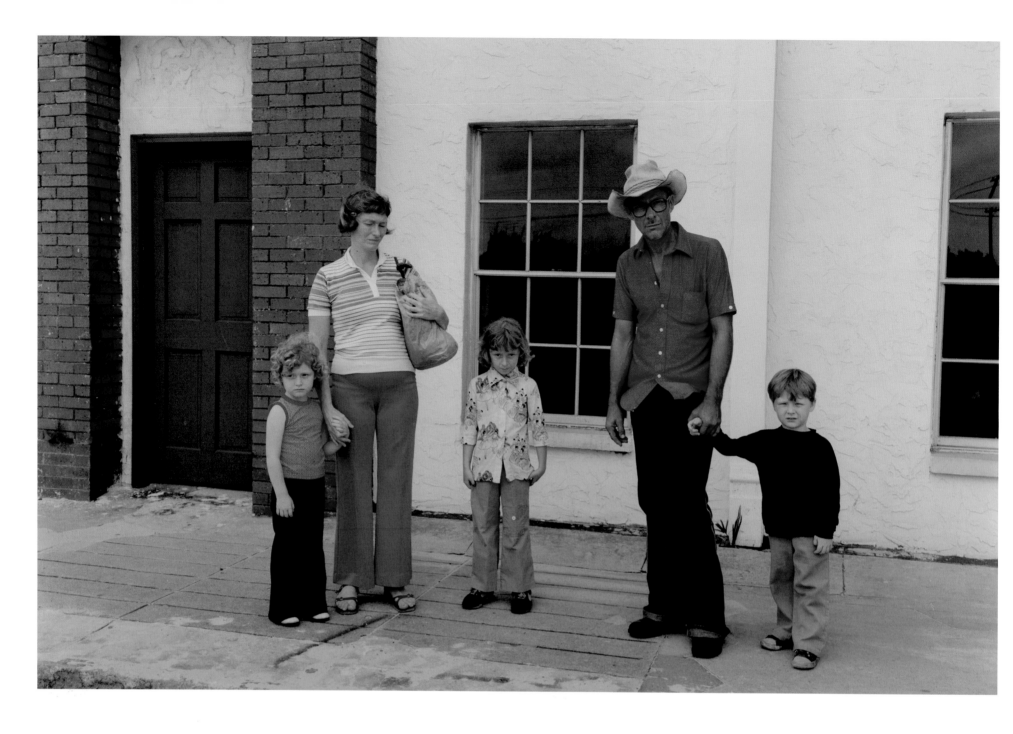

| PLATE 27 **Mitch Epstein,** *Ybor City, Florida, 1983*

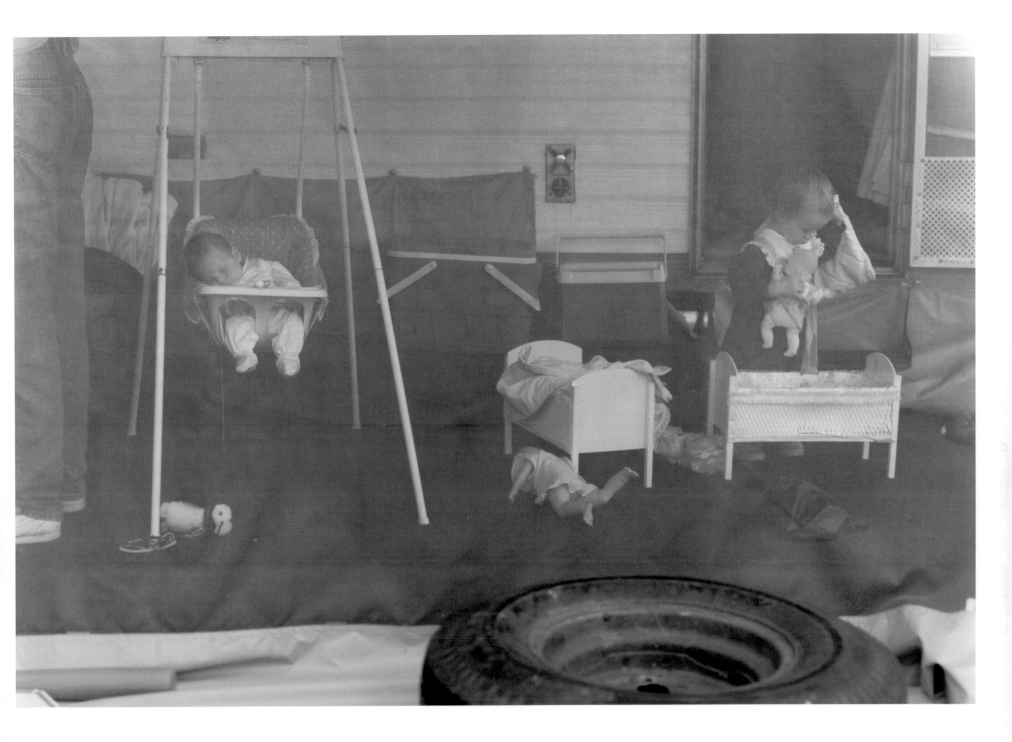

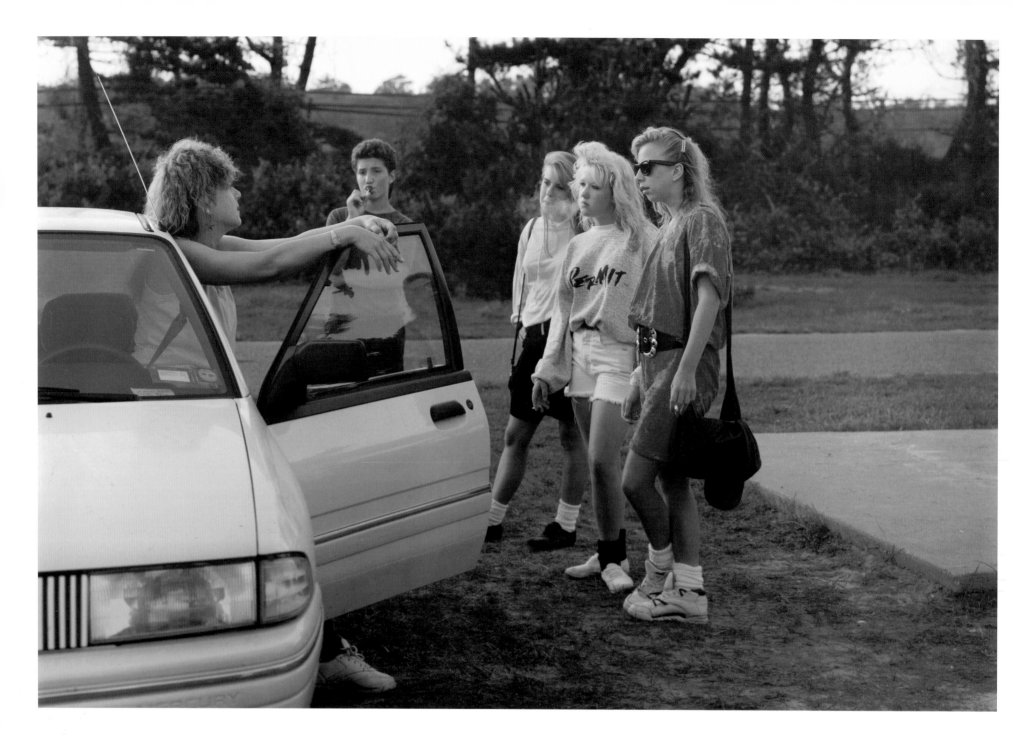

| PLATE 29 **Adam Bartos,** *Hither Hills State Park, Montauk, N.Y.*, 1991–94

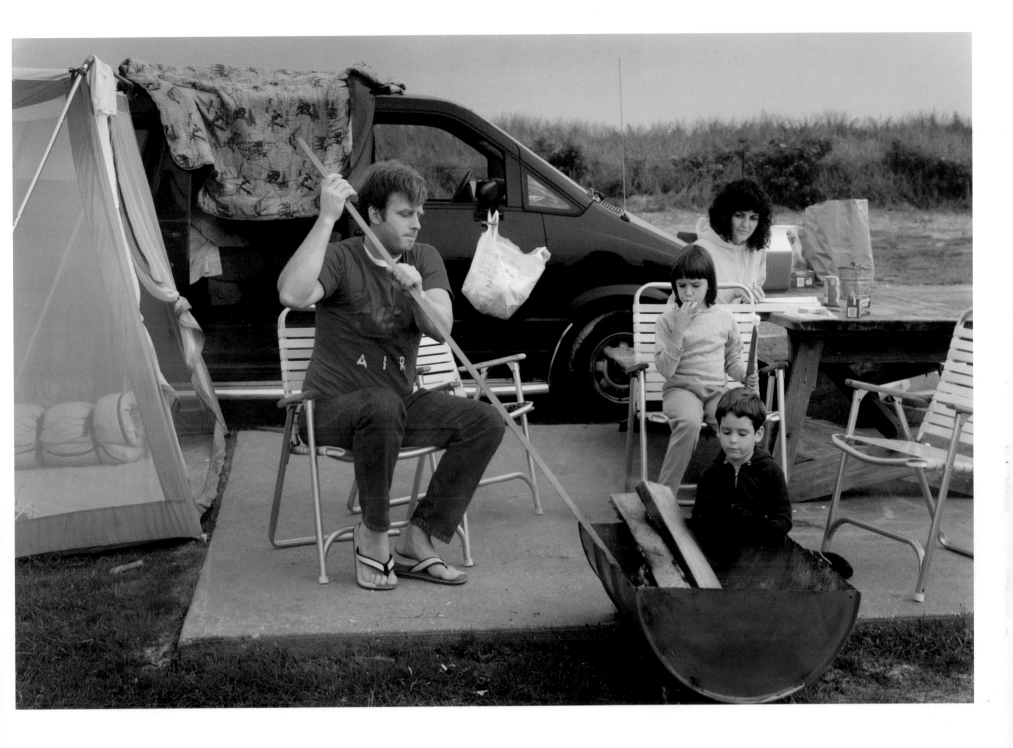

PLATE 31 Adam Bartos, *Hither Hills State Park, Montauk, N.Y.*, 1993

| PLATE 33 **Adam Bartos,** *Hither Hills State Park, Montauk, N.Y.,* 1990–94

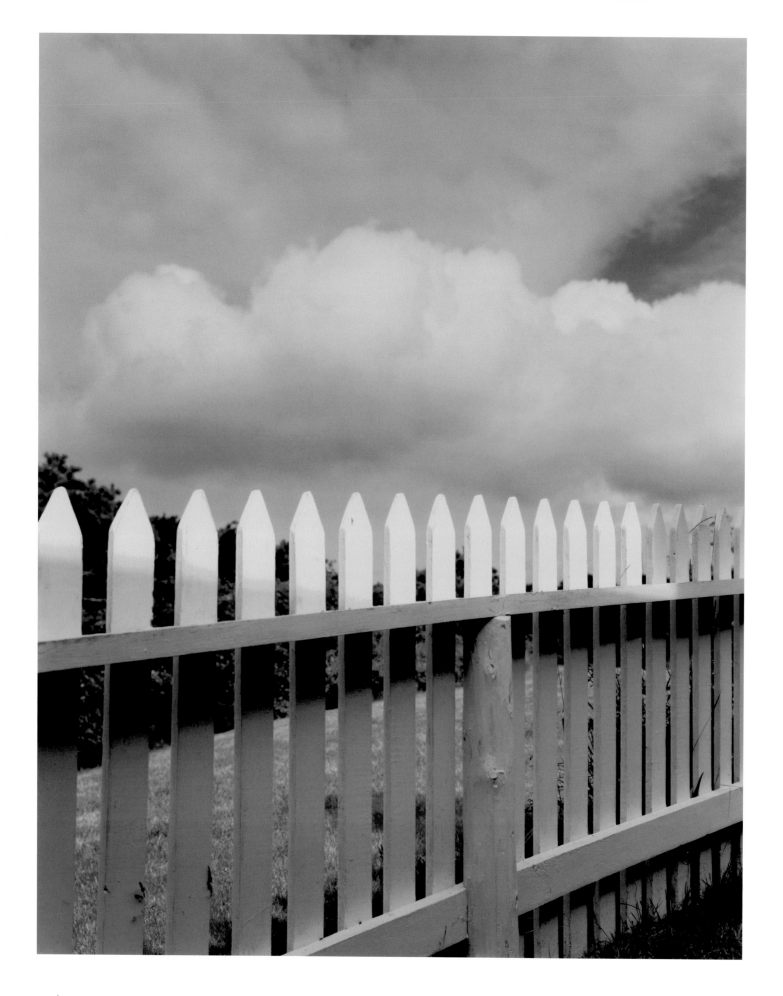

PLATE 35 Joel Meyerowitz, *Fence, Truro*, 1976

| PLATE 37 Alex Harris, *Genara Gurule's House, Río Lucío, New Mexico, August 1985*

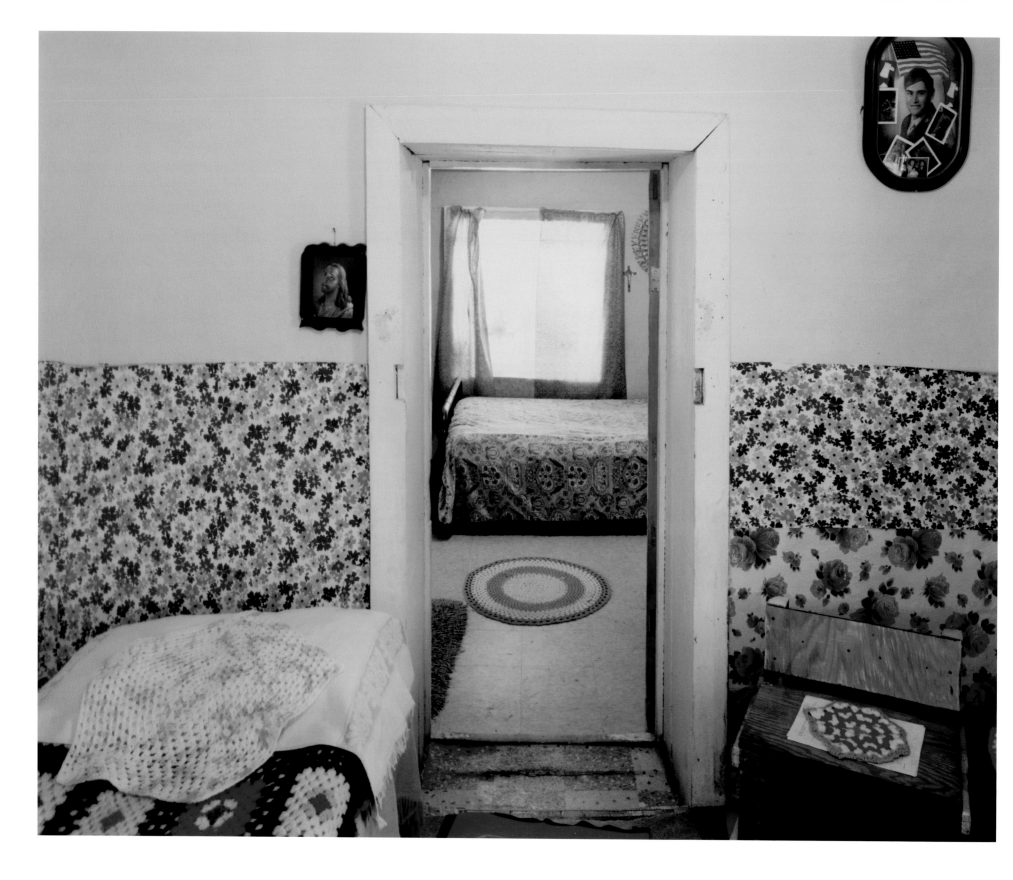

Alex Harris, *Onésimo and Eleanor Pacheco's House, Vallecito, New Mexico, May 1985*

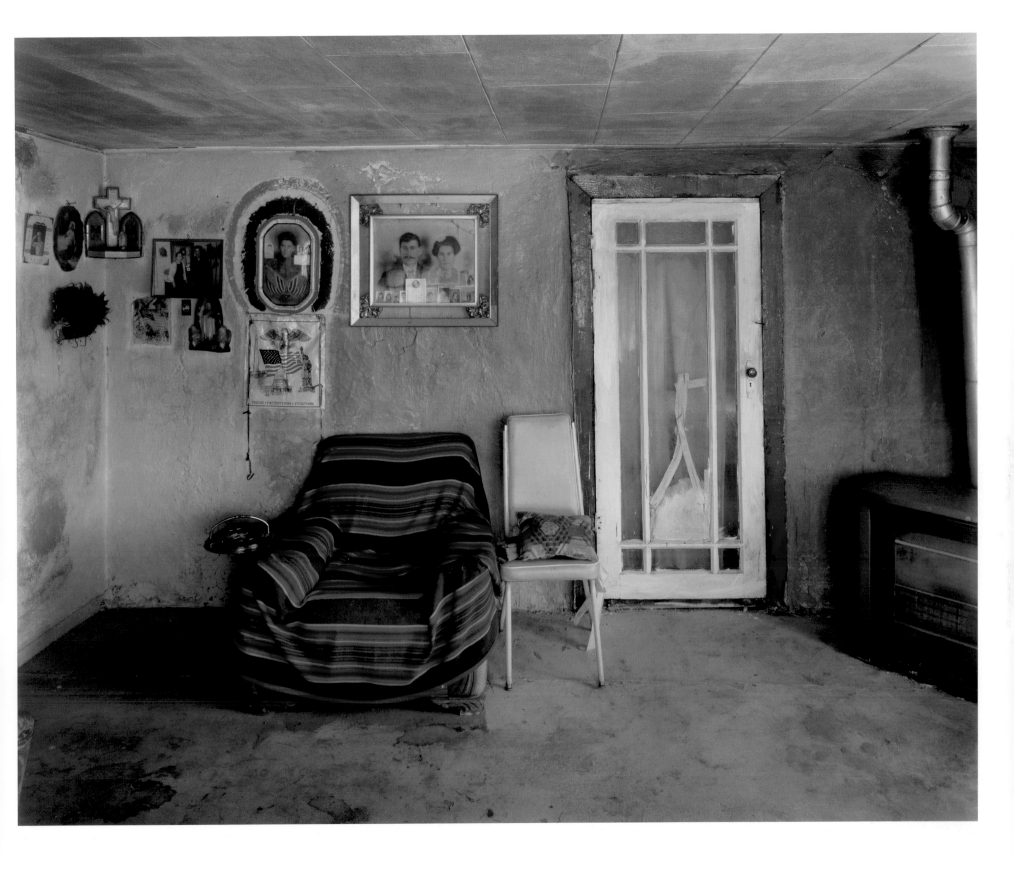

PLATE 41 Alex Harris, *Norlina, North Carolina*, March 1985

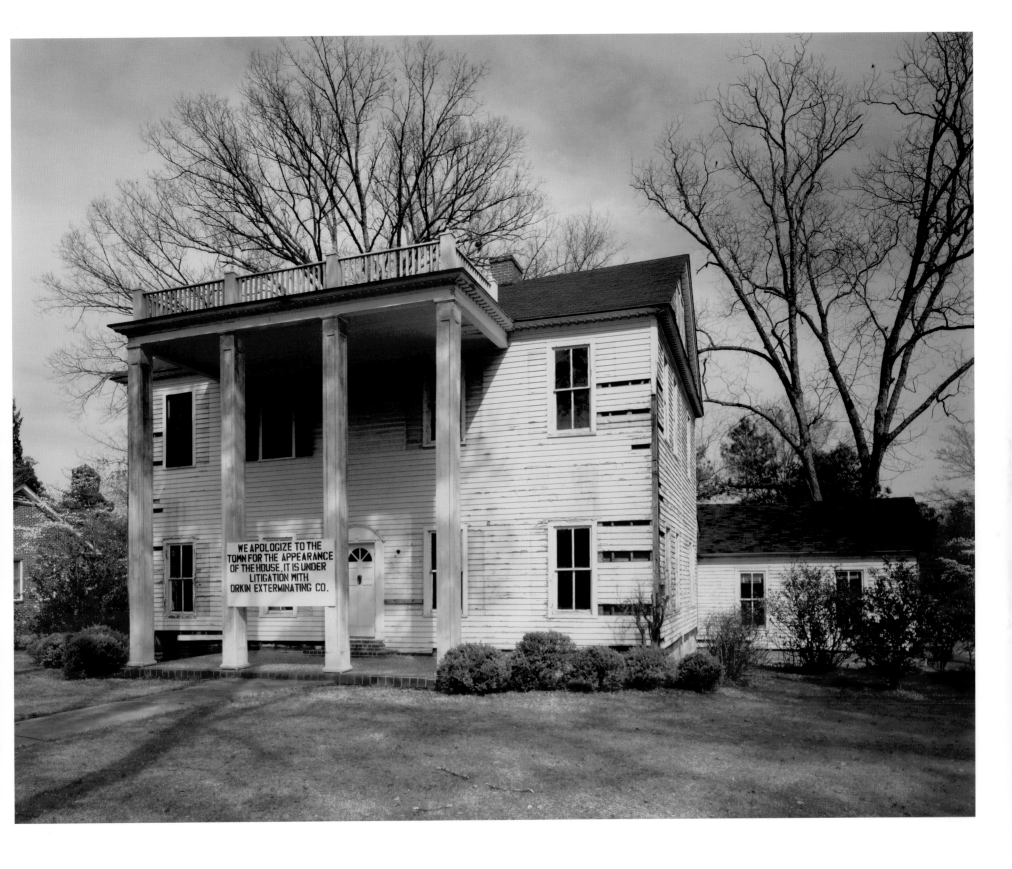

PLATE 42 Alex Harris, *Summerton, North Carolina, March 1985* | 79

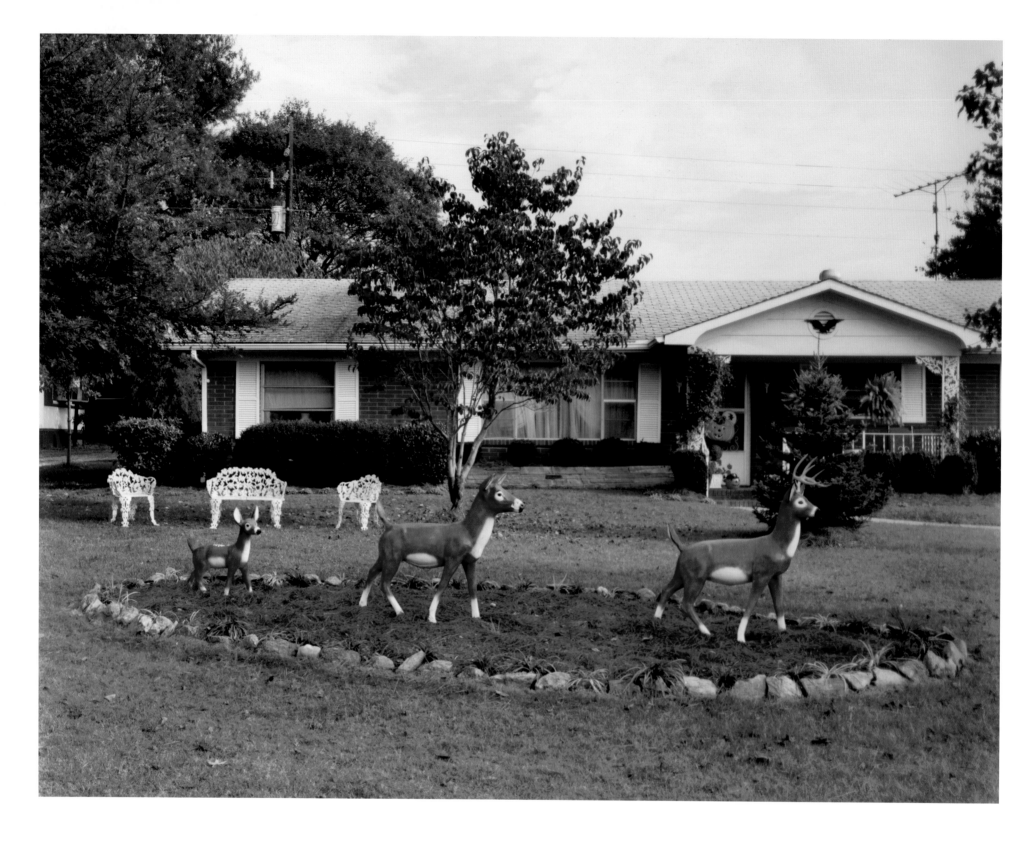

PLATE 43 Alex Harris, *Wake Forest, North Carolina*, October 1984

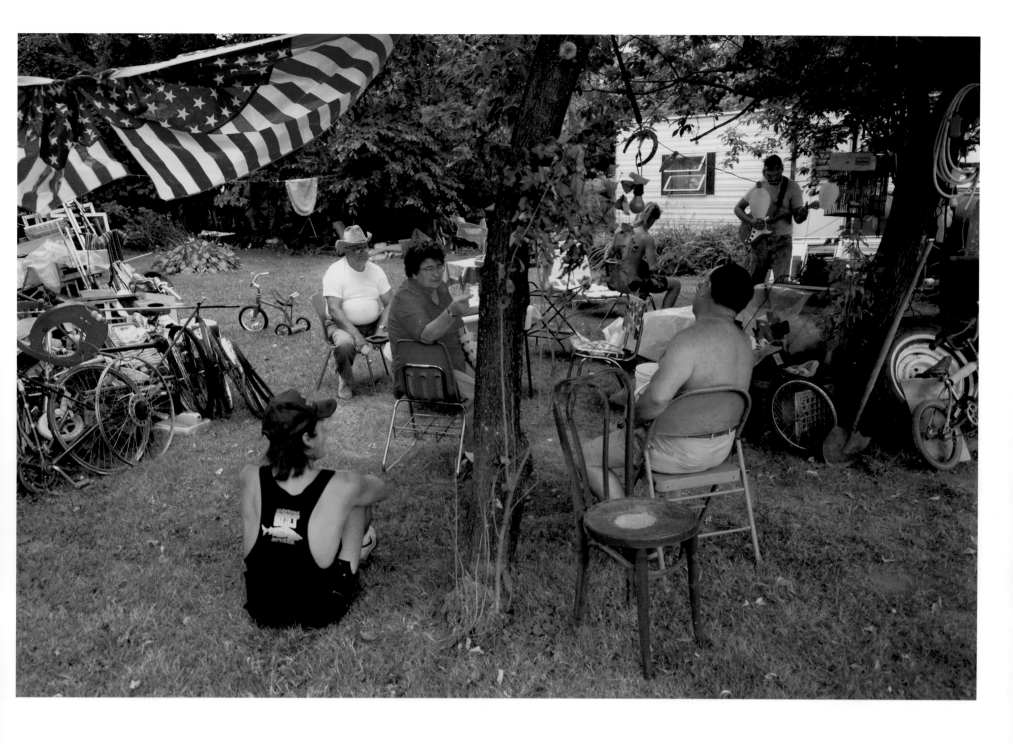

PLATE 44 Sheron Rupp, *Grand Isle, Vermont*, 1991 | 81

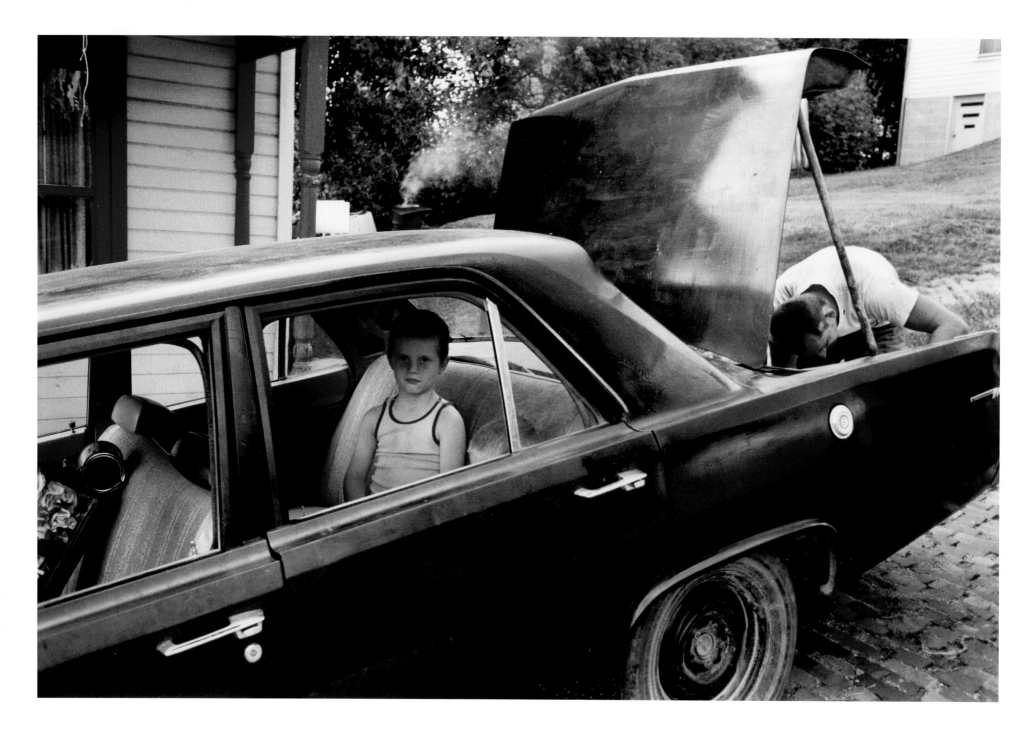

PLATE 45 Sheron Rupp, *Shawnee, Ohio*, 1983

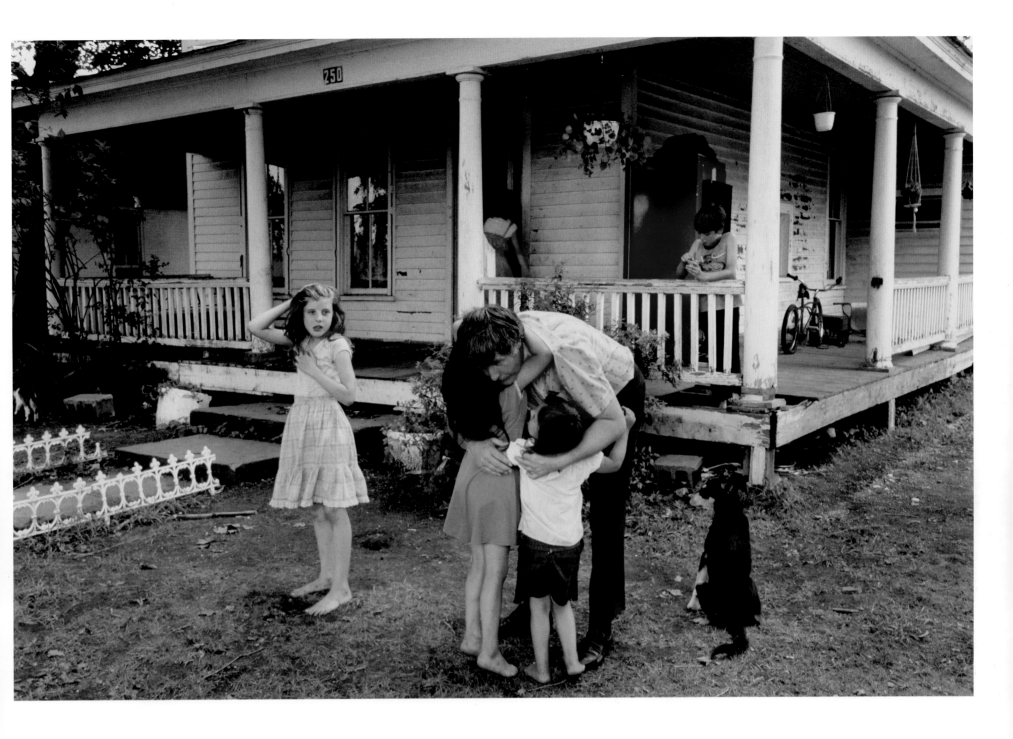

PLATE 46 Sheron Rupp, *Utica, Ohio*, 1983 | 83

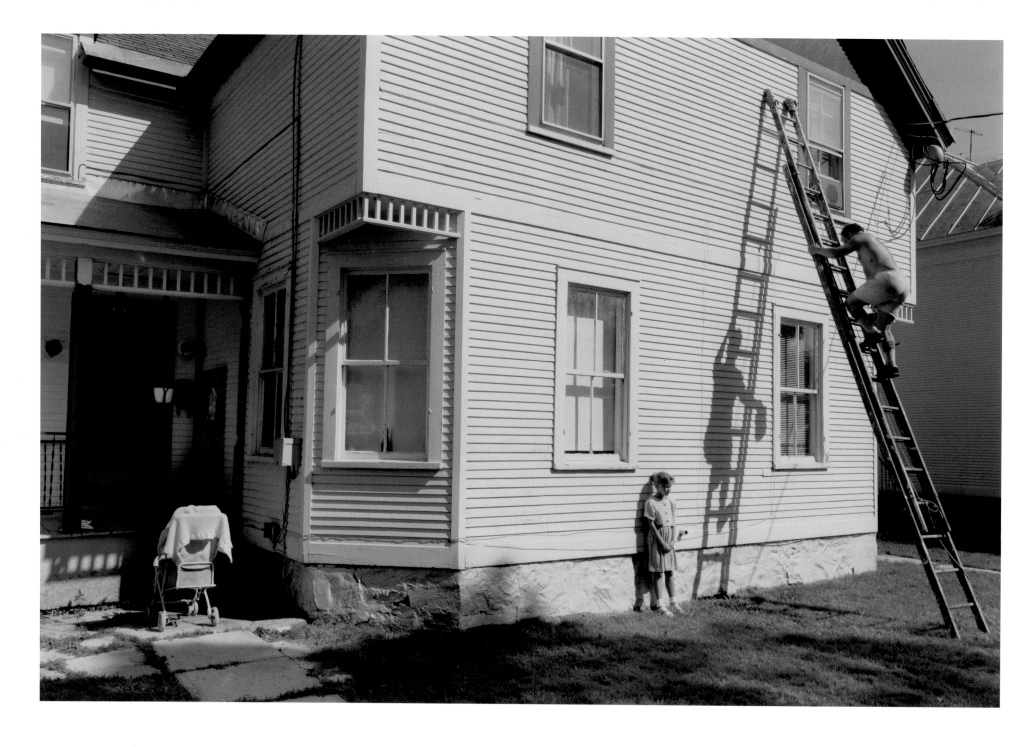

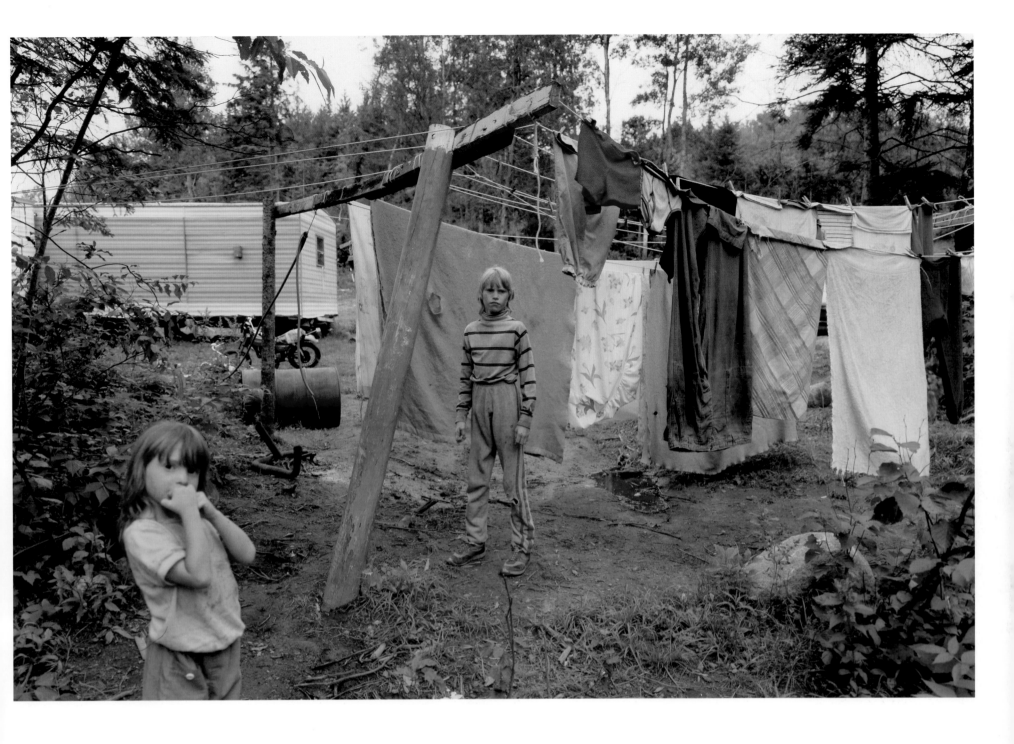

PLATE 48 Sheron Rupp, *Stevie, Sutton, Vermont*, 1990 | 85

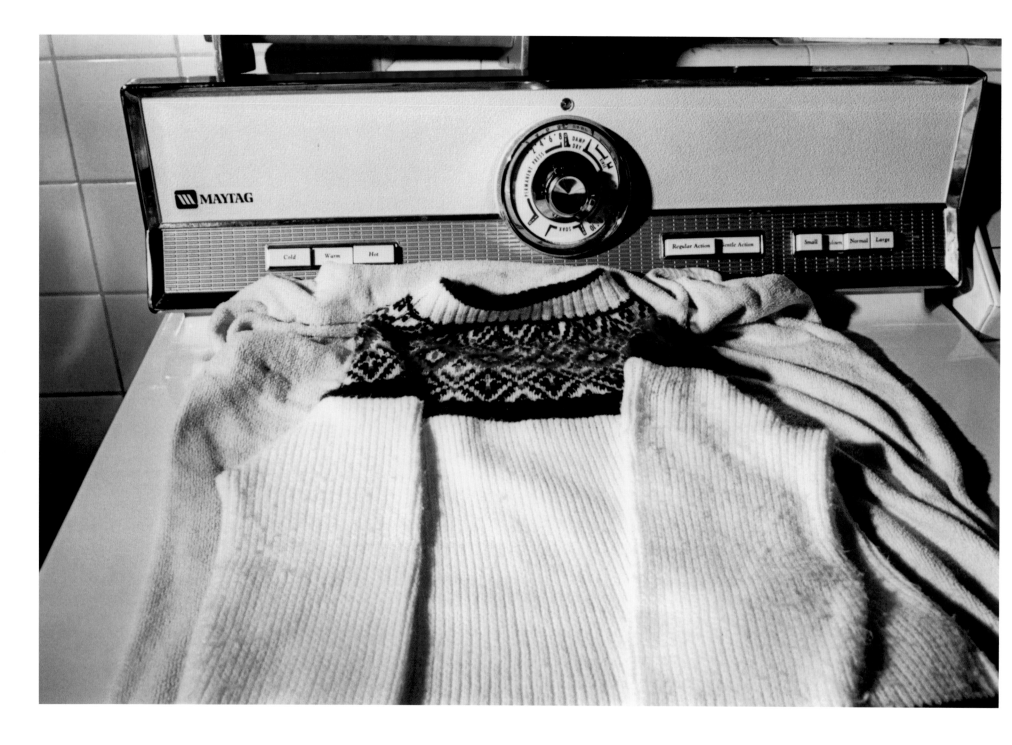

| PLATE 49 William Eggleston, *Memphis, 1971–1974*

PLATE 50 William Eggleston, *Untitled, 1965–1974* | 87

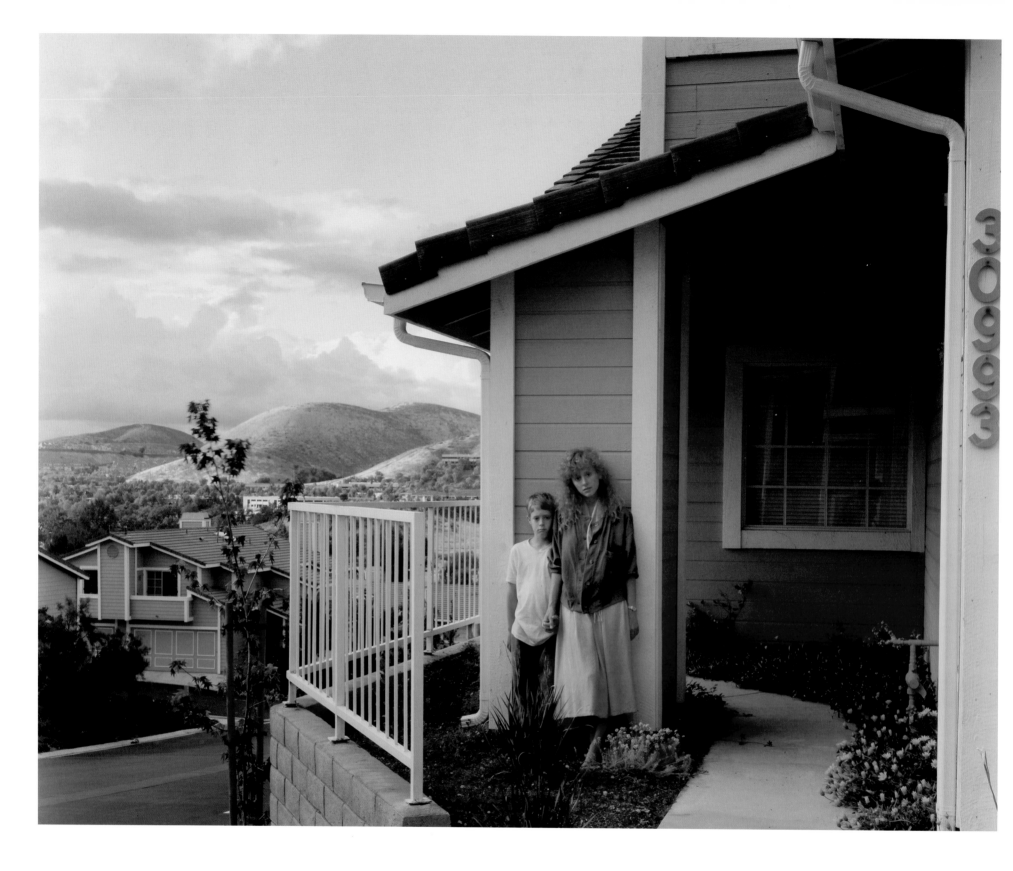

| PLATE 51 Joel Sternfeld, *Agoura, California, January 1988*

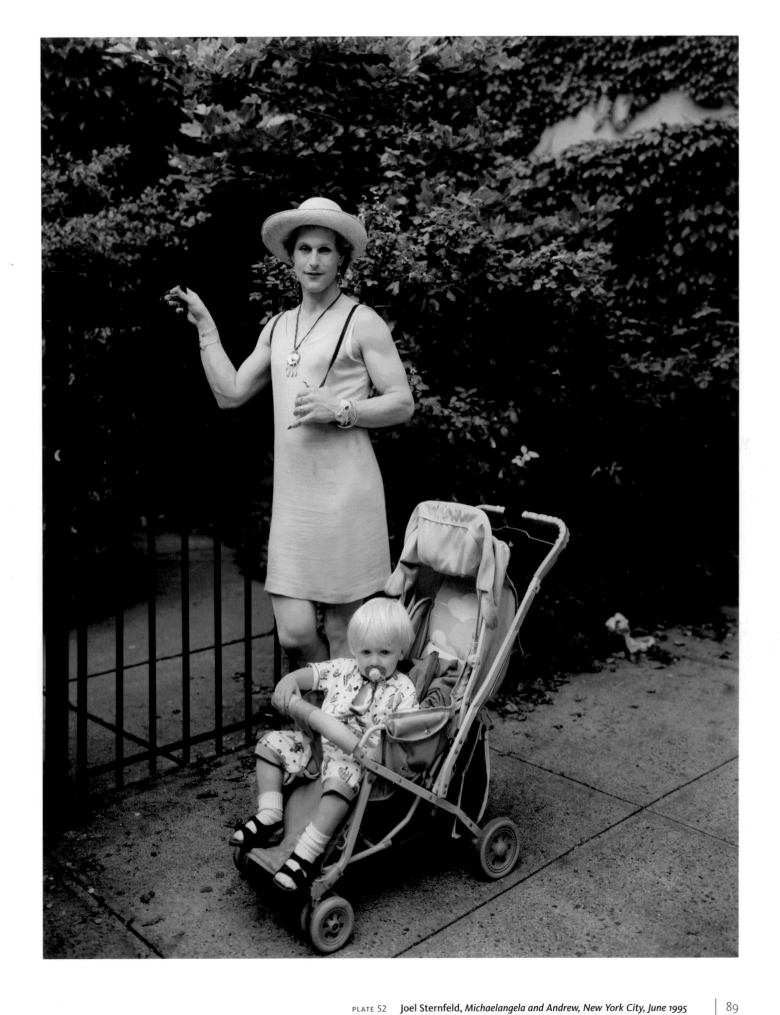

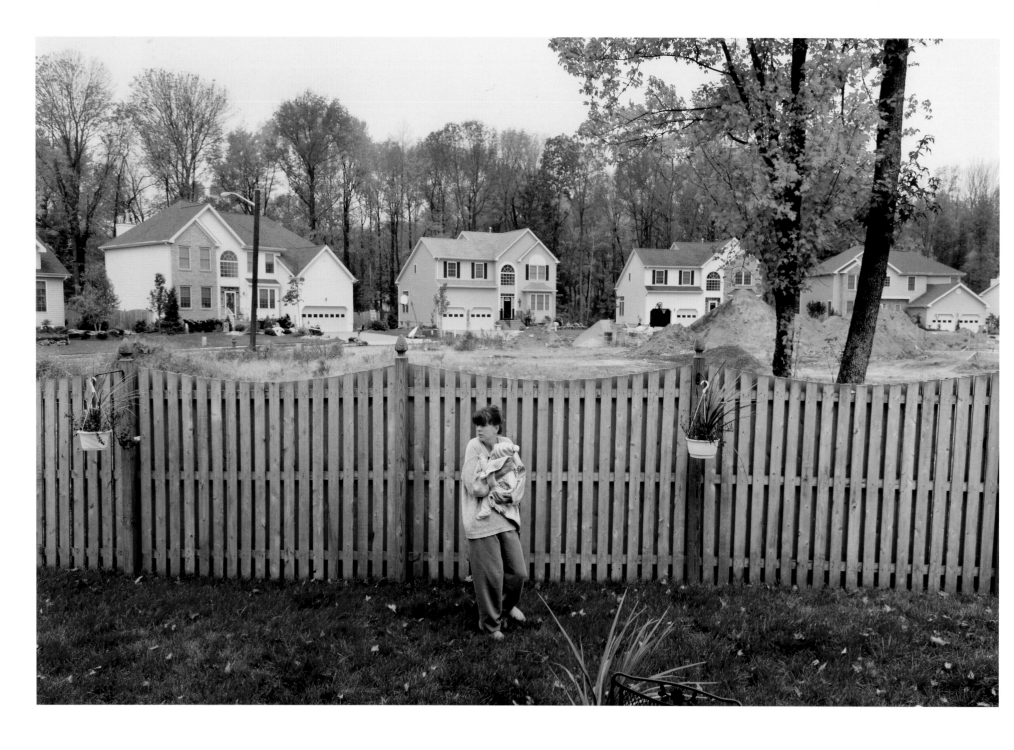

PLATE 53 Doug Dubois, *My Sister, Lise and Spencer, New Jersey,* 1999

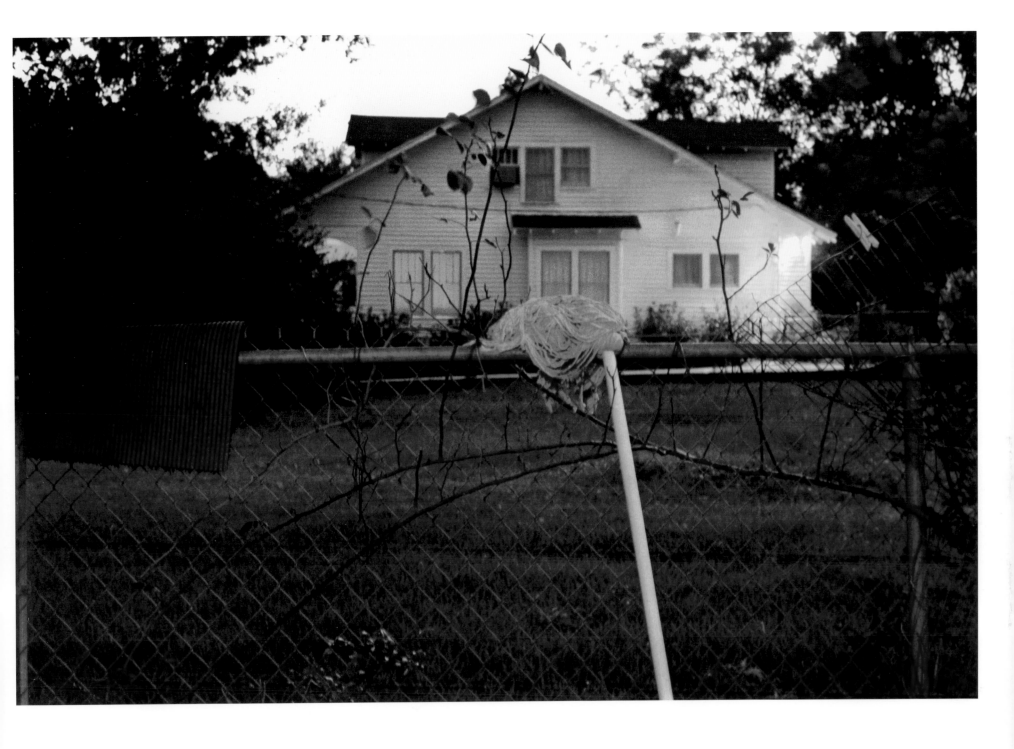

PLATE 54 William Eggleston, *Greenwood, 1971–1974* | 91

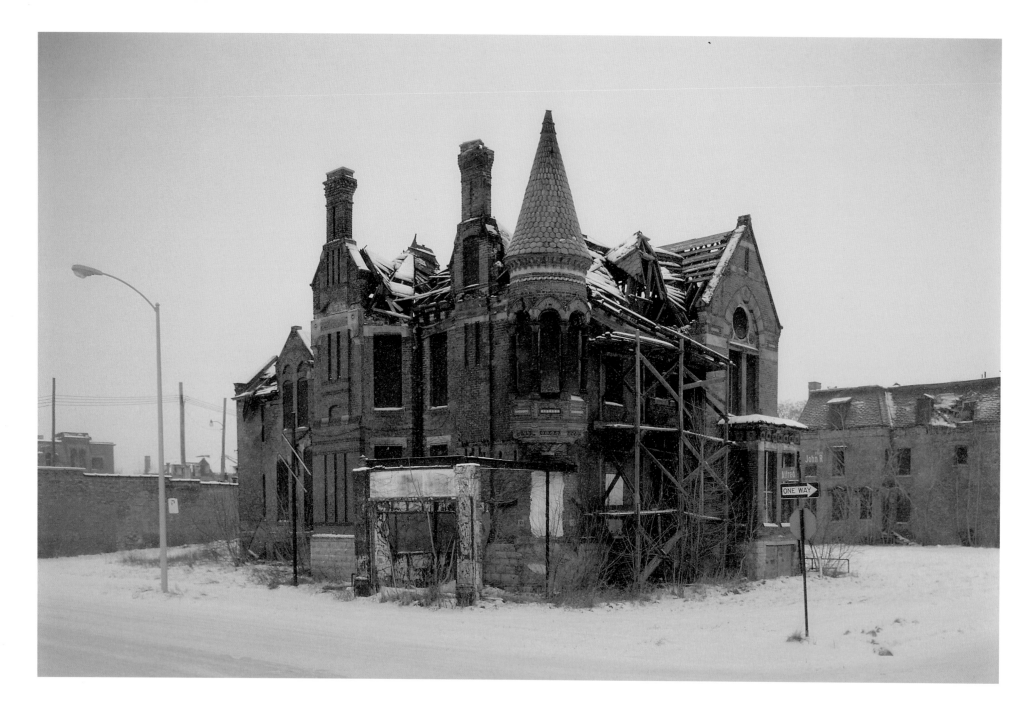

PLATE 55 Camilo José Vergara, *Ransom–Gillis Mansion in Ruins, Alfred and John R Streets*, Detroit, 1997

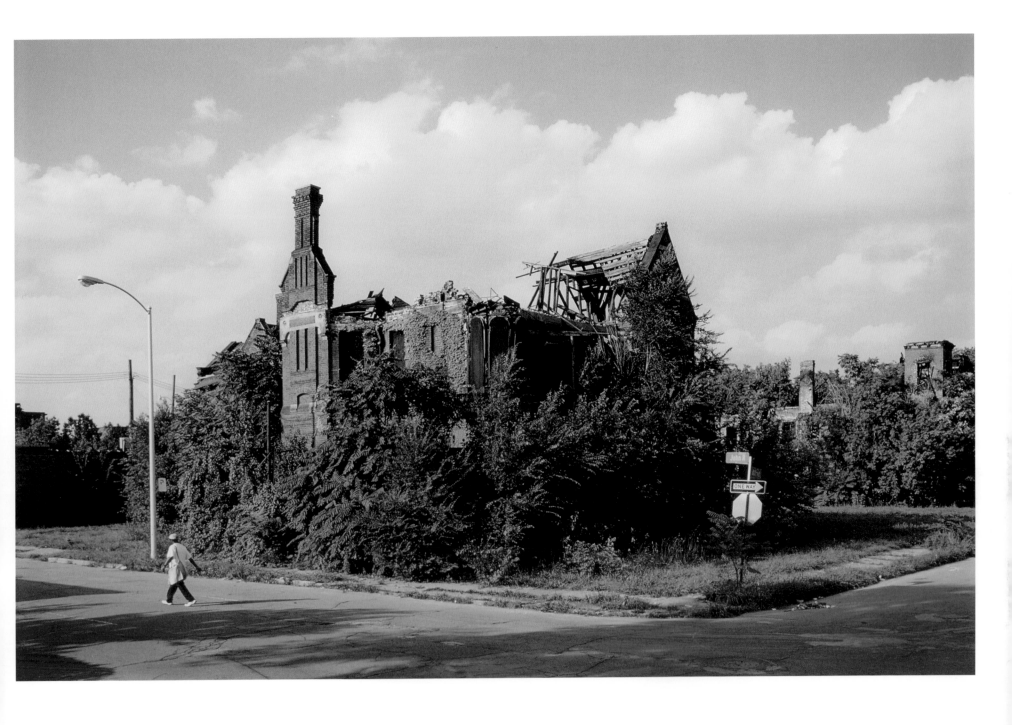

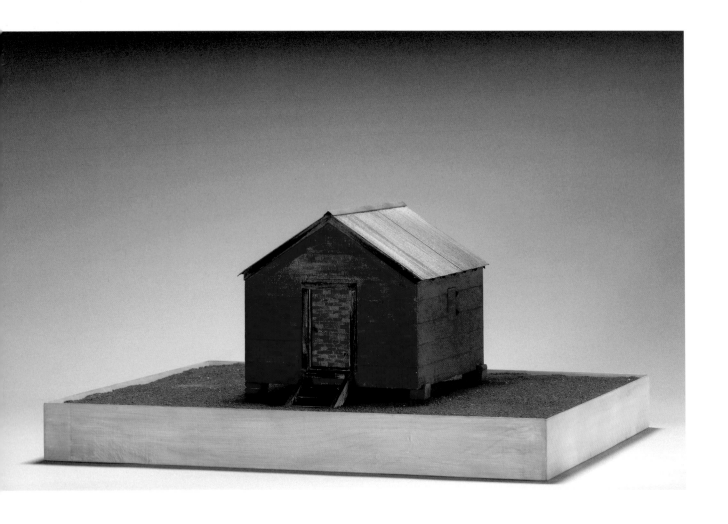

| PLATE 57 William Christenberry, *Red Building in Forest, Hale County, Alabama*, 1984–85

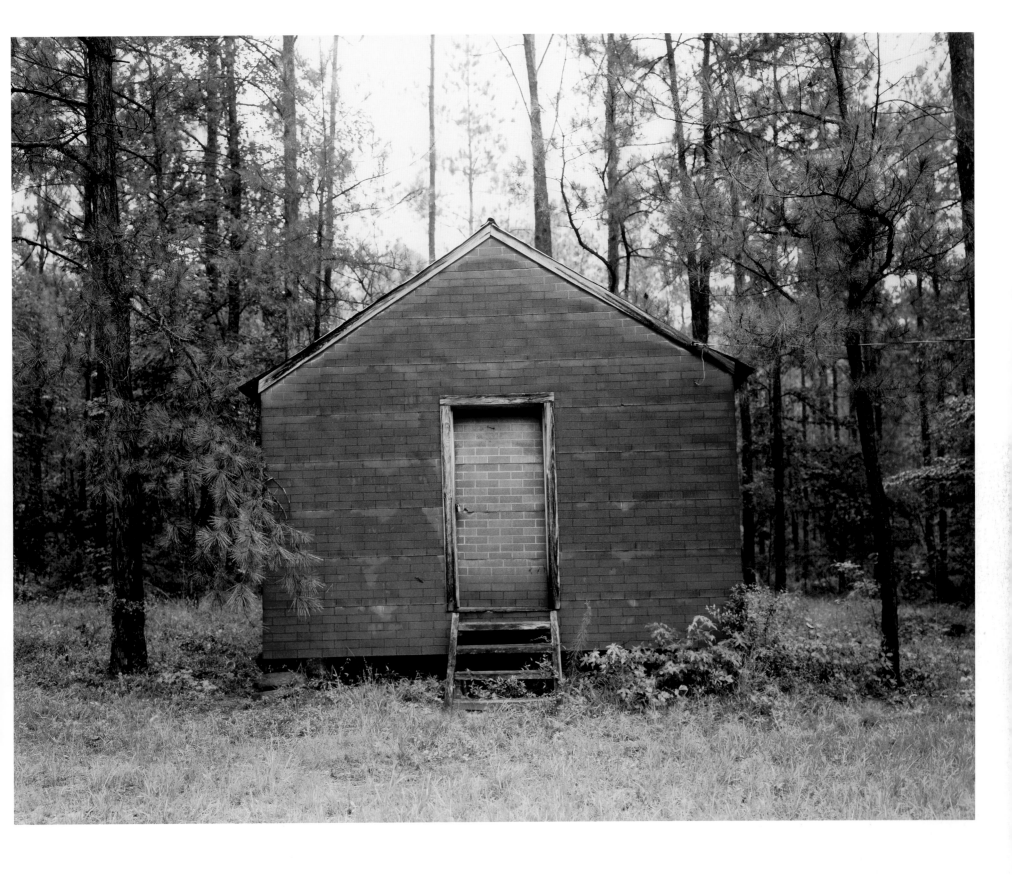

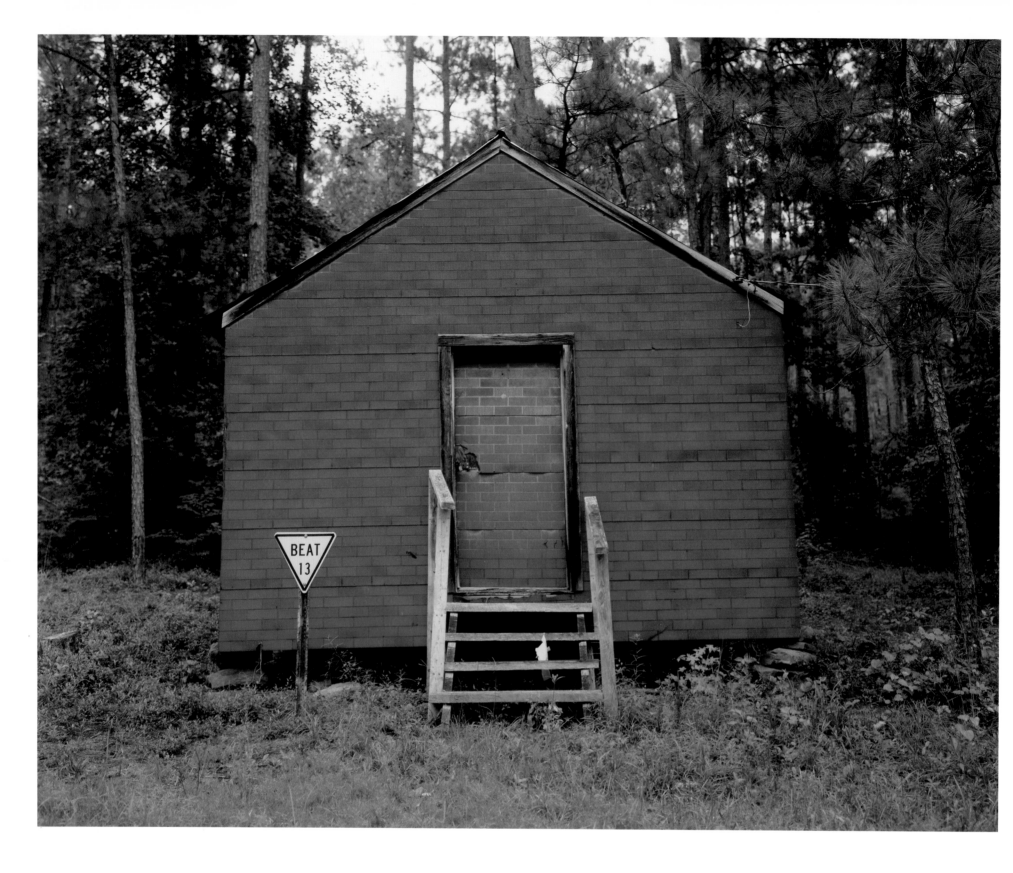

PLATE 59 William Christenberry, *Red Building in Forest, Hale County, Alabama*, 1994

| PLATE 61 Robert Adams, *El Paso County Fairgrounds, Calhan, Colorado,* 1968

PLATE 62 Robert Adams, *Pawnee Grassland, Colorado, 1984* 99

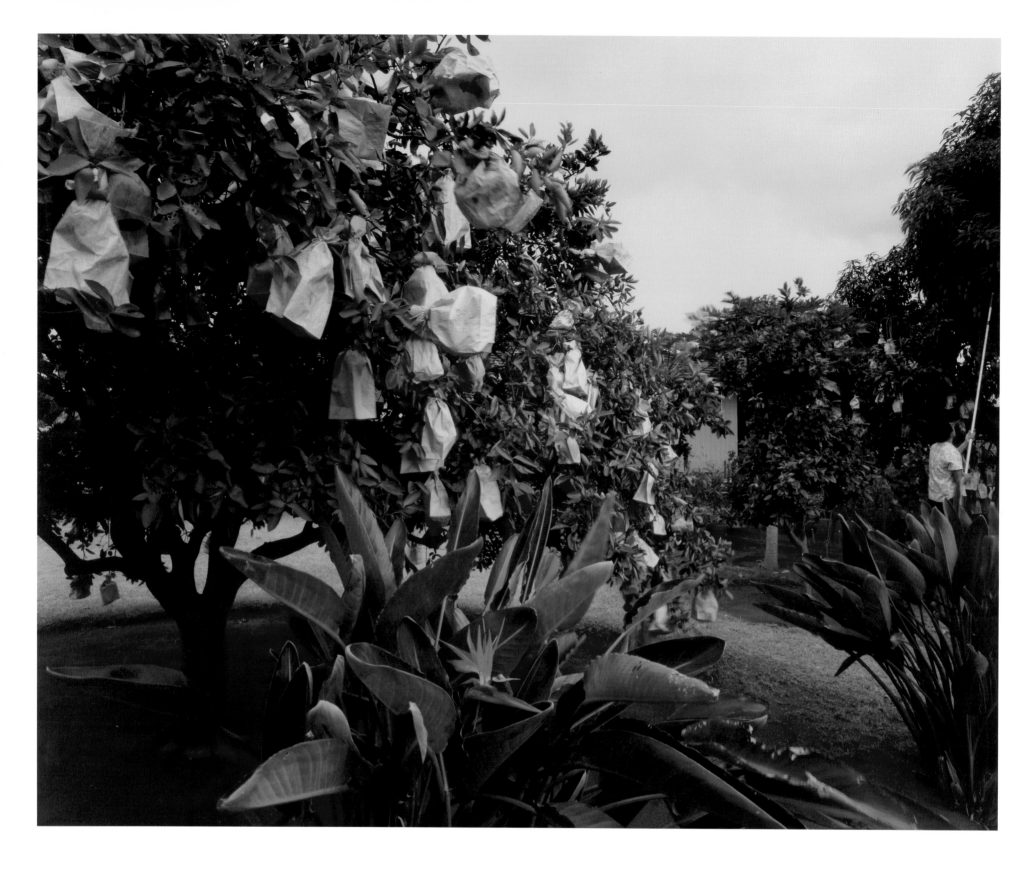

| PLATE 63 Virginia Beahan and Laura McPhee, *Kasahara's Garden, Kauai*, 1991

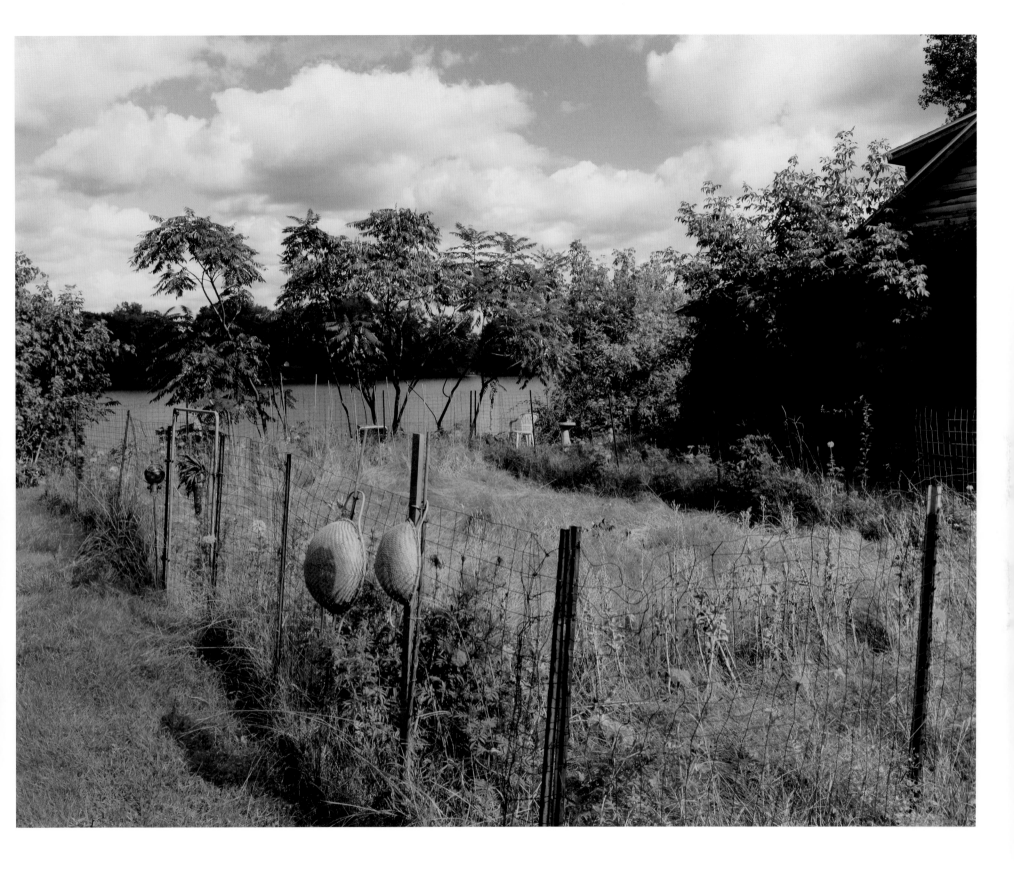

PLATE 64 Sheron Rupp, *Untitled*, 2003 | 101

PLATE 66 Sheron Rupp, *Wartrace, Tennessee, 1990* | 103

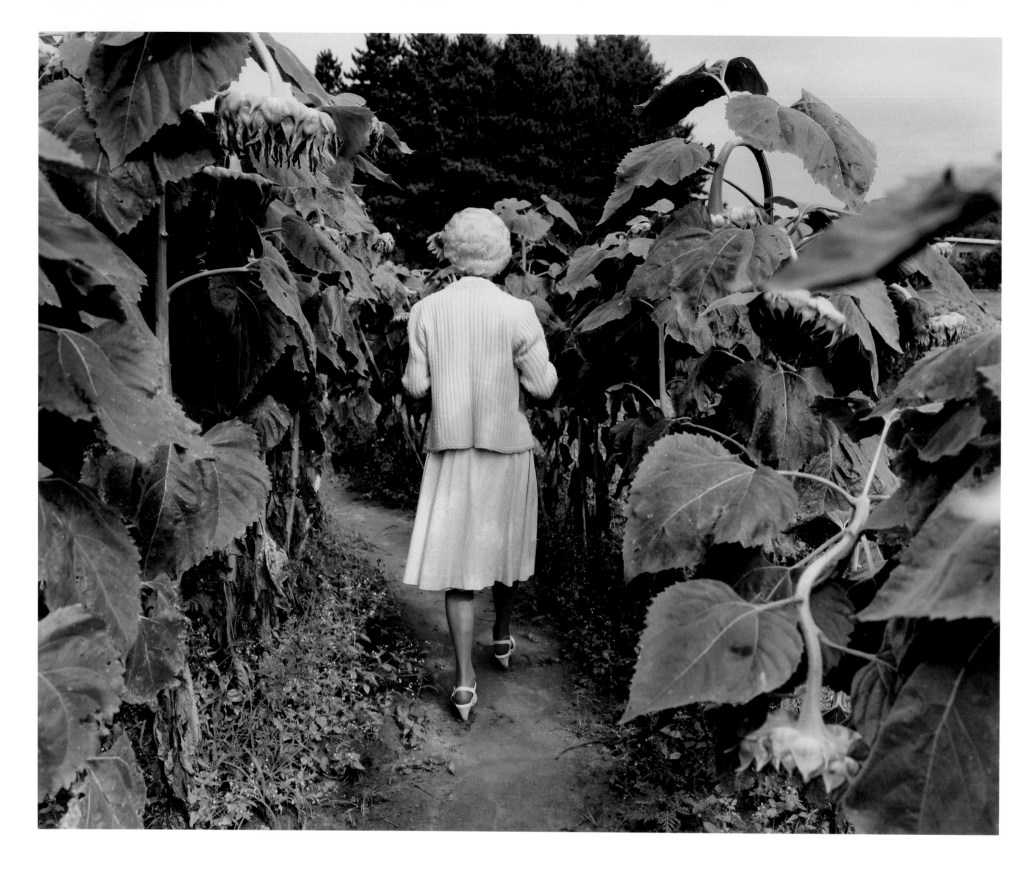

| PLATE 67 Sheron Rupp, *Trudy in Annie's Sunflower Maze, Amherst, Massachusetts,* 2000

PLATE 68 Rhea Garen, *Tree/House Freese Rd., Varna, NY*, 1993 | 105

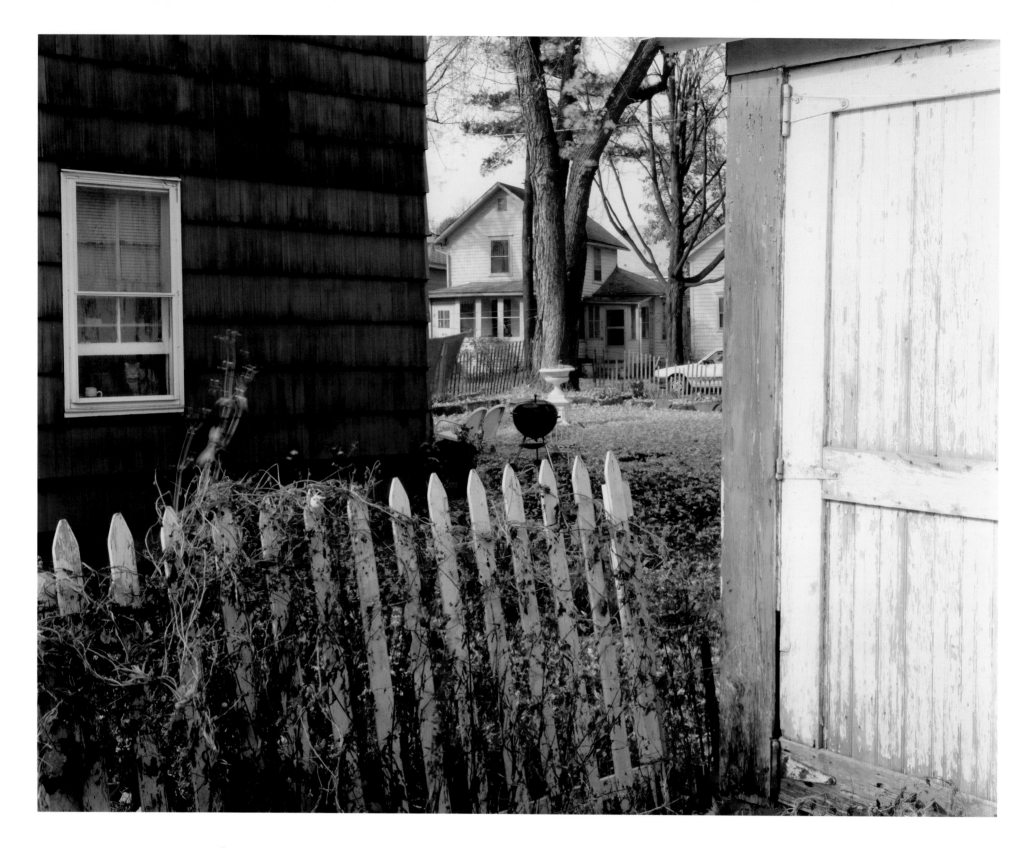

| PLATE 69 Rhea Garen, *Cascadilla St. Cat, Ithaca, NY*, 1992

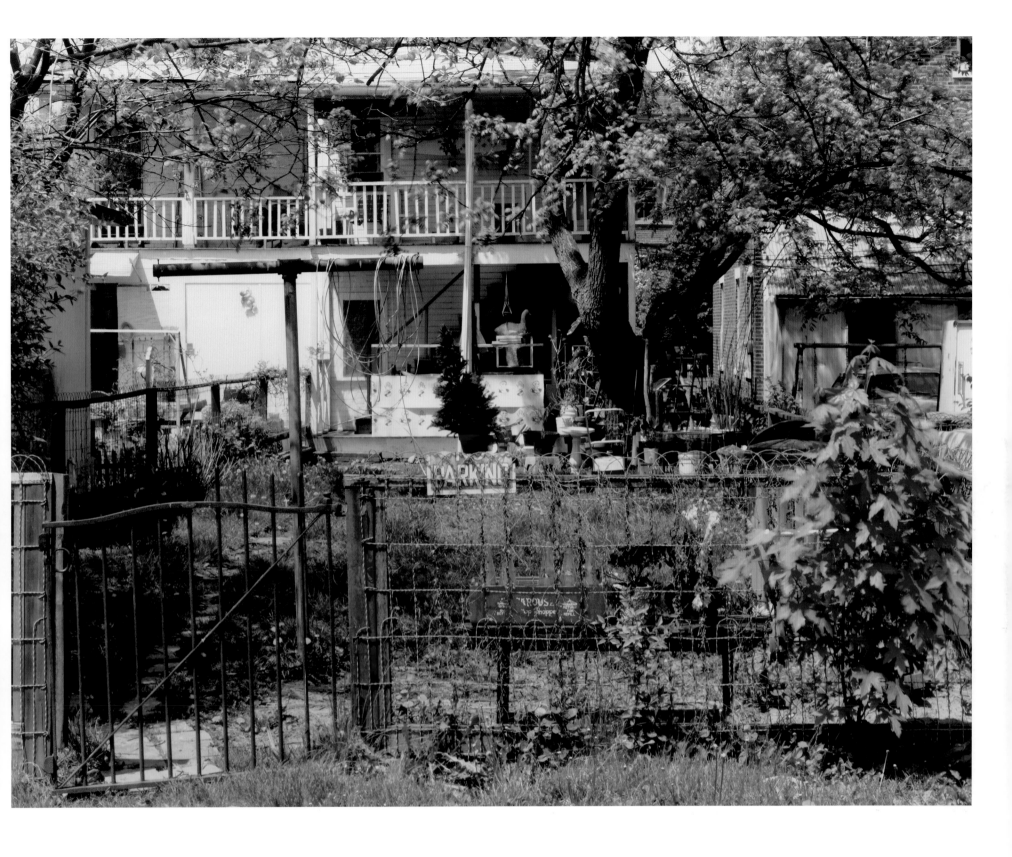

PLATE 70 Jack D. Teemer Jr., *Columbus, 1984* | 107

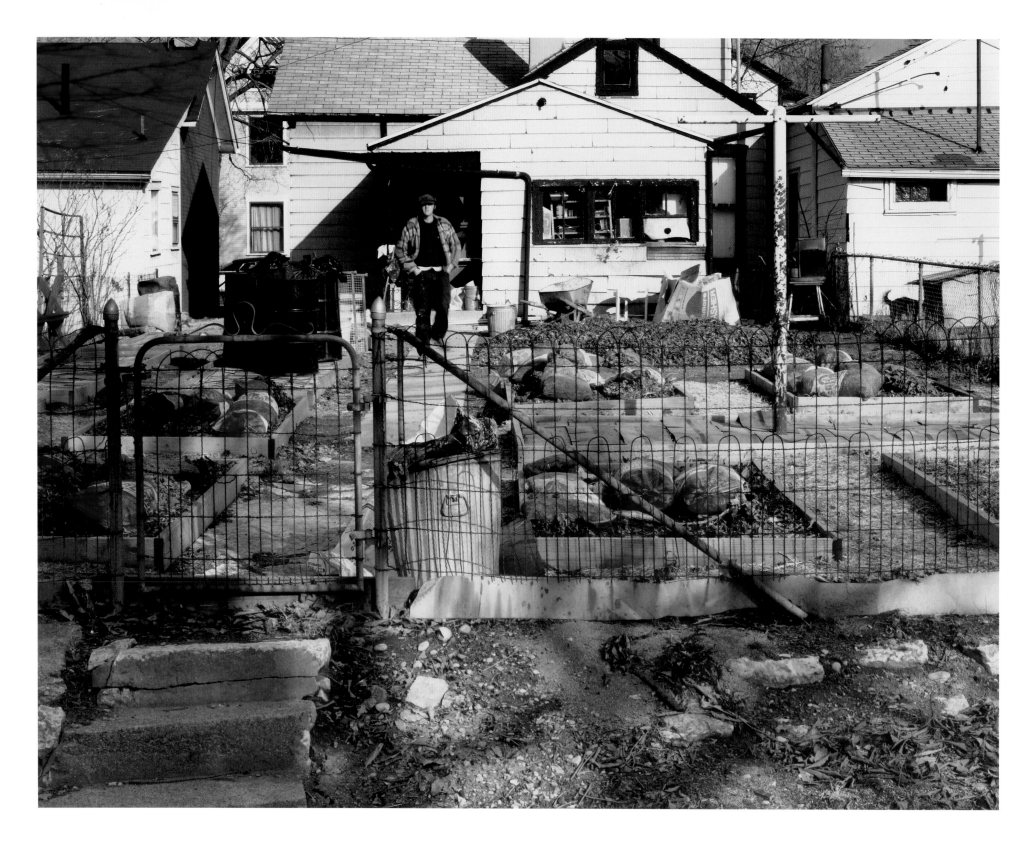

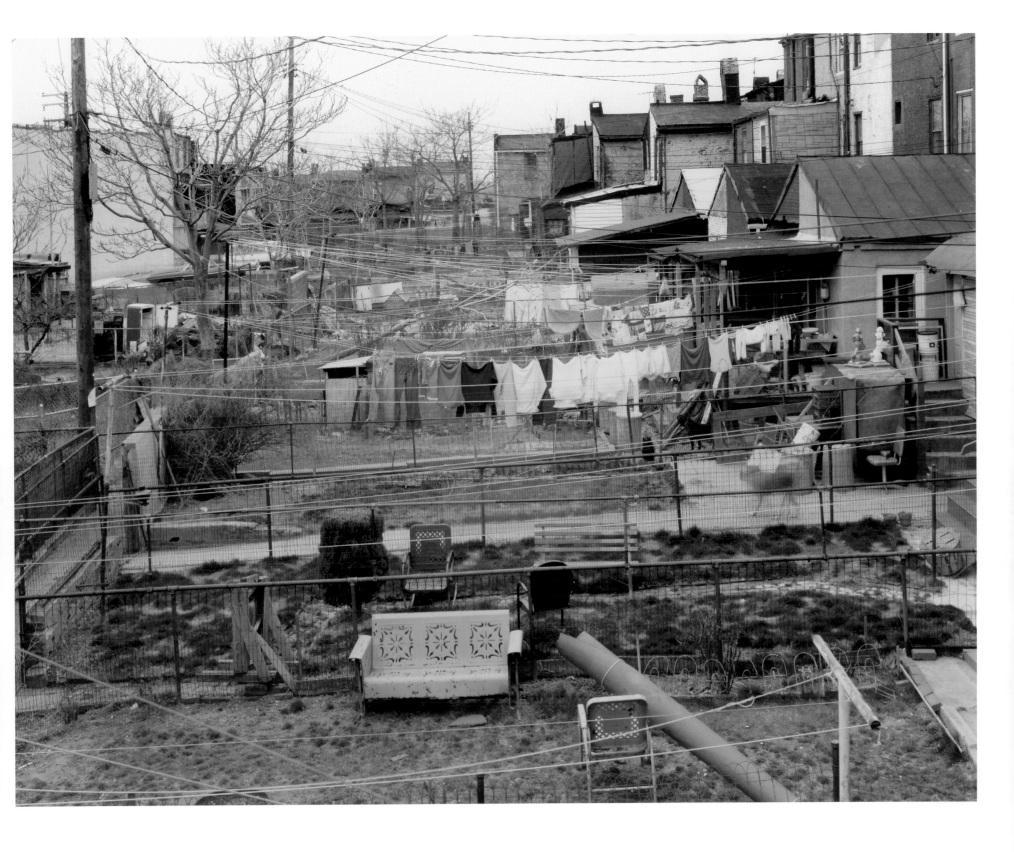

PLATE 72 Jack D. Teemer Jr., *Baltimore, 1980* 109

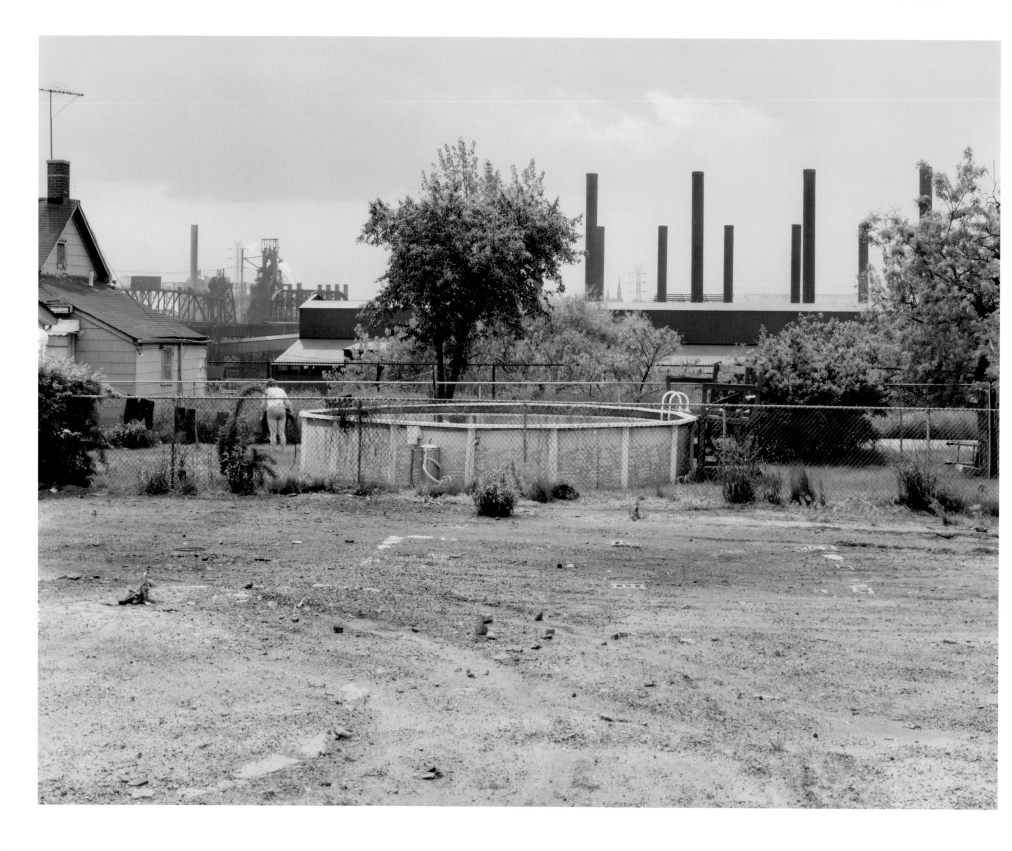

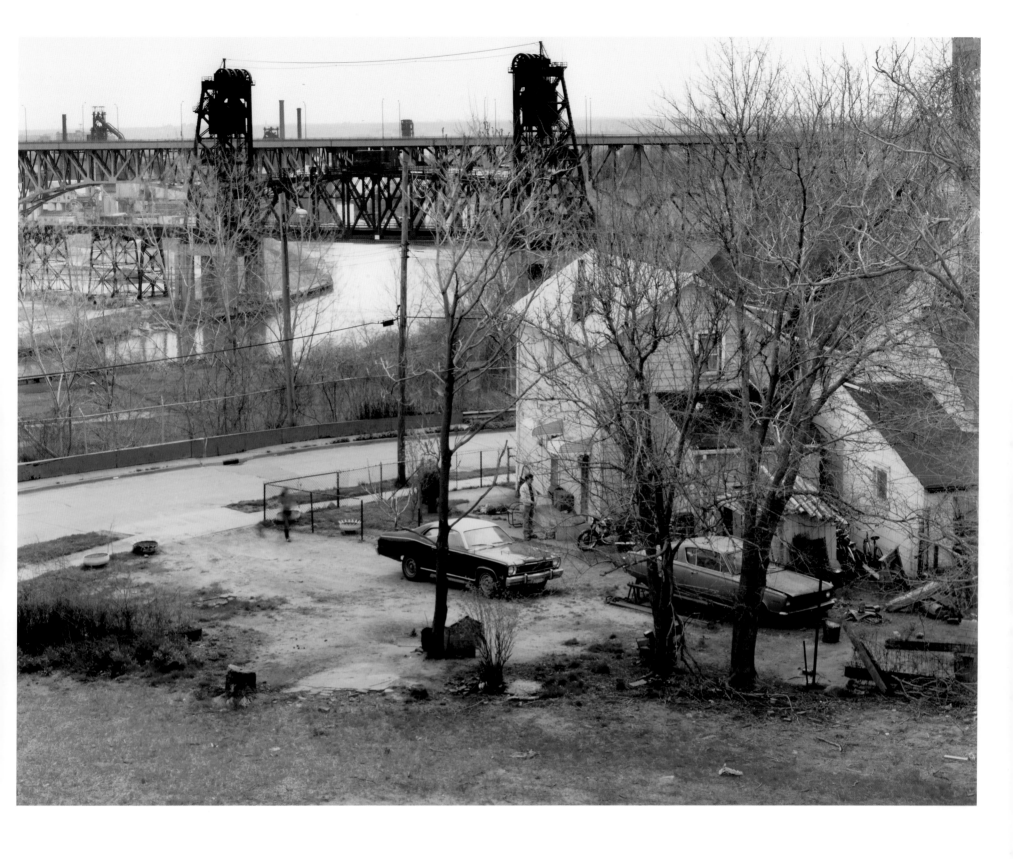

PLATE 74 Jack D. Teemer Jr., *Cleveland, 1983* | 111

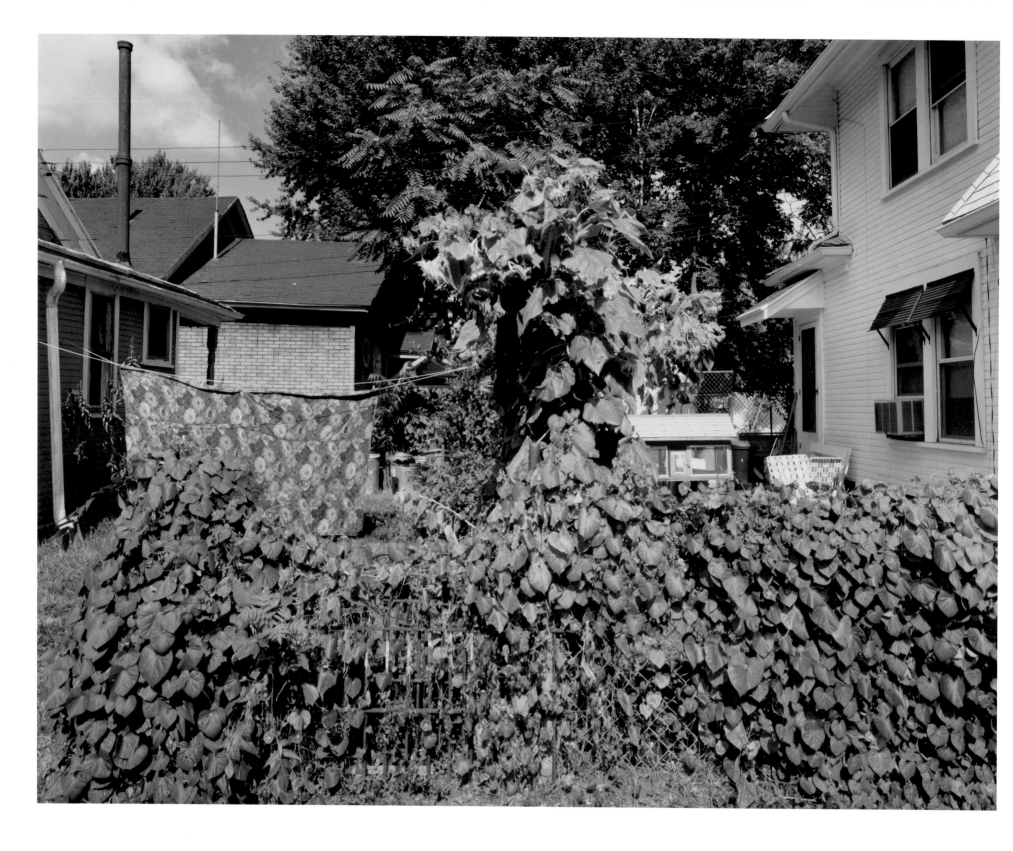

PLATE 75 Jack D. Teemer Jr., *Dayton, 1983*

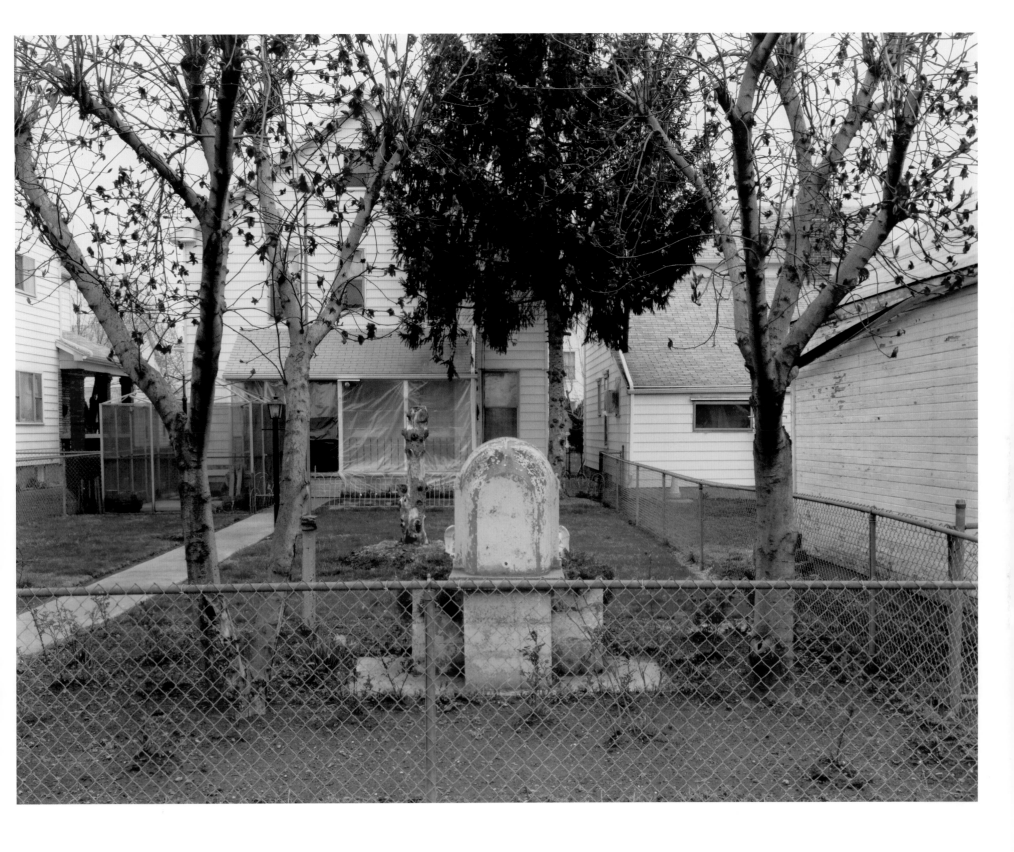

PLATE 76 Jack D. Teemer Jr., *Dayton, 1983* 113

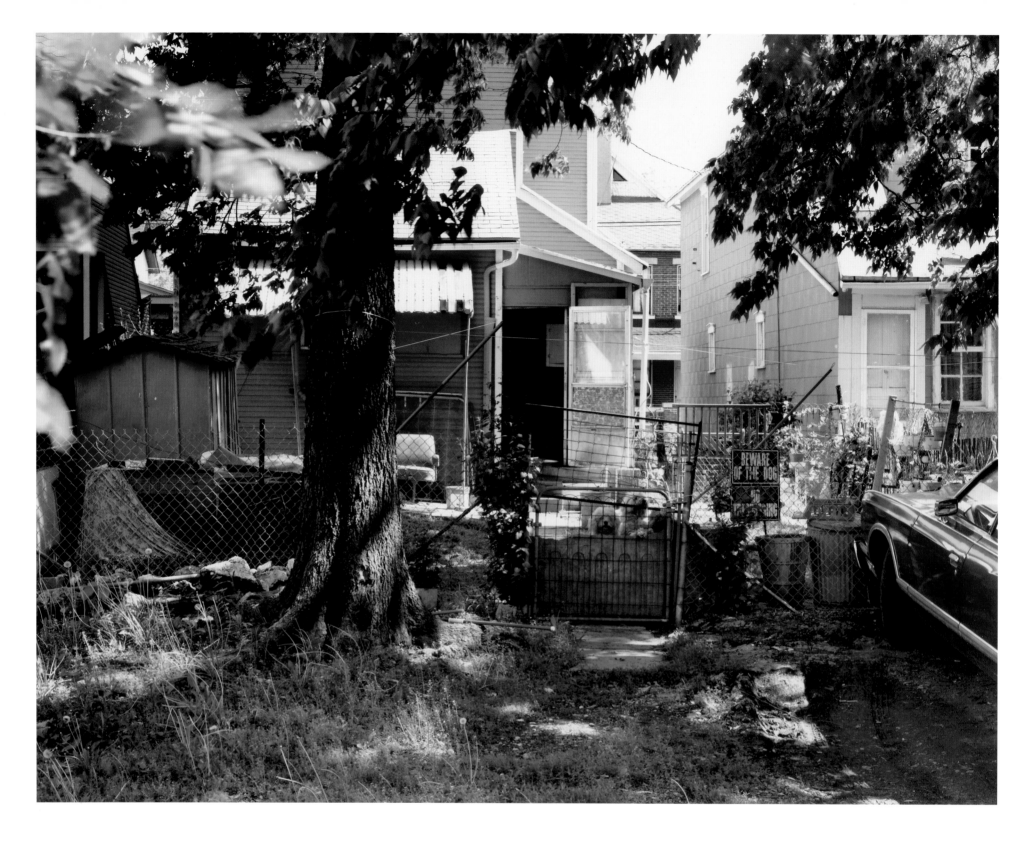

| PLATE 77 Jack D. Teemer Jr., *Dayton, 1984*

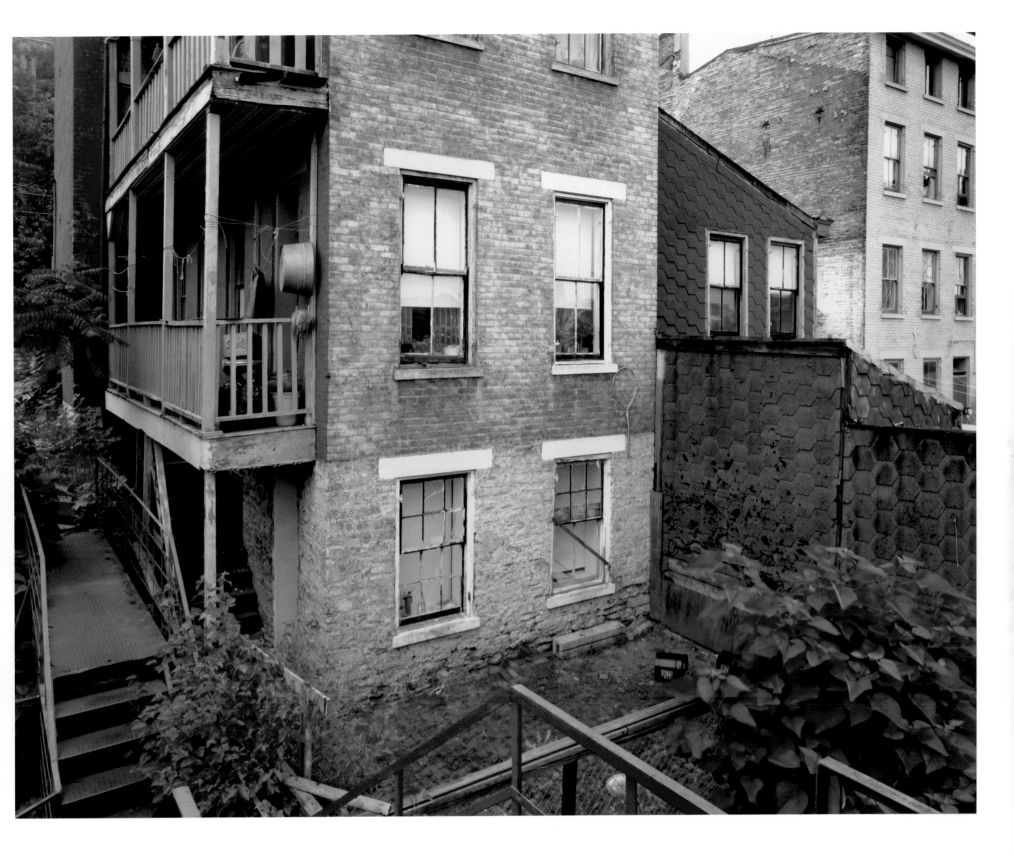

PLATE 78 Jack D. Teemer Jr., *Cincinnati, 1981* | 115

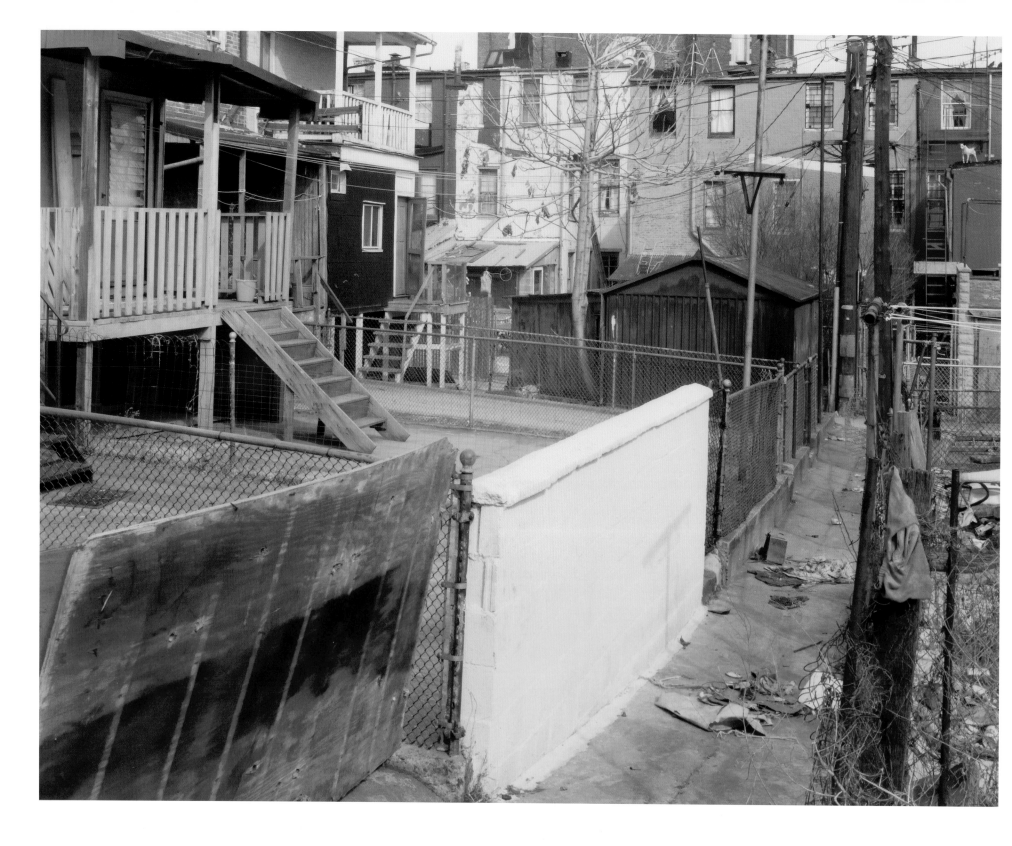

| PLATE 79 Jack D. Teemer Jr., *Baltimore, 1980*

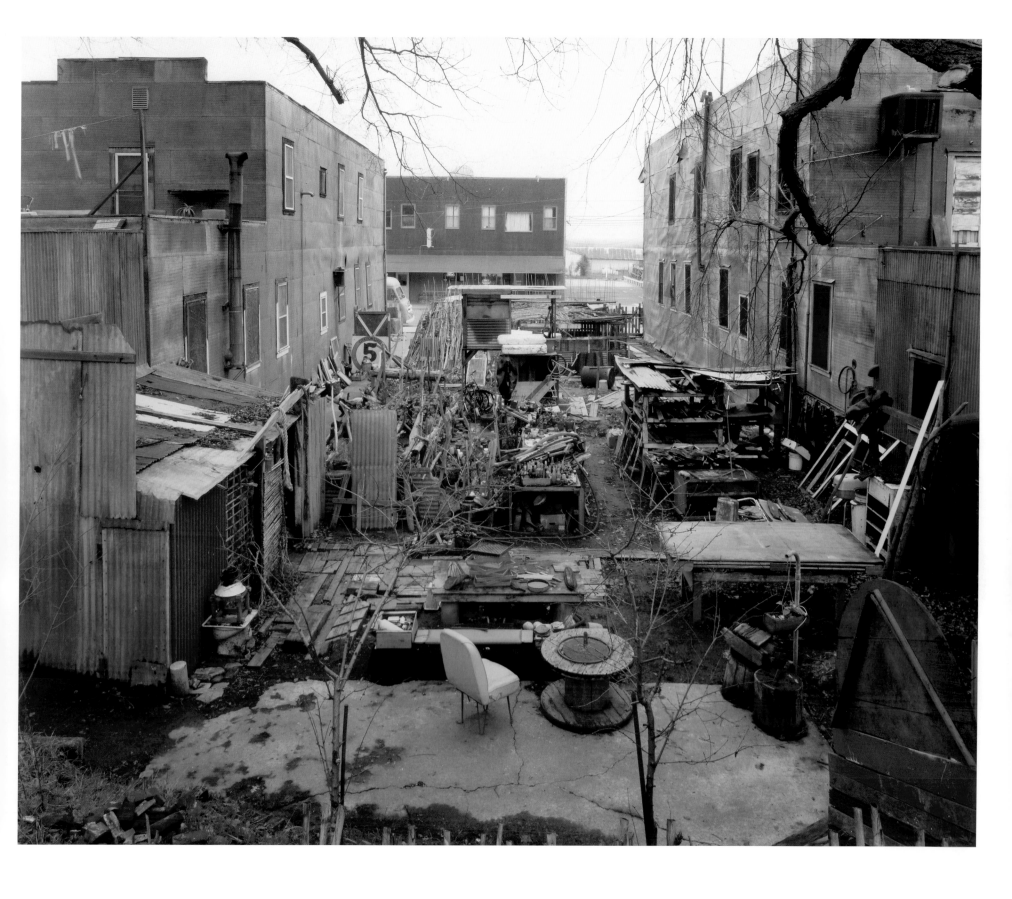

PLATE 80 Robert Dawson, *Back Lot, Isleton, California*, 1986 | 117

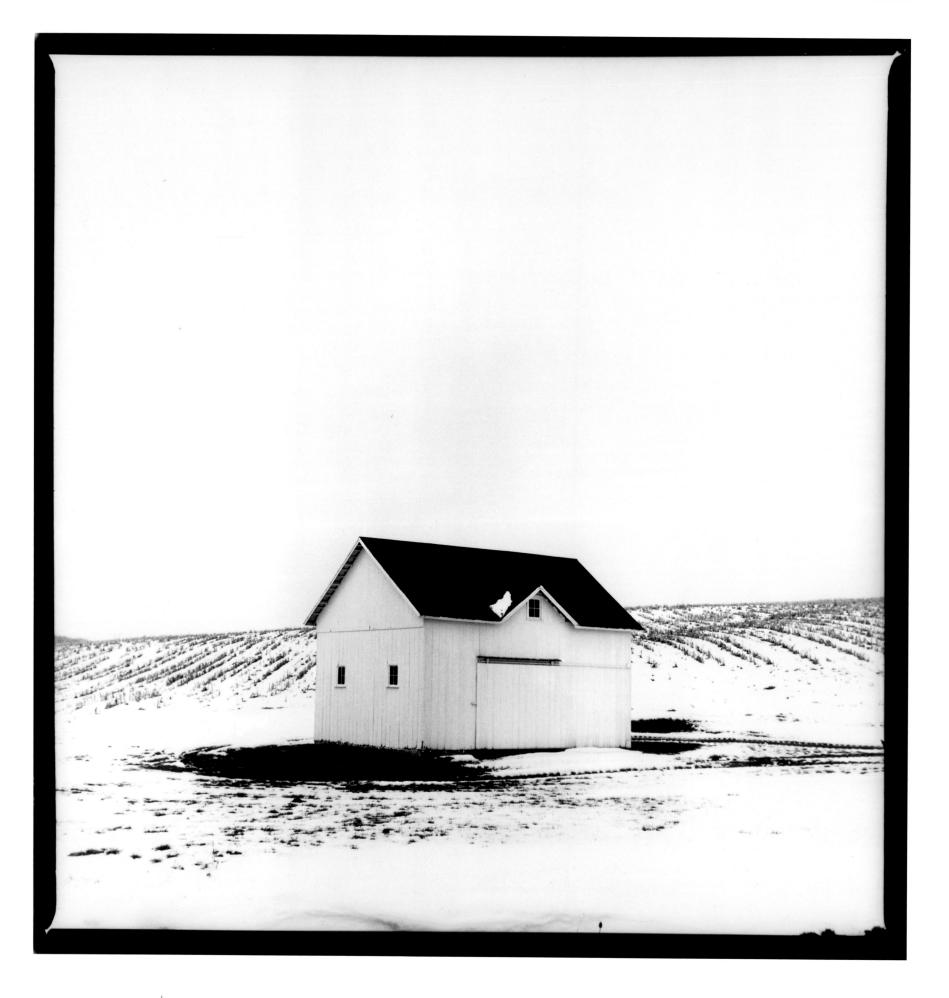

| PLATE 81 Gregory Spaid, *Pealer's Barn, Winter, Amity, Ohio*, 1992

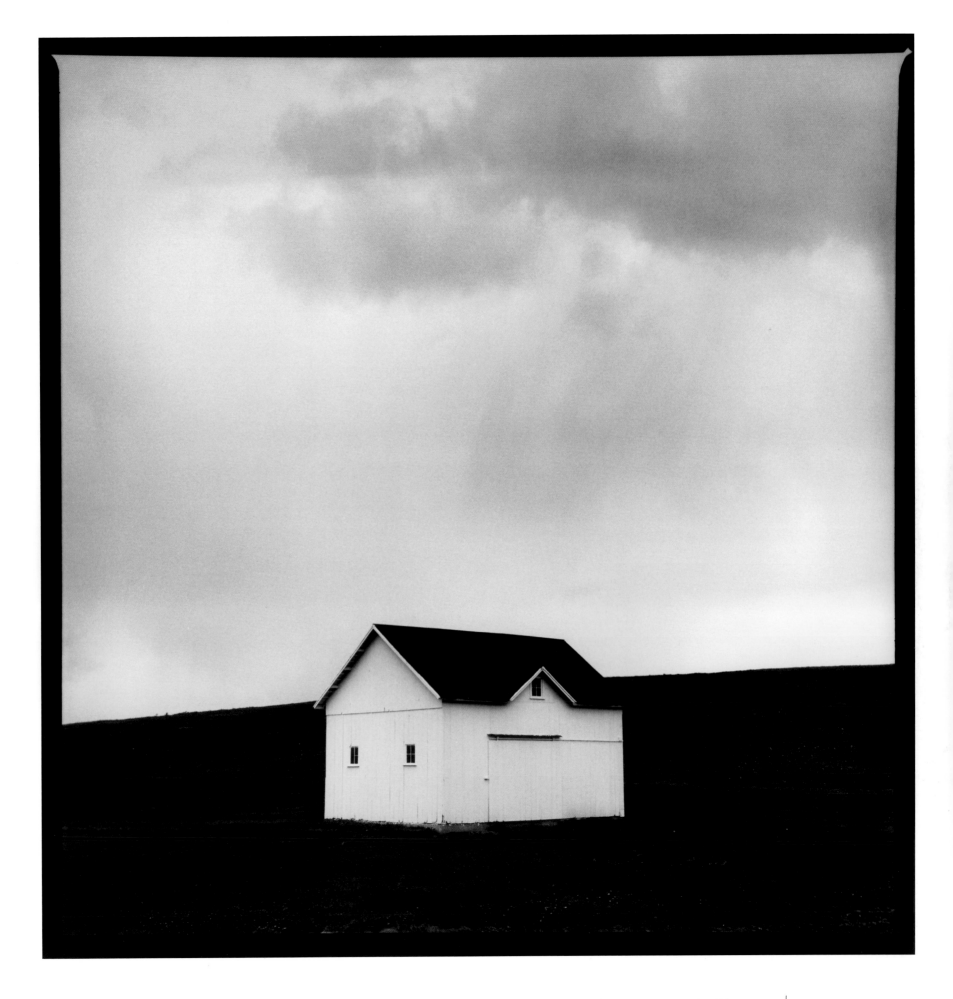

PLATE 82 Gregory Spaid, *Pealer's Barn, Summer, Amity, Ohio*, 1992 119

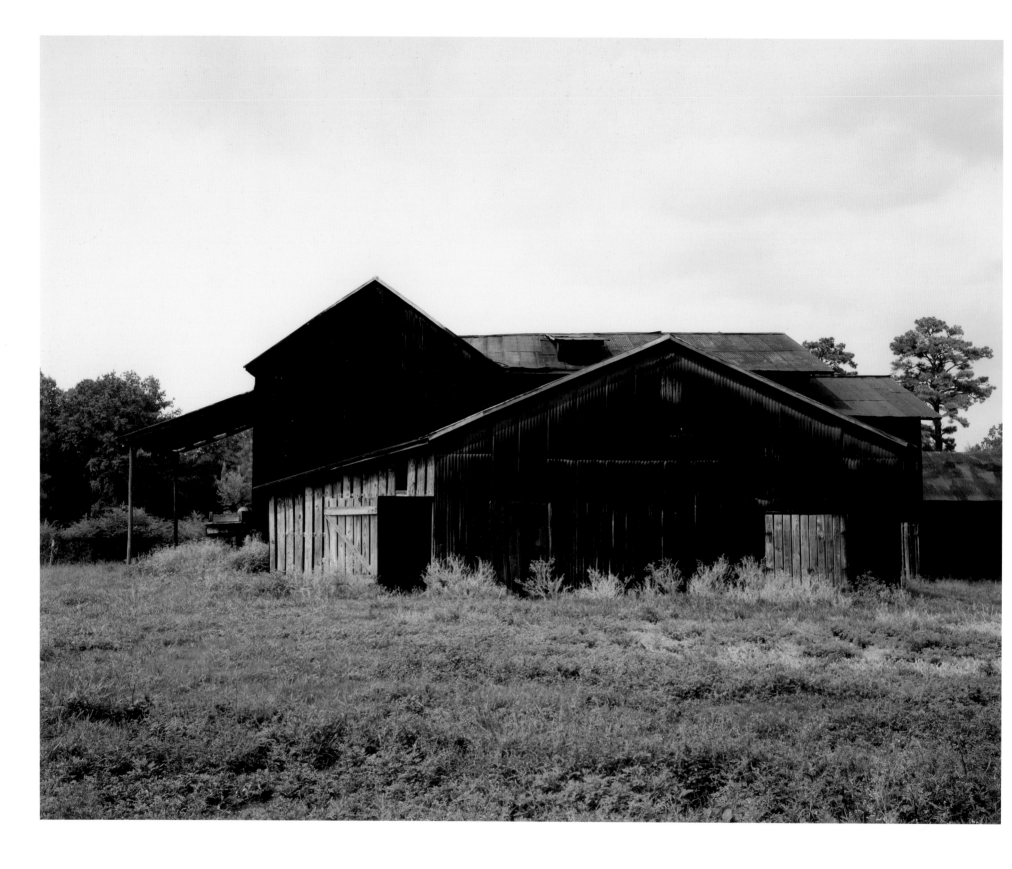

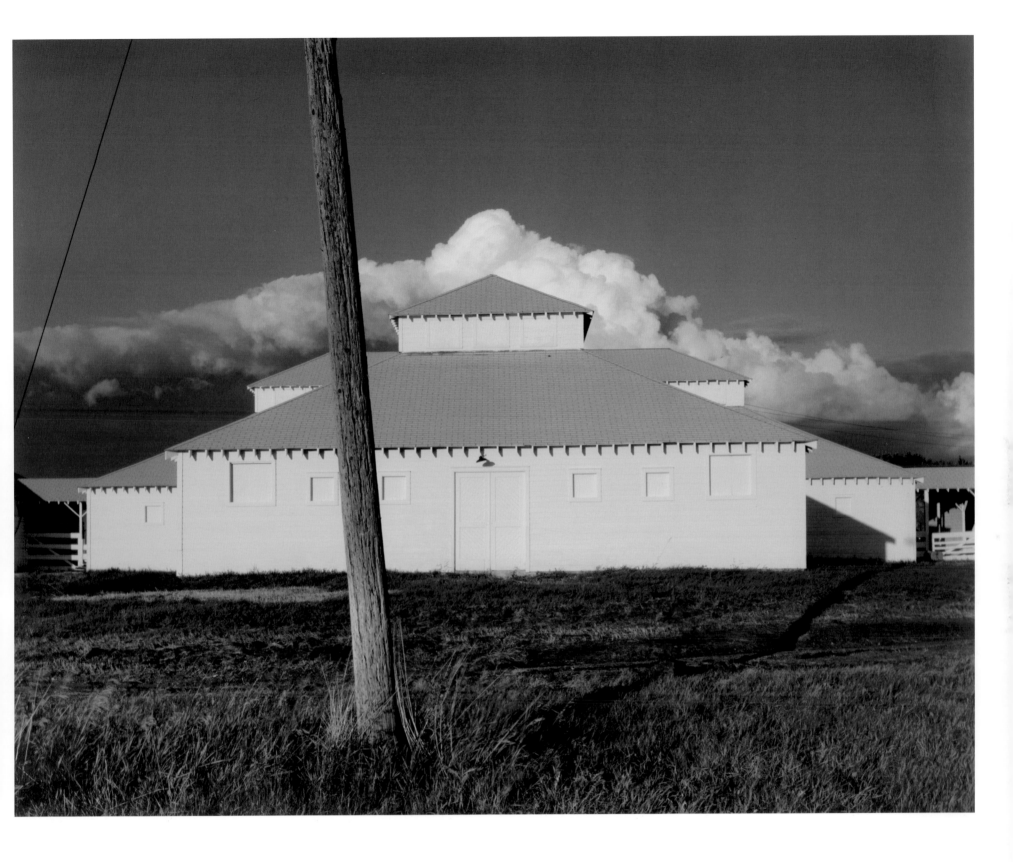

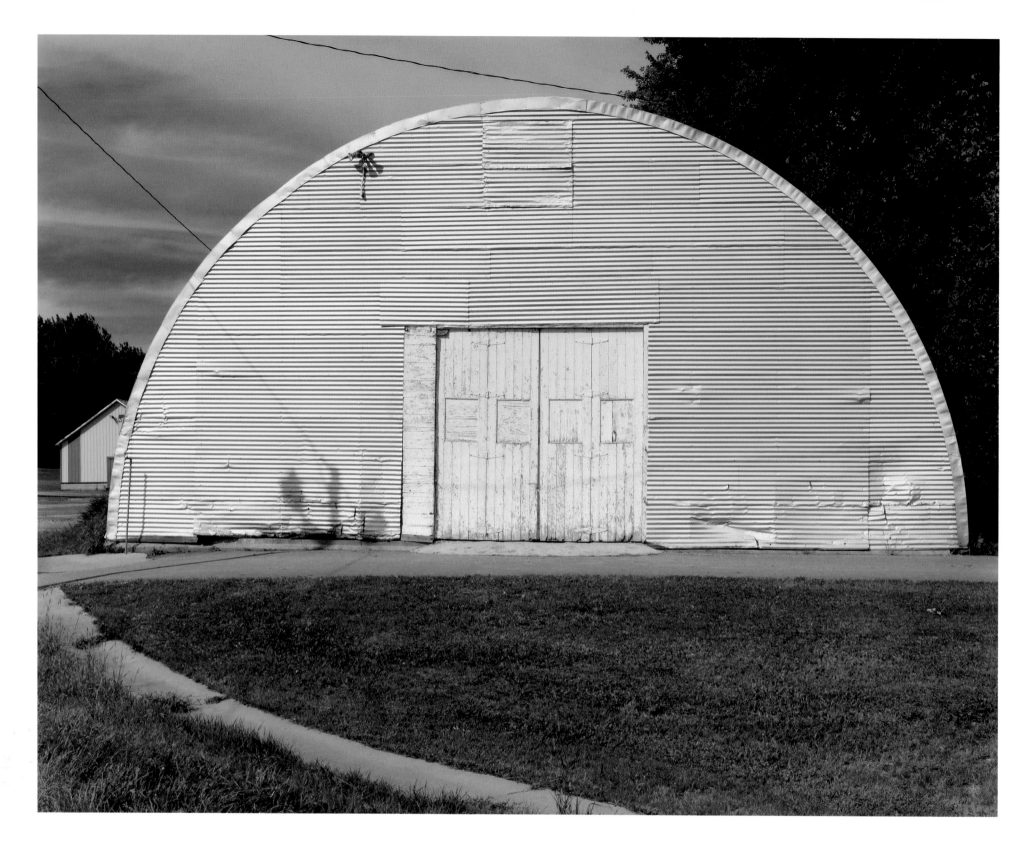

| PLATE 85 David Husom, *St. Croix County Fairgrounds, Glenwood City, WI*, 1995

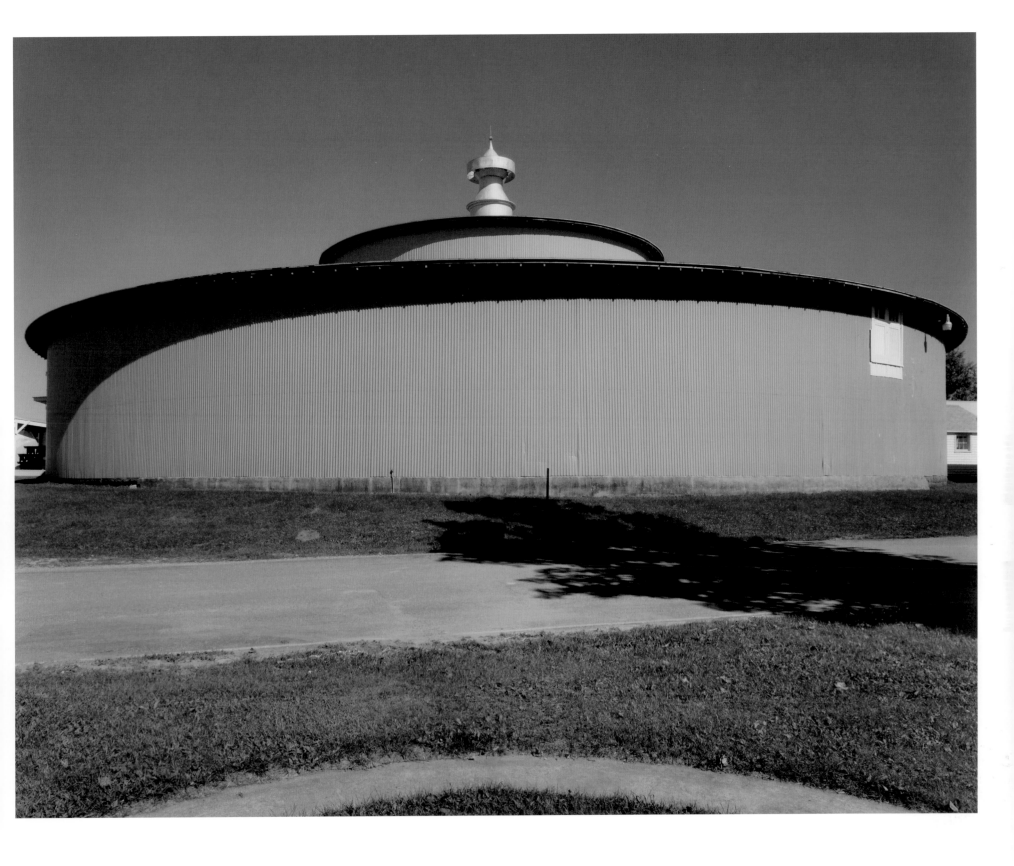

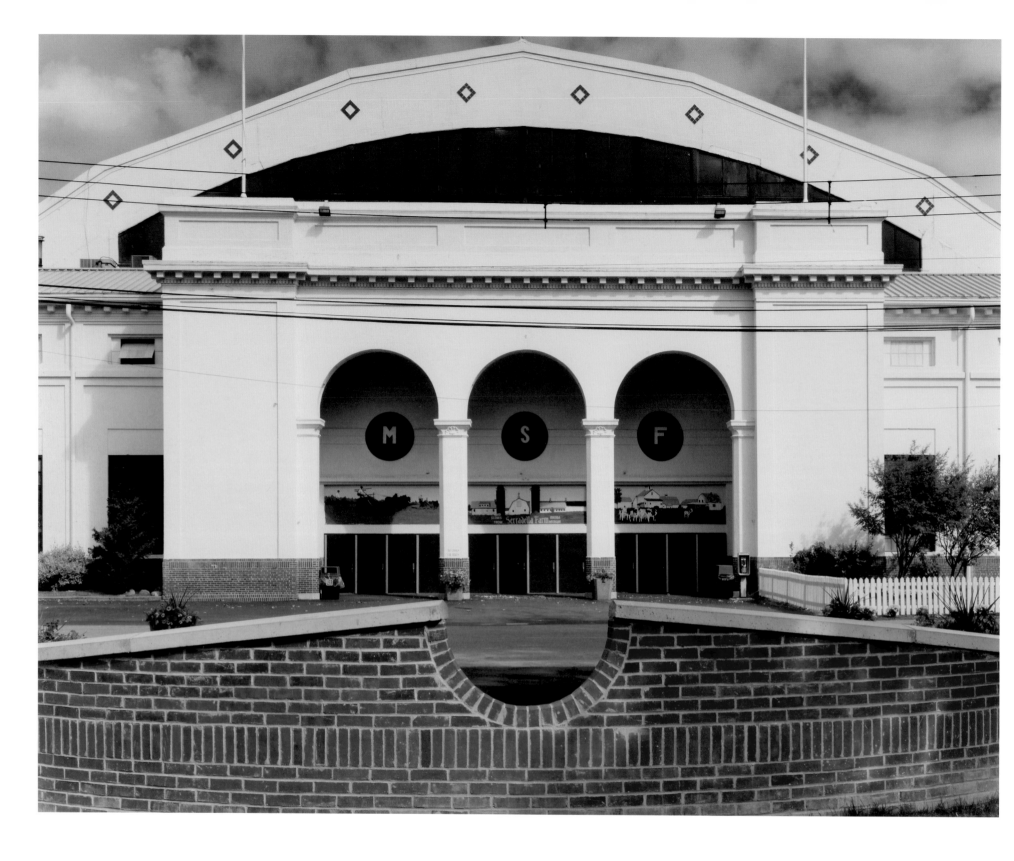

| PLATE 87 David Husom, *Michigan State Fairgrounds, Detroit, MI*, 1995

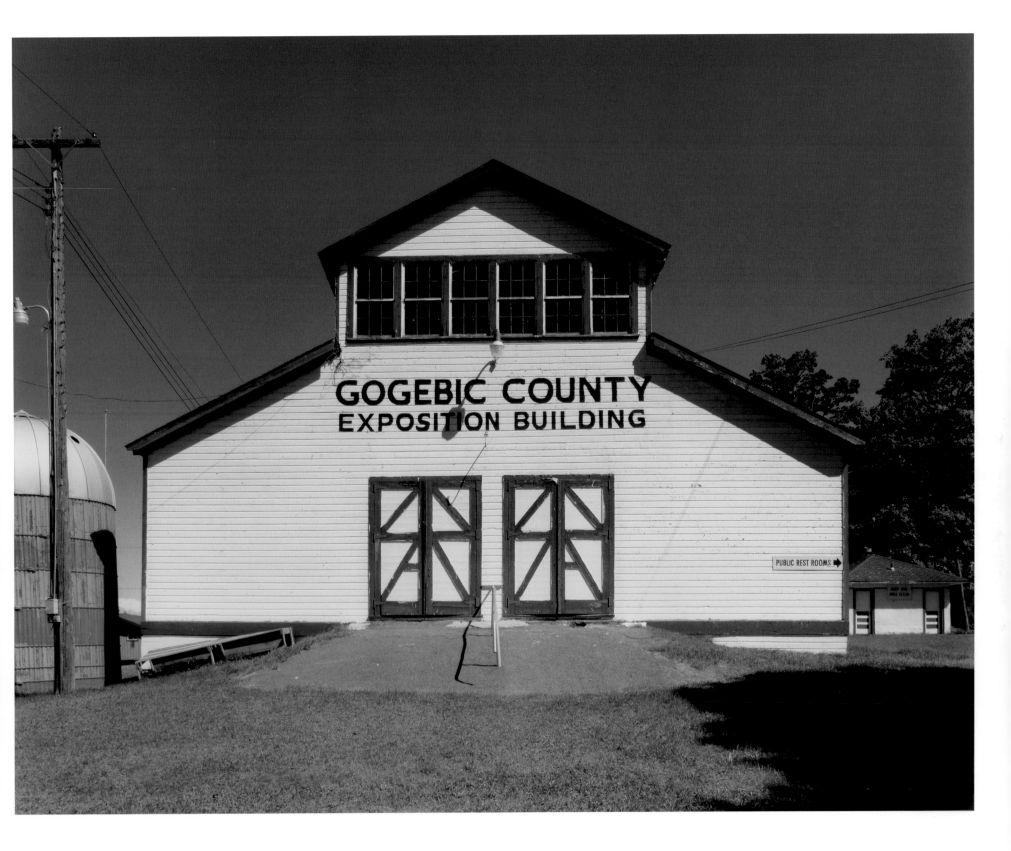

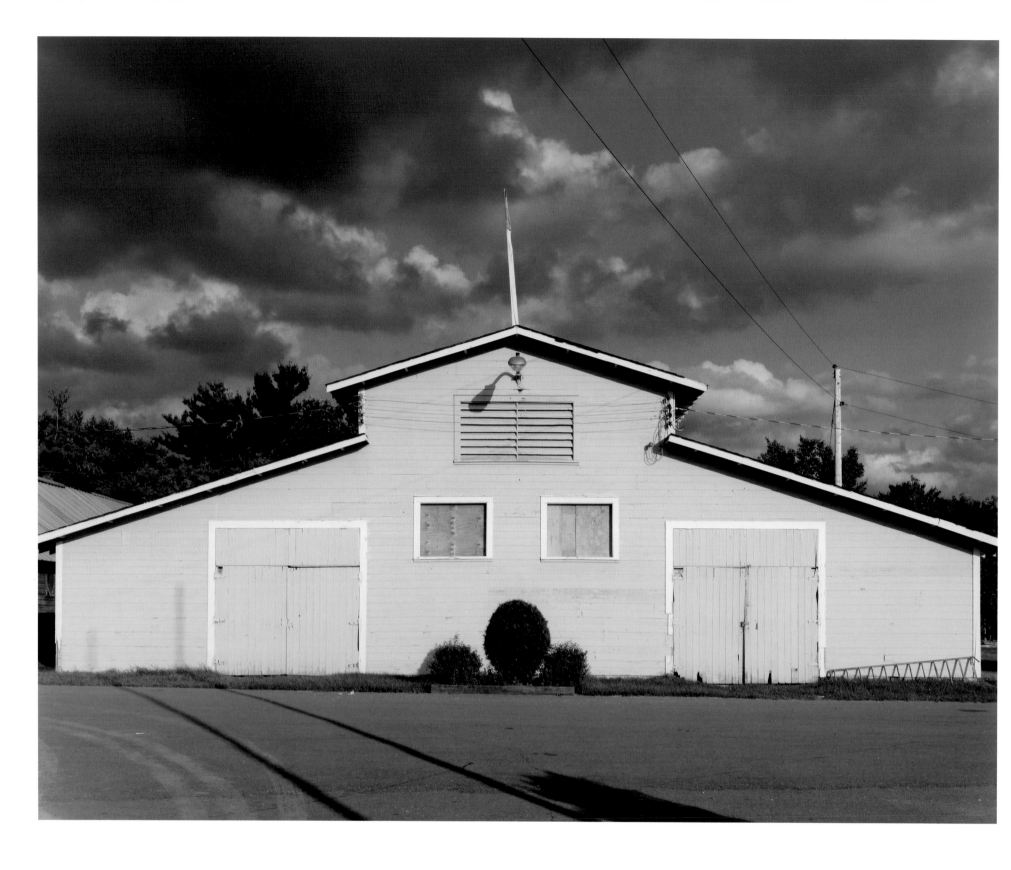

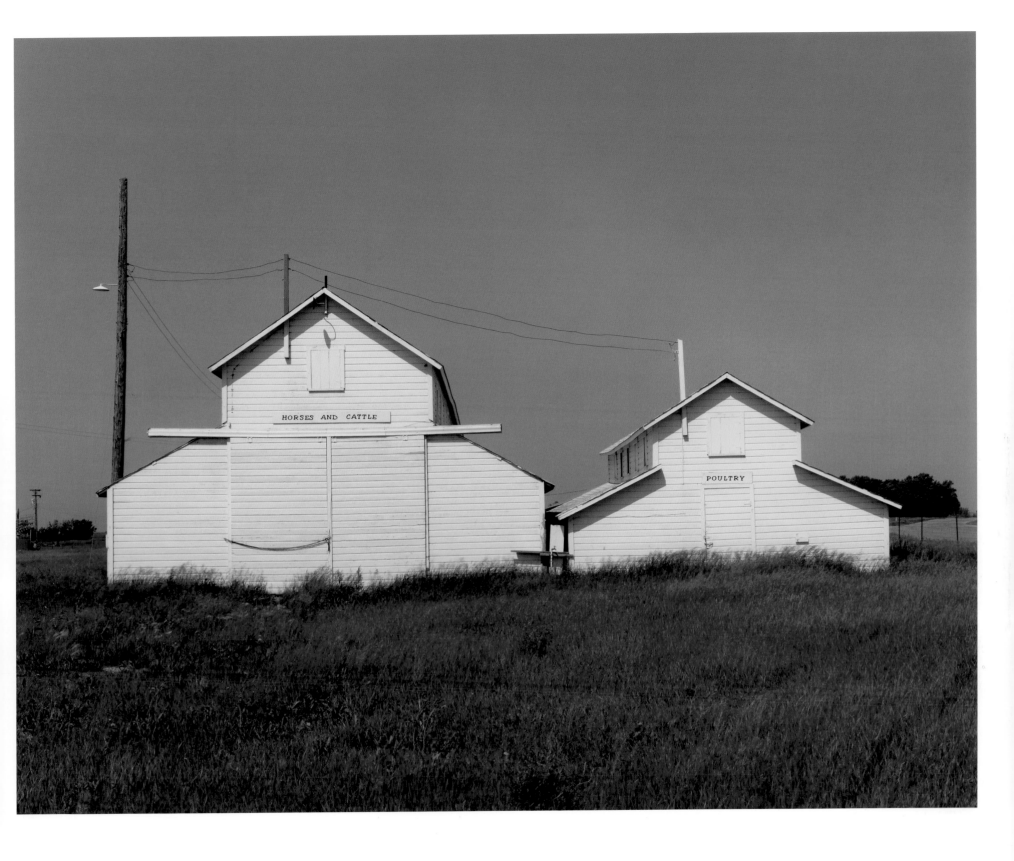

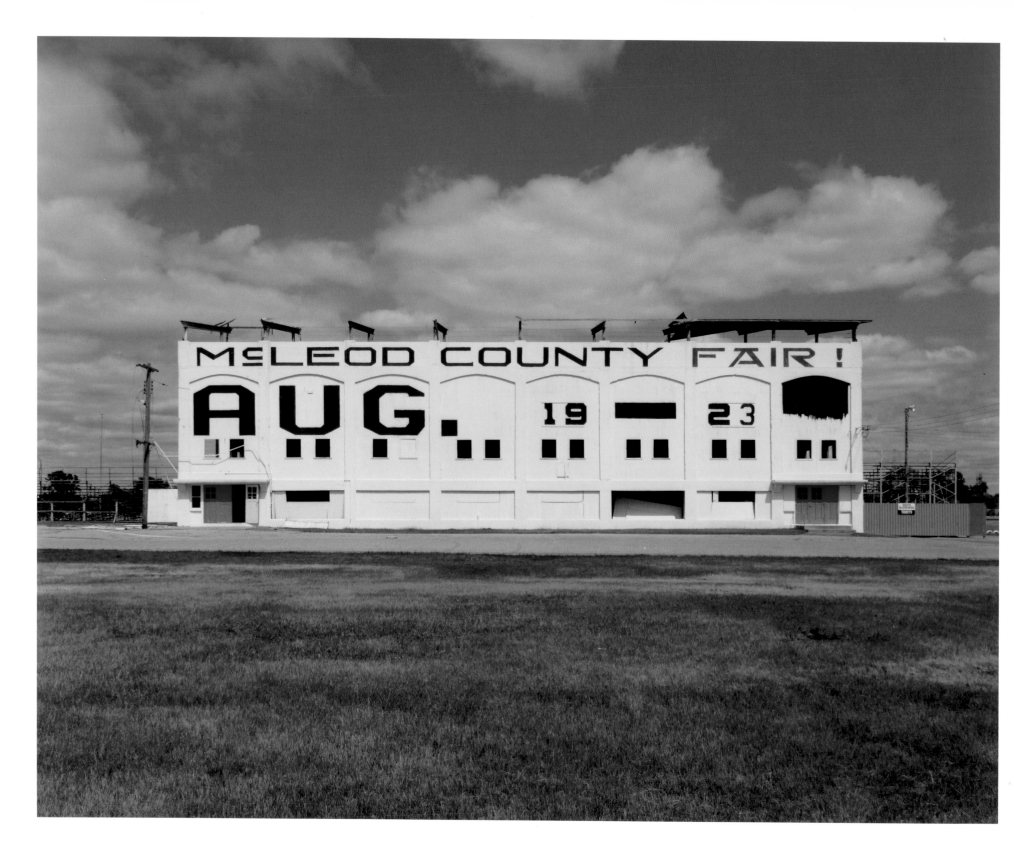

David Husom, *McLeod County Fairgrounds—After Tornado—Hutchinson, MN*, 1983

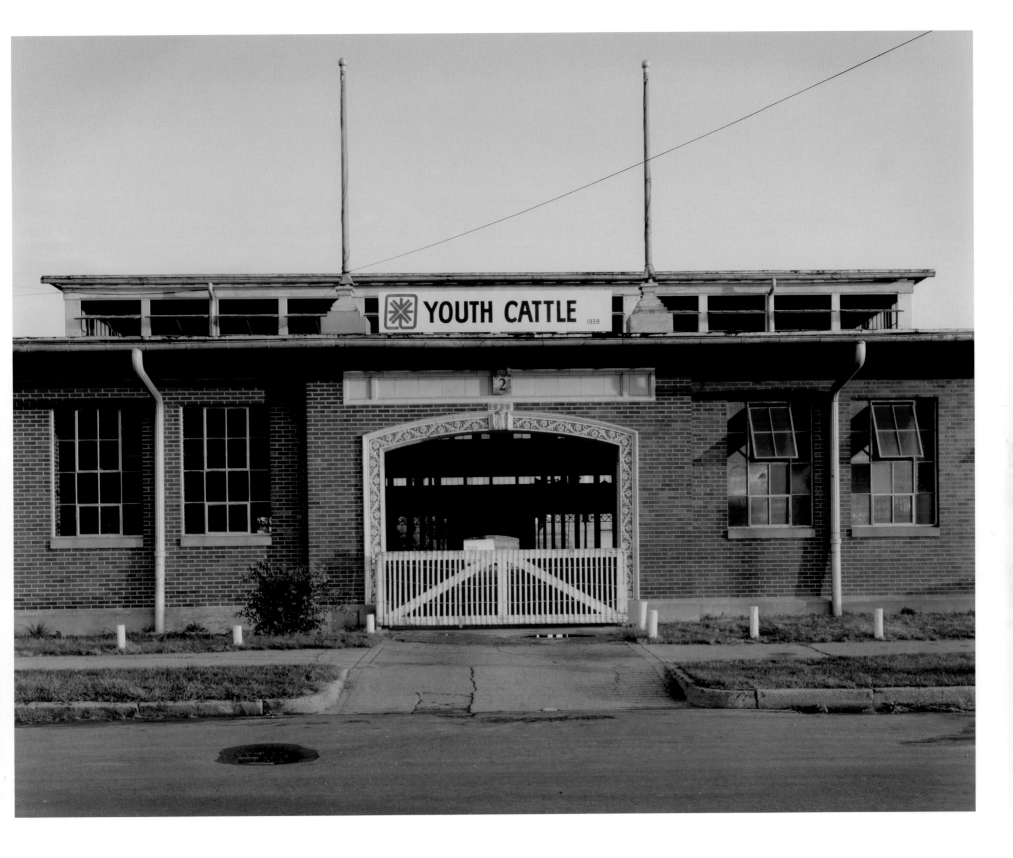

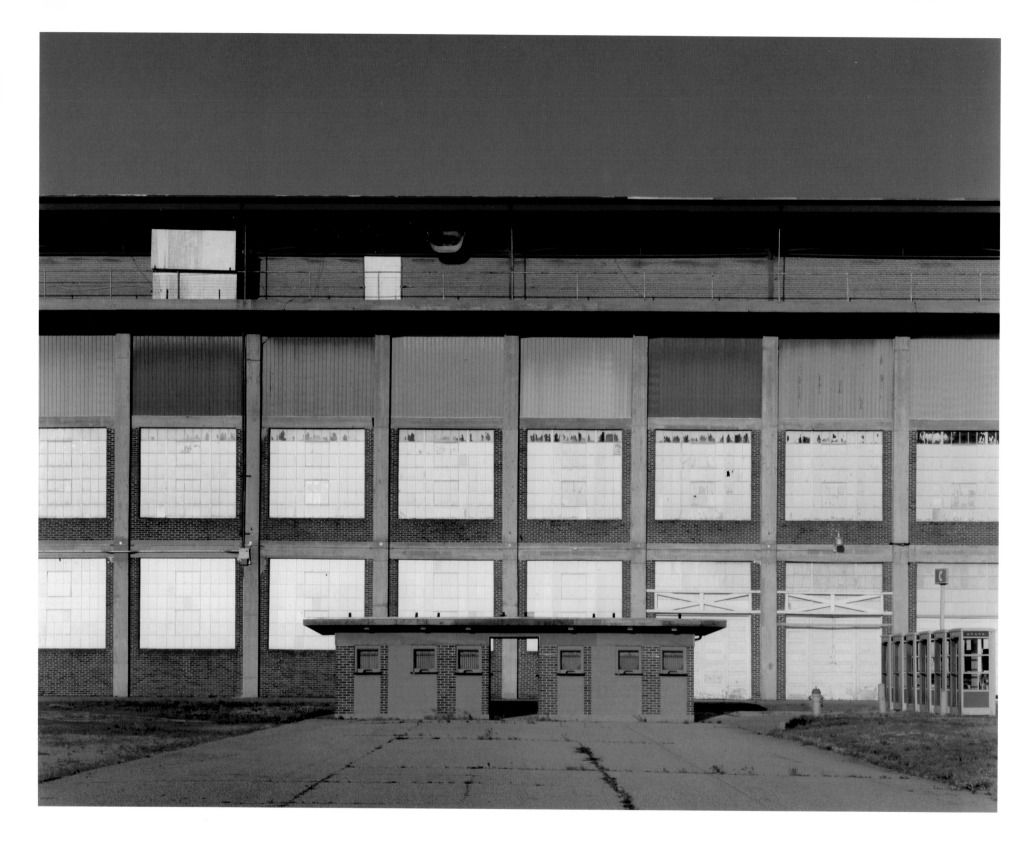

| PLATE 93 David Husom, *Nebraska State Fairgrounds, Lincoln, NE*, 1983

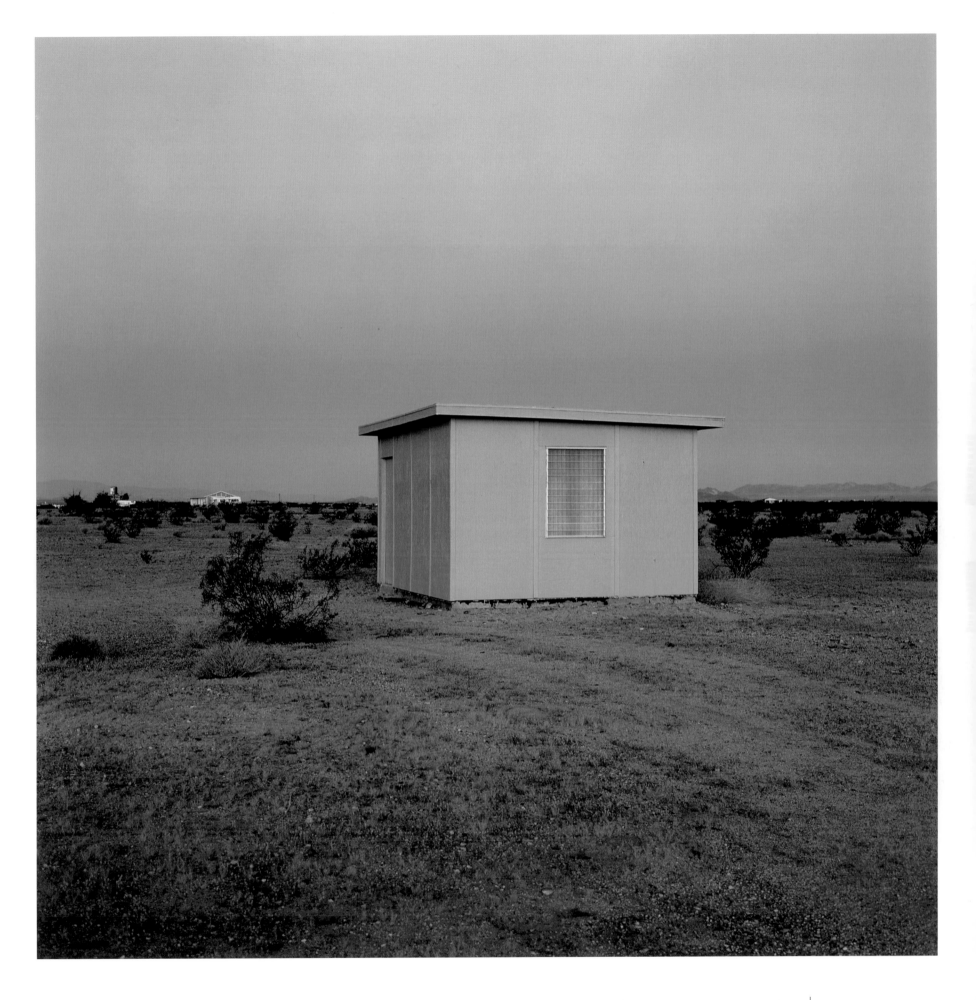

PLATE 94 John Divola, *N34°09.974′W115°48.890′*, 1995–98 | 131

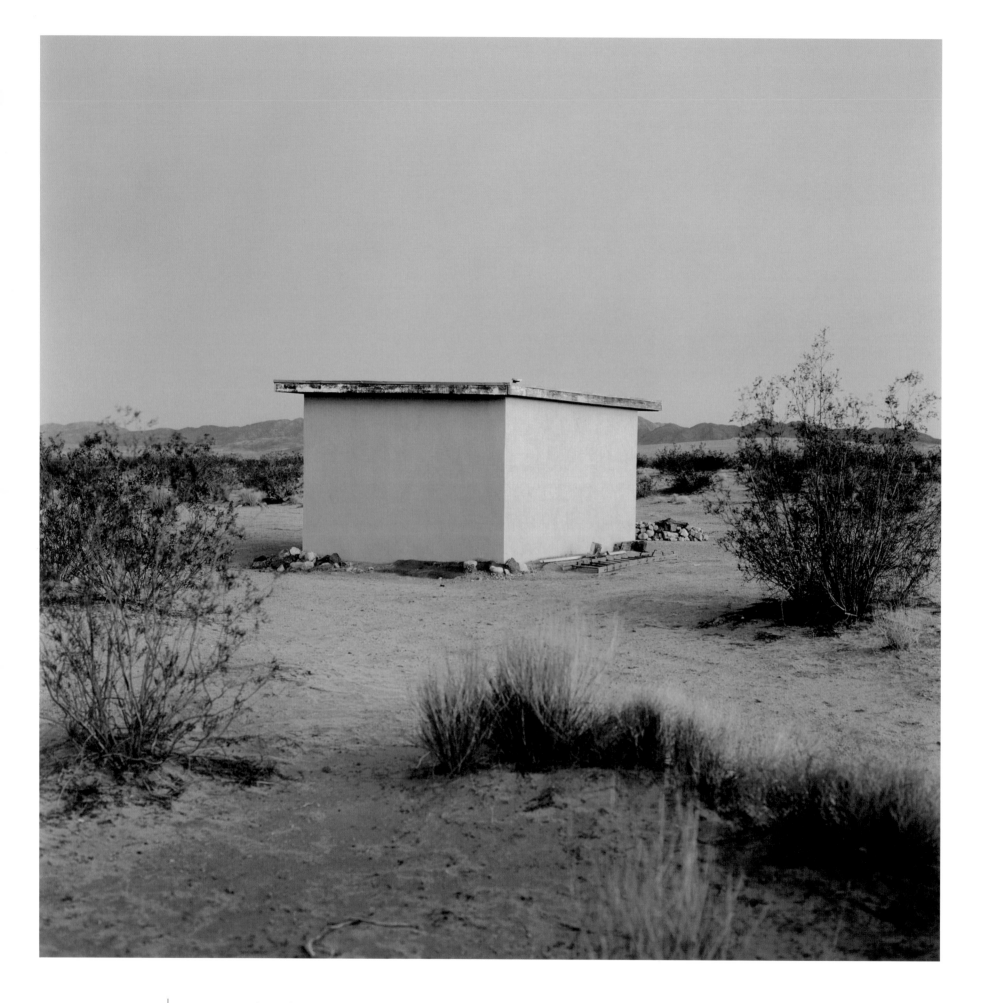

| PLATE 95 John Divola, *N34°09.967'W115°46.891'*, 1995–98

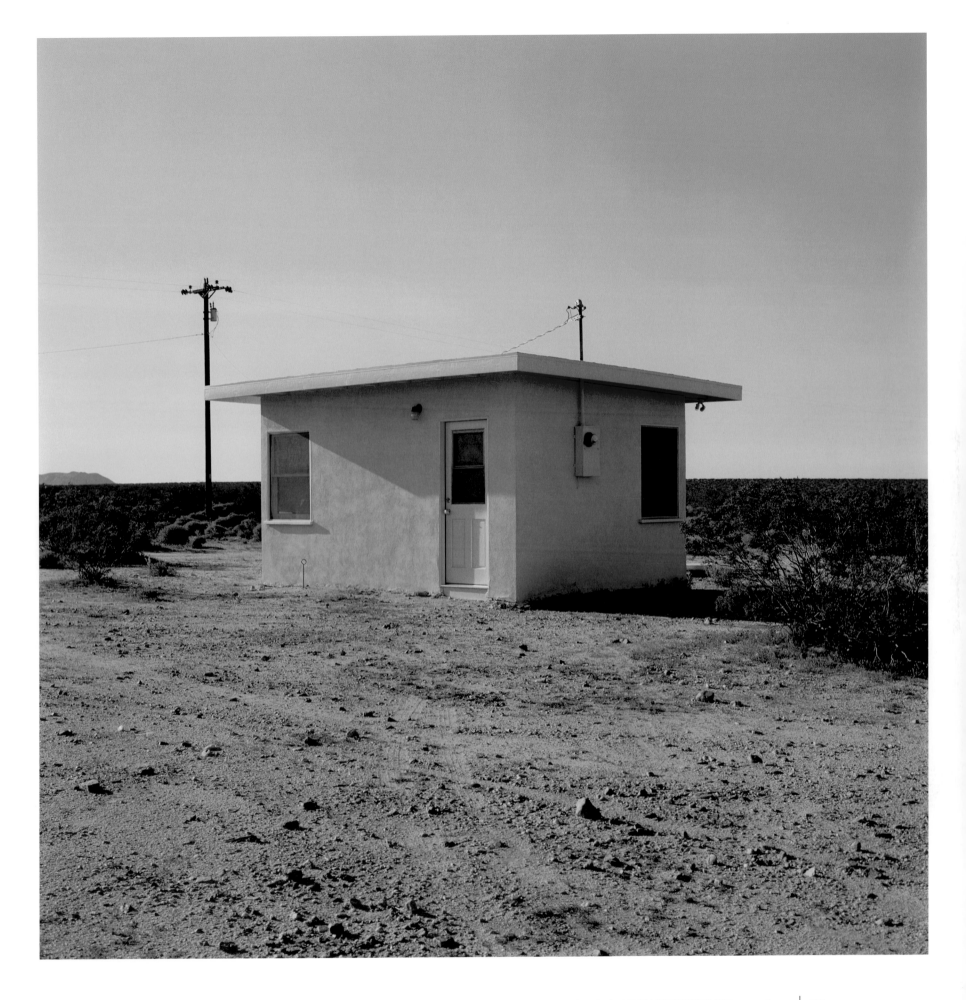

PLATE 96 John Divola, *N34°14.383′W116°14.758′*, 1995–98 | 133

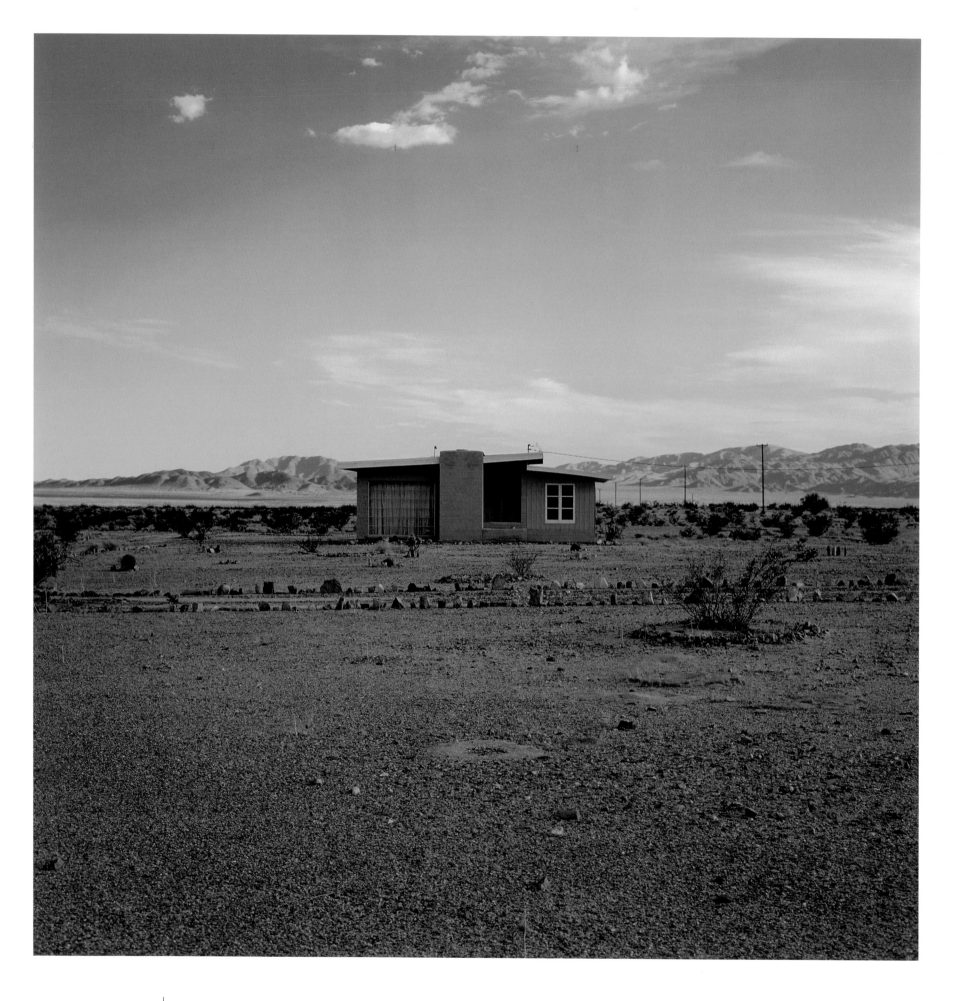

| PLATE 97 John Divola, *N34°09.900'W115°48.824'*, 1995–98

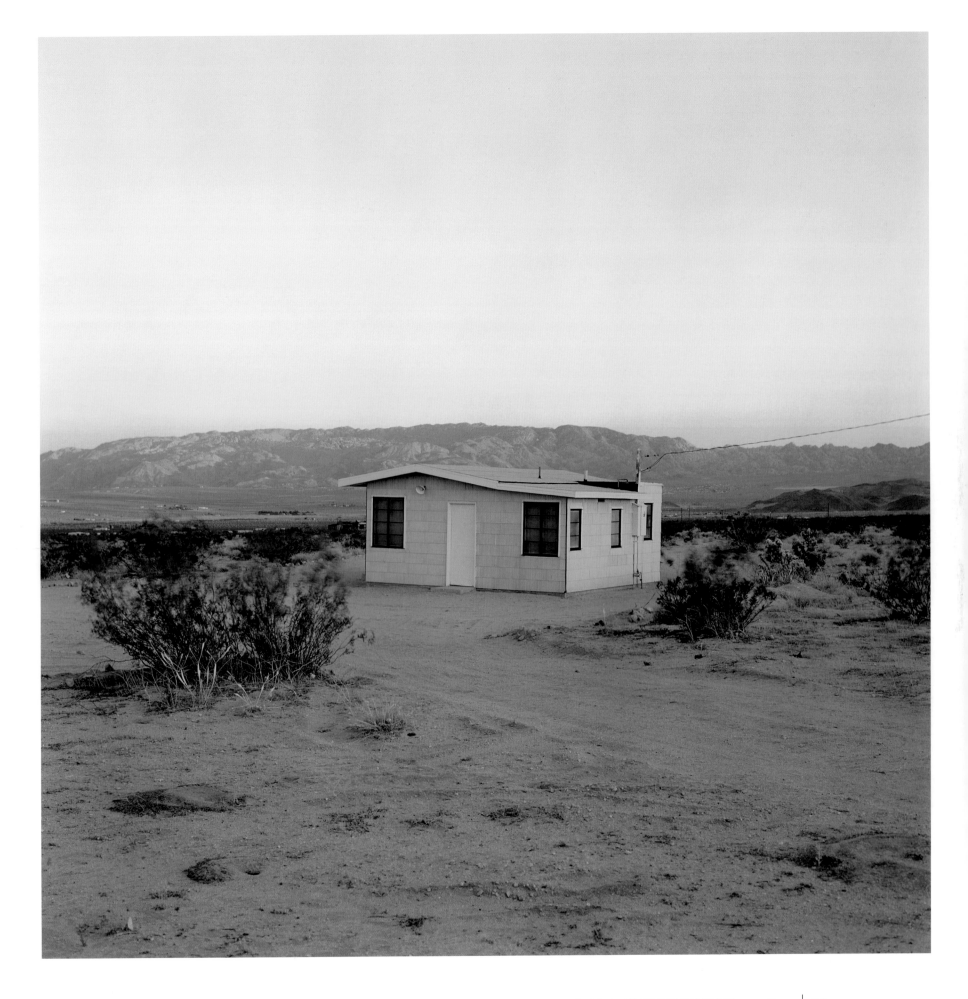

PLATE 98 John Divola, *N34°13.275'W116°10.883'*, 1995–98 | 135

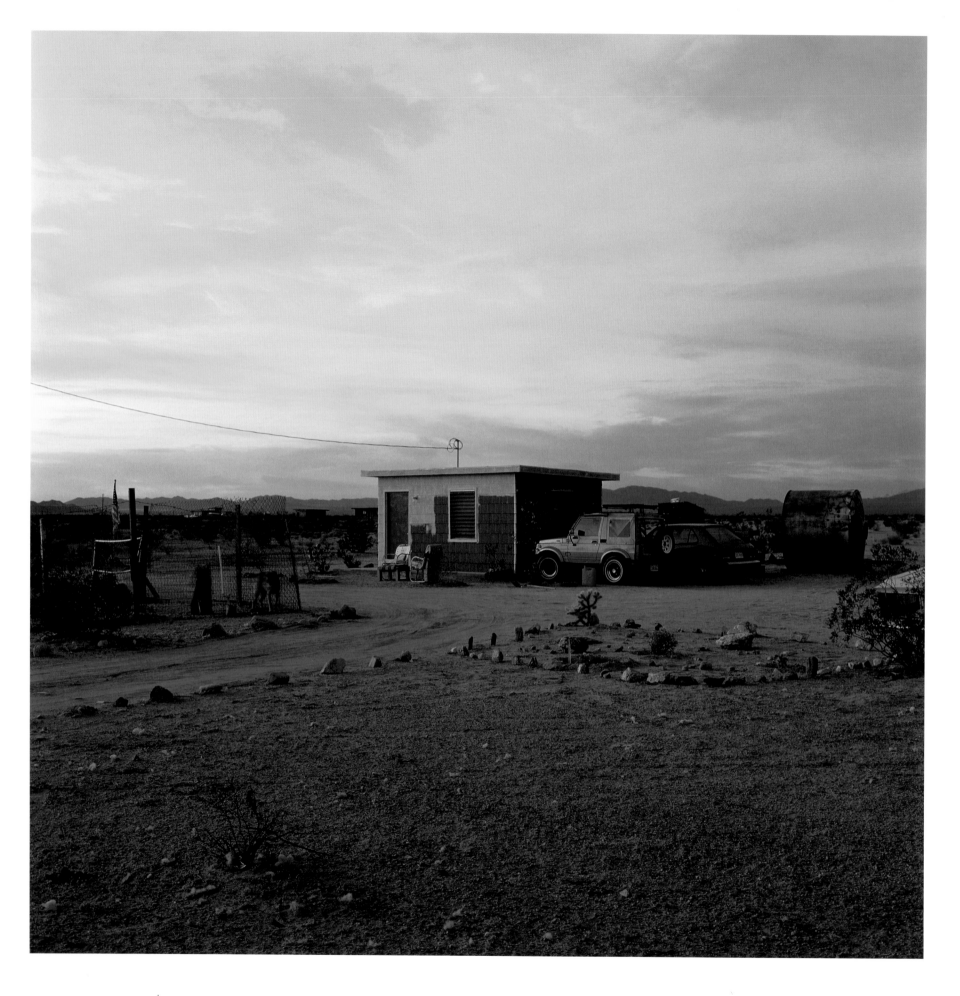

John Divola, *N34°09.951'W115°49.269'*, 1995–98

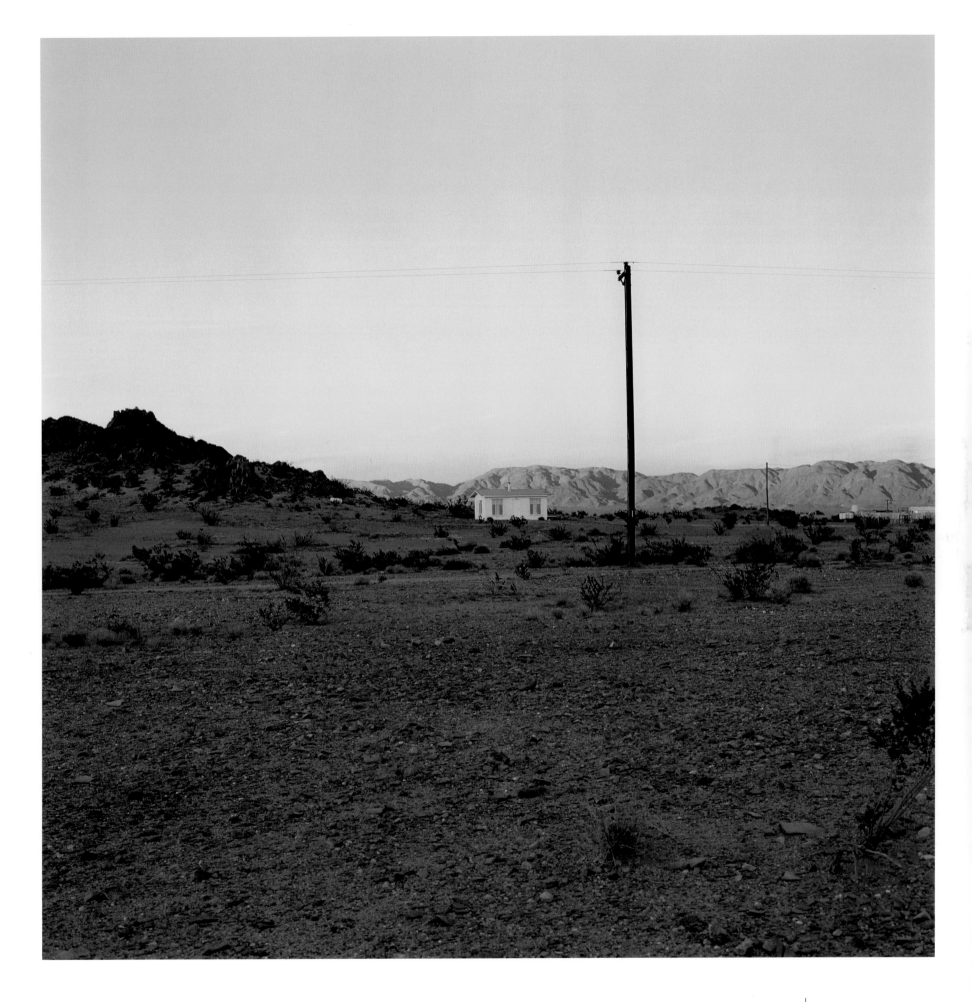

PLATE 100 John Divola, *N34°11.670'W115°55.347' #2*, 1995–98 | 137

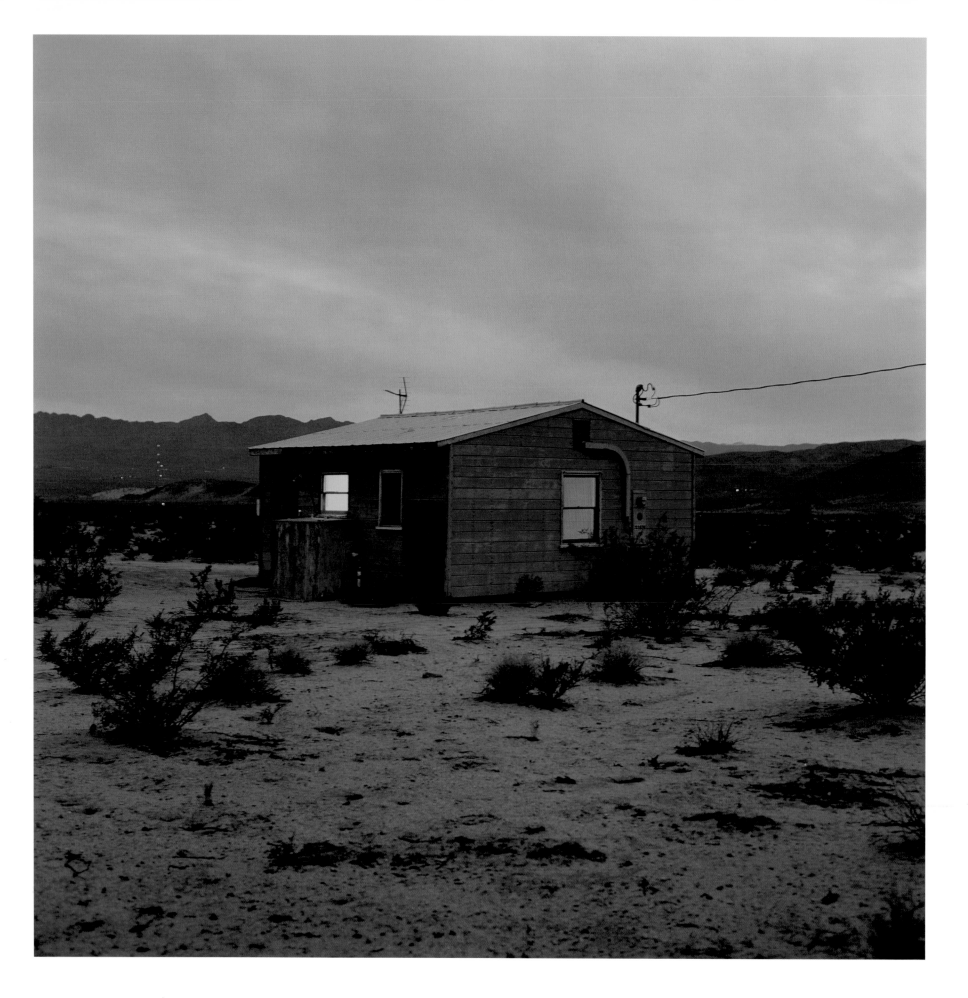

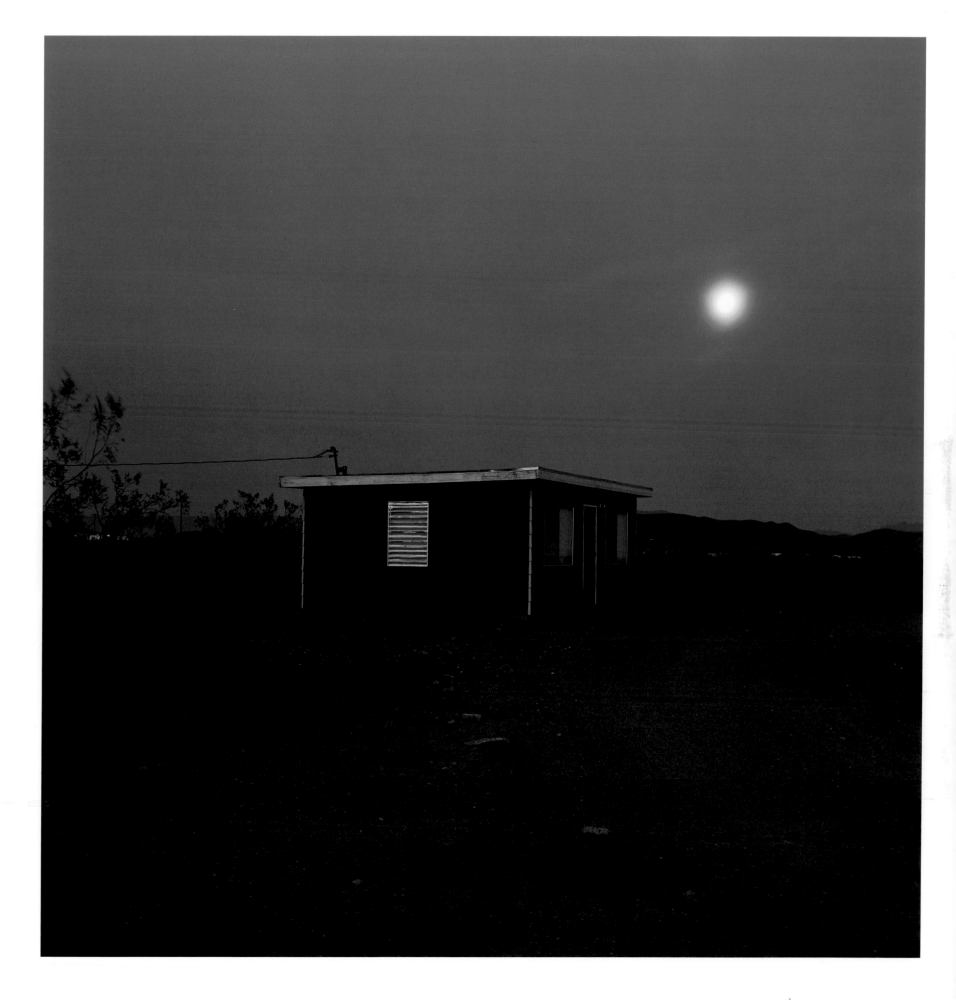

PLATE 102 John Divola, *N34°12.325'W116°01.374' #1*, 1995–98 139

| PLATE 103 **John Divola,** *N34°07.892'W115°54.426'*, 1995–98

PLATE 104 John Divola, *N34°10.388'W115°54.800'*, 1995–98 | 141

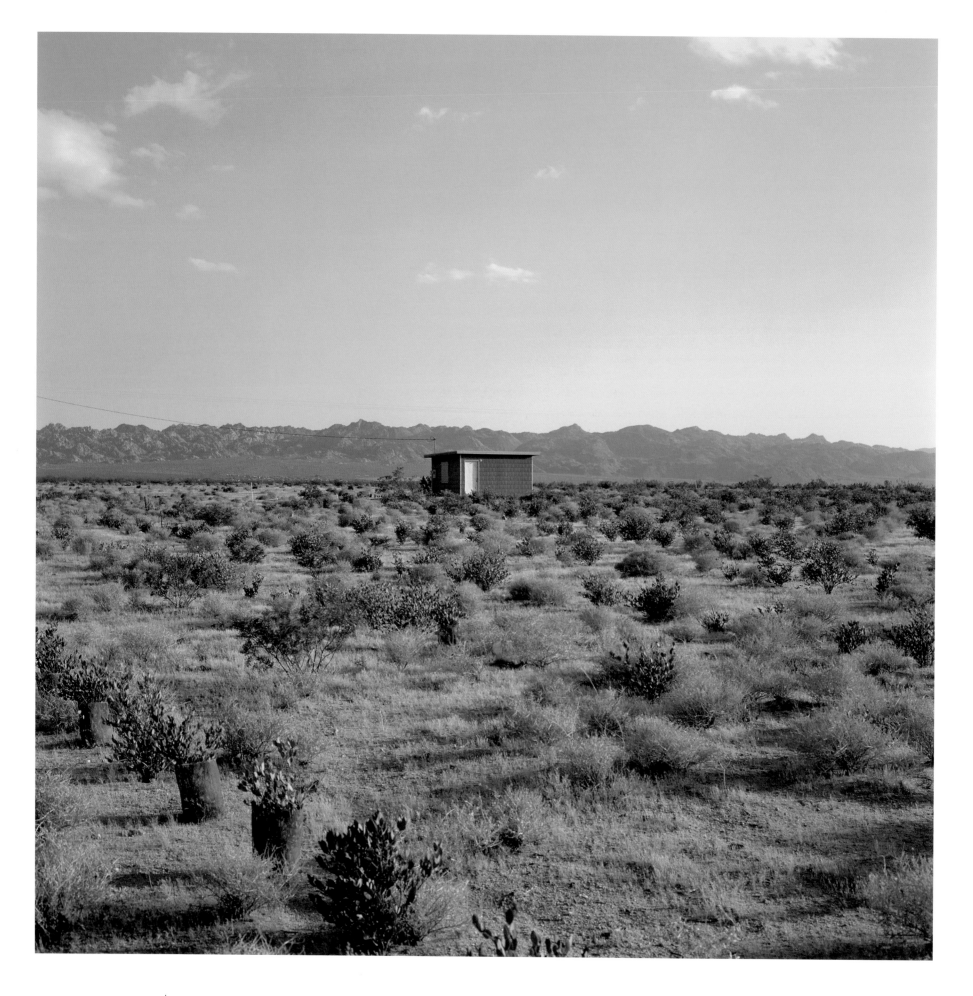

| PLATE 105 **John Divola**, *N34°10.744'W116°07.973'*, 1995–98

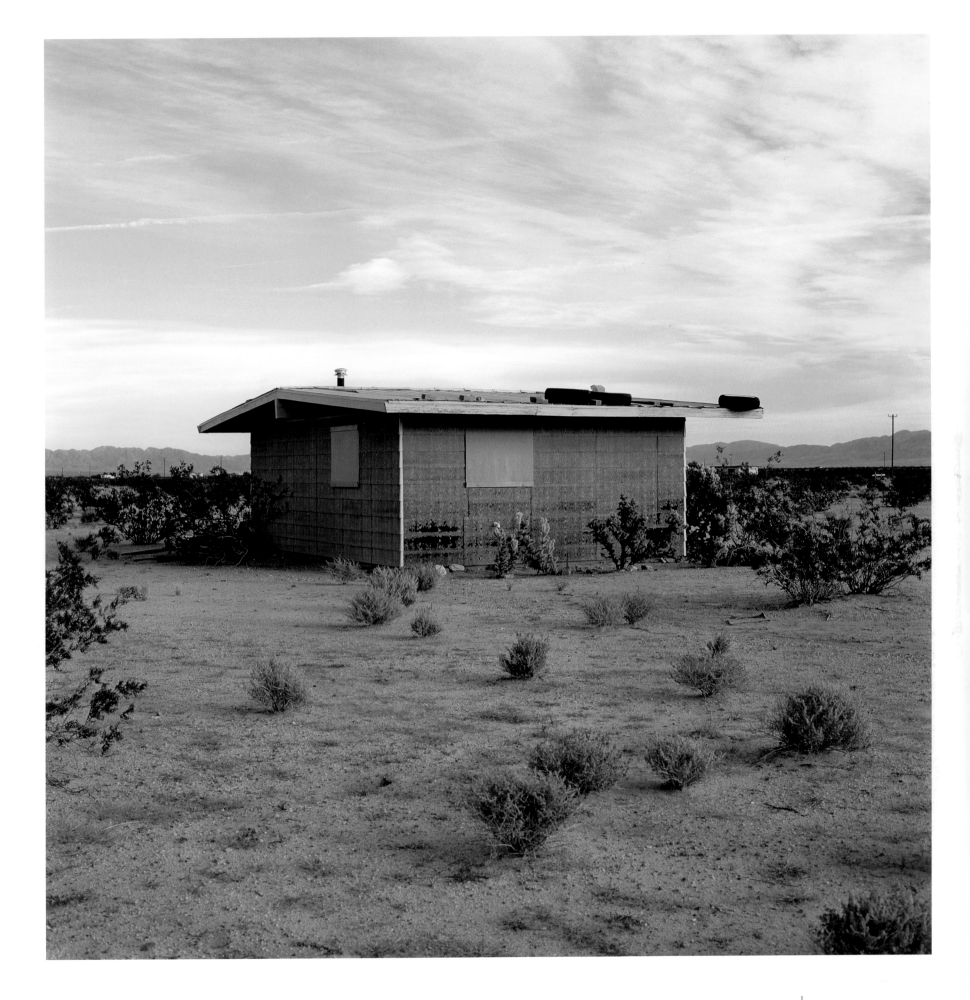

PLATE 106 John Divola, *N34°11.625'W115°50.782'*, 1995–98 | 143

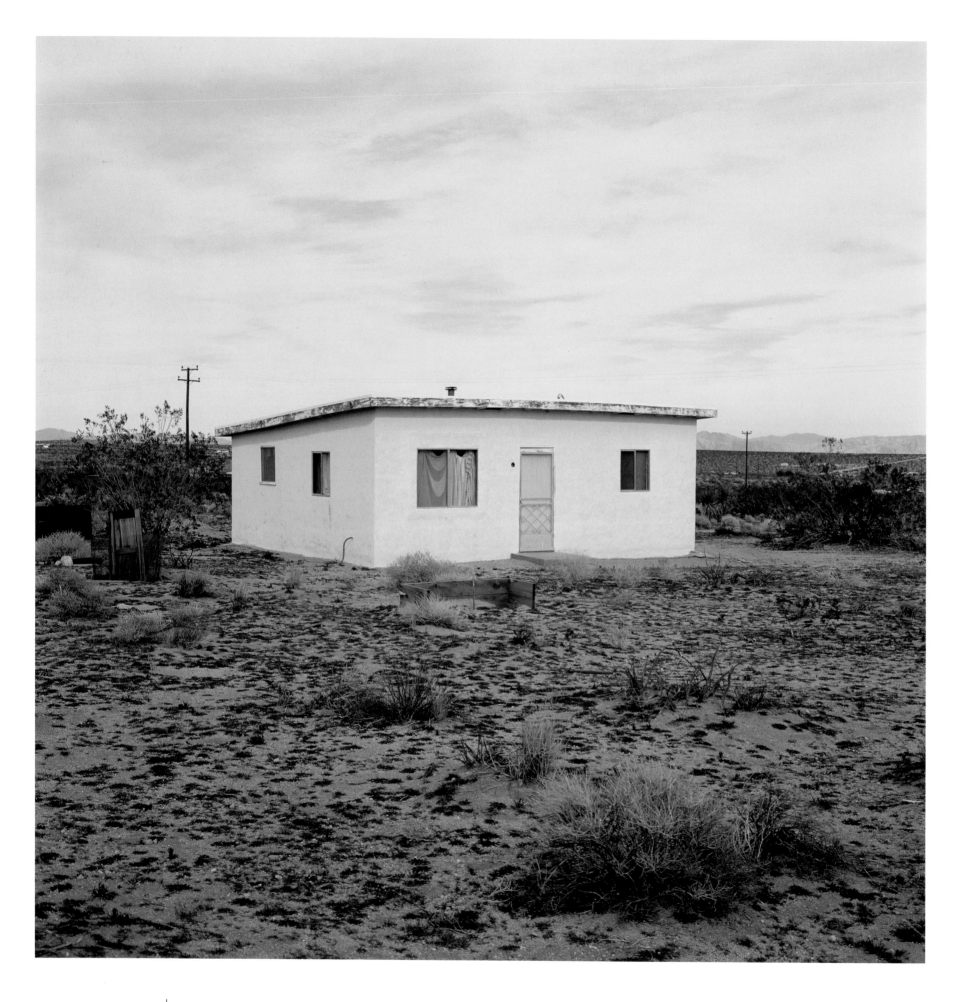

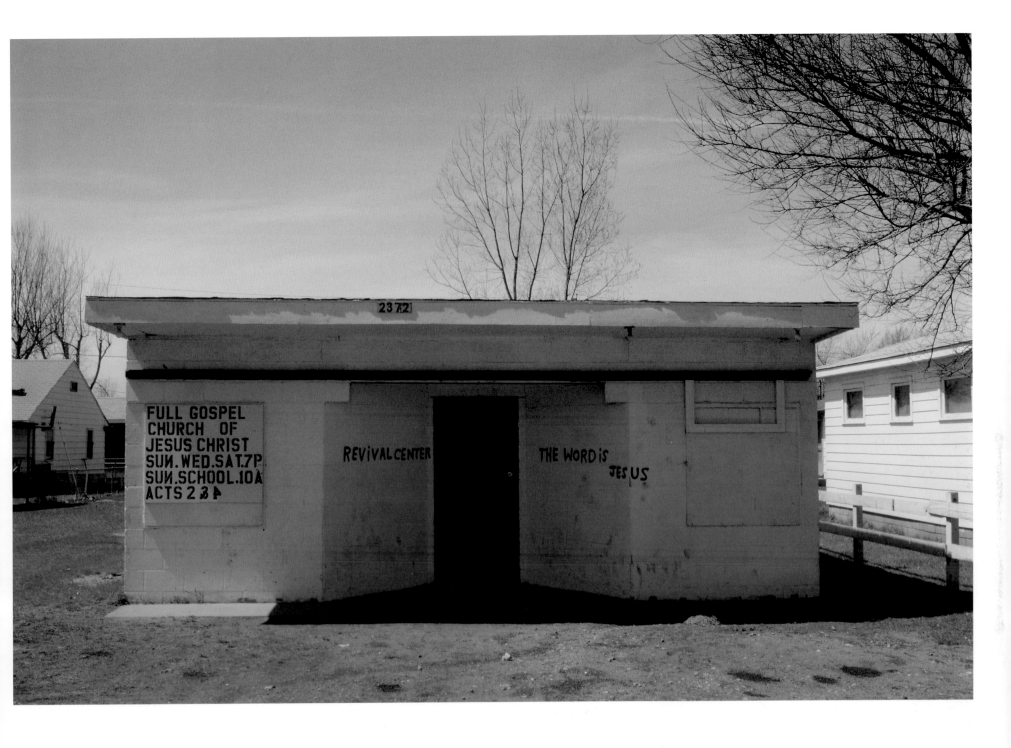

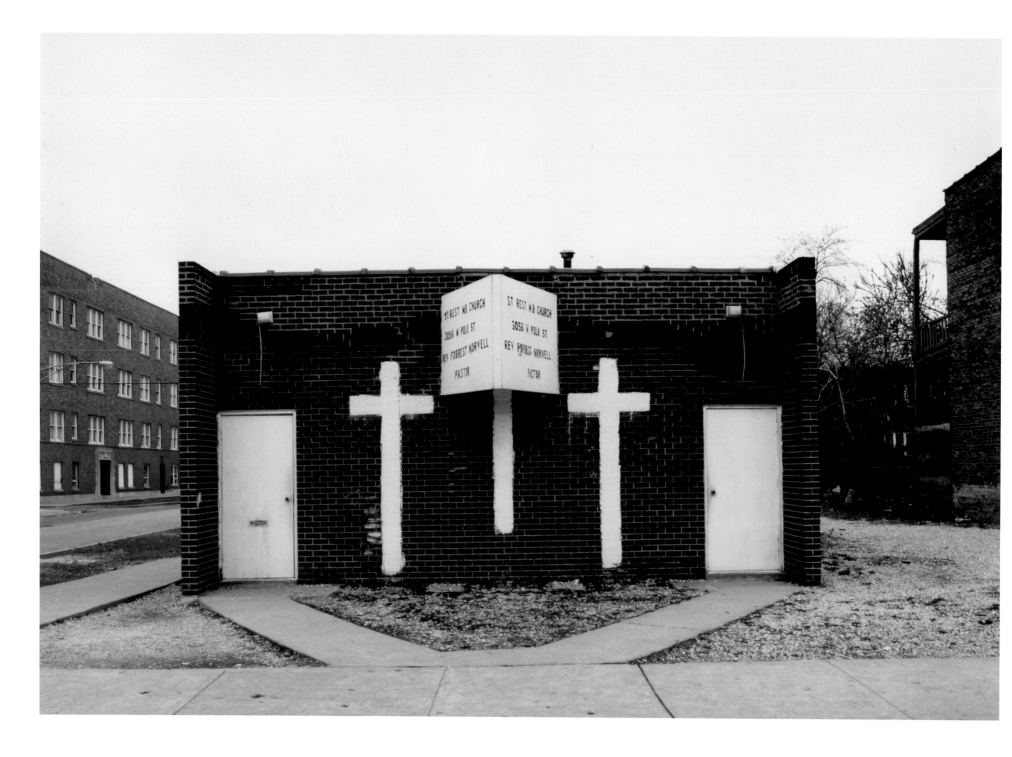

| PLATE 109 Camilo José Vergara, *St. Rest M.B. Church, 3056 West Polk St., Chicago,* 1980

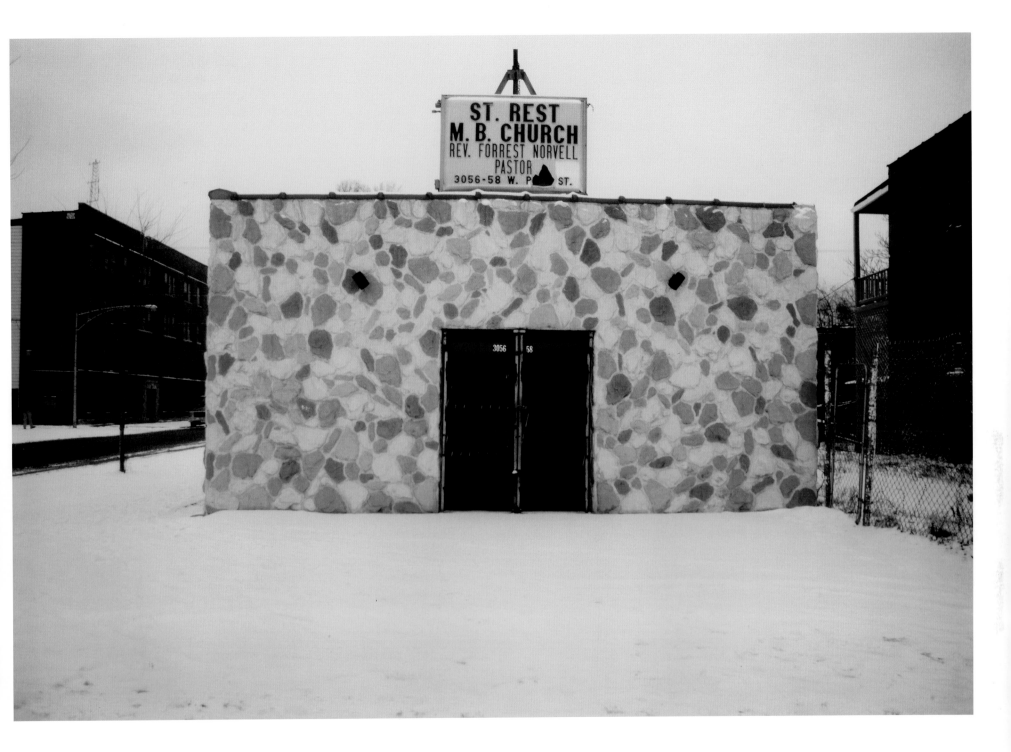

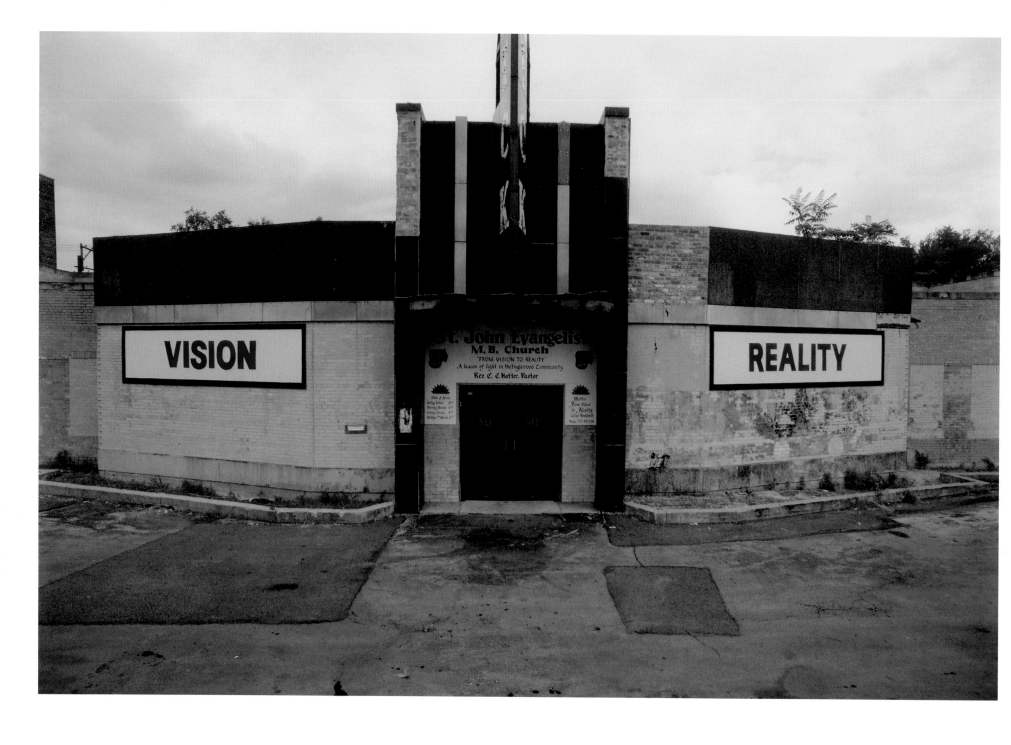

| PLATE 111 Camilo José Vergara, *St. John Evangelist M.B. Church, Former Crown Buick Dealership, 63rd St. East of Throop, Chicago,* 2001

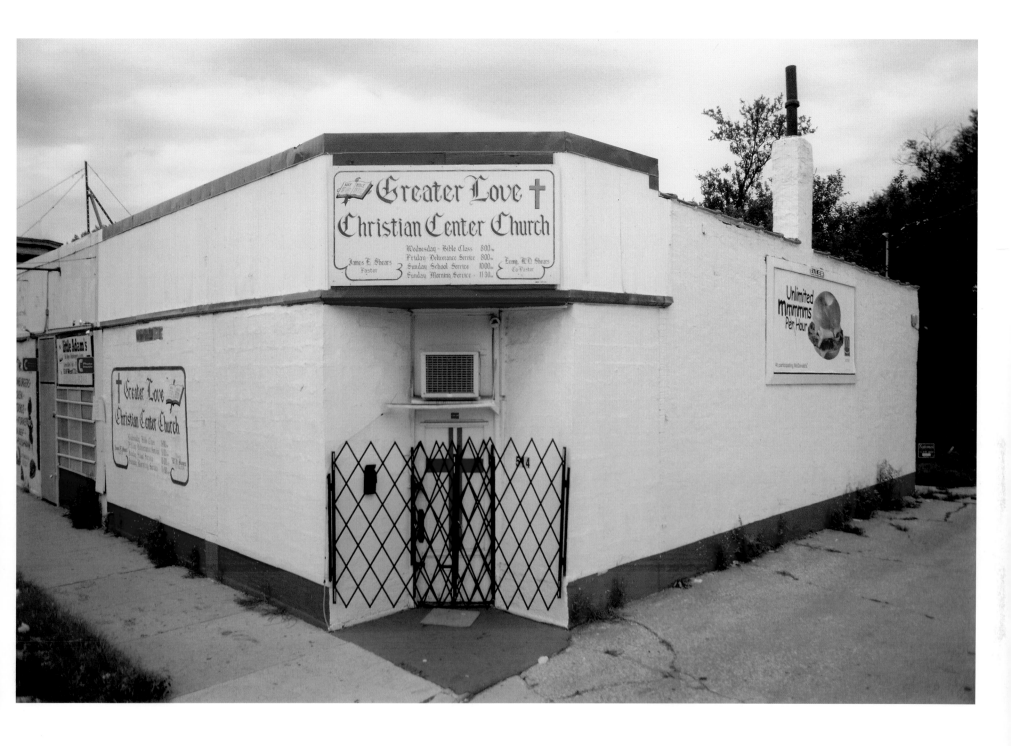

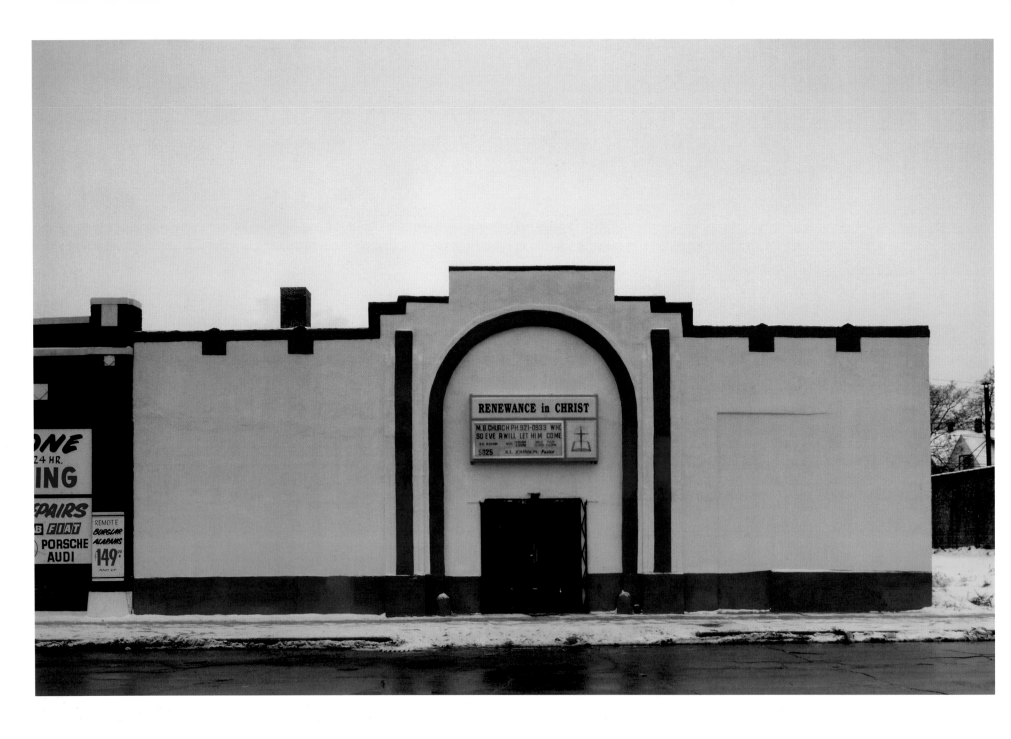

| PLATE 113 Camilo José Vergara, *Renewance in Christ, 5825 West Lake Street, Chicago,* 1990

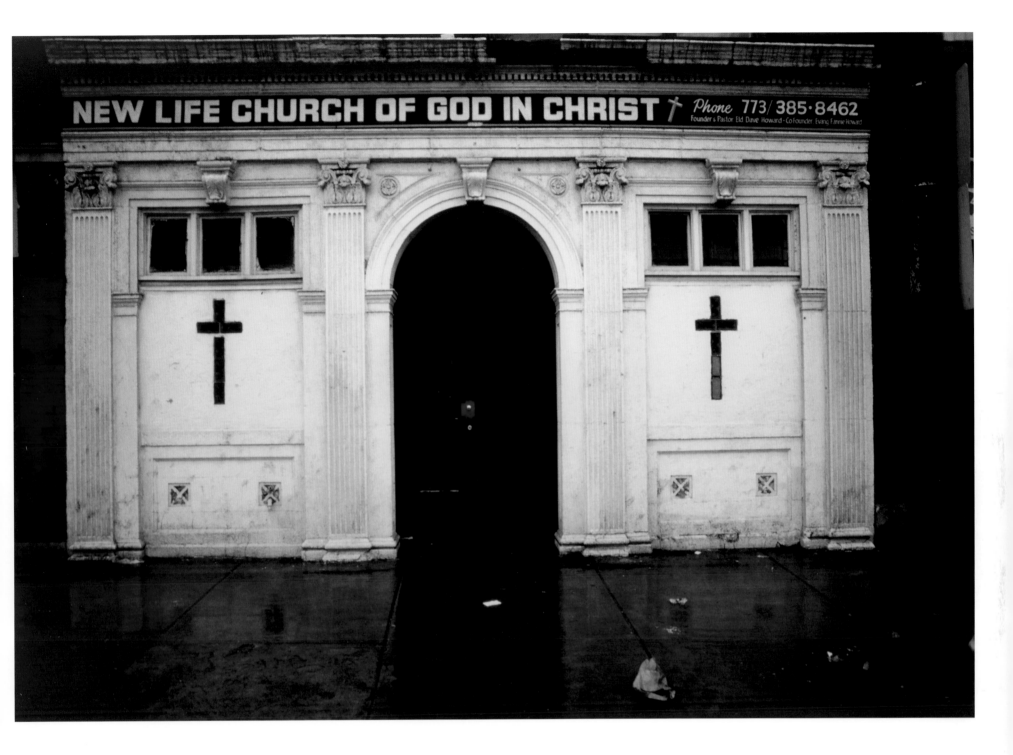

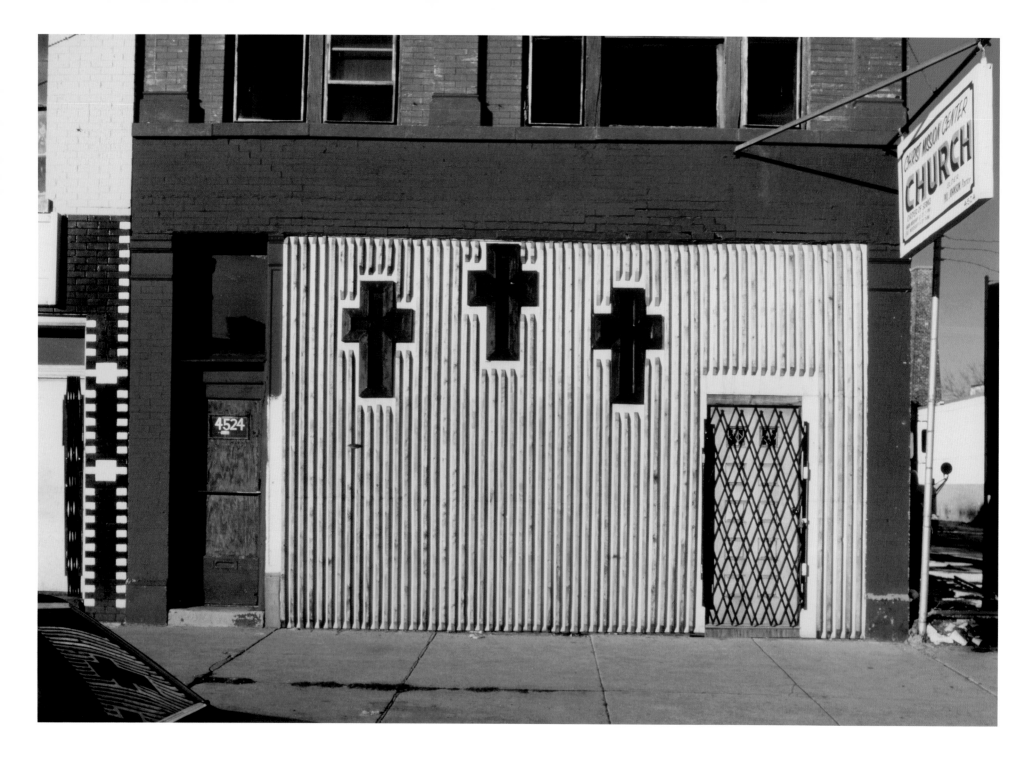

| PLATE 115 Camilo José Vergara, *Christ Mission Center, 4524 West Madison St., Chicago, 1987*

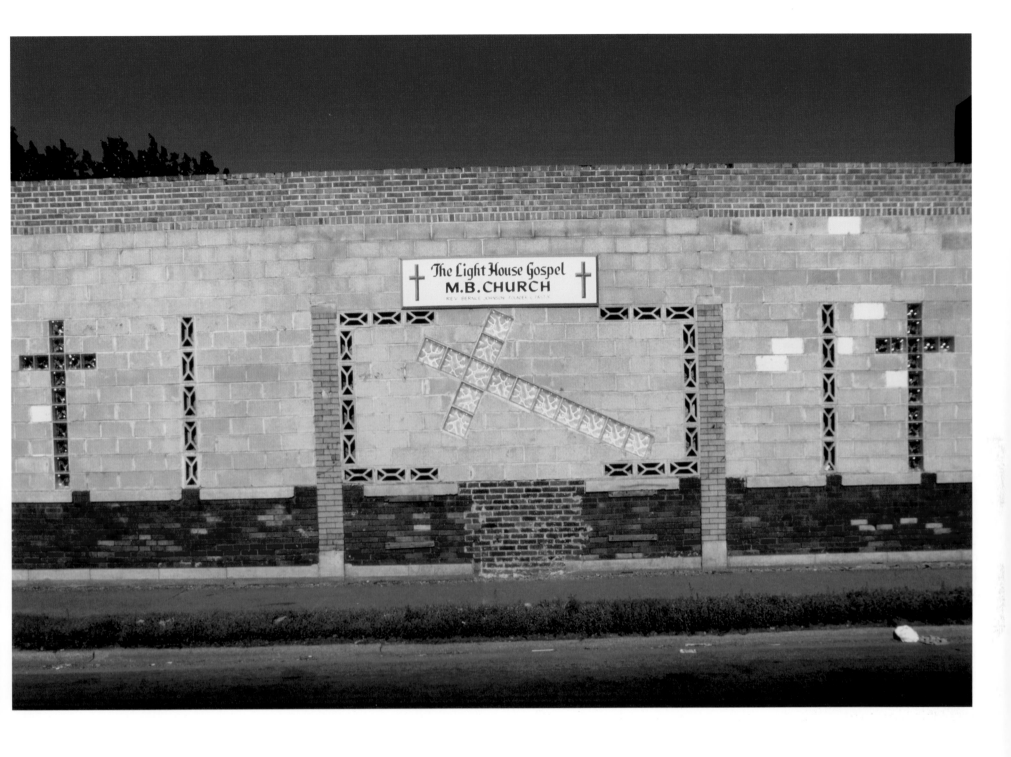

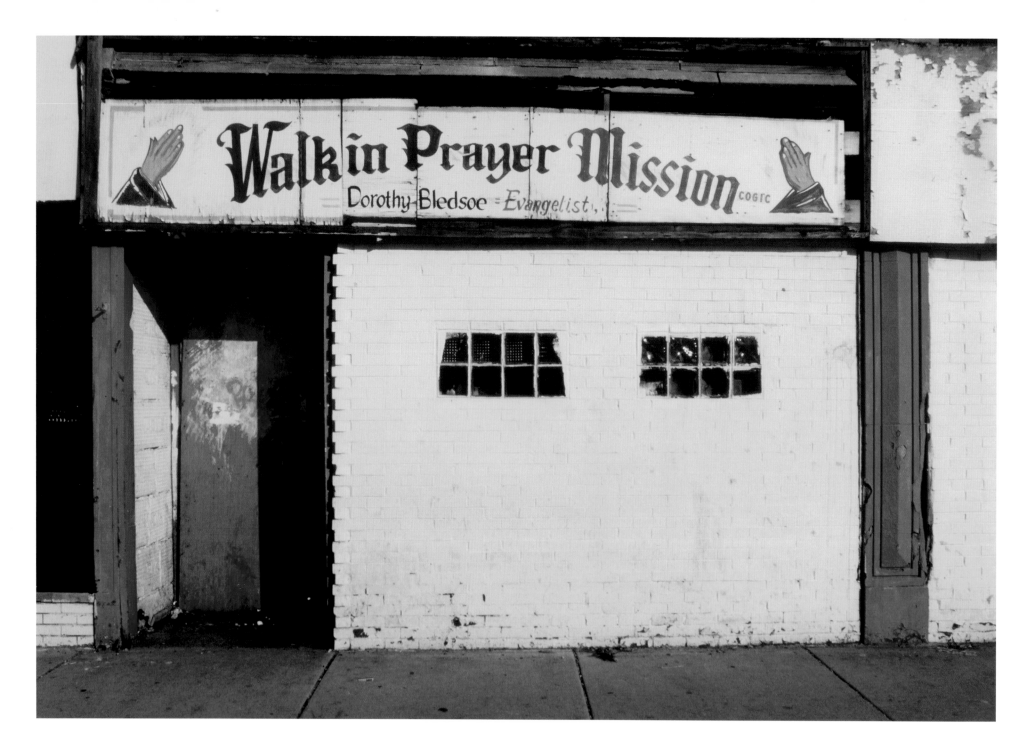

| PLATE 117 Camilo José Vergara, *Walk in Prayer Mission, Cottage Grove Ave. by 45th St., Chicago,* 2000

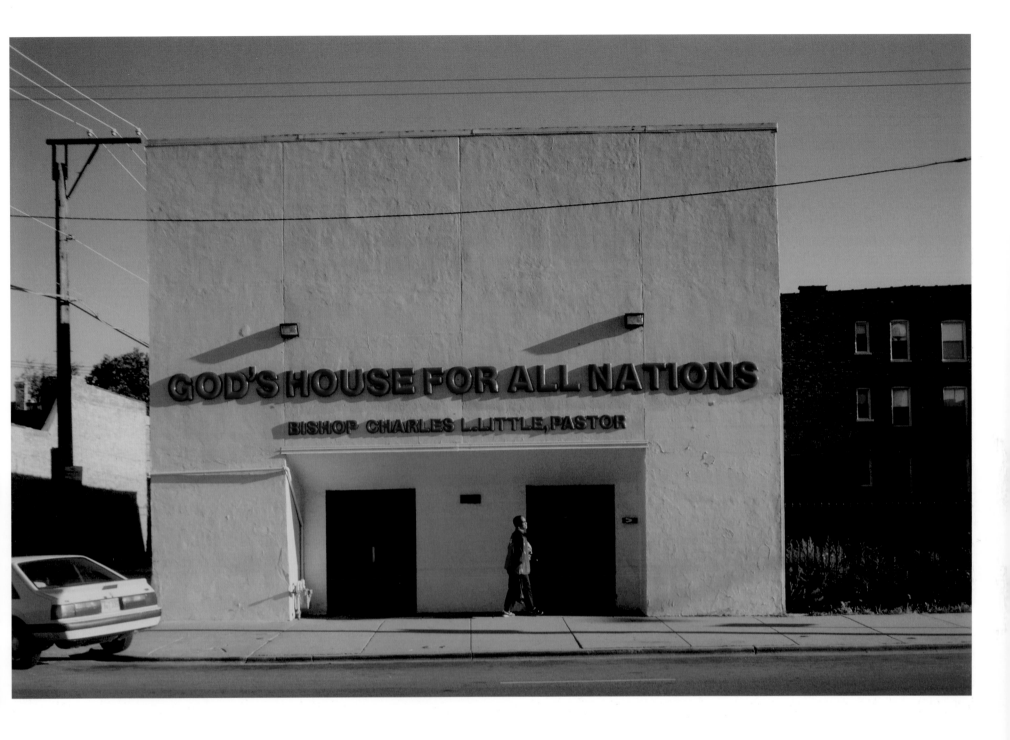

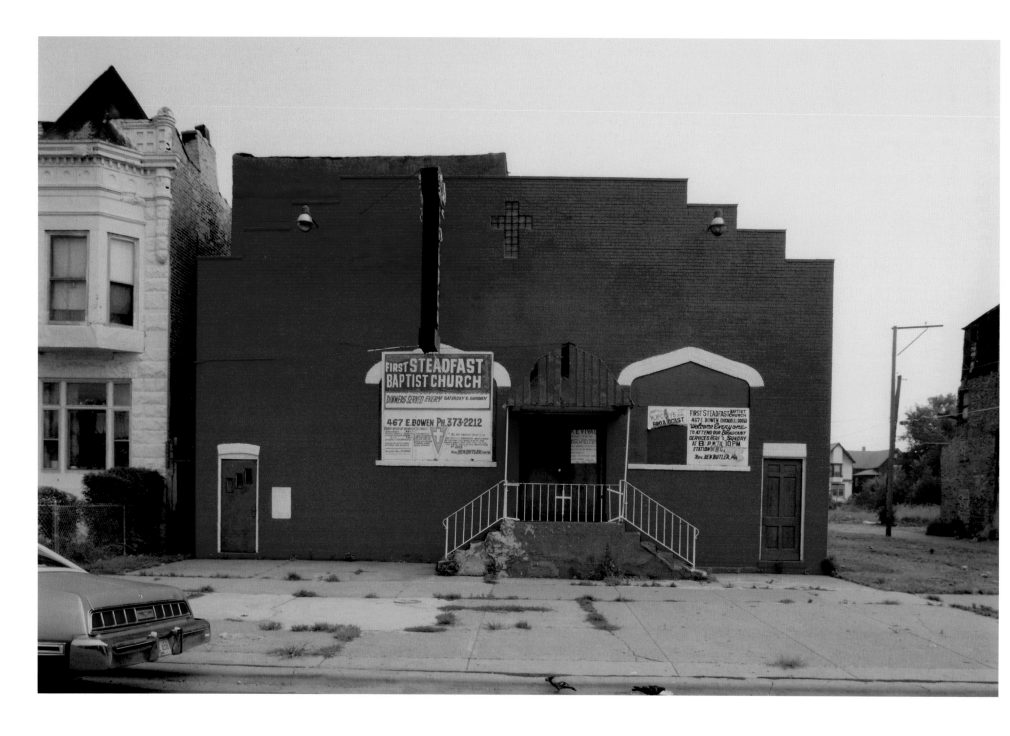

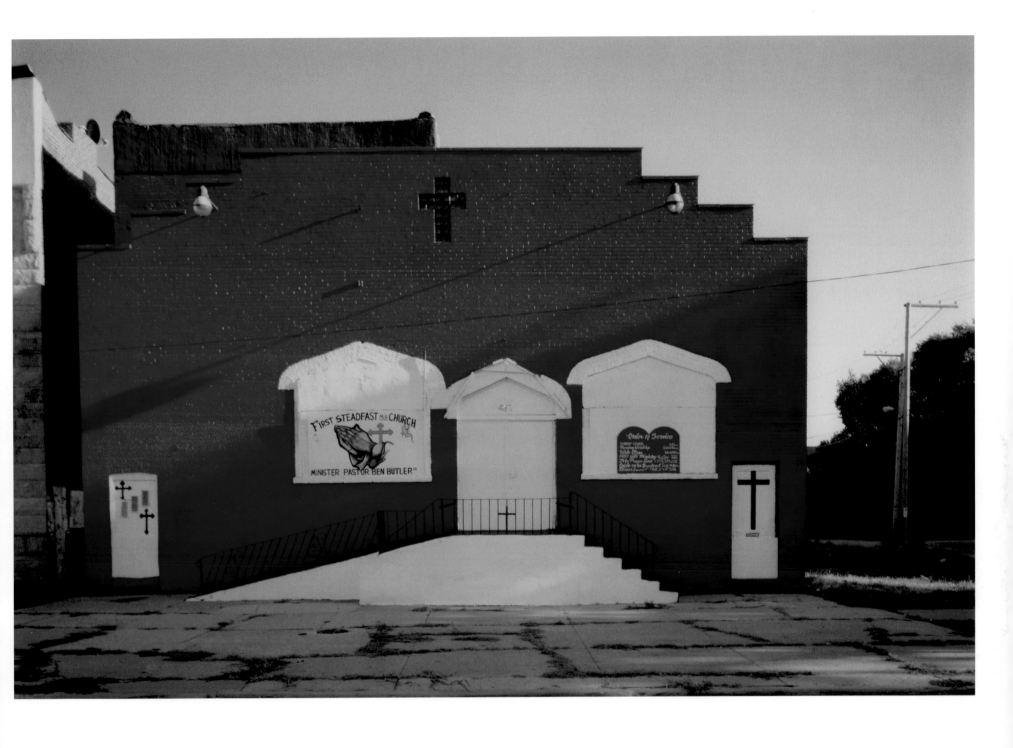

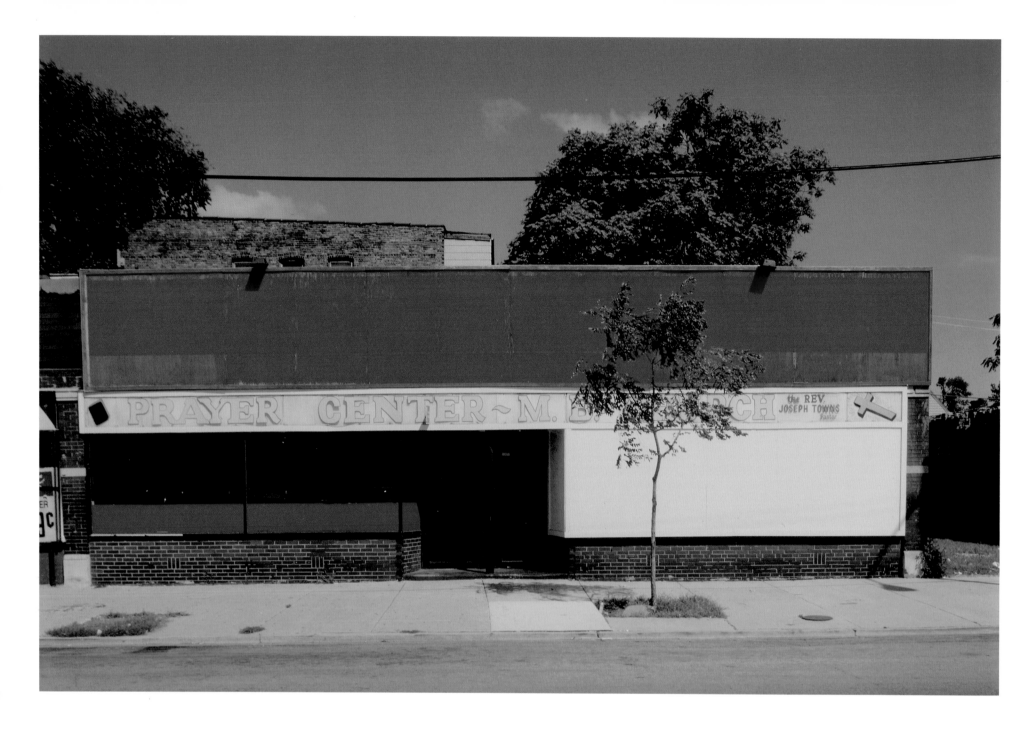

Camilo José Vergara, *Prayer Center M.B. Church, 7205 S. Halsted, Chicago*, 2001

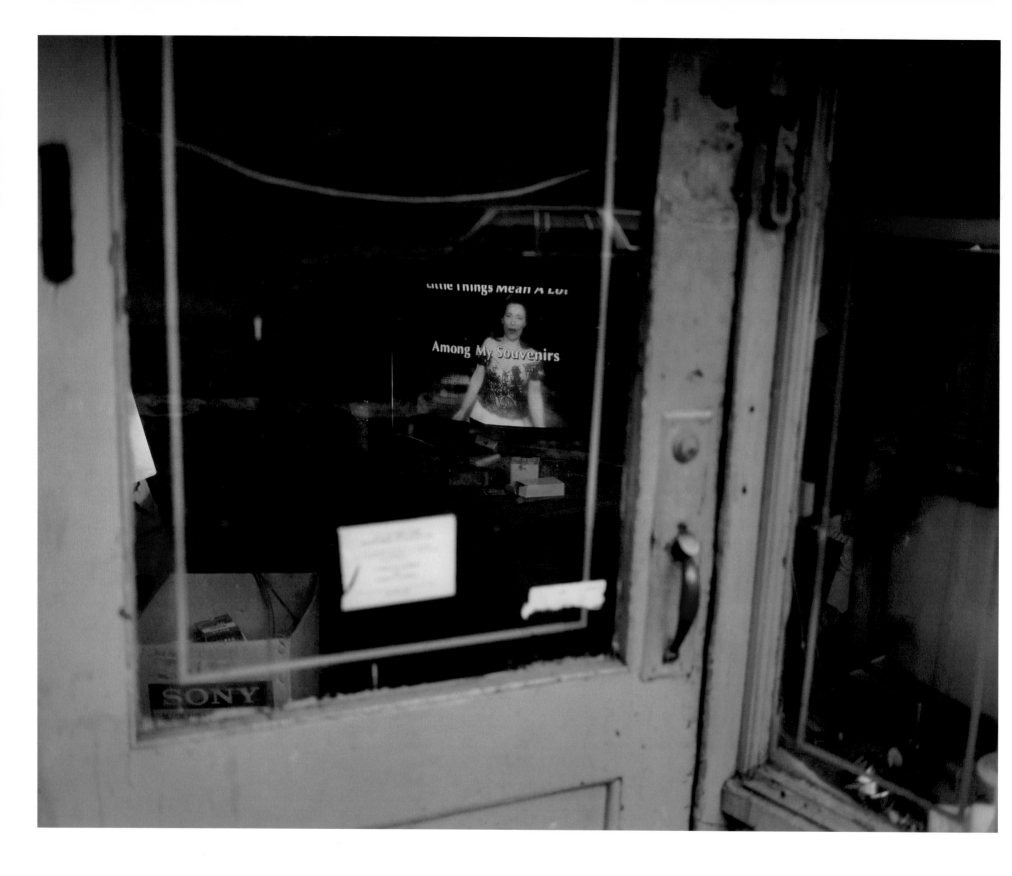

| PLATE 123 Mitch Epstein, *Untitled, New York, 1996*

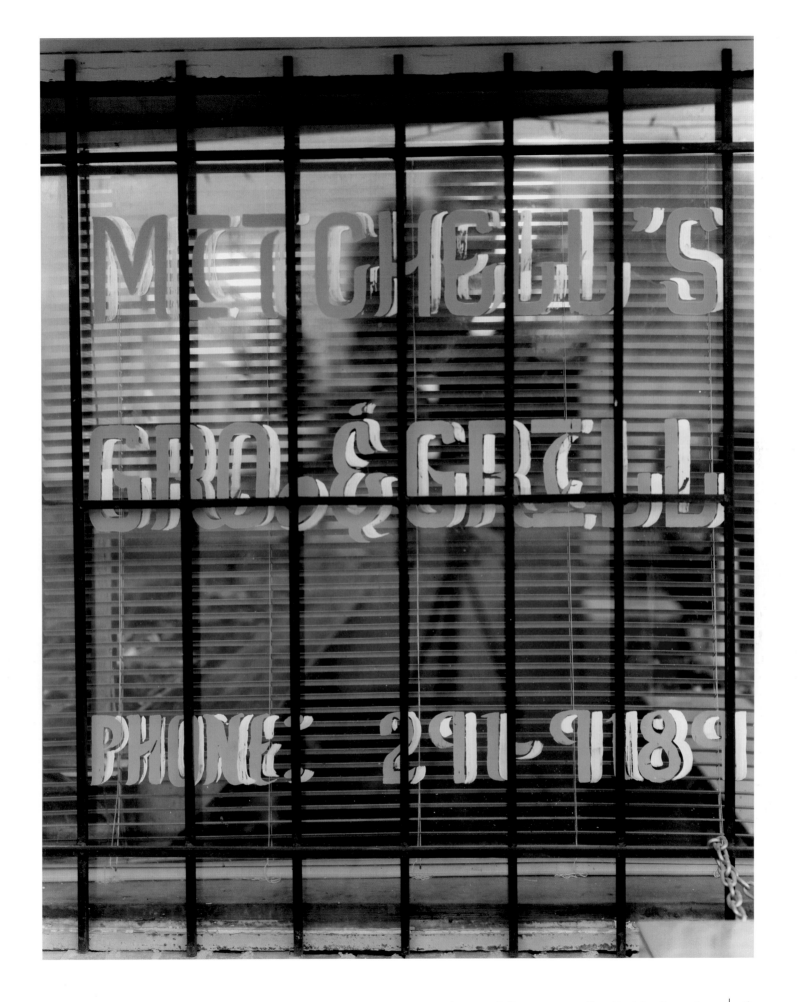

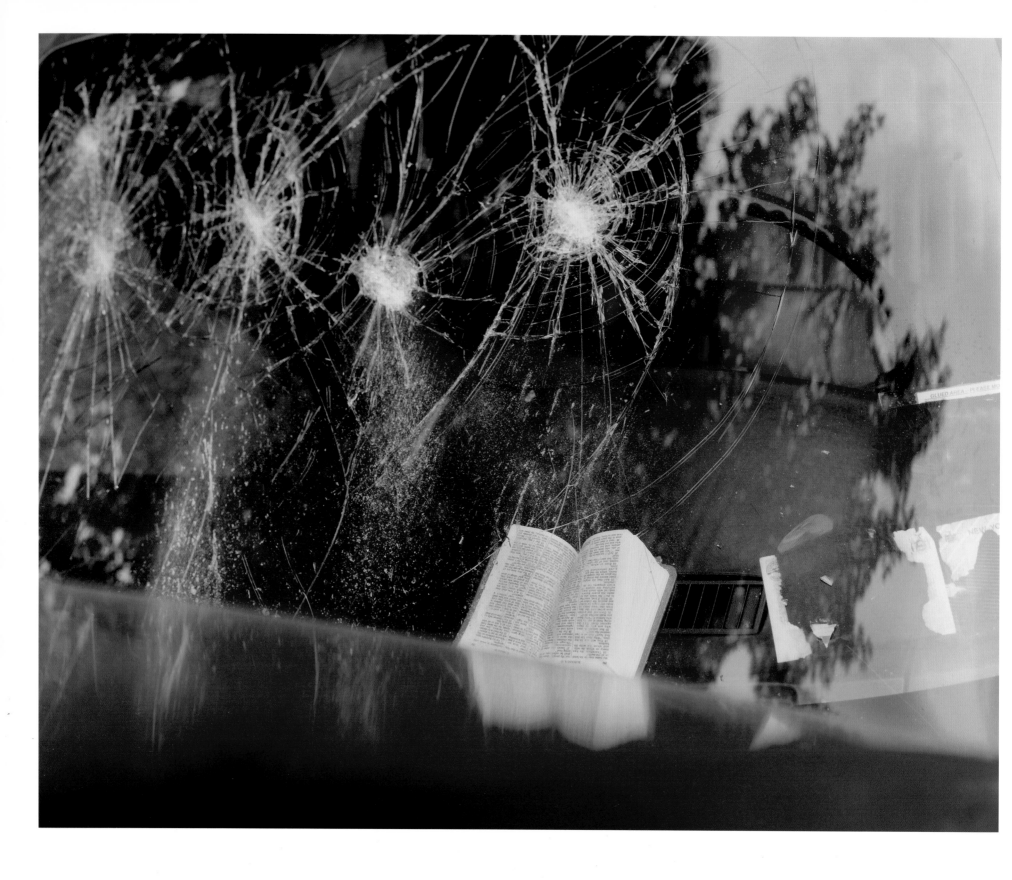

| PLATE 125 **Mitch Epstein**, *Untitled, New York, 1996*

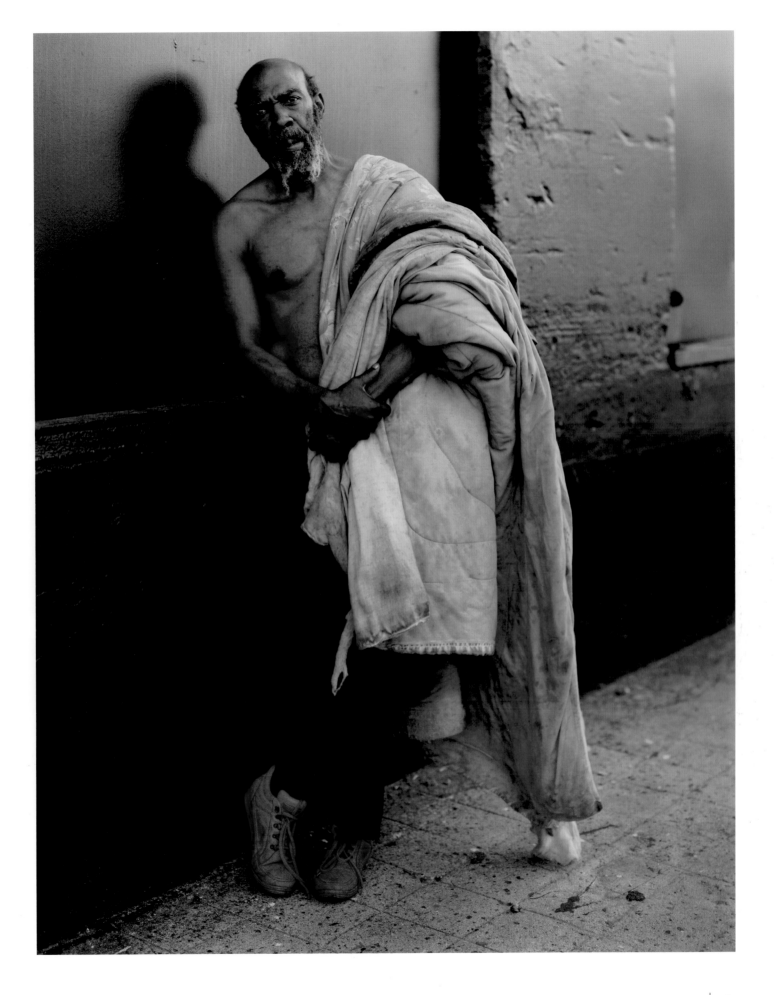

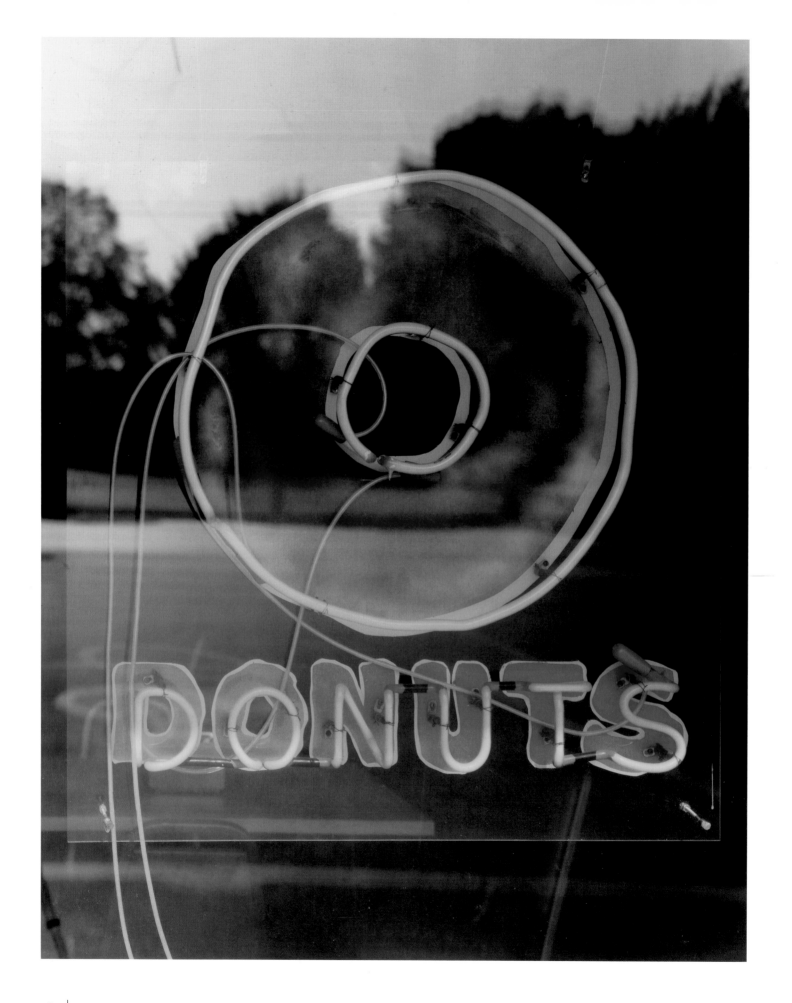

| PLATE 127 **Jim Dow**, *Donut Store Window Detail, US 71B, Springdale, Arkansas, 1995*

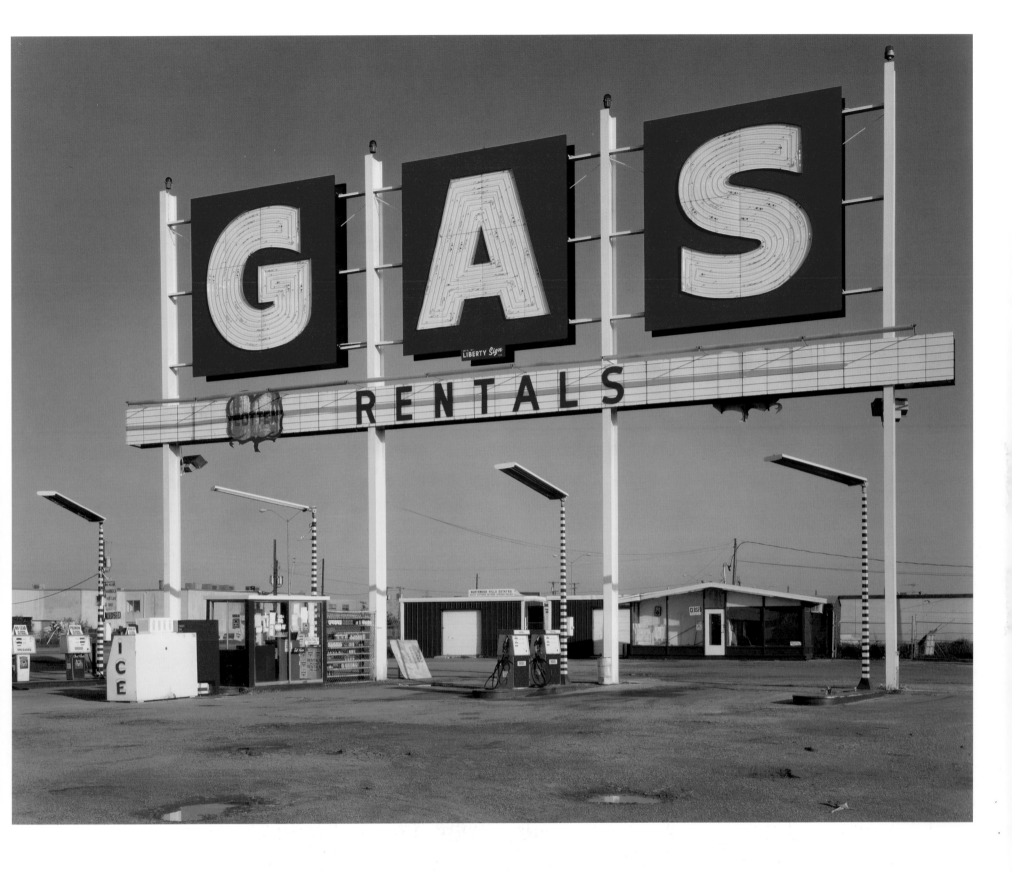

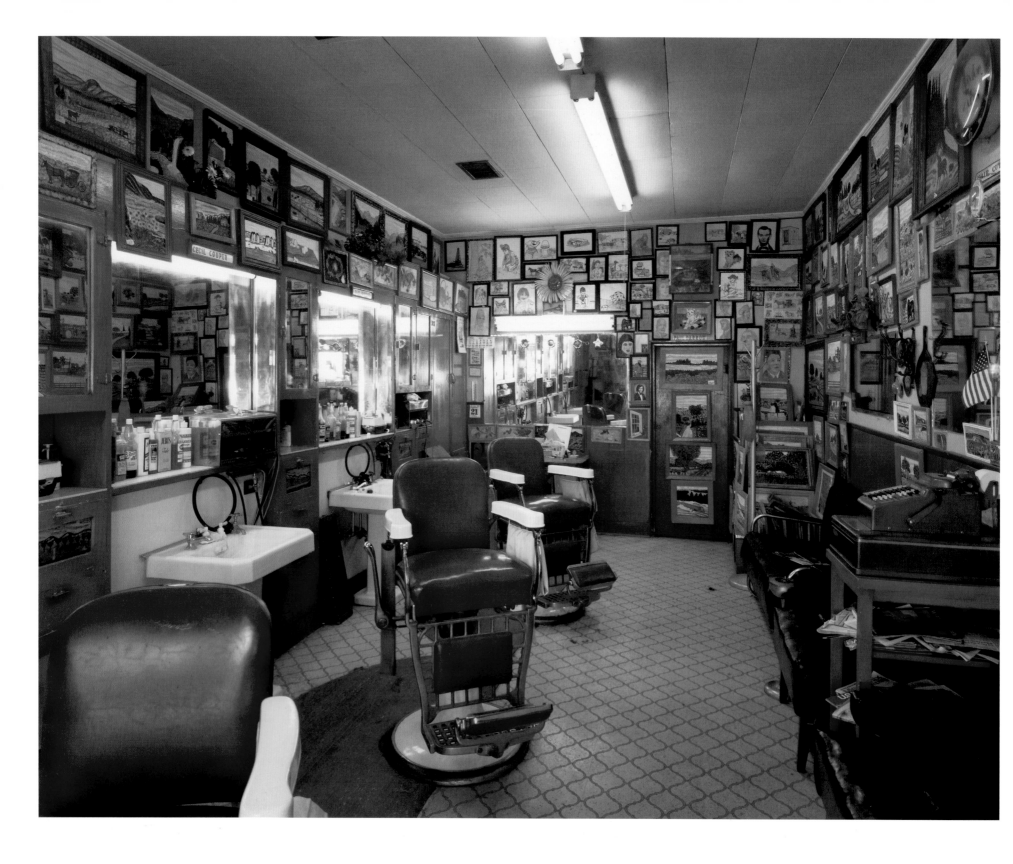

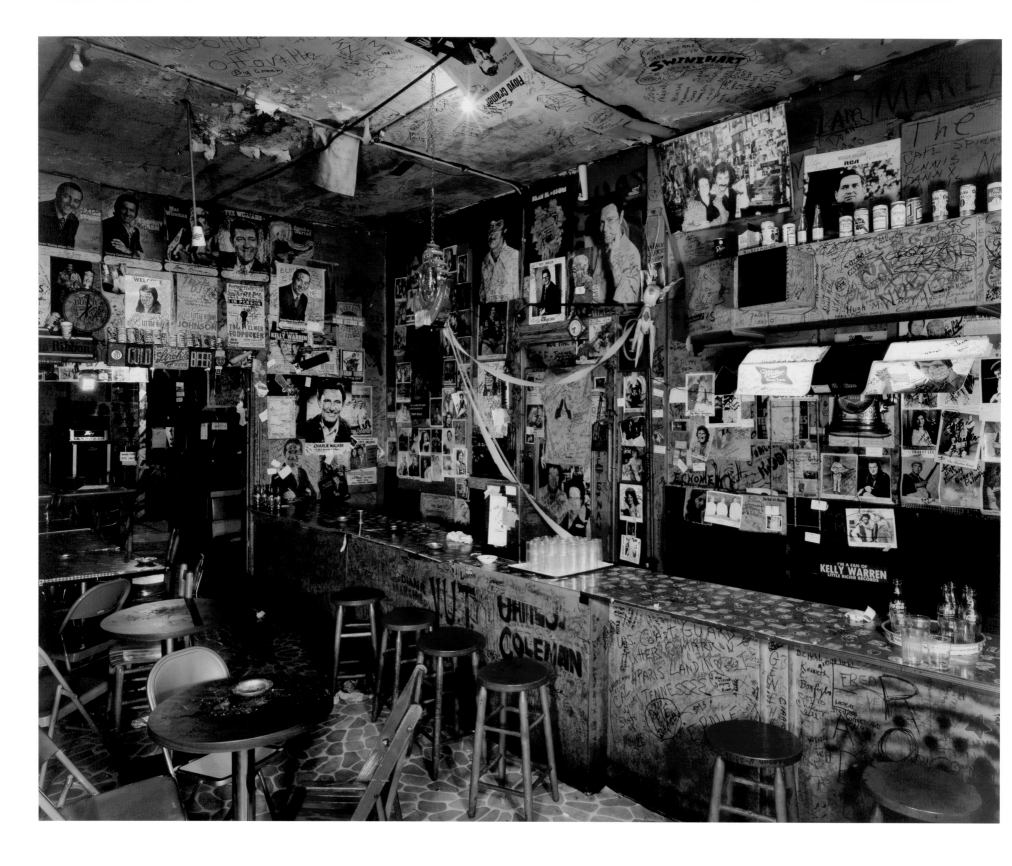

PLATE 133 **Jim Dow**, *Tootsie's Orchid Lounge, Upstairs Bar, Nashville, Tennessee*, 1977

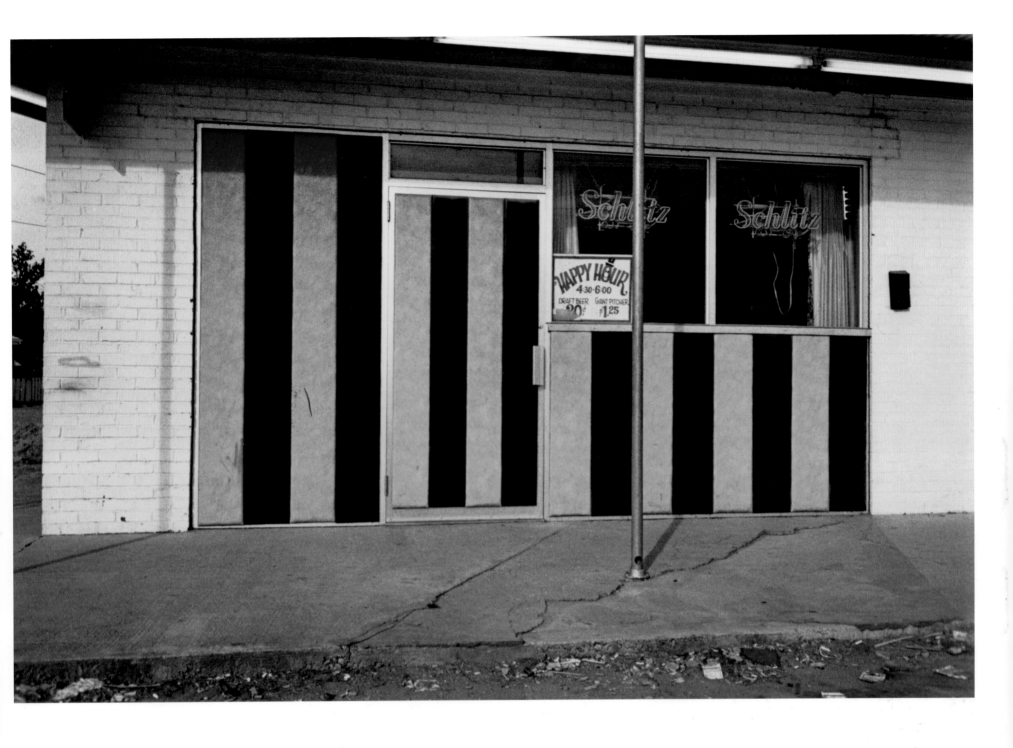

PLATE 134 William Eggleston, *Louisiana, 1971–1974* | 171

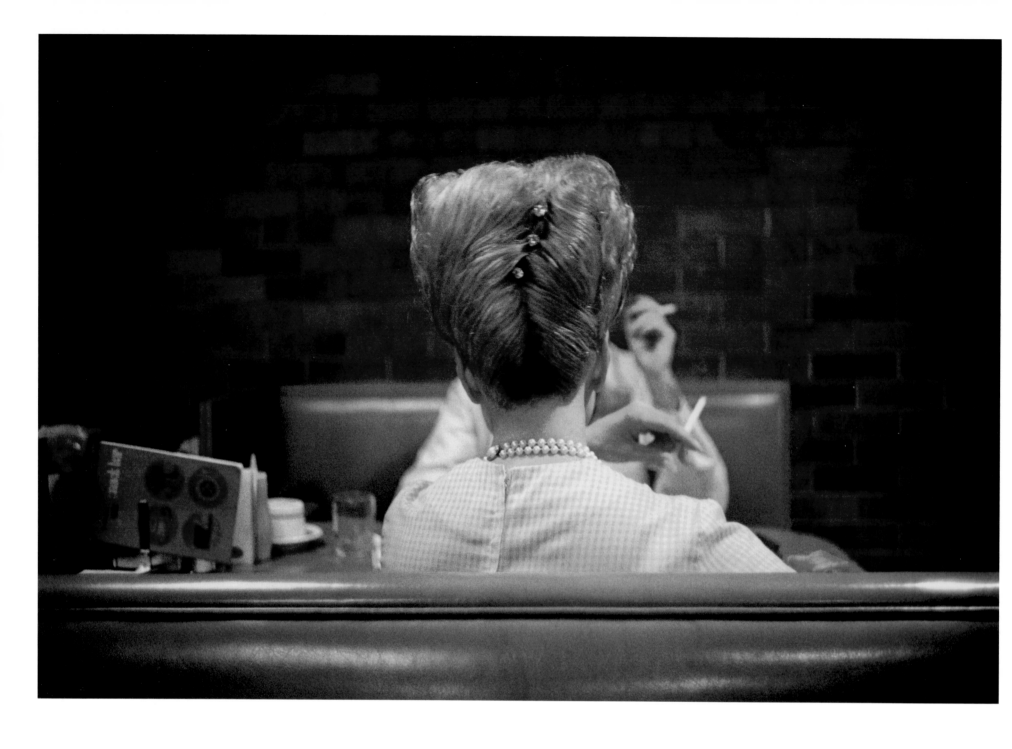

| PLATE 135 **William Eggleston,** *Memphis, 1965–1968*

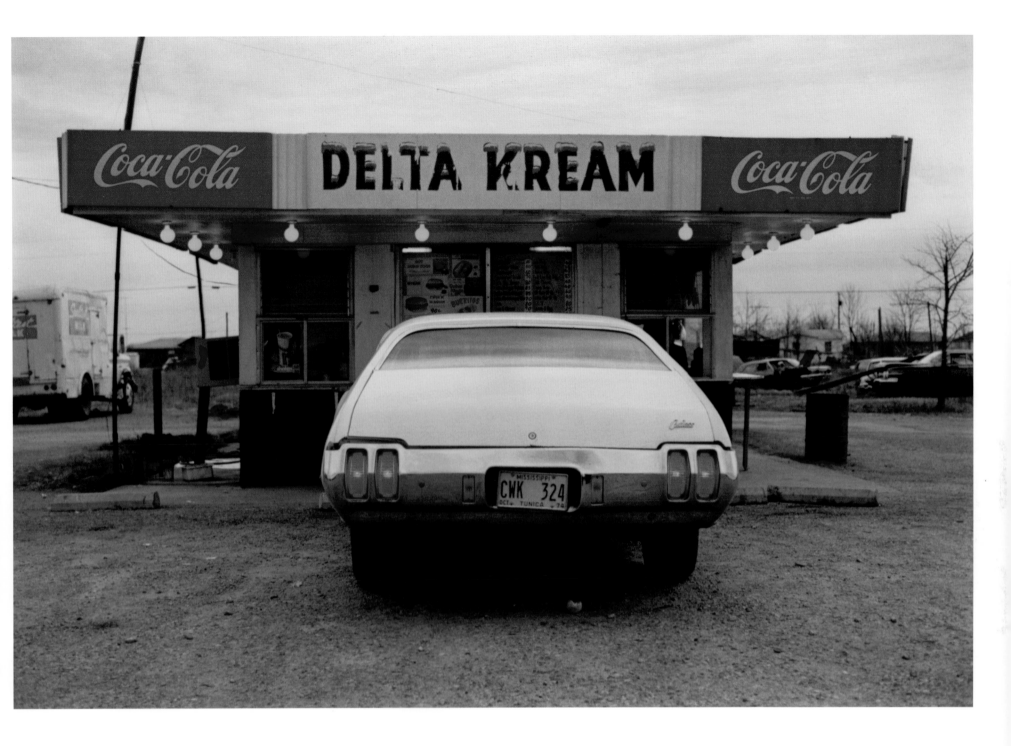

PLATE 136 William Eggleston, *Mississippi, 1971–1974* | 173

PLATE 138 William Eggleston, *Memphis, 1971–1974* | 175

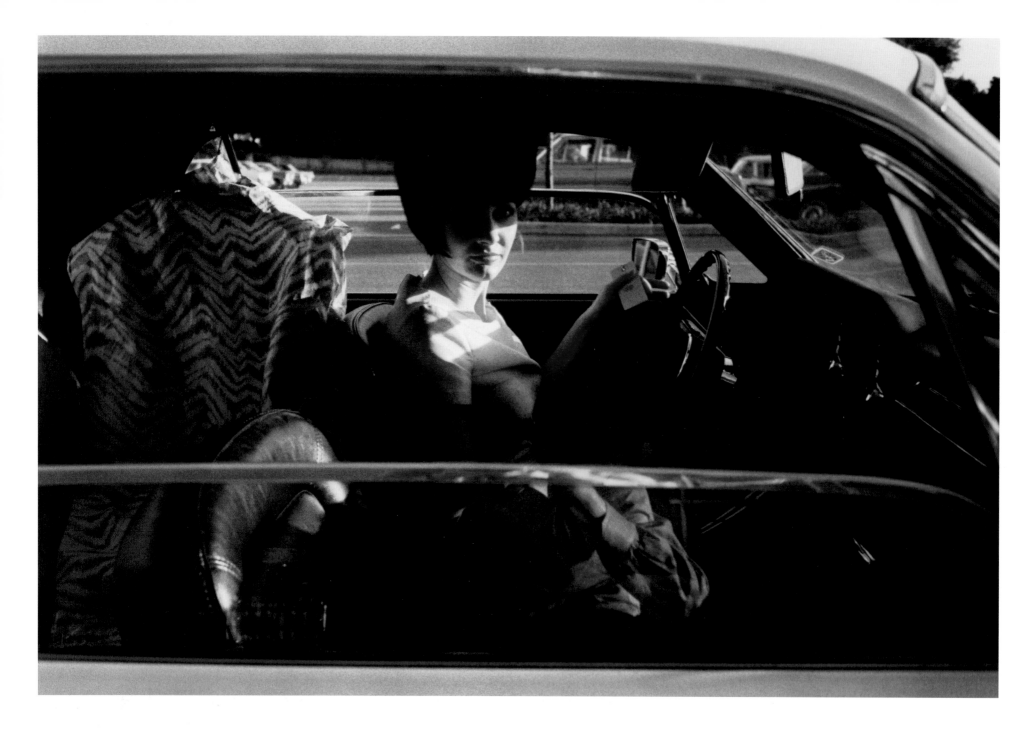

PLATE 139 **William Eggleston,** *Memphis, 1965–1968*

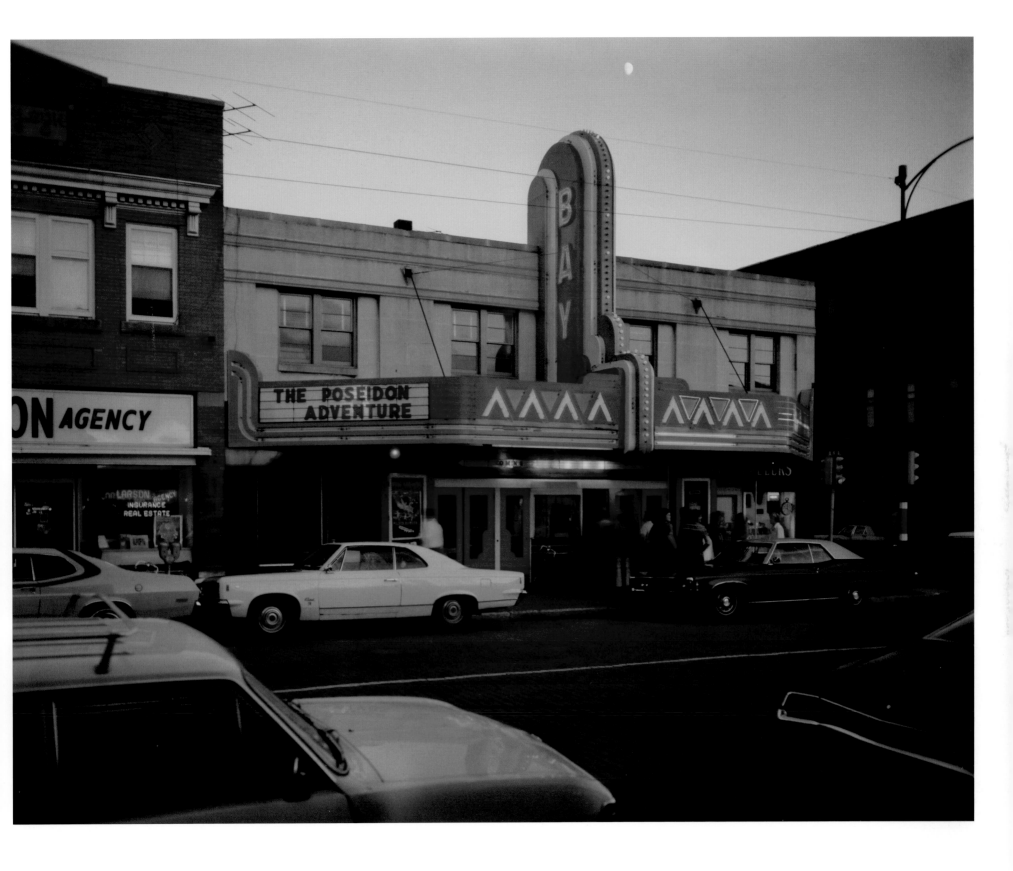

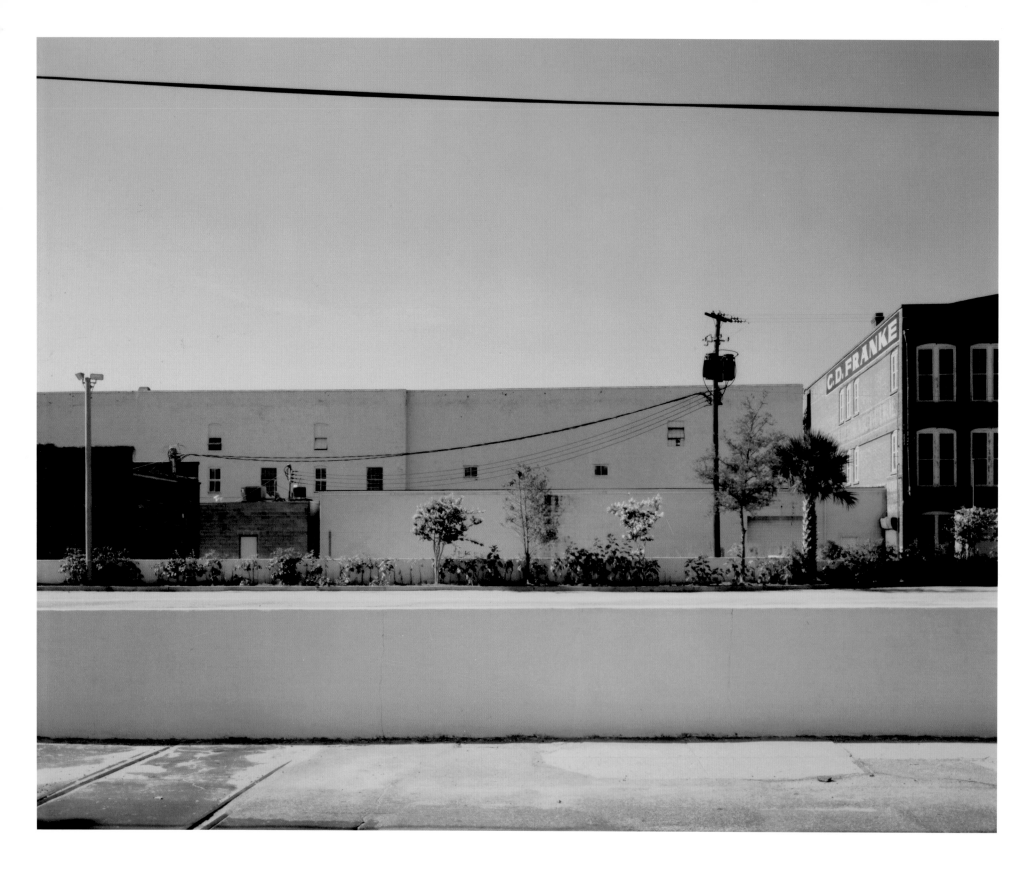

| PLATE 141 Stephen Shore, *Cumberland St., Charleston, South Carolina*, August 3, 1975

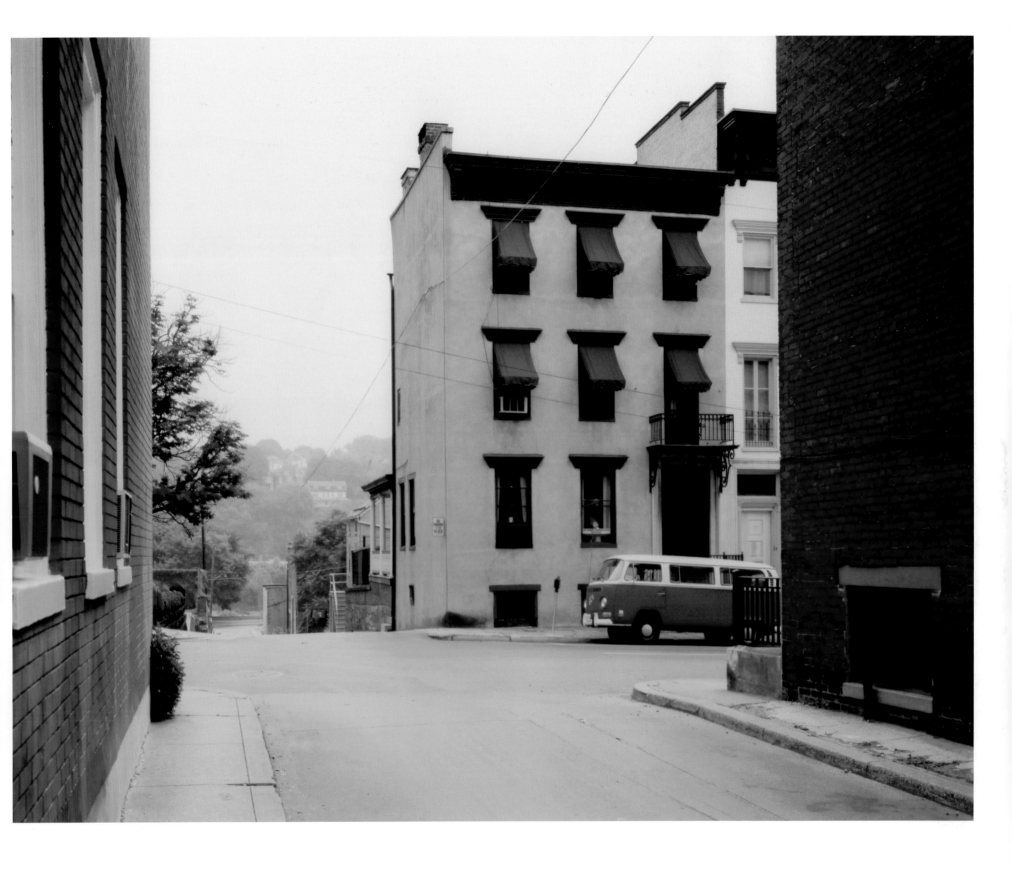

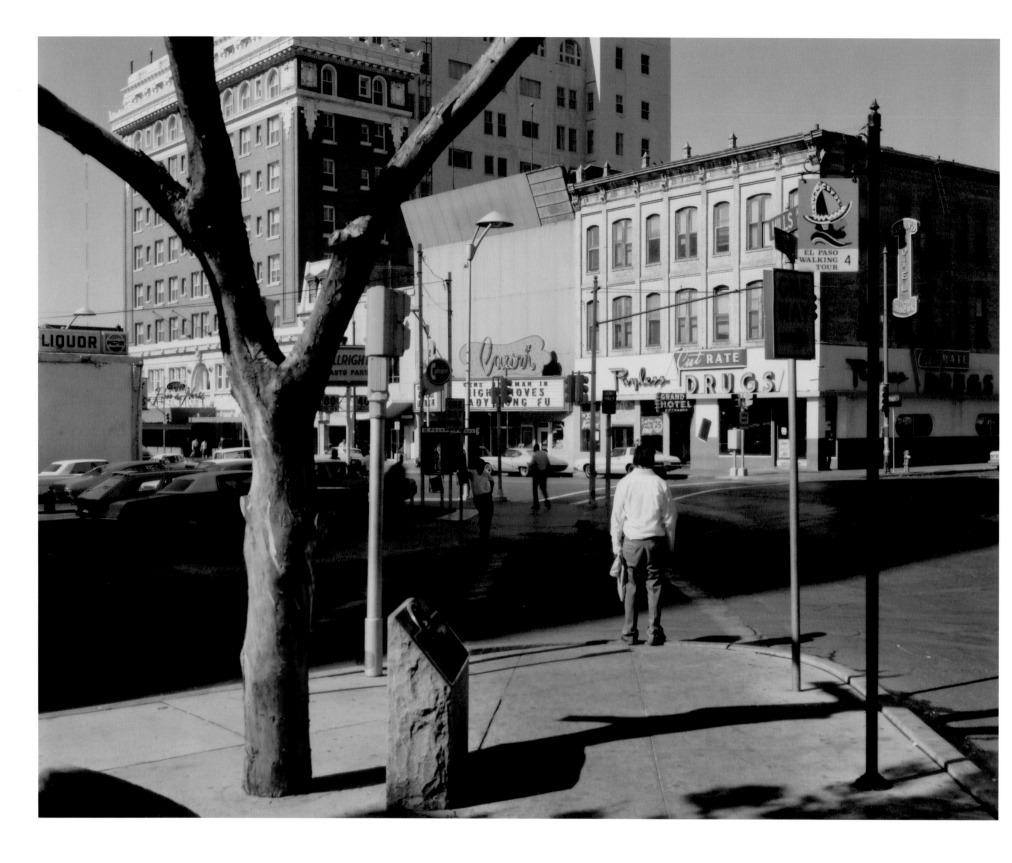

| PLATE 143 Stephen Shore, *El Paso St., El Paso, Texas,* July 5, 1975

The Northwest Corner of Florence and Normandie Avenues, Los Angeles, California, October 1993

On April 29, 1992, four white police officers on trial for the beating of motorist Rodney King were acquitted. A videotape of King's beating had been extensively televised. The not guilty verdicts became a catalyst for widespread civil unrest.

Riots began with several mob assaults at this intersection. Reginald Denny, a white truck driver, was pulled from his truck and severely beaten as a camera crew broadcast the event live from a news helicopter.

The Los Angeles Riots caused more than fifty deaths and an estimated one billion dollars worth of damage.

The Happy Land Social Club, 1959 Southern Boulevard, The Bronx, New York, June 1993

The Happy Land Social Club was a popular, unlicensed Honduran social club. On March 25, 1990, Julio Gonzalez was thrown out of the club for quarreling with Lydia Feliciano, his former girlfriend and a Happy Land employee. He bought a dollar's worth of gasoline, poured a trail of gas from the street through the club's single doorway, ignited it, and left. The fire killed eighty-seven people. Lydia Feliciano was one of five survivors.

Aisle 2, Row 3, Seat 5, Texas Theatre, 231 West Jefferson Boulevard, Dallas, Texas, November 1993

Lee Harvey Oswald was sitting in this seat when he was arrested by Dallas police at 1:50 P.M., November 22, 1963. The double feature playing that day was *Cry of Battle* and *War Is Hell*.

PLATE 146 Joel Sternfeld, *Aisle 2, Row 3, Seat 5, Texas Theatre, 231 West Jefferson Boulevard, Dallas, Texas, November 1993* 183

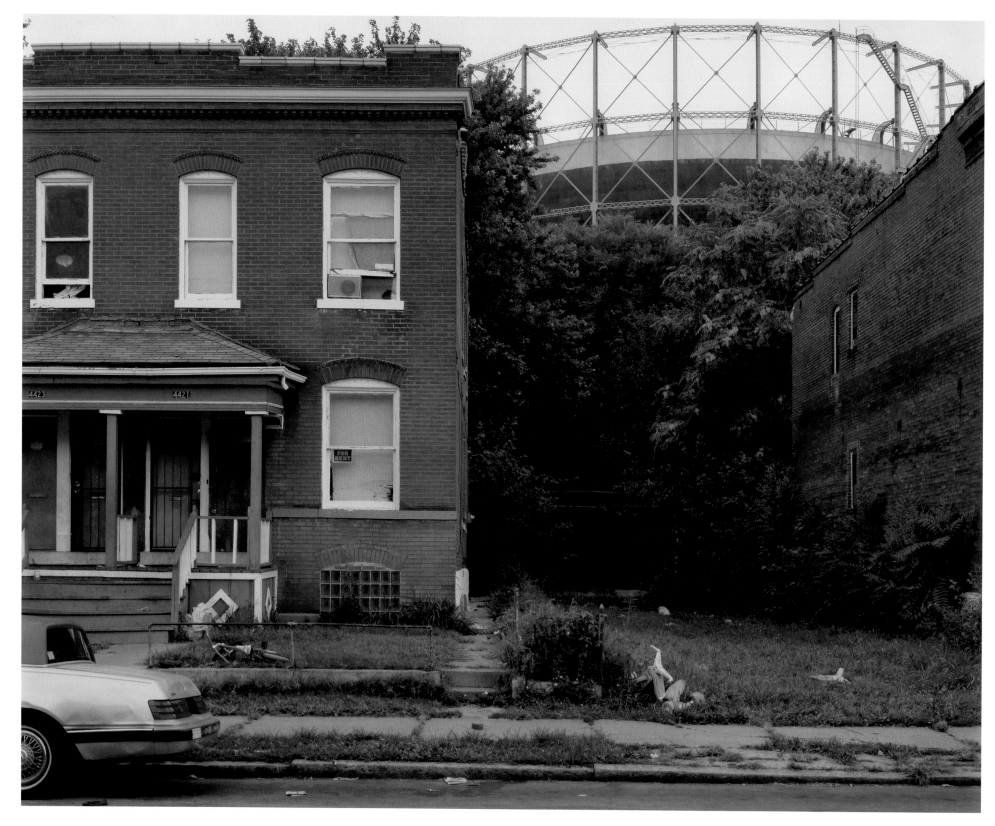

4421 Gibson Avenue, St. Louis, Missouri, August 1993

On the night of June 7, 1991, nine-year-old Christopher Harris was playing with friends on these steps. Felton Granger, a crack dealer trying to protect himself from a rival dealer, Marvel Jones, grabbed Harris and used him as a human shield. In the gunfire that ensued, Harris was shot in the back. Friends carried him to a relative's home nearby; he died in the emergency room of a local hospital within an hour. Granger and Jones are serving life sentences for Harris's death.

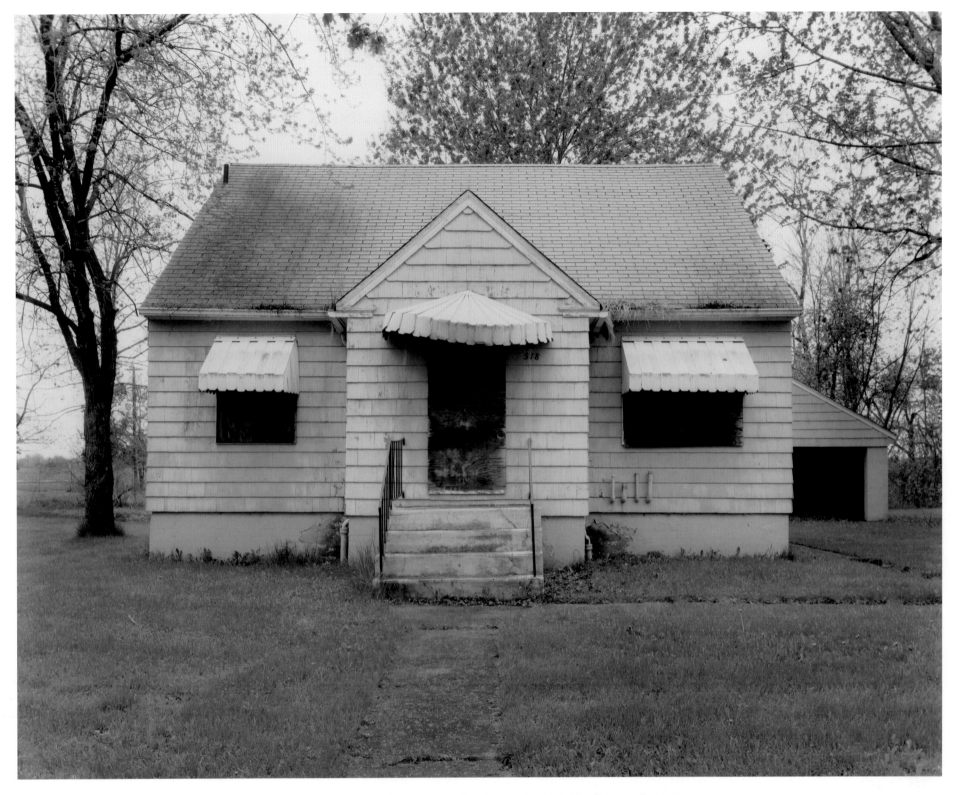

518 101st Street, Love Canal Neighborhood, Niagara Falls, New York, May 1994

From the 1920s through the 1950s, the city of Niagara Falls, the United States Army, and the Hooker Chemical Corporation dumped over two hundred different toxic chemicals into Love Canal. Many of them contained dioxin, one of the most lethal chemicals known. In 1953, Hooker Chemical covered the then-dry Love Canal with a thin layer of dirt, and sold it to the Niagara Falls Board of Education for one dollar. The terms of the sale stipulated that if anyone incurred physical harm or death because of the buried waste, Hooker could not be held liable. A school was constructed on the site of the waste dump and private homes were built nearby.

In the late 1970s, an unusually high number of birth defects, miscarriages, cancers, and other illnesses were reported in the Love Canal neighborhood by the Niagara Falls *Gazette*. Lois Gibbs, whose two children developed rare blood disorders, led a successful grassroots campaign to have the state of New York purchase the homes of five hundred families, enabling them to relocate.

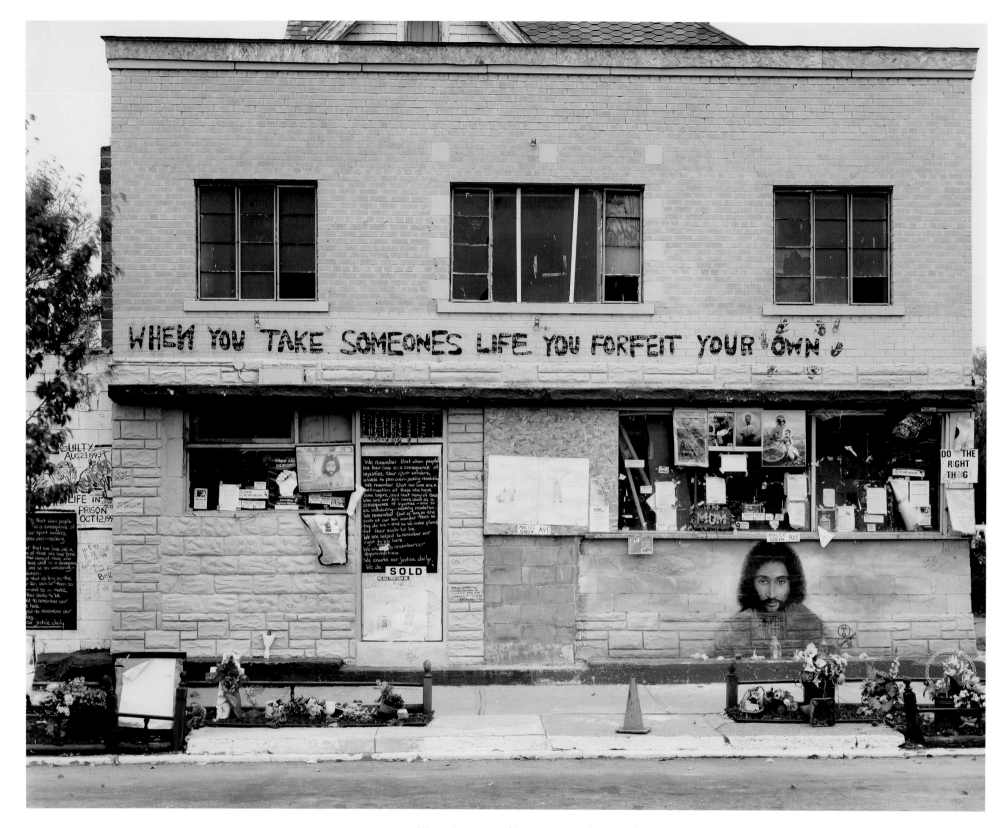

Warren Avenue at 23rd Street, Detroit, Michigan, October 1993

Malice Green dropped off a friend in front of this suspected crack house right before he was stopped by two police officers. After Green was asked to produce his driver's license and registration, a struggle ensued and the officers beat him to death with three-pound flashlights. The beating continued even after Green had been handcuffed and an ambulance had been flagged down.

Larry Nevers was found guilty of second-degree murder and sentenced to twelve to twenty-five years in prison. Walter Budzyn, convicted of the same crime, was given eight to eighteen years.

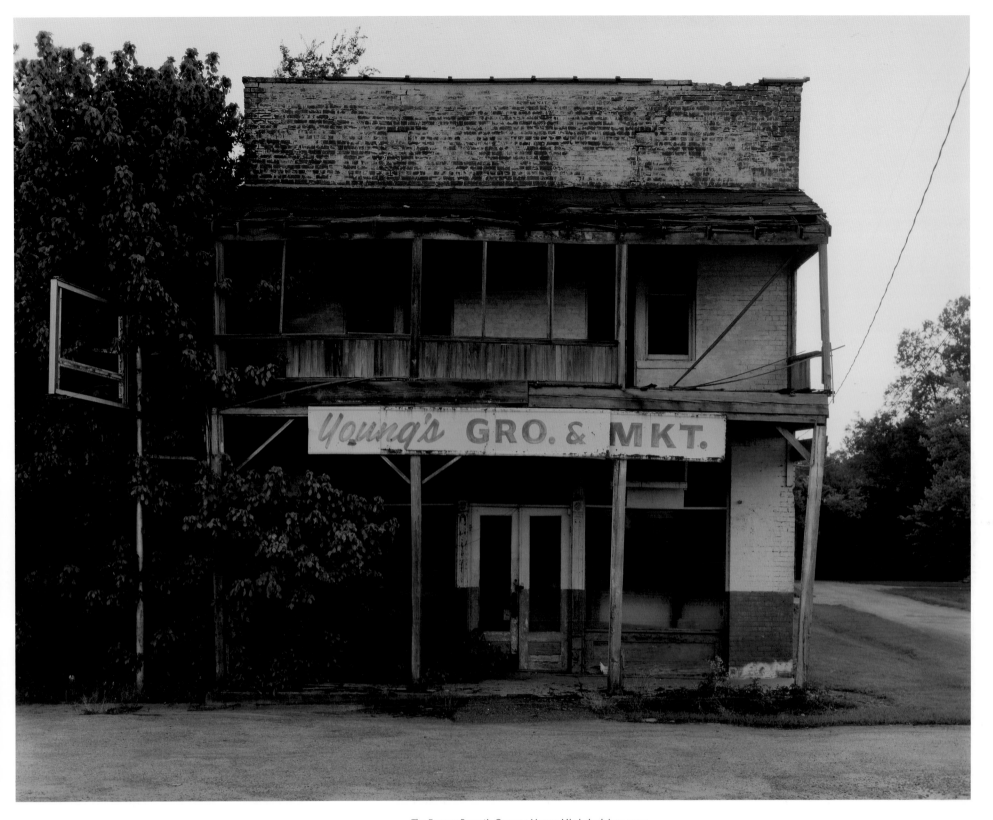

The Former Bryant's Grocery, Money, Mississippi, June 1994

In 1955, Emmet Till, a fourteen-year-old boy from Chicago, was visiting relatives near Money, Mississippi. Anxious to show new friends that he knew how to talk to white women, Till said, "Bye, baby," to Carolyn Bryant as he left this store.

Three days later, Bryant's husband, Roy, and his half-brother, J.W. Milam, kidnapped, tortured, and killed Till. Milam and Bryant were found not guilty by an all-male, all-white jury. The deliberations lasted a little over an hour.

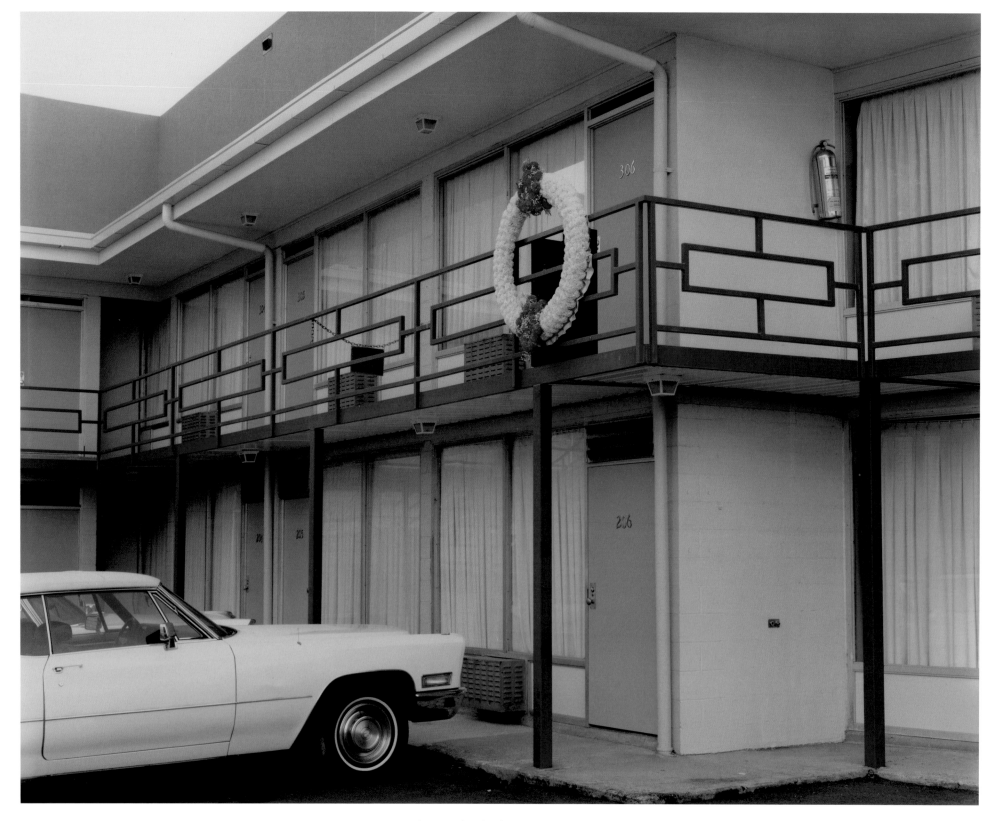

The National Civil Rights Museum, Formerly the Lorraine Motel, 450 Mulberry Street, Memphis, Tennessee, August 1993

Speaking at a rally on April 3, 1968, Dr. Martin Luther King, Jr., said:

Longevity has its place. But I'm not concerned about that now. I just want to do God's will. And He's allowed me to go up to the mountain. And I've looked over and I've seen the Promised Land. I may not get there with you. But I want you to know tonight that we, as a people, will get to the Promised Land. And I'm happy tonight. I'm not worried about anything. I'm not fearing any man. My eyes have seen the glory of the coming of the Lord.

The next day, he was assassinated on this balcony outside room 306.

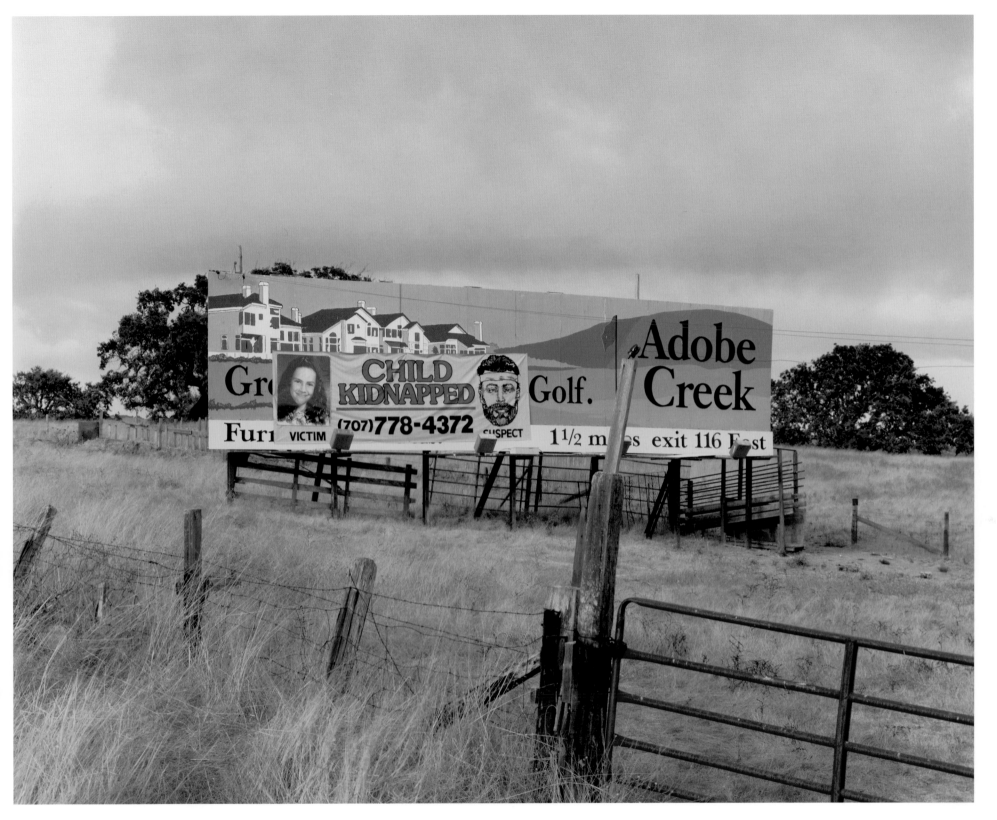

Highway 101, Petaluma, California, October 1993

Polly Klaas was abducted from her home in Petaluma during a slumber party on October 1, 1993. Within hours, a massive volunteer effort was organized to find the twelve-year-old girl. Millions of flyers bearing Polly's photograph and a police composite sketch of her abductor were distributed nationally. Large banners were affixed to billboards across Northern California.

Two months later, Richard Allen Davis, an ex-convict with a history of drug and alcohol abuse, led police to a wooded area fifty miles north of Petaluma where he had buried Polly Klaas's body.

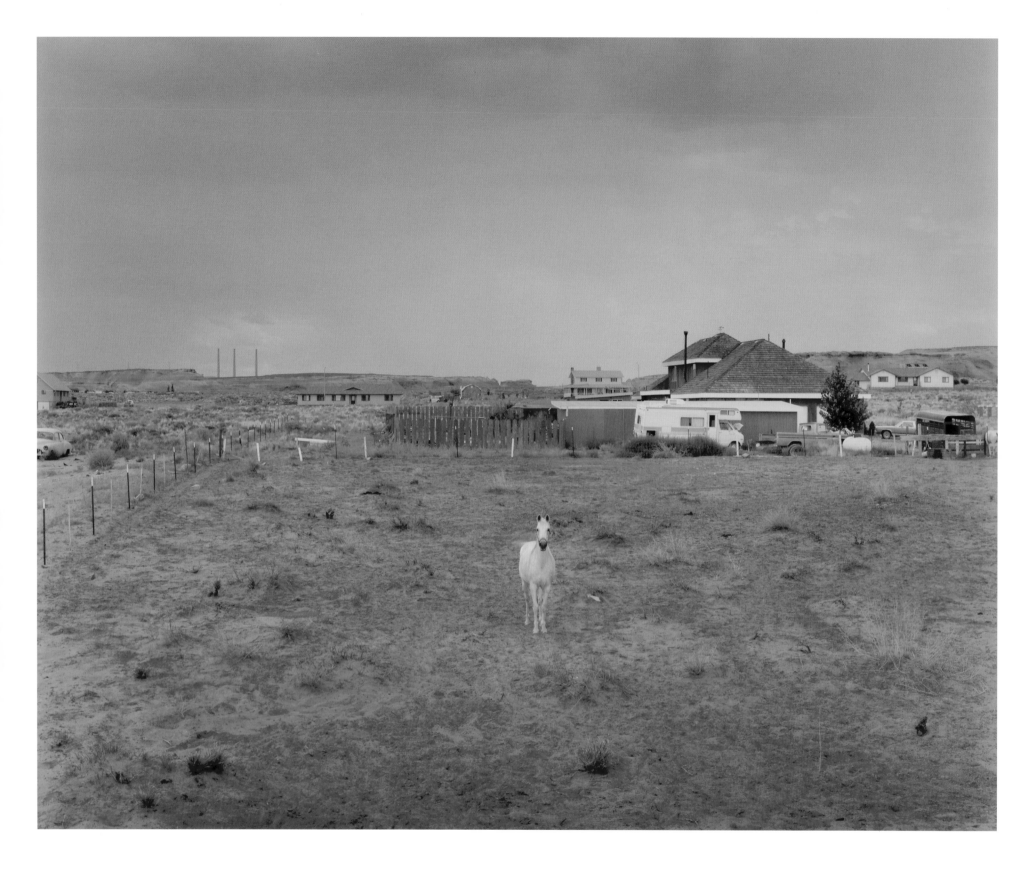

| PLATE 153 **Joel Sternfeld,** *Page, Arizona, August 1982 (Lone Horse)*

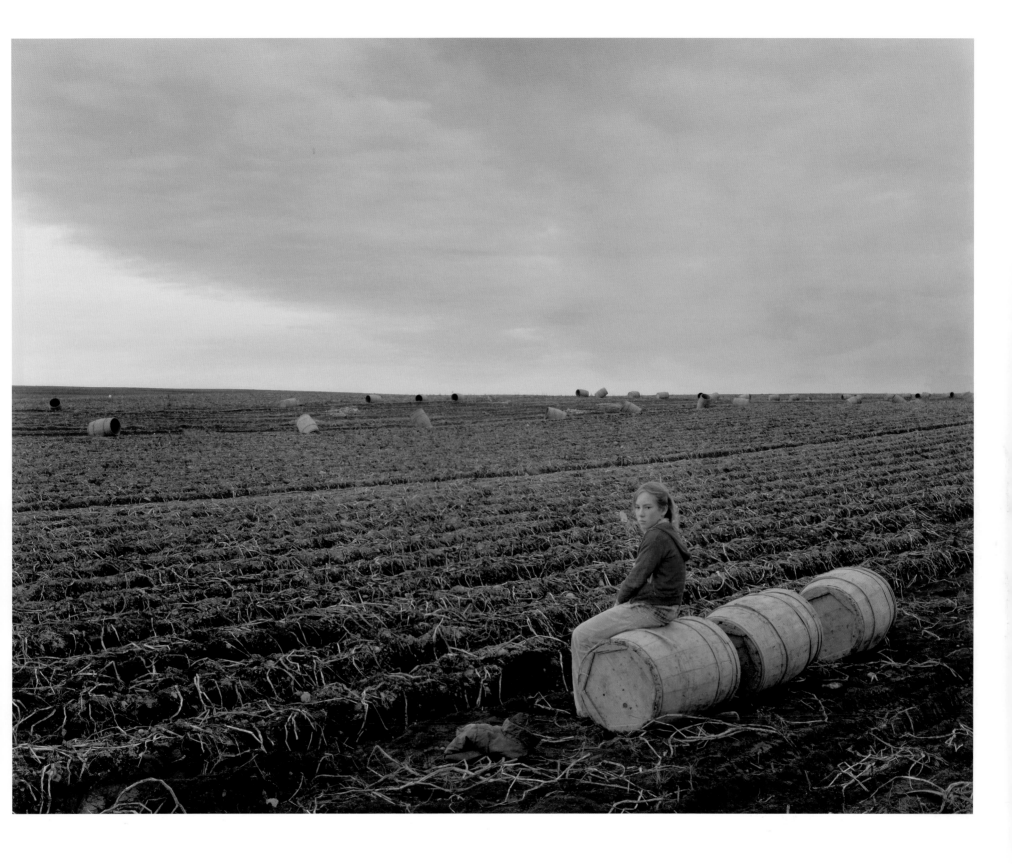

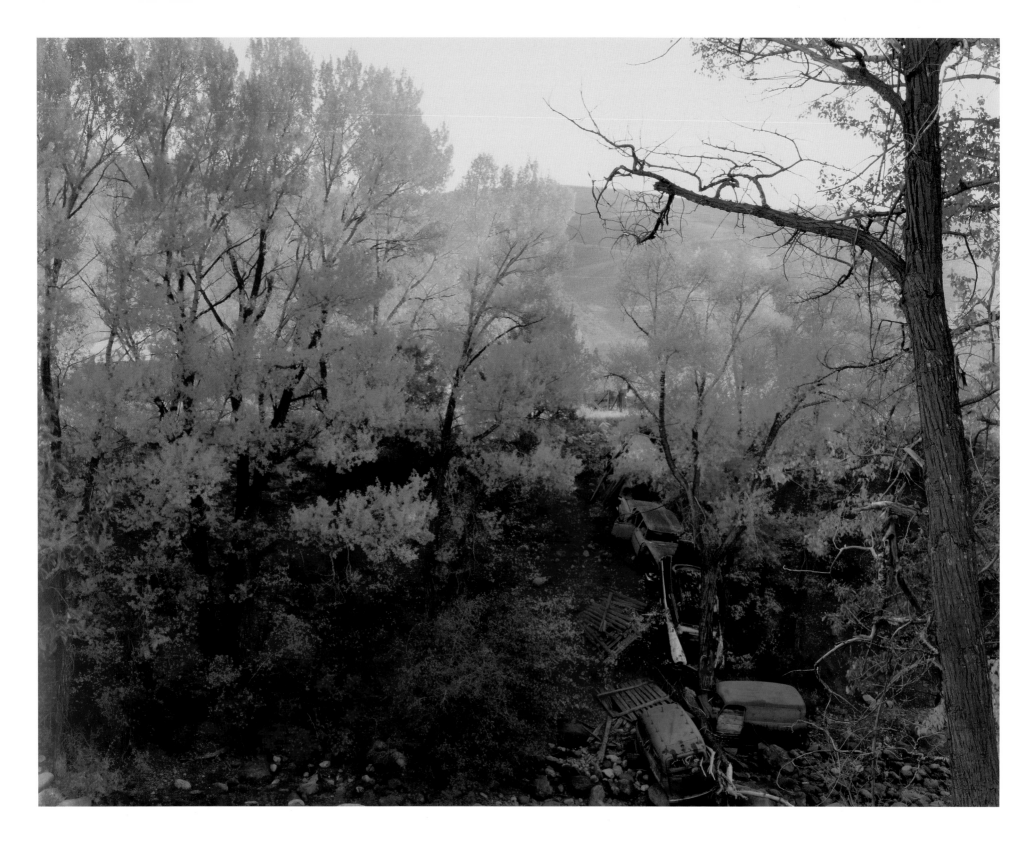

| PLATE 155 Joel Sternfeld, *Eagle Vail, Colorado, October 1980*

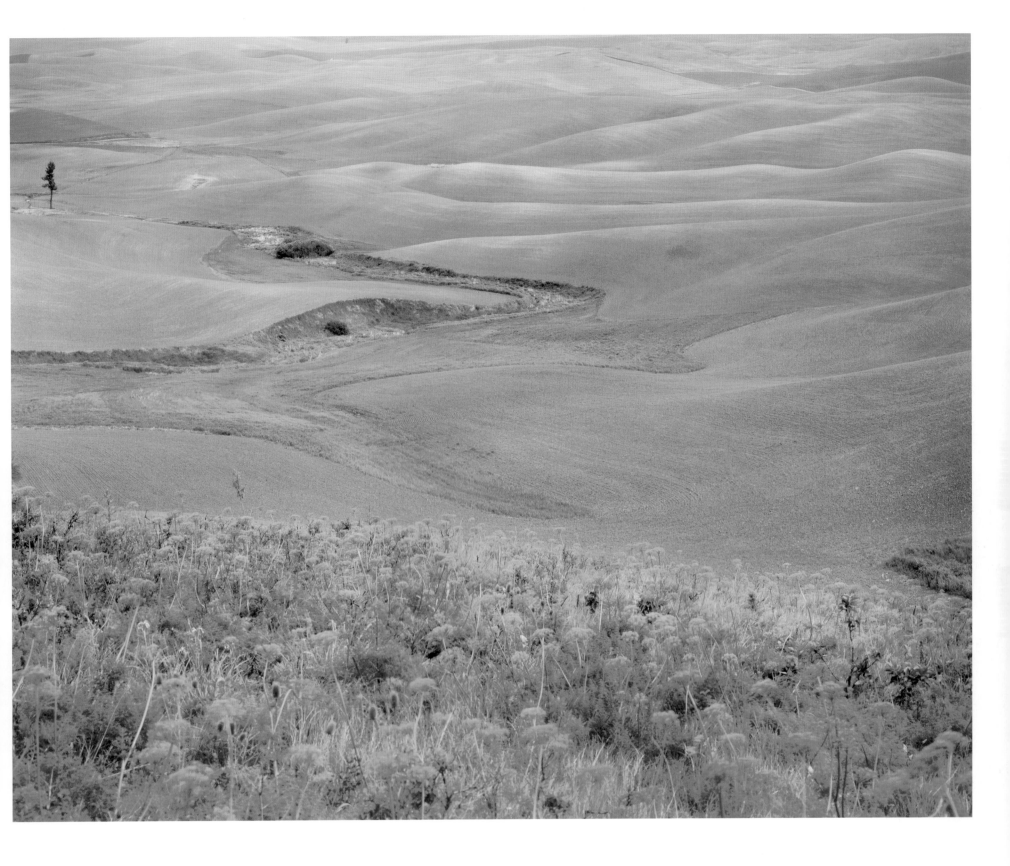

PLATE 157 **Virginia Beahan and Laura McPhee,** *Foundation of a Burned House, Santa Monica Mountains, California,* 1995

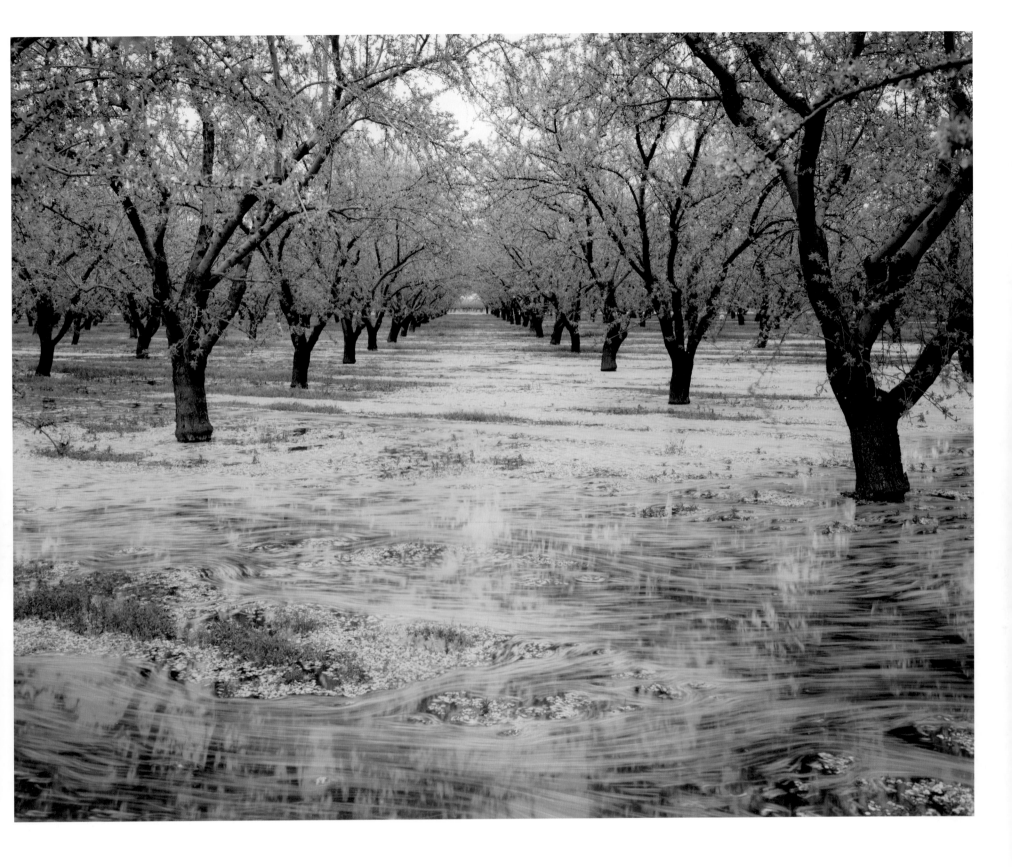

PLATE 158 Virginia Beahan and Laura McPhee, *Almond Trees and Flood Irrigation, Oakdale, California*, 1999

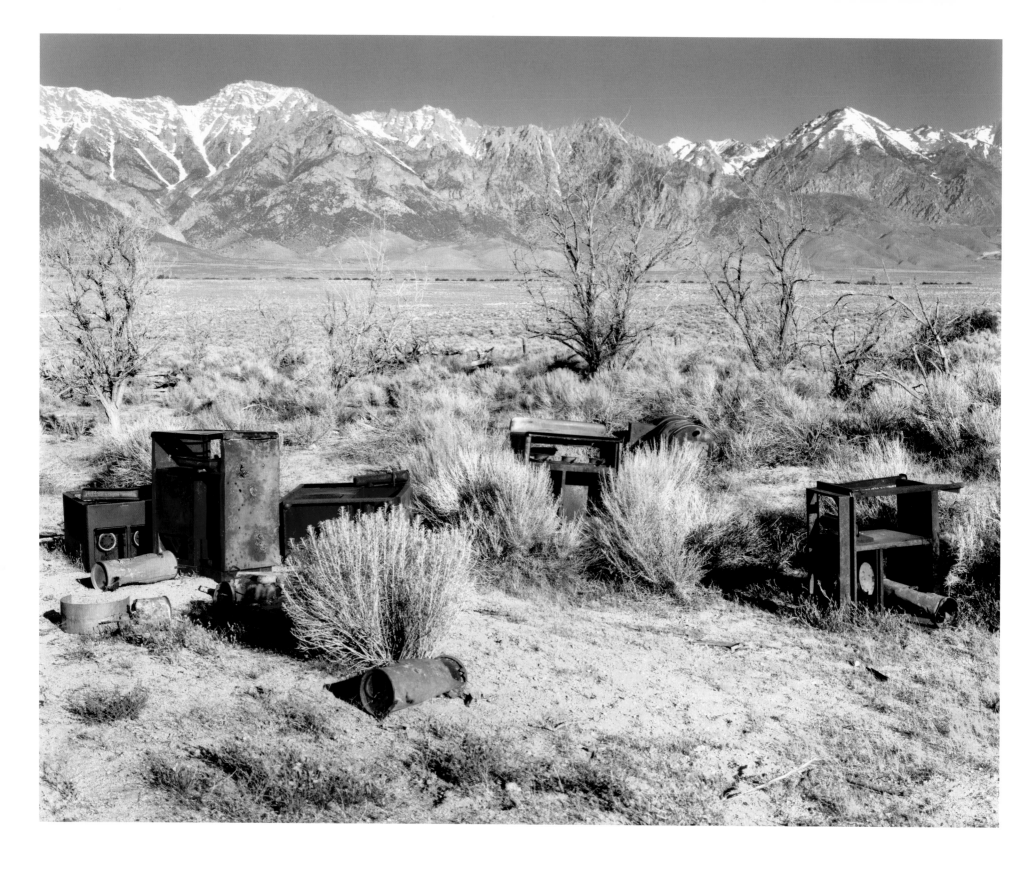

| PLATE 159 Virginia Beahan and Laura McPhee, *Apple Orchard, Manzanar Japanese-American Relocation Camp, Owens Valley, California*, 1995

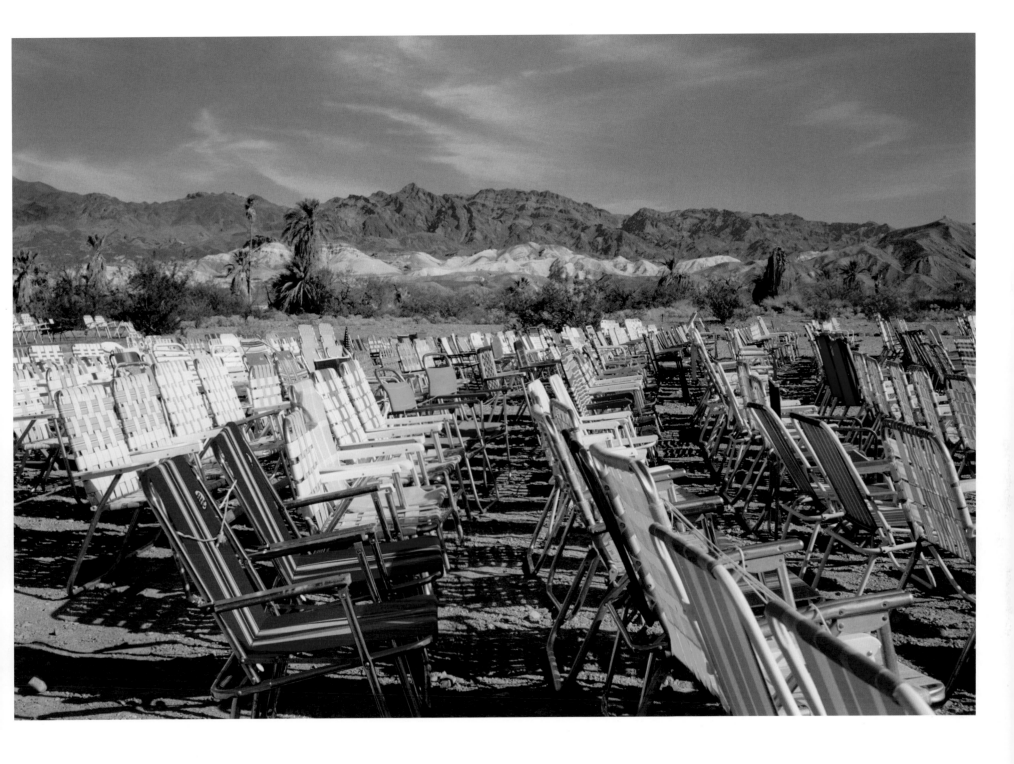

PLATE 161 Karen Halverson, *Mulholland at Multiview Drive, Los Angeles, California*, 1991

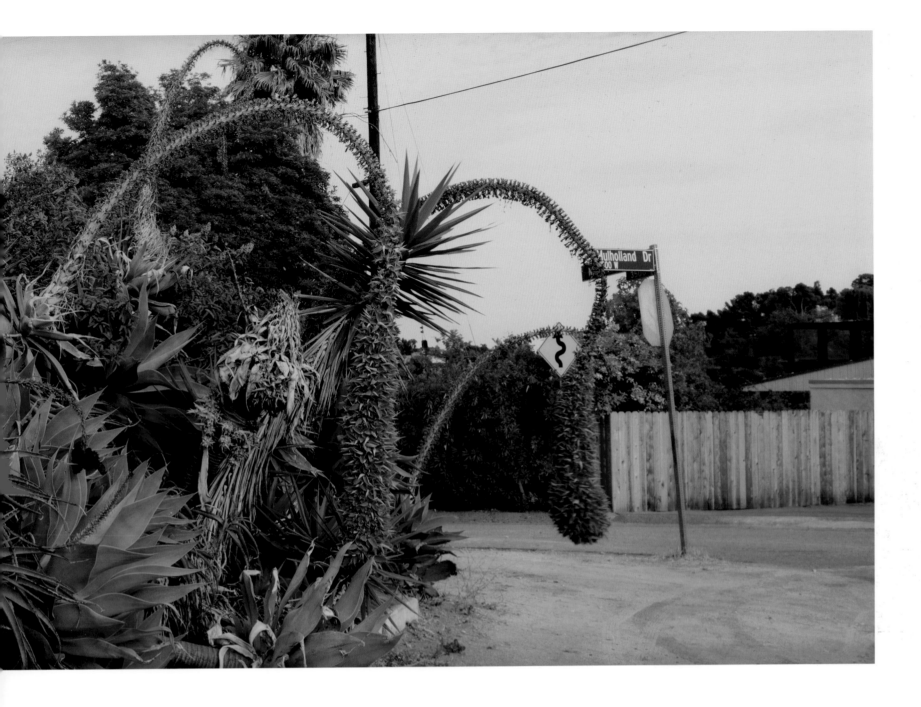

PLATE 162 Karen Halverson, *Mulholland at Beverly Glen, Los Angeles, California*, 1993

| PLATE 163 Karen Halverson, *Mulholland above Universal City, Los Angeles, California*, 1991

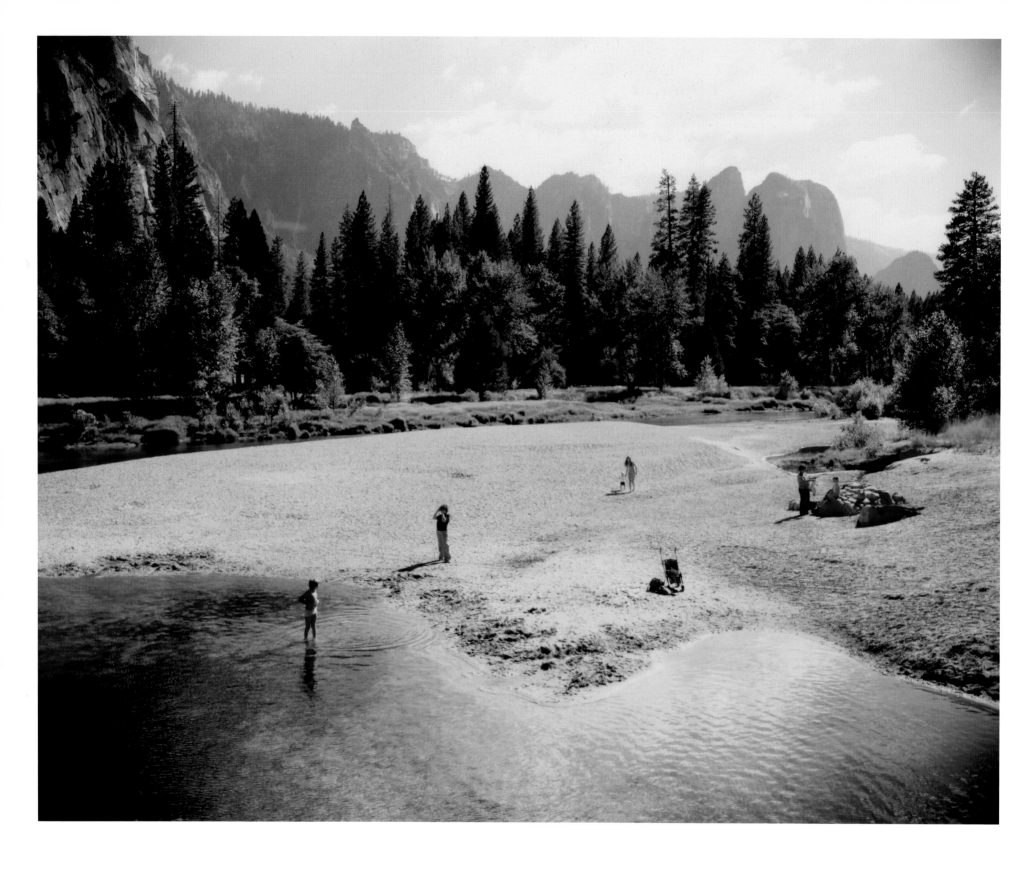

| PLATE 164 Stephen Shore, *Merced River, Yosemite National Park, California*, August 13, 1979

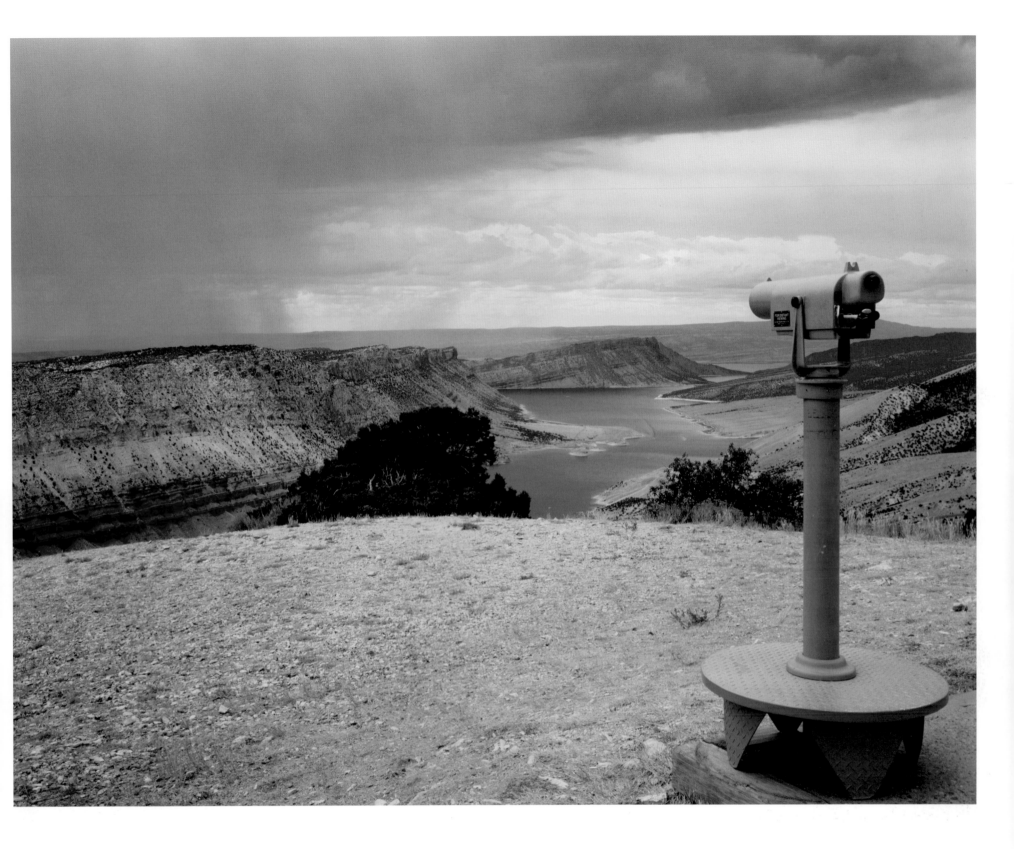

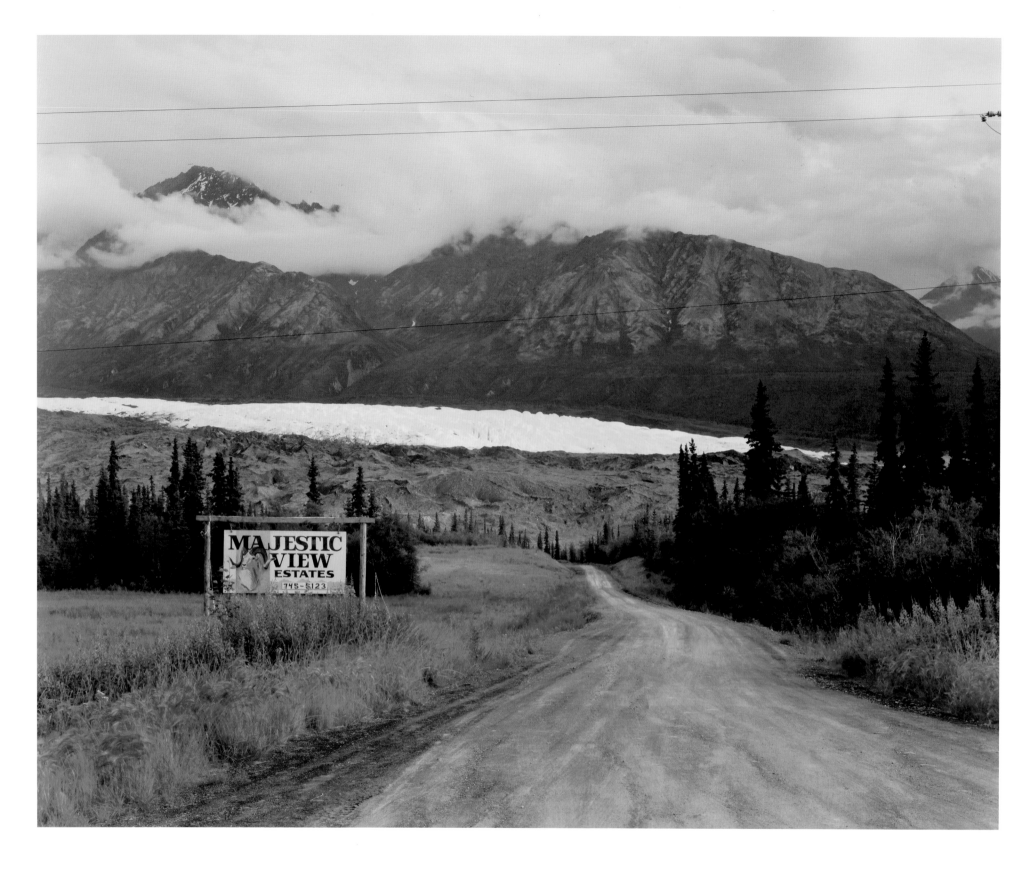

PLATE 166 Joel Sternfeld, *Matanuska Glacier, Matanuska Valley, Alaska, July 1984*

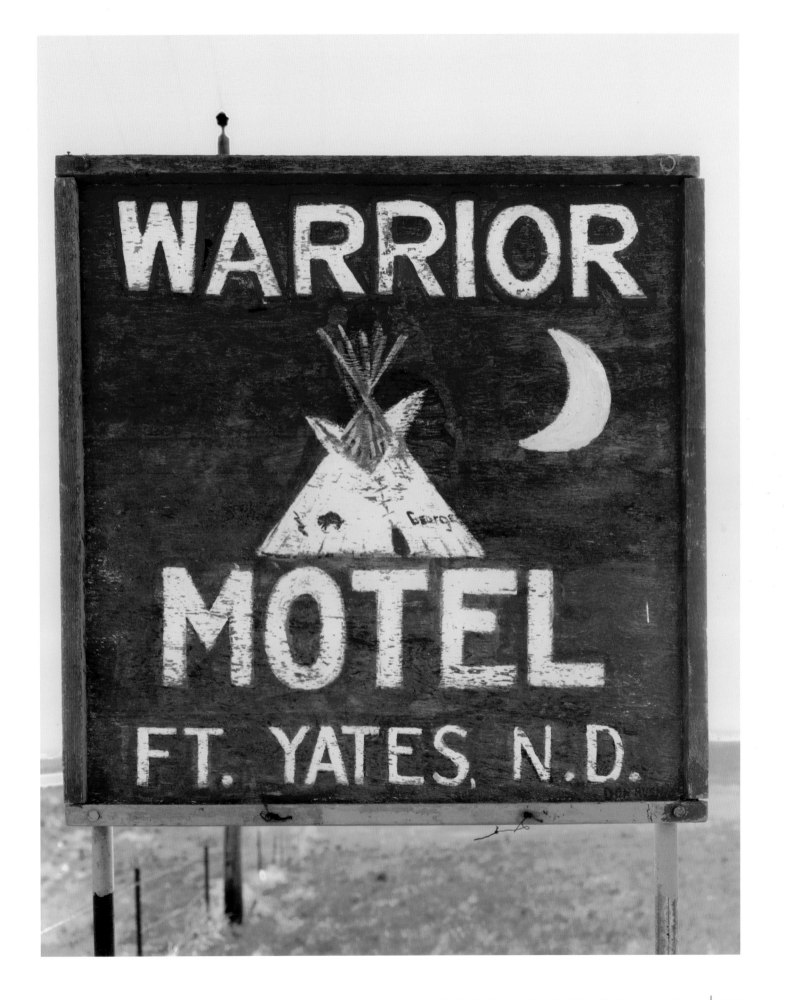

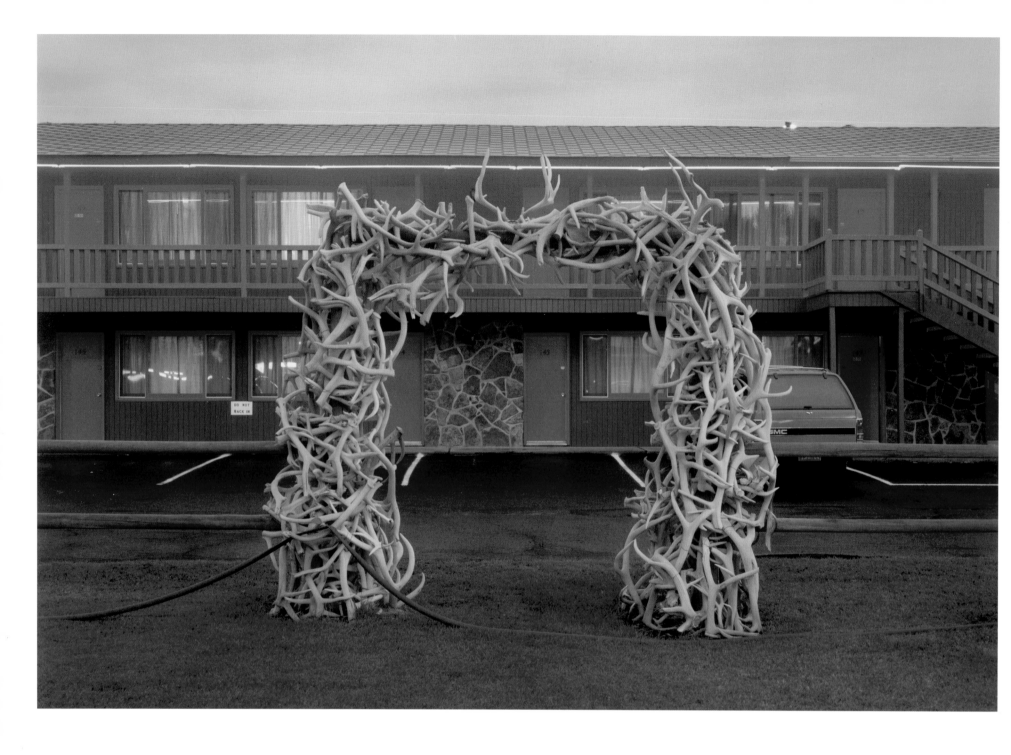

CHECKLIST

Compiled by Anne Lacoste

Complete captions for the photographs in the plate section are arranged here by the artist's last name, then by plate number.

Dimensions supplied are of the image, height × width.

Titles appear as provided by the photographers.

Unless otherwise indicated, all photographs are in the collection of the J. Paul Getty Museum.

ROBERT ADAMS

El Paso County Fairgrounds, Calhan, Colorado
Negative, 1968; print, 1995
Gelatin silver print
30.3 × 46 cm (11¹⁵⁄₁₆ × 18⅛ in.)
Gift of Nancy and Bruce Berman
98.XM.198.2
PLATE 61

Pawnee Grassland, Colorado
Negative, 1984; print, 1988
Gelatin silver print, edition 1/30
37.9 × 47.1 cm (14¹⁵⁄₁₆ × 18⁹⁄₁₆ in.)
Gift of Nancy and Bruce Berman
98.XM.198.1
PLATE 62

ADAM BARTOS

Hither Hills State Park, Montauk, N.Y.
1991–94
Chromogenic dye coupler print
49.1 × 72.2 cm (19⁵⁄₁₆ × 28⁷⁄₁₆ in.)
Gift of Nancy and Bruce Berman
98.XM.199.6
PLATE 28

Hither Hills State Park, Montauk, N.Y.
1991–94
Chromogenic dye coupler print
48.9 × 72.1 cm (19¼ × 28⅜ in.)
Gift of Nancy and Bruce Berman
98.XM.199.7
PLATE 29

Hither Hills State Park, Montauk, N.Y.
1991–94
Chromogenic dye coupler print
49.1 × 72.4 cm (19⁵⁄₁₆ × 28½ in.)
Gift of Nancy and Bruce Berman
98.XM.199.5
PLATE 30

Hither Hills State Park, Montauk, N.Y.
1993
Chromogenic dye coupler print
70.8 × 47.9 cm (27⅞ × 18⅞ in.)
Gift of Nancy and Bruce Berman
99.XM.61
PLATE 31

Hither Hills State Park, Montauk, N.Y.
1991–94
Chromogenic dye coupler print
49.1 × 72.2 cm (19⁵⁄₁₆ × 28⁷⁄₁₆ in.)
Gift of Nancy and Bruce Berman
98.XM.199.4
PLATE 32

Hither Hills State Park, Montauk, N.Y.
1990–94
Chromogenic dye coupler print
48.9 × 72.2 cm (19¼ × 28⁷⁄₁₆ in.)
Gift of Nancy and Bruce Berman
98.XM.199.8
PLATE 33

Hither Hills State Park, Montauk, N.Y.
1991–94
Chromogenic dye coupler print
71.8 × 48.7 cm (28¼ × 19³⁄₁₆ in.)
Gift of Nancy and Bruce Berman
98.XM.199.3
PLATE 34

VIRGINIA BEAHAN
AND LAURA MCPHEE

Kasahara's Garden, Kauai
1991
Chromogenic dye coupler print
47 × 66.7 cm (18½ × 26¼ in.)
Gift of Nancy and Bruce Berman
98.XM.200.5
PLATE 63

Streambed, the Palouse, Washington
2000
Chromogenic dye coupler print, edition 1/20
75.2 × 95.3 cm (29⅝ × 37½ in.)
Gift of Nancy and Bruce Berman
2002.63.3
PLATE 156

Foundation of a Burned House, Santa Monica Mountains, California
1995
Chromogenic dye coupler print, edition 1/20
76.3 × 95.3 cm (30¹⁄₁₆ × 37½ in.)
Gift of Nancy and Bruce Berman
2002.63.2
PLATE 157

Almond Trees and Flood Irrigation, Oakdale, California
1999
Chromogenic dye coupler print, edition 1/20
75.9 × 95.9 cm (29⅞ × 37¾ in.)
Gift of Nancy and Bruce Berman
2002.63.1
PLATE 158

Apple Orchard, Manzanar Japanese-American Relocation Camp, Owens Valley, California
1995
Chromogenic dye coupler print, edition 1/20
75.3 × 95.3 cm (29⅝ × 37½ in.)
Gift of Nancy and Bruce Berman
2003.517.5
PLATE 159

WILLIAM CHRISTENBERRY

Red Building in Forest, Hale County, Alabama
1984–85
Balsa and basswood, plywood, tempera, paper, and red soil
32.4 × 58.4 × 53.3 cm (12¾ × 23 × 21 in.)
Gift of Nancy and Bruce Berman
99.SE.66
PLATE 57

Red Building in Forest, Hale County, Alabama
Negative, 1983; print, 1994
Chromogenic dye coupler print
44.5 × 55.9 cm (17½ × 22 in.)
Lent by Nancy and Bruce Berman
PLATE 58

Red Building in Forest, Hale County, Alabama
1994
Chromogenic dye coupler print
44.5 × 55.9 cm (17½ × 22 in.)
Gift of Nancy and Bruce Berman
99.XM.65.2
PLATE 59

Red Building in Forest, Hale County, Alabama
Negative, 1991; print, 1994
Chromogenic dye coupler print
45.1 × 55.9 cm (17¾ × 22 in.)
Lent by Nancy and Bruce Berman
PLATE 60

Black Buildings (South View), Newbern, Alabama
Negative, 1981; print, 1993
Chromogenic dye coupler print
44.5 × 55.9 cm (17½ × 22 in.)
Gift of Nancy and Bruce Berman
99.XM.65.1
PLATE 83

ROBERT DAWSON

Back Lot, Isleton, California
From the *Great Central Valley Project*
1986
Chromogenic dye coupler print
45.7 × 55.9 cm (18 × 22 in.)
Gift of Nancy and Bruce Berman
99.XM.69
PLATE 80

JOHN DIVOLA

N34°09.974'W115°48.890'
From the *Isolated Houses* series
Negative, 1995–98; print, 1998
Lightjet print, edition 2/8
76.2 × 76.2 cm (30 × 30 in.)
Gift of Nancy and Bruce Berman
99.XM.88.19
PLATE 94

N34°09.967'W115°46.891'
From the *Isolated Houses* series
Negative, 1995–98; print, 1998
Lightjet print, edition 2/8
76.2 × 76.2 cm (30 × 30 in.)
Gift of Nancy and Bruce Berman
99.XM.88.8
PLATE 95

N34°14.383'W116°14.758'
From the *Isolated Houses* series
Negative, 1995–98; print, 1998
Lightjet print, edition 2/8
76.2 × 76.2 cm (30 × 30 in.)
Gift of Nancy and Bruce Berman
99.XM.88.17
PLATE 96

N34°09.900'W115°48.824'
From the *Isolated Houses* series
Negative, 1995–98; print, 1998
Lightjet print, edition 2/8
76.2 × 76.2 cm (30 × 30 in.)
Gift of Nancy and Bruce Berman
99.XM.88.5
PLATE 97

N34°13.275'W116°10.883'
From the *Isolated Houses* series
Negative, 1995–98; print, 1998
Lightjet print, edition 2/8
76.2 × 76.2 cm (30 × 30 in.)
Gift of Nancy and Bruce Berman
99.XM.88.16
PLATE 98

N34°09.951'W115°49.269'
From the *Isolated Houses* series
Negative, 1995–98; print, 1998
Lightjet print, edition 2/8
76.2 × 76.2 cm (30 × 30 in.)
Gift of Nancy and Bruce Berman
99.XM.88.7
PLATE 99

N34°11.670'W115°55.347' #2
From the *Isolated Houses* series
Negative, 1995–98; print, 1998
Lightjet print, edition 2/8
76.2 × 76.2 cm (30 × 30 in.)
Gift of Nancy and Bruce Berman
99.XM.88.13
PLATE 100

N34°11.115'W116°08.399'
From the *Isolated Houses* series
Negative, 1995–98; print, 1998
Lightjet print, edition 2/8
76.2 × 76.2 cm (30 × 30 in.)
Gift of Nancy and Bruce Berman
99.XM.88.12
PLATE 101

N34°12.325'W116°01.374' #1
From the *Isolated Houses* series
Negative, 1995–98; print, 1998
Lightjet print, edition 2/8
76.2 × 76.2 cm (30 × 30 in.)
Gift of Nancy and Bruce Berman
99.XM.88.24
PLATE 102

N34°07.892'W115°54.426'
From the *Isolated Houses* series
Negative, 1995–98; print, 1998
Lightjet print, edition 2/8
76.2 × 76.2 cm (30 × 30 in.)
Gift of Nancy and Bruce Berman
99.XM.88.2
PLATE 103

N34°10.388'W115°54.800'
From the *Isolated Houses* series
Negative, 1995–98; print, 1998
Lightjet print, edition 2/8
76.2 × 76.2 cm (30 × 30 in.)
Gift of Nancy and Bruce Berman
99.XM.88.1
PLATE 104

N34°10.744'W116°07.973'
From the *Isolated Houses* series
Negative, 1995–98; print, 1998
Lightjet print, edition 2/8
75.6 × 75.6 cm (29¾ × 29¾ in.)
Gift of Nancy and Bruce Berman
99.XM.88.11
PLATE 105

N34°11.625'W115°50.782'
From the *Isolated Houses* series
Negative, 1995–98; print, 1998
Lightjet print, edition 2/8
76.2 × 76.2 cm (30 × 30 in.)
Gift of Nancy and Bruce Berman
99.XM.88.23
PLATE 106

N34°13.930'W116°17.310'
From the *Isolated Houses* series
Negative, 1995–98; print, 1998
Lightjet print, edition 2/8
76.2 × 76.2 cm (30 × 30 in.)
Gift of Nancy and Bruce Berman
99.XM.88.29
PLATE 107

JIM DOW

Window @ Mitchell's BBQ, US 301, Wilson,
North Carolina
Negative, 1998; print, July 2000
Chromogenic dye coupler print, edition 1/25
51.5 × 40.8 cm (20¼ × 16¹⁄₁₆ in.)
Gift of Nancy and Bruce Berman
2002.66.8
PLATE 124

Donut Store Window Detail, US 71B,
Springdale, Arkansas
Negative, 1995; print, January 1996
Chromogenic dye coupler print, edition 1/25
51.3 × 40.7 cm (20³⁄₁₆ × 16 in.)
Gift of Nancy and Bruce Berman
2002.66.3
PLATE 127

Tony's BBQ @ Towing Service, US 11E @ I-81,
Mohawk Crossroads, Tennessee
Negative, 1998; print, July 2000
Chromogenic dye coupler print, edition 1/25
51.5 × 40.8 cm (20¼ × 16¹⁄₁₆ in.)
Gift of Nancy and Bruce Berman
2002.66.6
PLATE 128

Benches @ Night, Wilber's BBQ, US 70,
Goldsboro, North Carolina
Negative, 1998; print, July 2000
Chromogenic dye coupler print, edition 1/25
51.5 × 40.8 cm (20¼ × 16¹⁄₁₆ in.)
Gift of Nancy and Bruce Berman
2002.66.2
PLATE 129

Sign for "Gas" Station, Harry Hine Blvd.,
US 77, Dallas, Texas
Negative, 1979; print, October 1996
Chromogenic dye coupler print, edition 1/25
40.6 × 51.1 cm (16 × 20⅛ in.)
Gift of Nancy and Bruce Berman
99.XM.70.6
PLATE 130

Cactus Barbershop, Big Spring, Texas
Negative, 1980; print, January 1994
Chromogenic dye coupler print, edition 1/25
40.5 × 51.1 cm (15¹⁵⁄₁₆ × 20⅛ in.)
Gift of Nancy and Bruce Berman
98.XM.207.5
PLATE 131

University Club Library Detail Display of Books,
New York, New York
Negative, 1998; print, March 1999
Chromogenic dye coupler print, edition 3/25
41 × 50.8 cm (16⅛ × 20 in.)
Lent by Nancy and Bruce Berman
PLATE 132

Tootsie's Orchid Lounge, Upstairs Bar,
Nashville, Tennessee
Negative, 1977; print, July 1995
Chromogenic dye coupler print, edition 3/15
40.6 × 51.3 cm (16 × 20³⁄₁₆ in.)
Gift of Nancy and Bruce Berman
98.XM.207.25
PLATE 133

Sign for the Warrior Motel, Fort Yates,
North Dakota
Negative, 1981; print, January 2000
Chromogenic dye coupler print, edition 2/25
51.4 × 40.7 cm (20¼ × 16 in.)
Gift of Nancy and Bruce Berman
2003.520.2
PLATE 167

DOUG DUBOIS

My Grandmother's Bedroom, Ohio
Negative, 1990; print, 2001
Chromogenic dye coupler print
38.4 × 57.2 cm (15⅛ × 22½ in.)
Lent by Nancy and Bruce Berman
PLATE 7

My Grandmother
Negative, 1990; print, 2001
Chromogenic dye coupler print
57.5 × 38.7 cm (22⅝ × 15¼ in.)
Lent by Nancy and Bruce Berman
PLATE 8

Sign outside Wash House, Shannopin Mine,
Bobtown, PA
Negative, 1991; print, 2001
Chromogenic dye coupler print
54 × 38.4 cm (21¼ × 15⅛ in.)
Lent by Nancy and Bruce Berman
PLATE 9

Laundromat, Avella, PA
Negative, 1991; print, 2001
Chromogenic dye coupler print
39.1 × 57.5 cm (15⅜ × 22⅝ in.)
Lent by Nancy and Bruce Berman
PLATE 10

*Matthew, Tracy, Donna, Devon and Velvet
on Main St., Avella, PA*
Negative, 1992; print, 2001
Chromogenic dye coupler print
38.7 × 57.2 cm (15¼ × 22½ in.)
Lent by Nancy and Bruce Berman
PLATE 11

*Denise Fixes Her Screen Door, Main St.,
Avella, PA*
Negative, 1991; print, 2001
Chromogenic dye coupler print
57.5 × 38.4 cm (22⅝ × 15⅛ in.)
Lent by Nancy and Bruce Berman
PLATE 12

Main Street Facing North, Avella, PA
Negative, 1991; print, 2001
Chromogenic dye coupler print
38.4 × 57.2 cm (15⅛ × 22½ in.)
Lent by Nancy and Bruce Berman
PLATE 13

Main Street Facing South, Avella, PA
Negative, 1991; print, 2001
Chromogenic dye coupler print
38.4 × 56.8 cm (15⅛ × 22⅜ in.)
Lent by Nancy and Bruce Berman
PLATE 14

Abandoned Company House, Avella, PA
Negative, 1991; print, 2001
Chromogenic dye coupler print
56.8 × 38.1 cm (22⅜ × 15 in.)
Lent by Nancy and Bruce Berman
PLATE 15

Stage Curtain, Slovan Club, Avella, PA
Negative, 1991; print, 2001
Chromogenic dye coupler print
38.4 × 57.2 cm (15⅛ × 22½ in.)
Lent by Nancy and Bruce Berman
PLATE 16

My Sister, Lise and Spencer, New Jersey
Negative, 1999; print, 2001
Chromogenic dye coupler print
38.7 × 57.5 cm (15¼ × 22⅝ in.)
Promised gift of Nancy and Bruce Berman
PLATE 53

WILLIAM EGGLESTON

Memphis, 1971–1974
From the *Los Alamos* portfolio
Negative, 1971–74; print, 2001
Dye transfer print, edition 2/7
30.5 × 45.1 cm (12 × 17¾ in.)
Lent by Nancy and Bruce Berman
PLATE 49

Untitled, 1965–1974
From the *Los Alamos* portfolio
Negative, 1965–74; print, 2002
Dye transfer print, edition 1/7
30.5 × 45.1 cm (12 × 17¾ in.)
Lent by Nancy and Bruce Berman
PLATE 50

Greenwood, 1971–1974
From the *Los Alamos* portfolio
Negative, 1971–74; print, 2002
Dye transfer print, edition 2/7
30.5 × 45.1 cm (12 × 17¾ in.)
Lent by Nancy and Bruce Berman
PLATE 54

Louisiana, 1971–1974
From the *Los Alamos* portfolio
Negative, 1971–74; print, 2002
Dye transfer print, edition 2/7
30.5 × 45.1 cm (12 × 17¾ in.)
Lent by Nancy and Bruce Berman
PLATE 134

Memphis, 1965–1968
From the *Los Alamos* portfolio
Negative, 1965–68; print, 2001
Dye transfer print, edition 2/7
30.5 × 45.1 cm (12 × 17¾ in.)
Lent by Nancy and Bruce Berman
PLATE 135

Mississippi, 1971–1974
From the *Los Alamos* portfolio
Negative, 1971–74; print, 2002
Dye transfer print, edition 2/7
30.5 × 45.1 cm (12 × 17¾ in.)
Lent by Nancy and Bruce Berman
PLATE 136

Louisiana, 1971–1974
From the *Los Alamos* portfolio
Negative, 1971–74; print, 2002
Dye transfer print, edition 2/7
30.5 × 45.4 cm (12 × 17⅞ in.)
Lent by Nancy and Bruce Berman
PLATE 137

Memphis, 1971–1974
From the *Los Alamos* portfolio
Negative, 1971–74; print, 2002
Dye transfer print, edition 2/7
30.5 × 45.4 cm (12 × 17⅞ in.)
Lent by Nancy and Bruce Berman
PLATE 138

Memphis, 1965–1968
From the *Los Alamos* portfolio
Negative, 1965–68; print, 2002
Dye transfer print, edition 2/7
30.5 × 45.4 cm (12 × 17⅞ in.)
Lent by Nancy and Bruce Berman
PLATE 139

MITCH EPSTEIN

Newton Street Row Houses, 2000
From the *Family Business* series
2000
Chromogenic dye coupler print, edition 1/10
55.9 × 70.8 cm (22 × 27⅞ in.) sight
Lent by Nancy and Bruce Berman
PLATE 17

Pleasant Street, 2000
From the *Family Business* series
2000
Chromogenic dye coupler print, edition 1/10
55.9 × 70.8 cm (22 × 27⅞ in.) sight
Lent by Nancy and Bruce Berman
PLATE 18

*Parson's Paper Company Employee:
Clifford M. Collins, 2000*
From the *Family Business* series
2000
Chromogenic dye coupler print, edition 1/10
69.9 × 55.9 cm (27½ × 22 in.) sight
Lent by Nancy and Bruce Berman
PLATE 19

Flag, 2000
From the *Family Business* series
2000
Chromogenic dye coupler print, edition 1/10
69.9 × 55.9 cm (27½ × 22 in.) sight
Lent by Nancy and Bruce Berman
PLATE 20

Dad's Briefcase, 2000
From the *Family Business* series
2000
Chromogenic dye coupler print, edition 1/10
55.9 × 70.8 cm (22 × 27⅞ in.) sight
Lent by Nancy and Bruce Berman
PLATE 21

*Key Board for Epstein & Weiss Real Estate
at Epstein Furniture, 2000*
From the *Family Business* series
2000
Chromogenic dye coupler print, edition 1/10
55.9 × 70.8 cm (22 × 27⅞ in.) sight
Lent by Nancy and Bruce Berman
PLATE 22

Liquidation Sale I, 2000
From the *Family Business* series
2000
Chromogenic dye coupler print, edition 1/10
55.9 × 70.8 cm (22 × 27⅞ in.) sight
Lent by Nancy and Bruce Berman
PLATE 23

Office Door, 2000
From the *Family Business* series
2000
Chromogenic dye coupler print, edition 1/10
55.9 × 70.8 cm (22 × 27⅞ in.) sight
Lent by Nancy and Bruce Berman
PLATE 24

Mountain Park Number Board, 2000
From the *Family Business* series
2000
Chromogenic dye coupler print, edition 1/10
55.9 × 71.1 cm (22 × 28 in.) sight
Lent by Nancy and Bruce Berman
PLATE 25

*Miniature Golf, Mountain Park Amusement
Park, 2000*
From the *Family Business* series
2000
Chromogenic dye coupler print, edition 1/10
55.9 × 70.8 cm (22 × 27⅞ in.) sight
Lent by Nancy and Bruce Berman
PLATE 26

Ybor City, Florida, 1983
Negative, 1983; print, 1995
Chromogenic dye coupler print, edition 1/10
69.9 × 105.4 cm (27½ × 41½ in.)
Gift of Nancy and Bruce Berman
98.XM.208.3
PLATE 27

Untitled, New York, 1996
1996
Chromogenic dye coupler print, edition 3/15
56.5 × 69.9 cm (22¼ × 27½ in.)
Gift of Nancy and Bruce Berman
98.XM.208.7
PLATE 123

Untitled, New York, 1996
1996
Chromogenic dye coupler print, edition 3/15
56.5 × 69.9 cm (22¼ × 27½ in.)
Gift of Nancy and Bruce Berman
98.XM.208.4
PLATE 125

RHEA GAREN

Tree/House Freese Rd., Varna, NY
1993
Chromogenic dye coupler print
38.1 × 47 cm (15 × 18½ in.)
Gift of Nancy and Bruce Berman
98.XM.211.3
PLATE 68

Cascadilla St. Cat, Ithaca, NY
1992
Chromogenic dye coupler print
38.1 × 47 cm (15 × 18½ in.)
Gift of Nancy and Bruce Berman
98.XM.211.1
PLATE 69

KAREN HALVERSON

Furnace Creek, Death Valley, California
1992
Chromogenic dye coupler print, edition 6/50
40 × 58.4 cm (15¾ × 23 in.)
Gift of Nancy and Bruce Berman
99.XM.73.4
PLATE 160

Mulholland at Multiview Drive, Los Angeles, California
1991
Chromogenic dye coupler print, edition 6/10
41.9 × 127 cm (16½ × 50 in.)
Gift of Nancy and Bruce Berman
99.XM.73.6
PLATE 161

Mulholland at Beverly Glen, Los Angeles, California
1993
Chromogenic dye coupler print, edition 1/10
41.9 × 127 cm (16½ × 50 in.)
Gift of Nancy and Bruce Berman
99.XM.73.7
PLATE 162

Mulholland above Universal City, Los Angeles, California
1991
Chromogenic dye coupler print, edition 1/10
41.9 × 127 cm (16½ × 50 in.)
Lent by Nancy and Bruce Berman
PLATE 163

Flaming Gorge Reservoir, Utah/Wyoming
1994
Chromogenic dye coupler print
71.1 × 91.4 cm (28 × 36 in.)
Gift of Nancy and Bruce Berman
99.XM.73.3
PLATE 165

Dubois, Wyoming
1991
Chromogenic dye coupler print, edition 11/50
40 × 58.7 cm (15¾ × 23⅛ in.)
Gift of Nancy and Bruce Berman
99.XM.73.1
PLATE 168

ALEX HARRIS

Genara Gurule's House, Río Lucío, New Mexico
Negative, August 1985; print, 1994
Chromogenic dye coupler print
45.6 × 57.7 cm (17¹⁵⁄₁₆ × 22¹¹⁄₁₆ in.)
Gift of Nancy and Bruce Berman
2003.524.1
PLATE 37

Amadeo Sandoval's Kitchen and Bedroom, Río Lucío, New Mexico
Negative, June 1985; print, 1994
Chromogenic dye coupler print
44.6 × 56.8 cm (17⁹⁄₁₆ × 22⅜ in.)
Gift of Nancy and Bruce Berman
98.XM.214.3
PLATE 38

Onésimo and Eleanor Pacheco's House, Vallecito, New Mexico
Negative, May 1985; print, 1994
Chromogenic dye coupler print
48.8 × 59.7 cm (19³⁄₁₆ × 23½ in.)
Gift of Nancy and Bruce Berman
2003.524.3
PLATE 39

Amadeo Sandoval's Living Room, Río Lucío, New Mexico
Negative, June 1985; print, 1993
Chromogenic dye coupler print
45.6 × 57.3 cm (17¹⁵⁄₁₆ × 22⁹⁄₁₆ in.)
Gift of Nancy and Bruce Berman
98.XM.214.4
PLATE 40

Norlina, North Carolina
Negative, March 1985; print, 1995
Chromogenic dye coupler print
46.3 × 58.6 cm (18¼ × 23¹⁄₁₆ in.)
Gift of Nancy and Bruce Berman
2003.524.2
PLATE 41

Summerton, North Carolina
Negative, March 1985; print, 1995
Chromogenic dye coupler print
46.2 × 58.4 cm (18³⁄₁₆ × 23 in.)
Gift of Nancy and Bruce Berman
98.XM.214.15
PLATE 42

Wake Forest, North Carolina
Negative, October 1984; print, 1995
Chromogenic dye coupler print
45.6 × 58.5 cm (17¹⁵⁄₁₆ × 23¹⁄₁₆ in.)
Gift of Nancy and Bruce Berman
2003.524.6
PLATE 43

DAVID HUSOM

Mahnomen County Fairgrounds, Mahnomen, MN
Negative, 1980; print, 1995
Chromogenic dye coupler print
43.8 × 55.9 cm (17¼ × 22 in.)
Gift of Nancy and Bruce Berman
98.XM.216.16
PLATE 84

St. Croix County Fairgrounds, Glenwood City, WI
Negative, 1995; print, 1996
Chromogenic dye coupler print
44 × 55.9 cm (17⁵⁄₁₆ × 22 in.)
Gift of Nancy and Bruce Berman
99.XM.77.1
PLATE 85

Pierce County Fairgrounds, Ellsworth, WI
Negative, 1995; print, 1996
Chromogenic dye coupler print
44 × 56 cm (17⁵⁄₁₆ × 22¹⁄₁₆ in.)
Gift of Nancy and Bruce Berman
98.XM.216.6
PLATE 86

Michigan State Fairgrounds, Detroit, MI
Negative, 1995; print, 1996
Chromogenic dye coupler print
44 × 56 cm (17⁵⁄₁₆ × 22¹⁄₁₆ in.)
Gift of Nancy and Bruce Berman
98.XM.216.2
PLATE 87

Gogebic County Fairgrounds, Ironwood, MI
Negative, 1996; print, 1998
Chromogenic dye coupler print
44.1 × 56.4 cm (17⅜ × 22³⁄₁₆ in.)
Gift of Nancy and Bruce Berman
2002.68.2
PLATE 88

Northern Wisconsin State Fairgrounds, Chippewa Falls, WI
Negative, 1995; print, 1996
Chromogenic dye coupler print
44 × 56 cm (17⁵⁄₁₆ × 22¹⁄₁₆ in.)
Gift of Nancy and Bruce Berman
98.XM.216.10
PLATE 89

Big Stone County Fairgrounds, Clinton, MN
Negative, 1980; print, 1996
Chromogenic dye coupler print
44 × 55.9 cm (17⁵⁄₁₆ × 22 in.)
Gift of Nancy and Bruce Berman
98.XM.216.7
PLATE 90

McLeod County Fairgrounds—After Tornado—Hutchinson, MN
Negative, 1983; print, 1995
Chromogenic dye coupler print
44 × 55.9 cm (17⁵⁄₁₆ × 22 in.)
Gift of Nancy and Bruce Berman
98.XM.216.1
PLATE 91

Iowa State Fairgrounds, Des Moines, IA
Negative, 1981; print, 1995
Chromogenic dye coupler print
44 × 56 cm (17⁵⁄₁₆ × 22¹⁄₁₆ in.)
Gift of Nancy and Bruce Berman
2002.68.3
PLATE 92

Nebraska State Fairgrounds, Lincoln, NE
Negative, 1983; print, 1998
Chromogenic dye coupler print
44 × 56.3 cm (17⁵⁄₁₆ × 22³⁄₁₆ in.)
Gift of Nancy and Bruce Berman
2002.68.4
PLATE 93

MARY KOCOL

Christmas Tree, Somerville, Massachusetts
Negative, 1999; print, 2001
Chromogenic dye coupler print, edition 1/15
95.9 × 65.1 cm (37¾ × 25⅝ in.)
Gift of Nancy and Bruce Berman
2003.528
PLATE 36

JOEL MEYEROWITZ

Fence, Truro
Negative, 1976; print, 1992
Chromogenic dye coupler print
59.7 × 47.3 cm (23½ × 18⅝ in.)
Gift of Nancy and Bruce Berman
99.XM.82.2
PLATE 35

SHERON RUPP

Grand Isle, Vermont
1991
Chromogenic dye coupler print
38.1 × 56.5 cm (15 × 22¼ in.)
Gift of Nancy and Bruce Berman
2005.98.5
PLATE 44

Shawnee, Ohio
1983
Chromogenic dye coupler print
35.6 × 53.3 cm (14 × 21 in.)
Gift of Nancy and Bruce Berman
2005.98.3
PLATE 45

Utica, Ohio
1983
Chromogenic dye coupler print
35.6 × 53.3 cm (14 × 21 in.)
Gift of Nancy and Bruce Berman
2005.98.2
PLATE 46

St. Albans, Vermont
1991
Chromogenic dye coupler print
38.1 × 55.9 cm (15 × 22 in.)
Gift of Nancy and Bruce Berman
2005.98.1
PLATE 47

Stevie, Sutton, Vermont
1990
Chromogenic dye coupler print
38.1 × 56.5 cm (15 × 22¼ in.)
Gift of Nancy and Bruce Berman
2003.531
PLATE 48

Untitled
From the *Northampton, Massachusetts* series
2003
Chromogenic dye coupler print
43.8 × 54.6 cm (17¼ × 21½ in.)
Promised gift of Nancy and Bruce Berman
PLATE 64

Untitled
From the *Northampton, Massachusetts* series
2003
Chromogenic dye coupler print
43.8 × 54.6 cm (17¼ × 21½ in.)
Promised gift of Nancy and Bruce Berman
PLATE 65

Wartrace, Tennessee
1990
Chromogenic dye coupler print
38.1 × 56.5 cm (15 × 22¼ in.)
Gift of Nancy and Bruce Berman
2005.98.4
PLATE 66

Trudy in Annie's Sunflower Maze, Amherst, Massachusetts
2000
Chromogenic dye coupler print
43.8 × 54.6 cm (17¼ × 21½ in.)
Promised gift of Nancy and Bruce Berman
PLATE 67

STEPHEN SHORE

2nd St., Ashland, Wisconsin
Negative, July 9, 1973; print, 1995
Chromogenic dye coupler print
19.7 × 24.8 cm (7¾ × 9¾ in.)
Gift of Nancy and Bruce Berman
99.XM.84.1
PLATE 140

Cumberland St., Charleston, South Carolina
Negative, August 3, 1975; print, 1995
Chromogenic dye coupler print
20.5 × 25.6 cm (8¹/₁₆ × 10¹/₁₆ in.)
Gift of Nancy and Bruce Berman
99.XM.84.5
PLATE 141

Church St. & 2nd St., Easton, Pennsylvania
Negative, June 20, 1974; print, 1995
Chromogenic dye coupler print
20.3 × 25.4 cm (8 × 10 in.)
Gift of Nancy and Bruce Berman
99.XM.84.2
PLATE 142

El Paso St., El Paso, Texas
Negative, July 5, 1975; print, 1995
Chromogenic dye coupler print
20.3 × 25.6 cm (8 × 10¹/₁₆ in.)
Gift of Nancy and Bruce Berman
99.XM.84.4
PLATE 143

Merced River, Yosemite National Park, California
Negative, August 13, 1979; print, 1998
Chromogenic dye coupler print
20.5 × 25.4 cm (8¹/₁₆ × 10 in.)
Gift of Nancy and Bruce Berman
99.XM.84.3
PLATE 164

GREGORY SPAID

Pealer's Barn, Winter, Amity, Ohio
Negative, 1992; print, 1996
Gelatin silver print (selenium-toned)
46 × 45.6 cm (18⅛ × 17¹⁵/₁₆ in.)
Gift of Nancy and Bruce Berman
2003.532.7
PLATE 81

Pealer's Barn, Summer, Amity, Ohio
Negative, 1992; print, 1996
Gelatin silver print (selenium-toned)
45.4 × 45.1 cm (17⅞ × 17¾ in.)
Gift of Nancy and Bruce Berman
2003.532.6
PLATE 82

JOEL STERNFELD

Agoura, California, January 1988
Negative, January 1988; print, March 1995
Chromogenic dye coupler, edition 1/25
40.7 × 51.1 cm (16 × 20⅛ in.)
Gift of Nancy and Bruce Berman
2002.76.4
PLATE 51

Michaelangela and Andrew, New York City, June 1995
1995
Chromogenic dye coupler print, edition 1/7
113 × 88.9 cm (44½ × 35 in.) sight
Gift of Nancy and Bruce Berman
99.XM.86.2
PLATE 52

A Homeless Man with His Bedding, New York, New York, July 1994
Negative, July 1994; print, December 1996
Chromogenic dye coupler print
113 × 88.9 cm (44½ × 35 in.) sight
Gift of Nancy and Bruce Berman
99.XM.86.1
PLATE 126

The Northwest Corner of Florence and Normandie Avenues, Los Angeles, California, October 1993
From the *On This Site, Landscape in Memoriam* series
Negative, October 1993; print, 2005
Chromogenic dye coupler print
47 × 59.7 cm (18½ × 23½ in.)
Promised gift of Nancy and Bruce Berman
PLATE 144

The Happy Land Social Club, 1959 Southern Boulevard, The Bronx, New York, June 1993
From the *On This Site, Landscape in Memoriam* series
Negative, June 1993; print, 1994
Chromogenic dye coupler print, edition 2/7
47 × 60 cm (18½ × 23⅝ in.)
Lent by Nancy and Bruce Berman
PLATE 145

Aisle 2, Row 3, Seat 5, Texas Theatre, 231 West Jefferson Boulevard, Dallas, Texas, November 1993
From the *On This Site, Landscape in Memoriam* series
Negative, November 1993; print, November 1995
Chromogenic dye coupler print, edition 3/7
47 × 59.4 cm (18½ × 23⅜ in.)
Lent by Nancy and Bruce Berman
PLATE 146

4421 Gibson Avenue, St. Louis, Missouri, August 1993
From the *On This Site, Landscape in Memoriam* series
Negative, August 1993; print, September 1995
Chromogenic dye coupler print, edition 1/7
47.3 × 59.4 cm (18⅝ × 23⅜ in.)
Gift of Nancy and Bruce Berman
2002.76.3
PLATE 147

518 101st Street, Love Canal Neighborhood, Niagara Falls, New York, April 1994
From the *On This Site, Landscape in Memoriam* series
Negative, April 1994; print, March 1995
Chromogenic dye coupler print, edition 1/7
47.3 × 59.2 cm (18⅝ × 23⁵⁄₁₆ in.)
Lent by Nancy and Bruce Berman
PLATE 148

Warren Avenue at 23rd Street, Detroit, Michigan, October 1993
From the *On This Site, Landscape in Memoriam* series
Negative, October 1993; print, 1994
Chromogenic dye coupler print, edition 2/7
47.6 × 60.3 cm (18¾ × 23¾ in.)
Gift of Nancy and Bruce Berman
98.XM.225.5
PLATE 149

The Former Bryant's Grocery, Money, Mississippi, June 1994
From the *On This Site, Landscape in Memoriam* series
Negative, June 1994; print, March 1995
Chromogenic dye coupler print, edition 1/7
47.5 × 59.8 cm (18¹¹⁄₁₆ × 23⁹⁄₁₆ in.)
Gift of Nancy and Bruce Berman
98.XM.225.4
PLATE 150

The National Civil Rights Museum, Formerly the Lorraine Motel, 450 Mulberry Street, Memphis, Tennessee, August 1993
From the *On This Site, Landscape in Memoriam* series
Negative, August 1993; print, 1995
Chromogenic dye coupler print, edition 5/7
47 × 59.7 cm (18½ × 23½ in.)
Lent by Nancy and Bruce Berman
PLATE 151

Highway 101, Petaluma, California, October 1993
From the *On This Site, Landscape in Memoriam* series
Negative, October 1993; print, 1994
Chromogenic dye coupler print, edition 2/7
47.6 × 59.7 cm (18¾ × 23½ in.)
Lent by Nancy and Bruce Berman
PLATE 152

Page, Arizona, August 1982 (Lone Horse)
Negative, August 1982; print, August 1995
Chromogenic dye coupler print
40.8 × 50.8 cm (16¹⁄₁₆ × 20 in.)
Gift of Nancy and Bruce Berman
98.XM.225.2
PLATE 153

Potato Harvest, Aroostook County, Maine, October 1982
Negative, October 1982; print, November 1986
Chromogenic dye coupler print
34.3 × 43.2 cm (13½ × 17 in.)
Gift of Nancy and Bruce Berman
98.XM.225.3
PLATE 154

Eagle Vail, Colorado, October 1980
Negative, October 1980; print, April 1987
Chromogenic dye coupler print
33.3 × 42.9 cm (13⅛ × 16⅞ in.)
Lent by Nancy and Bruce Berman
PLATE 155

Matanuska Glacier, Matanuska Valley, Alaska, July 1984
Negative, July 1984; print, April 1987
Chromogenic dye coupler print
34.3 × 43.2 cm (13½ × 17 in.)
Lent by Nancy and Bruce Berman
PLATE 166

JACK D. TEEMER JR.

Columbus, 1984
From the *Color Photographs* portfolio
Negative, 1984; print, 1985
Chromogenic dye coupler print
20.5 × 26.2 cm (8¹⁄₁₆ × 10⁵⁄₁₆ in.)
Gift of Nancy and Bruce Berman
2005.99.1
PLATE 70

Dayton, 1983
From the *Color Photographs* portfolio
Negative, 1983; print, 1985
Chromogenic dye coupler print
20.5 × 26.2 cm (8¹⁄₁₆ × 10⁵⁄₁₆ in.)
Gift of Nancy and Bruce Berman
2005.99.3
PLATE 71

Baltimore, 1980
From the *Color Photographs* portfolio
Negative, 1980; print, 1985
Chromogenic dye coupler print
20.5 × 26.2 cm (8¹⁄₁₆ × 10⁵⁄₁₆ in.)
Gift of Nancy and Bruce Berman
2005.99.7
PLATE 72

Cleveland, 1983
From the *Color Photographs* portfolio
Negative, 1983; print, 1985
Chromogenic dye coupler print
20.5 × 26.2 cm (8¹⁄₁₆ × 10⁵⁄₁₆ in.)
Gift of Nancy and Bruce Berman
2005.99.4
PLATE 73

Cleveland, 1983
From the *Color Photographs* portfolio
Negative, 1983; print, 1985
Chromogenic dye coupler print
20.5 × 26.2 cm (8¹⁄₁₆ × 10⁵⁄₁₆ in.)
Gift of Nancy and Bruce Berman
2005.99.10
PLATE 74

Dayton, 1983
From the *Color Photographs* portfolio
Negative, 1983; print, 1985
Chromogenic dye coupler print
20.5 × 26.2 cm (8¹⁄₁₆ × 10⁵⁄₁₆ in.)
Gift of Nancy and Bruce Berman
2005.99.8
PLATE 75

Dayton, 1983
From the *Color Photographs* portfolio
Negative, 1983; print, 1985
Chromogenic dye coupler print
20.3 × 26.2 cm (8 × 10⁵⁄₁₆ in.)
Gift of Nancy and Bruce Berman
2005.99.5
PLATE 76

Dayton, 1984
From the *Color Photographs* portfolio
Negative, 1984; print, 1985
Chromogenic dye coupler print
20.5 × 26.2 cm (8¹⁄₁₆ × 10⁵⁄₁₆ in.)
Gift of Nancy and Bruce Berman
2005.99.9
PLATE 77

Cincinnati, 1981
From the *Color Photographs* portfolio
Negative, 1981; print, 1985
Chromogenic dye coupler print
20.6 × 26.4 cm (8⅛ × 10⅜ in.)
Gift of Nancy and Bruce Berman
2005.99.2
PLATE 78

Baltimore, 1980
From the *Color Photographs* portfolio
Negative, 1980; print, 1985
Chromogenic dye coupler print
20.5 × 26.2 cm (8¹⁄₁₆ × 10⁵⁄₁₆ in.)
Gift of Nancy and Bruce Berman
2005.99.6
PLATE 79

GEORGE A. TICE

Car for Sale, Paterson, New Jersey
Negative, April 1969; print, January 17, 1985
Gelatin silver print (selenium-toned)
48.9 × 39.1 cm (19¼ × 15⅜ in.)
Gift of Nancy and Bruce Berman
98.XM.227.2
PLATE 1

Joe's Barbershop, Paterson, New Jersey
Negative, December 1970; print, June 21, 1984
Gelatin silver print (selenium-toned)
38.9 × 49.5 cm (15⁵⁄₁₆ × 19½ in.)
Gift of Nancy and Bruce Berman
98.XM.227.10
PLATE 2

White Castle, Route #1, Rahway, New Jersey
Negative, September 1973; print, June 4, 2002
Gelatin silver print (selenium-toned)
38.4 × 48.6 cm (15⅛ × 19⅛ in.)
Lent by Nancy and Bruce Berman
PLATE 3

Petit's Mobil Station, Cherry Hill, New Jersey
Negative, November 1974; print, February 26, 2001
Gelatin silver print (selenium-toned)
38.4 × 48.9 cm (15⅛ × 19¼ in.)
Lent by Nancy and Bruce Berman
PLATE 4

Child's Bedroom, Paterson, New Jersey
Negative, April 1971; print, February 11, 1994
Gelatin silver print (selenium-toned)
48.9 × 38.9 cm (19¼ × 15⁵⁄₁₆ in.)
Gift of Nancy and Bruce Berman
98.XM.227.3
PLATE 5

Mobile Home, Carteret, New Jersey
Negative, November 1973; print, March 30, 2004
Gelatin silver print (selenium-toned)
38.7 × 48.6 cm (15¼ × 19⅛ in.)
Lent by Nancy and Bruce Berman
PLATE 6

CAMILO JOSÉ VERGARA

Ransom–Gillis Mansion in Ruins, Alfred and John R Streets, Detroit
1997
Chromogenic dye coupler print
38.4 × 59.1 cm (15⅛ × 23¼ in.)
Promised gift of Nancy and Bruce Berman
PLATE 55

Former Ransom. Gillis Mansion, Corner on Alfred and John R, Detroit
2000
Chromogenic dye coupler print
38.4 × 59.1 cm (15⅛ × 23¼ in.)
Promised gift of Nancy and Bruce Berman
PLATE 56

Full Gospel Church of Jesus Christ, Chicago Heights, Il.
1980
Chromogenic dye coupler print
22.2 × 33 cm (8¾ × 13 in.)
Gift of Nancy and Bruce Berman
2005.100.12
PLATE 108

St. Rest M.B. Church, 3056 West Polk St., Chicago
1980
Chromogenic dye coupler print
22.9 × 33 cm (9 × 13 in.)
Gift of Nancy and Bruce Berman
2005.100.8
PLATE 109

St. Rest M.B. Church, 3056–3058 West Polk St., Chicago
1997
Chromogenic dye coupler print
22.9 × 33 cm (9 × 13 in.)
Gift of Nancy and Bruce Berman
2005.100.9
PLATE 110

St. John Evangelist M.B. Church, Former Crown Buick Dealership, 63rd St. East of Throop, Chicago
2001
Chromogenic dye coupler print
22.2 × 33 cm (8¾ × 13 in.)
Gift of Nancy and Bruce Berman
2005.100.3
PLATE 111

Greater Love Christian Church, 514 West 71st St., Chicago
2001
Chromogenic dye coupler print
22.2 × 33 cm (8¾ × 13 in.)
Gift of Nancy and Bruce Berman
2005.100.11
PLATE 112

Renewance in Christ, 5825 West Lake Street, Chicago
1990
Chromogenic dye coupler print
21.9 × 33.3 cm (8⅝ × 13⅛ in.)
Gift of Nancy and Bruce Berman
2005.100.7
PLATE 113

Life Church of God in Christ, 3722 Chicago Ave.
2001
Chromogenic dye coupler print
22.9 × 33 cm (9 × 13 in.)
Gift of Nancy and Bruce Berman
2005.100.6
PLATE 114

Christ Mission Center, 4524 West Madison St., Chicago
1987
Chromogenic dye coupler print
22.9 × 33 cm (9 × 13 in.)
Gift of Nancy and Bruce Berman
2005.100.14
PLATE 115

The Light House Gospel M.B. Church, Sacramento Ave., Chicago
1989
Chromogenic dye coupler print
22.2 × 33 cm (8¾ × 13 in.)
Gift of Nancy and Bruce Berman
2005.100.10
PLATE 116

Walk in Prayer Mission, Cottage Grove Ave. by 45th St., Chicago
2000
Chromogenic dye coupler print
22.9 × 33 cm (9 × 13 in.)
Gift of Nancy and Bruce Berman
2005.100.5
PLATE 117

God's House for All Nations, 11 East 43rd St., Chicago
2001
Chromogenic dye coupler print
22.2 × 33 cm (8¾ × 13 in.)
Gift of Nancy and Bruce Berman
2005.100.13
PLATE 118

First Steadfast Baptist Church (1 of 2), 467 East Bowen St., Chicago
1987
Chromogenic dye coupler print
22.2 × 33 cm (8¾ × 13 in.)
Gift of Nancy and Bruce Berman
2005.100.1
PLATE 119

First Steadfast Baptist Church (2 of 2), 467 East Bowen St., Chicago
2001
Chromogenic dye coupler print
22.2 × 33 cm (8¾ × 13 in.)
Gift of Nancy and Bruce Berman
2005.100.2
PLATE 120

Prayer Center M.B. Church, 7205 S. Halsted, Chicago
2001
Chromogenic dye coupler print
22.2 × 33 cm (8¾ × 13 in.)
Gift of Nancy and Bruce Berman
2005.100.4
PLATE 121

Former Werth Appliance Center, Then a Church, State Street, Hammond, Ind.
2000
Chromogenic dye coupler print
39.1 × 58.4 cm (15⅜ × 23 in.)
Promised gift of Nancy and Bruce Berman
PLATE 122

BIOGRAPHIES

Compiled by Anne Lacoste

An asterisk () indicates that an
exhibition title was not available.*

ROBERT ADAMS
Born 1937 Orange, New Jersey
Lives in Astoria, Oregon

EDUCATION
University of Southern California, Ph.D. in English, 1965
University of Redlands, California, B.A. in English, 1959

SELECTED EXHIBITIONS
Robert Adams: Landscapes of Harmony and Dissonance, J. Paul
 Getty Museum, Los Angeles, 2006
*Robert Adams: Turning Back, A Photographic Journal of Re-
 exploration*, San Francisco Museum of Modern Art, 2005–6
*Sunlight, Solitude, Democracy, Home—Photographs by Robert
 Adams*, Douglas F. Cooley Memorial Art Gallery, Reed College
 Art Museum, Portland, Oregon, 2001
To the Mouth of the Columbia: Photographs by Robert Adams, Art
 Museum, Princeton University, 1998
*Listening to the River—Seasons in the American West: Photographs
 by Robert Adams*, Sprengel Museum, Hanover, Germany, 1994
 (traveling)
At the End of the Columbia River: Photographs by Robert Adams,
 Denver Art Museum, 1993
To Make It Home: Photographs of the American West, 1965–1986,
 Philadelphia Museum of Art, 1989 (traveling)
Prairie: Photographs by Robert Adams, Museum of Modern Art,
 New York, 1979
New Topographics: Photographs of a Man-Altered Landscape,
 George Eastman House, Rochester, New York, 1975 (group
 exhibition)
Photographs by Robert Adams and Emmet Gowin, Museum of
 Modern Art, New York, 1971 (group exhibition)

SELECTED PUBLICATIONS
Turning Back: A Photographic Journal of Re-exploration by Robert
 Adams. San Francisco; New York, 2005.
Sunlight, Solitude, Democracy, Home: Photographs by Robert Adams
 by Susan Fillin-Yen and Leo Rubienfien. Portland, Ore., 2001.
*California: Views by Robert Adams of the Los Angeles Basin,
 1978–1983* with essay by Robert Haas. San Francisco; New York,
 2000.
*What We Bought—The New World: Scenes from the Denver
 Metropolitan Area, 1970–1974* by Robert Adams and Thomas
 Welski. Hanover, Germany, 1995.
To Make It Home: Photographs of the American West by Robert
 Adams. New York, 1989.
Perfect Times, Perfect Places by Robert Adams. New York, 1988.
Los Angeles Spring by Robert Adams. New York, 1986.
*Our Lives and Our Children: Photographs Taken near the Rocky Flats
 Nuclear Weapons Plant* by Robert Adams. Millerton, N.Y., 1983.
The New West: Landscapes along the Colorado Front Range by
 Robert Adams with foreword by John Swarkowski. Boulder,
 Colo., 1974.

ADAM BARTOS
Born 1953 New York
Lives in New York

EDUCATION
New York University Film School, 1971–75

SELECTED EXHIBITIONS
Los Angeles, Yossi Milo Gallery, New York, 2006
Adam Bartos Photographs, Senior and Shopmaker Gallery, New
 York, 2003
Adam Bartos: Kosmos, Rose Gallery, Los Angeles, 2002
Adam Bartos, Historic Bollywood, Bombay Film Studios, Rose
 Gallery, Los Angeles, 2001
International Territory, Photographer's Gallery, London, 2000
Adam Bartos: Portraits and Still Lifes from Hither Hills, Gallery of
 Contemporary Photography, Los Angeles, 1997
Selected U.N. Photographs, Lieberman and Saul Gallery, New York,
 1991
New Color, New Work, Museum of Contemporary Photography,
 Columbia College, Chicago 1985 (group exhibition)
The New Color: A Decade of Color Photography, Everson Museum of
 Fine Arts, Syracuse, New York, 1981 (group exhibition)

SELECTED PUBLICATIONS
Boulevard by Adam Bartos with preface by Geoff Dyer. Göttingen,
 Germany, 2006.
Kosmos: A Portrait of the Russian Space Age by Adam Bartos with
 essay by Svetlana Boym. New York, 2001.
International Territory, The United Nations, 1945–95 by Adam Bartos
 and Christopher Hitchens. London; New York, 1994.
New Color/New Work: Eighteen Photographic Essays by Sally
 Eauclaire. New York, 1984.
The New Color Photography by Sally Eauclaire. New York, 1981.

VIRGINIA BEAHAN AND LAURA MCPHEE

VIRGINIA BEAHAN
Born 1946 Philadelphia
Lives in Lyme Center, New Hampshire

EDUCATION
Tyler School of Art, Temple University, Philadelphia, M.F.A. in
 Photography, 1984
Pennsylvania State University, State College, B.A. in English, 1968

SELECTED EXHIBITIONS
Family: Photos from Home, Howard Greenberg Gallery, New York,
 2005 (group exhibition)
The Altered Landscape, Presentation House Gallery, Vancouver,
 Canada, 2004 (group exhibition)
Cuba on the Verge: An Island in Transition, International Center of
 Photography, New York, 2003 (group exhibition)
The Country between Us, Laurence Miller Gallery, New York, 2002
No Ordinary Land: Encounters in a Changing Environment, Burden
 Gallery, New York, 1998 (traveling)
*The Dividing Line: Collaborative Landscape Photography by Virginia
 Beahan and Laura McPhee*, Rose Art Museum, Brandeis
 University, Waltham, Massachusetts, 1995

SELECTED PUBLICATIONS

Forces of Change: A New View of Nature by Daniel Botkin et al. Washington, D.C., 2000.

No Ordinary Land: Encounters in a Changing Environment by Virginia Beahan and Laura McPhee with introduction by Rebecca Solnit and foreword by John McPhee. New York, 1998.

The Dividing Line: Collaborative Landscape Photography by Virginia Beahan and Laura McPhee. Waltham, Mass., 1995.

LAURA MCPHEE
Born 1958 New York
Lives in Brookline, Massachusetts

EDUCATION

Rhode Island School of Design, Providence, M.F.A. in Photography, 1986
Princeton University, B.A. in Art History, 1980

SELECTED EXHIBITIONS

Laura McPhee, River of No Return, Museum of Fine Arts, Boston, 2006
Laura McPhee: Kolkata. Bonni Benrubi Gallery, New York, 2005
Laura McPhee, Bernard Toale Gallery, Boston, 2004
The Country between Us, Laurence Miller Gallery, New York, 2002
No Ordinary Land: Encounters in a Changing Environment, Burden Gallery, New York, 1998 (traveling)
The Dividing Line: Collaborative Landscape Photography by Virginia Beahan and Laura McPhee, Rose Art Museum, Brandeis University, Waltham, Massachusetts, 1995

SELECTED PUBLICATIONS

Forces of Change: A New View of Nature by Daniel Botkin et al. Washington, D.C., 2000.

Girls: Ordinary Girls and Their Extraordinary Pursuits by Jenny McPhee, Laura McPhee, and Martha McPhee. New York, 2000.

No Ordinary Land: Encounters in a Changing Environment by Virginia Beahan and Laura McPhee with introduction by Rebecca Solnit and foreword by John McPhee. New York, 1998.

The Dividing Line: Collaborative Landscape Photography by Virginia Beahan and Laura McPhee. Waltham, Mass., 1995.

WILLIAM CHRISTENBERRY
Born 1936 Tuscaloosa, Alabama
Lives in Washington, D.C.

EDUCATION

University of Alabama, Tuscaloosa, M.A. in Painting, 1959
University of Alabama, Tuscaloosa, B.A. in Fine Arts, 1958

SELECTED EXHIBITIONS

Passing Time: The Art of William Christenberry, Smithsonian American Art Museum, Washington D.C., 2006-7
William Christenberry, SK Stiftung Kultur, August Sander Archiv, Cologne, Germany, 2002
Reconstruction: William Christenberry's Art, Center for Creative Photography and University of Arizona Museum of Art, Tucson, 1996 (traveling)
William Christenberry: The Early Works, 1954 to 1968, Morris Museum of Art, Augusta, Georgia, 1996
Photographs and Sculpture, Pace/MacGill Gallery, New York, 1992

Of Time and Place: Walker Evans and William Christenberry, Amon Carter Museum, Fort Worth, Texas, 1990 (traveling group exhibition)
Southern Exposure, Cranbrook Art Museum, Bloomfield Hills, Michigan, 1990
William Christenberry: Southern Views, Institute for the Arts, Rice University, Houston, Texas, 1982 (traveling)
**Corcoran Gallery of Art, Washington, D.C., 1973 (traveling)

SELECTED PUBLICATIONS

William Christenberry: Southern Places, with foreword by Elizabeth Broun and essays by Walter Hopps, Andy Grundberg, and Howard N. Fox. Washington, D.C., 2006.

Christenberry Reconstruction: The Art of William Christenberry by Trudy Wilner Stack. Jackson, Miss., 1996.

William Christenberry: The Early Years, 1954–1968 by J. Richard Gruber. Augusta, Ga., 1996.

Of Time and Place: Walker Evans and William Christenberry by Thomas W. Southall with excerpts by James Agee and stories by William Christenberry. San Francisco, 1990.

Southern Photographs by William Christenberry with introduction by R. H. Cravens. Millerton, N.Y., 1983.

ROBERT DAWSON
Born 1950 Sacramento, California
Lives in San Francisco

EDUCATION

University of California, Berkeley, Ph.D. in Geography
San Francisco State University, M.A.
University of California, Santa Cruz, B.A.

SELECTED EXHIBITIONS

Awakening from the California Dream: An Environmental History, San Francisco Public Library, 2003 (traveling)
Awakening from the California Dream, Oakland Museum of California, 1999
**Vision Gallery, San Francisco, 1993
Between Home and Heaven: Contemporary American Landscape Photography, National Museum of American Art, Smithsonian Institution, Washington, D.C., 1992 (group exhibition)
Robert Dawson, Blue Sky Gallery, Portland, Oregon, 1990
Robert Dawson, Silver Image Gallery, Seattle, 1989
Robert Dawson Photographs, Gallery Min, Tokyo, 1988
The Great Central Valley Project, California Academy of Sciences, San Francisco, 1986 (group exhibition)
**San Francisco Camerawork, 1982

SELECTED PUBLICATIONS

A Doubtful River by Robert Dawson, Peter Goin, and Mary Webb. Reno, 2000.

Farewell, Promised Land: Waking from the California Dream by Robert Dawson and Gray A. Brechin. Berkeley, 1999.

The Great Central Valley: California's Heartland: A Photographic Project by Stephen Johnson and Robert Dawson with text by Gerald Haslam. Berkeley, 1993.

Arid Waters: Photographs from the Water in the West Project, ed. Peter Goin with text by Ellen Manchester. Reno, 1992.

Robert Dawson Photographs. Tokyo, 1988.

JOHN DIVOLA
Born 1949 Los Angeles
Lives in Riverside, California

EDUCATION

University of California, Los Angeles, M.F.A., 1974
University of California, Los Angeles, M.A., 1973
California State University, Northbridge, B.A., 1971

SELECTED EXHIBITIONS

John Divola, Blue Sky Gallery, Portland, Oregon, 2006
Dogs Chasing My Car in the Desert, Charles Cowles Gallery, New York, 2004
X-Files, Patricia Faure Gallery, Los Angeles, 2003
Isolated Houses, Janet Borden Gallery, New York, 2001
WX6276, V8102, KU100382, X14149, X13194, X10117, V8161, WX6230: Seven Song Birds and a Rabbit, Jan Kesner Gallery, Los Angeles, 1995
California Photography: Remaking Make Believe, Museum of Modern Art, New York, 1989 (traveling group exhibition)
John Divola, Gallery Min, Tokyo, 1987
John Divola: Selected Work, 1974–1985, Los Angeles Municipal Art Gallery, Barnsdall Park, 1985
Color Transformations, Jo Ann Callis and John Divola, University Art Gallery, University of California at Berkeley, 1980 (group exhibition)
John Divola: Recent Work, Center for Creative Photography, University of Arizona, Tucson, 1976
24 from L.A., San Francisco Museum of Modern Art, 1973 (group exhibition)

SELECTED PUBLICATIONS

John Divola: Three Acts with essay by David Campany and interview by Jan Tumlir. New York, 2006.

Dogs Chasing My Car in the Desert by John Divola. Tucson, 2004.

Isolated Houses by John Divola. Tucson, 2000.

Continuity by John Divola. Santa Monica, 1997.

Divola and Fulton: Landscape, Mystery and Metaphor by Abby Wasserman. Oakland, 1989.

John Divola. Tokyo, 1987.

JIM DOW
Born 1942 Boston
Lives in Belmont, Massachusetts

EDUCATION

Rhode Island School of Design, Providence, M.F.A. in Graphic Design and Photography, 1968
Rhode Island School of Design, Providence, B.F.A. in Graphic Design and Photography, 1965

SELECTED EXHIBITIONS

Jim Dow: Baseball Stadiums, 1980–1982, Museum of Fine Arts, Houston, 2005
Time Passing, North Dakota Museum of Art, Grand Forks, 2004
Jim Dow: Establishments, Janet Borden Gallery, New York, 2003
Photographs of America's Baseball Stadiums, Art Institute of Boston, Lesley College, 2003
Jim Dow: Corner Shops of Britain, Janet Borden Gallery, New York, 1995
**Robert Freidus Gallery, New York, 1983

Court House, Museum of Modern Art, New York, 1977 (traveling group exhibition)

SELECTED PUBLICATIONS

Subway Series. New York, 2004.
Corner Shops of Britain by Jim Dow. New York, 1995.
American Independents: Eighteen Color Photographers by Sally Eauclaire. New York, 1987.
Spirit of Sport, ed. Constance Sullivan. Boston, 1985.
New Color/New Work: Eighteen Photographic Essays by Sally Eauclaire. New York, 1984.
Court House: A Photographic Document, ed. Richard Pare; conceived and directed by Phyllis Lambert et al. New York, 1978.

DOUG DUBOIS
Born 1960 Dearborn, Michigan
Lives in Syracuse, New York

EDUCATION

San Francisco Art Institute, M.F.A. in Photography, 1988
Hampshire College, Amherst, Massachusetts, B.A. in Film and Photography, 1983

SELECTED EXHIBITIONS

Doug Dubois, Blue Sky Gallery, Portland, Oregon, 2006
The Vigil, Center for Photography at Woodstock, New York, 2005
Doug Dubois: Photographs, Everson Museum of Art, Syracuse, New York, 2001
Family Documents: Photographs by Doug Dubois and Sheron Rupp, Columbus Museum of Art, Ohio, 1997–98 (group exhibition)
*Rhode Island School of Design, Providence, 1997
*Hampshire College, Amherst, Massachusetts, 1992
Pleasures and Terrors of Domestic Comfort, Museum of Modern Art, New York, 1991 (traveling group exhibition)
*Diego Rivera Gallery, San Francisco, 1986

SELECTED PUBLICATIONS

The Spirit of Family by Al and Tipper Gore with Gail Buckland and Katy Homans. New York, 2002.
Avella. El Paso, 1997.
Flesh and Blood: Photographers' Images of Their Own Families, ed. Alice Rose George, Abigail Heyman, and Ethan Hoffman with essays by Ann Beattie and Andy Grundberg. New York, 1992.
Pleasures and Terrors of Domestic Comfort by Peter Galassi. New York, 1991.
Close to Home: Seven Documentary Photographers, ed. David Featherstone. San Francisco, 1989.

WILLIAM EGGLESTON
Born 1939 Memphis, Tennessee
Lives in Memphis, Tennessee

EDUCATION

Vanderbilt University, Nashville
Delta State College, Cleveland, Mississippi
University of Mississippi, Oxford

SELECTED EXHIBITIONS

William Eggleston: The Night Club Portraits 1973, Cheim and Read, New York, 2005
William Eggleston: Los Alamos, Museum Ludwig, Cologne, Germany, 2003 (traveling)
William Eggleston and the Color Tradition, J. Paul Getty Museum, Los Angeles, 1999–2000 (group exhibition)
William Eggleston. Morals of Vision, Westfälischer Kuntsverein, Münster, Germany, 1998
William Eggleston: Ancient and Modern, Barbican Art Gallery, London, 1992 (traveling)
William Eggleston: The Democratic Forest, Corcoran Gallery of Art, Washington, D.C., 1990
William Eggleston: Color Photographs from the American South, Victoria and Albert Museum, London, 1983 (traveling)
Troubled Waters, Charles Cowles Gallery, New York, 1980
Election Eve, Corcoran Gallery of Art, Washington, D.C., 1977
William Eggleston: Color Photographs, 1966–1977, Castelli Graphics/Leo Castelli, New York, 1977
Photographs by William Eggleston, Museum of Modern Art, New York, 1976 (traveling)
*Jefferson Place Gallery, Washington, D.C., 1974

SELECTED PUBLICATIONS

William Eggleston: Los Alamos, ed. Thomas Weski. Zurich; New York, 2003.
William Eggleston. Arles; Paris, 2001.
The Hasselblad Award 1998: William Eggleston, ed. Gunilla Knape. Göteborg, Sweden; Zurich; New York, 1999.
William Eggleston, Ancient and Modern. New York, 1992.
Faulkner's Mississippi with text by Willie Morris and photographs by William Eggleston. Birmingham, Ala., 1990.
The Democratic Forest by William Eggleston with introduction by Eudora Welty. London, 1989.
William Eggleston's Guide with essay by John Szarkowski. New York, 1976.

MITCH EPSTEIN
Born 1952 Holyoke, Massachusetts
Lives in New York

EDUCATION

The Cooper Union, New York, 1972–74
Rhode Island School of Design, Providence, 1971–72
Union College, New York, 1970–71

SELECTED EXHIBITIONS

Mitch Epstein Retrospective, SK Stiftung Kultur, Cologne, Germany, 2006
Mitch Epstein Recreation: American Photographs, 1973–1988, Sikkema Jenkins, New York, 2005
Mitch Epstein: Family Business, PowerHouse, Memphis, Tennessee, 2003
Mitch Epstein: The City, Rose Gallery, Los Angeles, 2001
Mitch Epstein: Recreation, Brent Sikkema, New York, 2001
In the Caribbean: Mitch Epstein Photographs, Cleveland Museum of Art, 1994
Mitch Epstein: In Pursuit of India, Fogg Art Museum, Cambridge, Massachusetts, 1991
Mitch Epstein: In Pursuit of India, Santa Barbara Museum of Art, 1989
*Light Gallery, New York, 1979

SELECTED PUBLICATIONS

Mitch Epstein: Recreation, American Photographs, 1973–1988. Göttingen, Germany, 2005.
Family Business by Mitch Epstein. Göttingen, Germany, 2003.
The City by Mitch Epstein. New York, 2001.
Vietnam: A Book of Changes by Mitch Epstein. New York, 1996.
Fire Water Wind: Photographs from Tenri by Mitch Epstein with foreword by Tenrikyo Doyusha. Tenri, 1995
In Pursuit of India by Mitch Epstein with introduction by Anita Desai. New York, 1987.

RHEA GAREN
Born 1959 Offenbach, Germany
Lives in Ithaca, New York

EDUCATION

University of Illinois, Champaign, Illinois, M.F.A. in Photography, 1990
Cornell University, Ithaca, New York, B.A. in Biology, 1981

SELECTED EXHIBITIONS

2003 Upstate Invitational Show, Rochester Contemporary Gallery, New York, 2003 (group exhibition)
Panoramic Views, State of the Art Gallery, Ithaca, New York, 2000
William Eggleston and the Color Tradition, J. Paul Getty Museum, Los Angeles, 1999–2000 (group exhibition)
Snapshots and Roadside Attractions: Photographs by Rhea Garen and Kent Loeffler, State of the Art Gallery, Ithaca, New York, 1997 (group exhibition)
Selected Works, State of the Art Gallery, Ithaca, New York, 1995
*Olive Tjaden Gallery, Cornell University, Ithaca, New York, 1993
*Hartell Gallery, Cornell University, Ithaca, New York, 1989

SELECTED PUBLICATION

Nine Artists: Cornell Council for the Arts Invitational. Ithaca, N.Y., 1997.

KAREN HALVERSON
Born 1941 Syracuse, New York
Lives in Los Angeles

EDUCATION
Columbia University, New York, M.A. in Anthropology, 1975
Brandeis University, Waltham, Massachusetts, M.A. in History of Ideas, 1965
Stanford University, California, B.A. in Philosophy, 1963

SELECTED EXHIBITIONS
Karen Halverson, Rose Gallery, Los Angeles, 2003
Downstream: Colorado River Series and Recent Works, Klotz Sirmon Gallery, New York, 2002
In Response to Place: Photographs from the Nature Conservancy's Last Great Places, Corcoran Gallery of Art, Washington, D.C., 2001 (traveling group exhibition)
Shiprock and Beyond, Dartmouth College, Hanover, New Hampshire, 1997
Selections from the Colorado River Series, Paul Kopeikin Gallery, Los Angeles, 1996
Selections from the Mulholland Series, Troyer Fitzpatrick Lassman Gallery, Washington, D.C., 1994
*Witkin Gallery, New York, 1991
Desert/Sky/Lines, Sandra Berler Gallery, Washington D.C., 1990
Night Images, Witkin Gallery, New York, 1988

SELECTED PUBLICATIONS
Downstream by Karen Halverson. Berkeley, forthcoming.
Contemporary Desert Photography: The Other Side of Paradise by Marilyn Cooper and Katherine Hough. Palm Springs, Calif., 2005.
The Great Wide Open: Panoramic Photographs of the American West by Jennifer A. Watts and Claudia Bohn-Spector. London, 2001.
In Response to Place: Photographs from the Nature Conservancy's Last Great Places with foreword by Terry Tempest Williams and essay by Andy Grundberg. Boston, 2001.
Between Home and Heaven: Contemporary American Landscape Photography from the Consolidated Natural Gas Company Collection of the National Museum of American Art, Smithsonian Institution with essays by Merry A. Foresta, Stephen Jay Gould, Karal Ann Marling. Washington D.C., 1992.

ALEX HARRIS
Born 1949 Atlanta, Georgia
Lives in Durham, North Carolina

EDUCATION
Yale University, New Haven, Connecticut, B.A. in Psychology, 1971

SELECTED EXHIBITIONS
Experience Corps and the New Wave of Civic Engagement, Russell Senate Office Building, Washington, D.C., 2005
Alex Harris: Photographs, 1998–2000, Duke University, Special Collections Library, Durham, North Carolina, 2003
Alex Harris: Islas en el Tiempo, IVAM Centre Julio González, Valencia, Spain, 2000

Red White Blue and God Bless You: A Portrait of Northern New Mexico by Alex Harris, International Center of Photography Midtown, New York, 1994 (traveling)
Color Work, Light Factory, Charlotte, North Carolina, 1983
The Last and First Eskimos, Duke University, Durham, North Carolina, 1977 (traveling)
*Addison Gallery of American Art, Phillips Academy, Andover, Massachusetts, 1974
*Southeastern Center for Contemporary Art, Winston-Salem, North Carolina, 1973
The Mind of the South and the Southern Soul, University of North Carolina, Chapel Hill, 1972

SELECTED PUBLICATIONS
Islas en el Tiempos by Alex Harris. Valencia, Spain, 2000.
Old and on Their Own by Robert Coles with photographs by Alex Harris and Thomas Roma. Durham, N.C., 1998.
Red White Blue and God Bless You: A Portrait of Northern New Mexico by Alex Harris. Albuquerque, 1992.
River of Traps: A Village Life by William deBuys and Alex Harris. Albuquerque, 1990.
The Essential Landscape: The New Mexico Photographic Survey, ed. Steven A. Yates with photographs by Thomas Barrow et al.; and essay by J. B. Jackson. Albuquerque, 1985.
The Last and First Eskimos by Robert Coles with photographs by Alex Harris. Boston, 1978.
The Old Ones of New Mexico by Robert Coles with photographs by Alex Harris. Albuquerque, 1973.

DAVID HUSOM
Born 1948 Minneapolis, Minnesota
Lives in Saint Paul, Minnesota

EDUCATION
University of Minnesota, Minneapolis, M.F.A. in Photography and Film, 1973
University of Minnesota, Minneapolis, B.F.A. in Photography and Film, 1970

SELECTED EXHIBITIONS
Midwestern Vernacular: Fairgrounds and River Towns—Photography by David Husom, Baldwin Photographic Gallery, Middle Tennessee State University, Murfreesboro, 2005
*Portland Art Center, Maine, 1985
Fairgrounds: A Photographic Survey, Sioux City Art Center, Iowa, 1983 (group exhibition)
*Southern Light Gallery, Amarillo, Texas, 1982
Six Photographers, The College of St. Catherine, St. Paul, Minnesota, 1978 (traveling group exhibition)
*Hanson-Cowles Gallery, Minneapolis, Minnesota, 1977

SELECTED PUBLICATION
Six Photographers. Saint Paul, Minn., 1978.

MARY KOCOL
Born 1962 Hartford, Connecticut
Lives in Somerville, Massachusetts

EDUCATION
Rhode Island School of Design, Providence, M.F.A. in Photography, 1987
University of Connecticut, Storrs, B.F.A. in Photography, 1984

SELECTED EXHIBITIONS
Collecting Light: Pictures from the Winter Season, Julia Margaret Cameron Museum, Isle of Wight, Great Britain, 2005–6
Mary Kocol: Collecting Light, Gallery Naga Fine Arts, Boston, 2004
Mary Kocol: Recent Work, Gallery Naga Fine Arts, Boston, 2002
Recent Color Photographs, Somerville Museum, Massachusetts, 1992
Pleasures and Terrors of Domestic Comfort, Museum of Modern Art, New York, 1991 (traveling group exhibition)
*Sarah Doyle Gallery, Brown University, Providence, Rhode Island, 1989

SELECTED PUBLICATION
Pleasures and Terrors of Domestic Comfort by Peter Galassi. New York, 1991.

JOEL MEYEROWITZ
Born 1938 New York
Lives in New York and Provincetown, Massachusetts

EDUCATION
Ohio State University, Columbus, B.A. in Painting and Medical Drawing, 1959

SELECTED EXHIBITIONS
After September 11: Images from Ground Zero, Center for Documentary Arts, Salt Lake City, Utah, 2003 (traveling)
Looking South: New York Landscapes, 1981–2001. Ariel Meyerowitz Gallery, New York, 2001
Early Street Work, 1966–1976, Ariel Meyerowitz Gallery, New York, 2000
At the Water's Edge, Sandra Berler Gallery, Washington, D.C., 1996
Joel Meyerowitz: On the Street, Color Photographs, 1963–1973, Art Institute of Chicago, 1994–95
The White Nights, Cleveland Museum of Fine Arts, 1989
A Summer's Day, Hong Kong Arts Centre, 1985 (traveling)
St. Louis and the Arch: Photographs by Joel Meyerowitz, St. Louis Art Museum, Missouri, 1979
Cape Light: Color Photographs by Joel Meyerowitz, Museum of Fine Arts, Boston, 1978
My European Trip: Photographs from a Moving Car, Museum of Modern Art, New York, 1968

SELECTED PUBLICATIONS
Tuscany: Inside the Light by Joel Meyerowitz and Maggie Barrett. New York, 2003.
Joel Meyerowitz by Colin Westerbeck. London; New York, 2001.
Bay/Sky by Joel Meyerowitz with foreword by Norman Mailer. Boston, 1993.
Creating a Sense of Place by Joel Meyerowitz. Washington, D.C., 1990.

St. Louis and the Arch: Photographs by Joel Meyerowitz with preface by James N. Wood. Boston, 1980.

Cape Light: Color Photographs by Joel Meyerowitz with foreword by Clifford S. Ackley and interview by Bruce K. MacDonald. Boston, 1978.

SHERON RUPP
Born 1943 Mansfield, Ohio
Lives in Northampton, Massachusetts

EDUCATION
University of Massachusetts, Amherst, M.F.A. in Photography, 1982
Denison University, Granville, Ohio, B.A. in Sociology and Psychology, 1965

SELECTED EXHIBITIONS
Picturing Northampton, Smith College Museum of Art, Northampton, Massachusetts, 2004 (group exhibition)
Lens Landscape, Museum of Fine Arts, Boston, 2002–3 (group exhibition)
Game Face, Smithsonian Institution, Arts and Industries Building, Washington, D.C., 2001–2 (traveling group exhibition)
In Montana with Beth, Cleveland Museum of Art, 2000
Family Documents: Photographs by Doug Dubois and Sheron Rupp, Columbus Museum of Art, Ohio, 1997–98 (group exhibition)
*Carpenter Center for Visual Arts, Harvard University, Cambridge, Massachusetts, 1997
*O. K. Harris Gallery, New York, 1992
Pleasures and Terrors of Domestic Comfort, Museum of Modern Art, New York, 1991 (traveling group exhibition)
Sheron Rupp, Blue Sky Gallery, Portland, Oregon, 1991
Sheron Rupp: Color Photographs, Photo Center Gallery, New York University, Tisch School of the Arts, New York, 1987

SELECTED PUBLICATIONS
Picturing Northampton. Northampton, Mass., 2004.
Pleasures and Terrors of Domestic Comfort by Peter Galassi. New York, 1991.
Cross Currents/Cross Country: Recent Photography from the Bay Area and Massachusetts with essays by Anne Wilkes Tucker and Pamela Allura. San Francisco; Boston, 1988.

STEPHEN SHORE
Born 1947 New York
Lives in Stone Ridge, New York

EDUCATION
Photographic training at a workshop given by Minor White, 1970

SELECTED EXHIBITIONS
Stephen Shore: American Surfaces, P.S.1 Contemporary Art Center, Long Island City, New York, 2005–6
The Biographical Landscape: The Photography of Stephen Shore, 1968–1993, organized by Aperture Foundation, 2004 (traveling)
Uncommon Places: The Complete Works: Photographs by Stephen Shore, 303 Gallery, New York, 2003

American Surfaces, 1972, SK Stiftung Kultur, Cologne, Germany, 1999 (traveling)
Stephen Shore: Photographs, 1973–1993, Westfälischer Kunstverein, Münster, Germany, 1995 (traveling)
Stephen Shore, Center for Creative Photography, Tucson, 1985
Stephen Shore, Art Institute of Chicago, 1984
Stephen Shore, Museum of Modern Art, New York, 1976
Stephen Shore, Metropolitan Museum of Art, New York, 1971

SELECTED PUBLICATIONS
Stephen Shore: Uncommon Places: The Complete Works with essay by Stephan Schmidt-Wulffen and conversation with Lynne Tillman. New York, 2004.
Essex County by Stephen Shore. Tucson, 2002.
Stephen Shore, Uncommon Places: Fifty Unpublished Photographs, 1973–1978. Düsseldorf; Paris, 2002.
American Surfaces, 1972 by Stephen Shore. Munich, 1999.
The Nature of Photographs by Stephen Shore. Baltimore, 1998.
Stephen Shore: Photographs, 1973–1993, ed. Heinz Liesbrock with introduction by James L. Enyeart and texts by Hilla and Bernd Becher et al. London, 1995.
The Gardens at Giverny: A View of Monet's World by Stephen Shore with essays by Gerald Van Der Kemp and Daniel Wildenstein and introduction by John Rewald. Millerton, N.Y., 1983.
Uncommon Places: Photographs by Stephen Shore. Millerton, N.Y, 1982.

GREGORY SPAID
Born 1946 Mishawaka, Indiana
Lives in Gambier, Ohio

EDUCATION
Indiana University, Bloomington, M.F.A. in Art, 1976
Kenyon College, Gambier, Ohio, B.A., 1969

SELECTED EXHIBITIONS
Claiming the Landscape, Alva Gallery, New London, Connecticut, 2002 (group exhibition)
Plain Pictures, Etc., Kenyon College, Gambier, Ohio, 1997
Gregory Spaid, The Midtown Y Gallery, New York, 1994
Gregory Spaid Photographs, Pittsburgh Filmmakers Gallery, 1994
Gregory Spaid's Road Show, Colburn Gallery, Kenyon College, Gambier, Ohio, 1985
Anonymous Walls, Etc., Photographs by Gregory Spaid, Common Gallery, Columbus, Indiana, 1977

SELECTED PUBLICATIONS
On Nantucket by Gregory Spaid. New London, N.H., 2002.
The Man Who Created Paradise by Gene Logsdon with photographs by Gregory Spaid and foreword by Wendell Berry. Athens, Ohio, 2001.
Grace by Gregory Spaid. New London, N.H., 2000.

JOEL STERNFELD
Born 1944 New York
Lives in New York

EDUCATION
Dartmouth College, Hanover, New Hampshire, B.A. in Art, 1965

SELECTED EXHIBITIONS
Sweet Earth: Experimental Utopias in America, Luhring Augustine Gallery, New York, 2005
Joel Sternfeld: Walking the High Line, Pace/MacGill Gallery, New York, 2001–2
Stranger Passing: Collected Portraits by Joel Sternfeld, San Francisco Museum of Modern Art, 2001
On This Site: Landscape in Memoriam, Art Institute of Chicago, 1997
Campagna Romana: The Roman Countryside, Museum of Fine Arts, Boston, 1992 (traveling)
American Prospects: Photographs of Joel Sternfeld, Museum of Fine Arts, Houston, Texas, 1987 (traveling)
Joel Sternfeld, Dartmouth College, Hanover, New Hampshire, 1985 (traveling)
Three Americans: Photographs by Robert Adams, Jim Goldberg, and Joel Sternfeld, Museum of Modern Art, New York, 1984 (group exhibition)
Larry Fink and Joel Sternfeld, San Francisco Museum of Modern Art, 1981 (group exhibition)
*Pennsylvania Academy of the Fine Arts, Philadelphia, 1976

SELECTED PUBLICATIONS
Sweet Earth: Experimental Utopias in America by Joel Sternfeld. Göttingen, Germany, 2006.
Treading on Kings: Protesting the G8 in Genoa by Joel Sternfeld. Göttingen, Germany, 2002.
Joel Sternfeld: Walking the High Line with essays by Adam Gopnik and John Stilgoe. Göttingen, Germany, 2001.
Stranger Passing by Joel Sternfeld with essays by Douglas R. Nickel and Ian Frazier. Boston; London, 2001.
Hart Island by Melinda Hunt and Joel Sternfeld. Zurich; New York, 1998.
On This Site: Landscape in Memoriam by Joel Sternfeld. San Francisco, 1996.
Campagna Romana: The Countryside of Ancient Rome by Joel Sternfeld with essays by Richard Brilliant and Theodore E. Stebbins Jr. New York, 1992.
American Prospects: Photographs by Joel Sternfeld with introduction by Andy Grundberg and afterword by Anne W. Tucker. New York, 1987.

JACK D. TEEMER JR.
Born 1948 Baltimore
Died 1992 Dayton, Ohio

EDUCATION
University of Maryland, Baltimore, M.F.A., 1979
University of Maryland, Baltimore, B.A., 1977

SELECTED EXHIBITIONS
*Akron Art Museum, Ohio, 1983
*Blue Sky Gallery, Portland, Oregon, 1983
RTA#12, Creative Photography Gallery, University of Dayton, Ohio, 1981
*Hartman Gallery, Baltimore, 1979

SELECTED PUBLICATION
American Independents: Eighteen Color Photographers by Sally Eauclaire. New York, 1987.

GEORGE A. TICE
Born 1938 Newark
Lives in Atlantic Highlands, New Jersey

EDUCATION
Joined a camera club at age fourteen and briefly studied commercial photography at Newark Vocational and Technical High School

SELECTED EXHIBITIONS
George Tice: Urban Landscapes, International Center of Photography, New York, 2002
George Tice: Selected Photographs, 1953–1999, Ariel Meyerowitz, New York, 2000
Stone Walls, Grey Skies, National Museum of Photography, Film and Television, Bradford, England, 1991
George Tice: "Hometowns," The Photographer's Gallery, Palo Alto, California, 1989
George A. Tice, Photographic Museum of Finland, Helsinki, 1985
Urban Landscapes, Rutgers University Art Gallery, New Brunswick, New Jersey, 1975
Paterson, New Jersey, Metropolitan Museum of Art, New York, 1972
Fields of Peace, Witkin Gallery, New York, 1970
Recent Photographs, Gallery 216, New York, 1966

SELECTED PUBLICATIONS
George Tice: Urban Landscapes with introduction by Brian Wallis. New York, 2002.
George Tice: Selected Photographs, 1953–1999. Boston, 2001.
Hometowns: An American Pilgrimage by George A. Tice. Boston, 1988.
Urban Landscapes: A New Jersey Portrait by George A. Tice. New Brunswick, N.J., 1975.
Seacoast Maine: People and Places by Martin Dibner with photographs by George A. Tice. New York, 1973.
Paterson by George A. Tice. New Brunswick, N.J., 1972.
Fields of Peace: A Pennsylvania German Album with text by Millen Brand and photographs by George A. Tice. New York, 1970.

CAMILO JOSÉ VERGARA
Born 1944 Santiago, Chile
Lives in New York

EDUCATION
Columbia University, New York, M.A. in Sociology 1977
University of Notre Dame, South Bend, Indiana, B.A. in Sociology, 1968

SELECTED EXHIBITIONS
*Gallery of Photography, Dublin, Ireland, 2006
Subway Memories: Photographs by Camilo José Vergara, Museum of the City of New York, 2004-5
Twin Towers Remembered, National Building Museum, Washington, D.C., 2001
Camilo José Vergara-American Ruins, Rose Gallery, Los Angeles, 2000
El Nuevo Mundo: The Landscape of Latino Los Angeles, Cooper-Hewitt National Design Museum, Smithsonian Institution, New York, 1999 (traveling)
Vergara's Chicago, Chicago Historical Society, 1999
They Saw a Very Great Future Here, Getty Research Institute, Los Angeles, 1996
In Transit, New Museum of Contemporary Art, New York, 1995
The New American Ghetto, Columbia University School of Architecture, New York, 1992 (traveling)

SELECTED PUBLICATIONS
How the Other Half Worships by Camilo José Vergara. New Brunswick, N.J., 2005.
Unexpected Chicagoland by Camilo José Vergara and Timothy J. Samuelson. New York, 2001.
American Ruins by Camilo José Vergara. New York, 1999.
The New American Ghetto by Camilo José Vergara. New Brunswick, N.J., 1995.
Silent Cities: The Evolution of the American Cemetery by Kenneth T. Jackson with photographs by Camilo José Vergara. New York, 1989.

Note: Page numbers in *italics*
refer to illustrations.